SHOOTING KENNEDY

E. F. Jost
Buffalo
10/23/03

UNIVERSITY OF CALIFORNIA PRESS

Berkeley Los Angeles London

SHOOTING KENNEDY

JFK AND THE CULTURE OF IMAGES

David M. Lubin

University of California Press
Berkeley and Los Angeles, California

University of California Press, Ltd.
London, England

Library of Congress Cataloging-in-Publication Data

Lubin, David

 Shooting Kennedy : JFK and the culture of images / David Lubin.
 p. cm.
 ISBN 0-520-22985-1
 1. Kennedy, John F. (John Fitzgerald), 1917–1963—Pictorial works.
 2. Onassis, Jacqueline Kennedy, 1929—Pictorial works. 3. Kennedy,
 John F. (John Fitzgerald), 1917–1963—Assassination—Pictorial works.
 4. Presidents—United States—Pictorial works. 5. Presidents' spouses—
 United States—Pictorial works. 6. Photography—Social aspects—
 United States—History— 20th century. 7. Mass media—Social
 aspects—United States—History—20th century. 8. Popular culture—
 United States—History—20th century. 9. Art and popular culture—
 United States—History—20th century. 10. United States—Civilization—
 1945–. I. Title: JFK and the culture of images. II. Title.
E842.1 .L83 2003
306'.0973'09045—dc21 2003001856

Manufactured in Canada

12 11 10 09 08 07 06 05 04 03
10 9 8 7 6 5 4 3 2 1

Published with the assistance of the Getty Grant Program.

*The publisher also gratefully acknowledges the generous
contribution to this book provided by the Art Endowment
of the University of California Press Associates, which is
supported by a major gift from the Ahmanson Foundation.*

CONTENTS

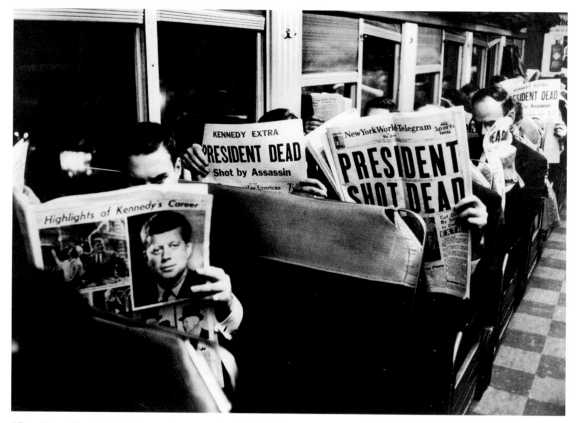

"President Shot Dead," November 22, 1963 (Carl Mydans, photographer)

PREFACE AND ACKNOWLEDGMENTS

John F. Kennedy's assassination was not televised. Yet within fifteen minutes of the shooting, as news bulletins interrupted radio and television broadcasts throughout the land, half the population of the United States learned of the event, and within the hour, nine out of ten Americans knew that the president had been shot. By late afternoon, according to statistical surveys, virtually everyone in the continental United States who was capable of understanding knew that the president was dead. The rest of the world found out almost as quickly. "The news traveled like some deadly contagion," a reporter wrote from London. In Moscow, a TV announcer burst into tears on the air. In what amounted to a poignant demonstration of the newly emerging concept of the Earth as a global village, spontaneous gatherings of mourners assembled in public plazas throughout the world, east and west, with lit candles, solemn faces, and photographs of the slain president framed in black bunting.

A single death is a tragedy, said Joseph Stalin; a million, a statistic. The brutal realism of his remark seems well founded. The genocidal slayings and catastrophic mass deaths that have punctuated the global rhythms of the past century have stirred onlookers with emotions of horror, pity, and outrage, and sooner or later have resulted in concerted diplomatic, humanitarian, or military efforts to prevent more killing. But, as Stalin recognized, death en masse fails to move observers in the way that tragedy does, because the dead and dying remain largely nameless and faceless and thus are quickly forgotten by those who never knew them in the first place.

Millions of people throughout the world felt as though they knew Jack Kennedy. He appeared frequently in their living rooms, brought there almost daily by newspapers, magazines, radio, and television. Listening to his memorably eloquent speeches, enjoying the delicious offhand wit of his televised press conferences, and poring over the extensive photo coverage that he and his beautiful young family received during the golden age of popular picture magazines such as *Life* and *Look*, observers in Amer-

ica and abroad experienced a rapport with Kennedy, whose aura was that of someone remarkable yet reassuringly familiar.

Given that this book hinges on the shooting of JFK and filters that event through a wide-ranging selection of art and popular culture from the time, perhaps I should lay out my own limited memories of that weekend as a seventh-grader in Columbus, Ohio. In all, they consist of four scenic images. In one I sit at my school desk looking up at the loudspeaker to take in the disembodied voice of the principal, Mr. Stoltzenberg, as he announces that the president lies dying in Dallas (though I'm sure he didn't put it that way). I remember glancing at a pretty girl in my class, Jackie Wagner, who sported a "Jackie" haircut and idolized the first lady, but I must confess I can't recall her reaction to the news. In the second memory I am at home that rainy Friday evening. My father grumbles that instead of respectfully going dark for the weekend, our neighborhood movie theater, owned, no less, by a disreputable cousin of ours, is proceeding with its scheduled screenings of the latest Jayne Mansfield sex farce, *Promises! Promises!* In the third memory tableau, our family is gathered around the television set in my parents' bedroom a day and a half later when we see the accused assassin, Lee Harvey Oswald, gunned down in the Dallas police station by Jack Ruby. Finally, I remember the tediously slow, endlessly drawn-out funeral mass and procession on television all day on a school-free Monday when I would much rather have watched game shows and *I Love Lucy* reruns. Instead of hearing the laugh tracks I would have preferred, I listened to muffled drums, clip-clopping horses, and news announcers who filled long stretches of air time with either somber silence or repetitive commentaries delivered in hushed, reverential tones.

As may be clear by now, this book is only partially about John Kennedy. In a way, he's my MacGuffin. "MacGuffin" is the term Alfred Hitchcock used for a narrative pretext; it's the question or object of inquiry that starts one of his plots in motion (why did the lady vanish? why do the birds attack?) and keeps it rolling along, but it's not the real reason he wants to tell the story. This book is less about JFK than about the television I didn't get to watch the day of his funeral. It's about that TV set in the parental bedroom. It's about Jayne Mansfield's bosoms (as we called them in those days), indecorously displayed, despite the national tragedy, on the screen of my local cinema but completely off-limits to everything but the feverish imagination of my seventh-grade self. It's about the ineluctable interplay in modern America between desire (the booty of real or imaginary pleasures constantly dangled before us for a price) and death (which, it must be said, can also be a source of pleasure, as for example in lurid headlines, celebrity funerals, and maudlin movies-of-the-week about fatal ailments). In the book I attempt to map the dialectic in postwar America between self-gratification and public obligation, between popular culture and history.

When I was growing up, history and obligation (in the form, let's say, of home-

work or that televised funeral) were always supposed to trump the self-indulgence and narcissistic pleasures promised by pop culture (comic books, movies, fast food) but rarely did so in a clean, decisive way. *Shooting Kennedy* examines their intersection. Culture, popular or otherwise, is not a mere side effect of history or a glittering distraction from it but is instead integral to it, playing an active role in the making of that history. Presidents, prime ministers, and princes, no less than butchers, bakers, and bankers, make decisions large and small based on paradigms of right and wrong established for them and continually reinforced—or challenged—by art and entertainment.

While the book investigates the representative lives and marriage of Jack and Jackie Kennedy and other members of their generation as revealed in photographs that spoke to viewers then—and still speak now—because of the ways those pictures borrowed from or played upon the ephemeral popular culture of the period, it also seeks to show how these same pictures derived from enduring works of art and literature produced over a span of centuries. Ancient Greek sculptors established a visual language for depicting male physical beauty that remains our underlying evaluative standard today; ancient Roman sculptors taught us what facial expression to wear and bodily postures to assume when we wish to dedicate ourselves to a noble cause; seventeenth-century Dutch painters gave us our current notions of what constitutes a cozy, homey environment; and eighteenth-century French artists provided the prototypes of aristocratic elegance and gravitas. It doesn't matter if you've never taken a class in art history; you cannot escape these artistic lineages. Through public and private education, mass reproduction, and constant imitation, parody, and distillation, they have filtered down into the public consciousness to affect in no small way our viewing of pictures of the Kennedys and the meanings we derive from them.

These are familiar images I am writing about, several of them among the best-known, most-often-reproduced pictures of the past century: the first lady climbing on the trunk of the Lincoln Continental convertible, whether to escape the killing pit or recover a fragment of her husband's skull; the new president, Lyndon Johnson, taking the oath of office on Air Force One; Ruby bursting out of a crowd to shoot Oswald; the stoic widow walking behind the funeral caisson or standing hand in hand with her children; adorable little John John poignantly saluting his fallen father. These images are so famous that they have in a sense become invisible. We look right past them, as if they were panes of glass, into what we take to be the historical reality behind them. We incorrectly assume that we scrutinize them only because they show important historical events as they were occurring and not because they are in themselves compelling works of art or popular culture, complex instances of visual representation that only appear to be simple, straightforward, and "see-through."

Iconic images such as these have generally received a free pass from careful visual and cultural analysis because they suppress their precedents and seem entirely natu-

ral. I'll grant you the obvious, that these images are famous because they show famous events, but only if we can add what's less obvious. And that is that these particular pictures, as opposed to other photos now forgotten, are famous even more because they look like or call to mind or somehow otherwise invoke and engage a wide range of previous pictures (and literatures and historical actors and events) that have already staked a claim on the cultural imagination. These images are not transparent, innocent, and natural but rather *historical*—not because they offer eyewitness reports on history but rather because they have a history, are part of a history, and further extend that history.

This book argues that the Kennedy images derive their power in good measure from their ability to activate latent memories of other powerful images in the histories of art and popular culture. I employ the methods of art history to explore how these images derived their shape and meaning from earlier images and the techniques of cultural history to examine the relationship of the images to the society that produced and imbibed them. Yet because it starts with the images themselves and proceeds outward to the social and cultural issues they raise, it often ranges backward and forward in time nonsequentially, juxtaposing historical eras in what might seem a nonrigorous and nonhistorical manner. My subject—the impact of images on images—calls for this nonlinear approach, as does my presiding theme, that any given moment of the present is invariably suffused with multiple and discontinuous moments of the past or, more specifically the case here, visual images make sense to us only because they reactivate images we've already absorbed, sometimes at second or third hand, and invested with meaning.

Inevitably we approach images with a vision both enlarged and constrained by what literary theorists call a horizon of expectations: the knowledge, presuppositions, and interpretive competency individual viewers bring to an image that enable them to make emotional and intellectual sense of it. Differing horizons of expectations lead to differing interpretations of the same picture.

Though my research has left me skeptical of conspiracy theories about the death of the president, *Shooting Kennedy* puts forth a conspiracy theory of its own—a visual-culture conspiracy theory. By tracing out an endless series of previously unnoticed links between people, events, and artistic products, it perhaps resembles the elaborate concoctions of those assassination buffs who latch onto the most random, disconnected pieces of evidence and proceed to show how they fall together into incriminating patterns.

The difference, though, is that the "conspiracy" explored here is not a murder plot but the accretion of a complex and ubiquitous visual culture year by year, decade by decade, century by century, of hundreds, thousands, and ultimately millions of "bits" of visual information. Moreover, I don't believe that this "conspiracy," if that's what

it can be called, is the handiwork of a powerful cabal in editorial offices, corporate boardrooms, and government bureaus that determines what the rest of us see, feel, and remember—although I warrant that that sort of operational behavior does in fact occur.

Instead, I think that visual culture (by which I also mean musical and narrative culture) is far too vast and pervasive to be under the conscious and deliberate control of any handful of people or organizations, secret or otherwise. The word *conspire* comes from the Latin prefix *com-* (together) and verb *spirare* (to breathe). Hence conspirators are those who breathe together. To live in the national, and now global, visual culture of America is almost automatically to conspire with millions of others in its maintenance and growth, breathing it in and breathing it out every day of our lives. We all partake of the oxygen of our communal visual environment, and it's virtually impossible for anyone either to make a visual image or make sense of it without drawing breath from that shared environment, which can be healthful and invigorating as well as toxic and stultifying.

For better or worse, we now live in an age when everything seems connected to everything else. In casual conversation we talk about the "small-world effect" and "six degrees of separation," affirming our sense of unsuspected connections through mutual acquaintances. In more serious terms, we worry about the rampant spread of AIDS and other ravaging diseases by way of long and difficult-to-break chains of sexual transmission. Environmentalists have shown us that we live amid interconnected ecosystems, the disruption of any one of which destabilizes all the others. We have learned that, through our telephones, we can "reach out and touch" others almost anywhere in the world and, through our computers and the Internet, we are linked—or caught—in a worldwide web, but also that fluctuations of the economy in the remotest corner of the globe cause ripple effects in the economy at home. Jet travel allows the first world to go touring the third but also, as September 11 demonstrated, the third to take its revenge on the first.

This is a book about connectivity: about links and relationships, especially during the postwar information age presided over by John F. Kennedy. Our perceptions of JFK and his era, not to mention our own, rely entirely upon endlessly replicated and infinitely elastic chains of images from art, literature, and the media that constantly inform us, often in contradictory ways, of who we are, who we ought to be, and where we belong.

I WISH TO THANK Jules Prown, Phil Smith, and Sarah Watts for their comments on some of my early forays into this material. My home institution, Wake Forest University, offered support in a variety of ways that include covering the cost of illustra-

tions and providing a succession of industrious research assistants: Brook Woods, Brooke Johnson, Adam Rutledge, Sarah Wiles, Elena Maria Jimenez, and Emily Hedgpeth. Among my seminar students whose research found its way into the following pages are Damon Chang (on the presidential motorcade), Kerry Church (food in 1963), Tamara Dunn (Bob Jackson's photograph of Ruby shooting Oswald), Alicia Haines (Marilyn Monroe over the subway grate), Laurie Hunt (the Zapruder film), Jessica Jackson (John John's salute), Emilie Johnson (travel and tourism), Dean Schwartz (passenger jets), and Kendall Scully (Happenings).

For their promptness, professionalism, and good cheer in helping me with my often arcane research questions, I'd also like to thank Matt Fulgham and Martha Murphy of the JFK Assassination Records Collection at the National Archive; James B. Hill of the JFK Library and Museum; Zoran Sinobad of the Motion Picture, Broadcasting, and Recorded Sound Division of the Library of Congress; and Megan Bryant and Gary Mack of the Sixth Floor Museum at Dealey Plaza.

My greatest intellectual debt in the writing of this book is to Alex Nemerov, Kirstin Ringelberg, Jennifer Roberts, and George Roeder. In their respective commentaries on the manuscript at various stages, each of them displayed a knack for conveying heavy insights with a light touch. I am particularly grateful to my editor, Stephanie Fay, who coaxed this project into being and judiciously guided it through each and every phase.

At last I come to Libby Lubin. How fortunate I am to have been married for a quarter of a century to such a clever writer, merciless editor, and beautiful companion.

1

Twenty-six Seconds

IT MAY BE THE saddest movie ever made. And only twenty-six seconds long. It's sad in the way that classical tragedy is sad, its hero tumbling from on high. Yet there's no catharsis here, no beam of illumination amid the darkness. From *Hamlet* or *Oedipus* we come away with self-knowledge, having seen our flaws writ large in the lives of the doomed prince and king. But what does this modern tragedy teach? Only that even the best, most powerful, most charismatic of us, shining in glory, riding in triumph, may be felled without notice by the meteorite from the sky.

The movie is sad in other ways. It's a domestic tragedy. A man is stricken suddenly and inexplicably, and his wife turns to him in befuddlement, not recognizing his plight. His elbows fly up and his hands jerk uncontrollably. She hastens to his side but is powerless to restore him to himself. Like some Halloween skeleton dangled on strings, he performs a demented *danse macabre* with those pumping arms and wagging hands, his nervous system twitching out of control, while she looks on aghast and makes a futile effort to stay his flailing appendages.

And then he's gone, the husband of ten years' time, the right half of his head a scarlet starburst as his body lurches toward her in a wicked parody of conjugal attraction. If the swift and brutal demise of a public hero is sad, so, this film implicitly claims, is the ultimate futility of love, marriage, and companionship.

We might call it a nihilist film. Or existentialist. Or dada. As I show later in this chapter, the twenty-six-second home movie made by the Dallas dressmaker Abraham Zapruder amply embodies the modernist art, theater, and philosophy emanating from

advanced circles in Europe and America in the postwar era. But for now I want to focus on its sadness.

It is sad, too, because it is a home movie, and home movies, no matter how joyful in subject or lighthearted in tone, ultimately suffuse their viewers with sadness. Let me explain. The first movies ever filmed were, in essence, home movies, not because they featured domestic subjects and settings but because amateurs made them. Two businessmen from Lyons, the brothers Lumière, invented a device for taking and projecting moving pictures. In the late summer of 1895 they set it up in front of their father's factory to film workers leaving at the end of a shift. The movie lasts but seconds, and nothing of consequence occurs. Workers simply pass through the plant gates and walk forward, in the direction of the camera.

Still, in its straightforward account of effervescent everyday life, this minuscule movie amounts to a memento mori, a reminder of human mortality. However vibrant the scene, however full of quotidian vivacity, it's a document of death, for its protagonists died long ago and their lives and way of living will never come again. Even though suppliers and advertisers of home movie merchandise have done everything in their power to promote the idea that home movies or videos are about *fun* and *joy* and *good times*, all the same, they are melancholy documents. They make plainly visible the decay that inevitably besets us all. They remind us that we rust.

The eighty-four-year-old Louis Lumière reminisced on the eve of his death about those first motion pictures that he and his brother, Auguste, had filmed so long ago, including one entitled *L'Arrive du train en gare* (The train enters the station). That film, he recalled, "which I took at the station of La Ciotat in 1895, shows on the platform a little girl who is skipping along, one hand held by her mother and the other by her nurse. The child is my eldest daughter, afterwards Mrs. Tratieux, and she is now four times a grandmother."

Home movies carry an aura of almost instant *pastness* that commercial films go to extraordinary lengths to erase. Even when they take place in distant history and attempt to re-create that history in the most persuasive manner possible, theatrical features need to have a contemporary feel and sheen about them to succeed at the box office. Just as scary rides at the amusement park must not be so dilapidated as to be truly scary, Hollywood movies about olden times must not seem truly old. Audiences prefer re-creations of the past to look brand-new. That is why the wordsmiths, hairdressers, costumers, set designers, cinematographers, and sound track composers are well paid for doing their job, which is to render the past palatable to contemporary tastes. (Claudette Colbert's tightly curled coiffure marks her version of *Cleopatra* as a stylish product of the early 1930s as distinctly as Elizabeth Taylor's heavily lacquered, pseudo-hieroglyphic hairstyle bespeaks the hairspray aesthetic of the early 1960s.) Home movies, which, to be sure, concern themselves with the present, not the past,

don't boast such high "production values." If they did, they'd no longer be home movies. Consequently they age almost immediately.

Thus, even if the Zapruder film did not bear witness to the assassination of a leader, the violent destruction of a human body, and the wreckage of a marriage, it would still be sad, confronting the viewer with *le temps perdu*. Madame Tratieux, a child when that train pulled into the station, will never be so again no matter how often the film is screened, nor will President and Mrs. Kennedy ever ride again in glory through the streets of Dallas on a bright November day except in the opening seconds of the dress-maker's home movie.

ABRAHAM ZAPRUDER DIED in 1970. Thirty years later I met his son, a Washington attorney. I asked him if he thought his father would have filmed the motorcade if Nixon had been president. He thought not. "My father loved Kennedy, and that's why he was there." So the motorcade footage, which ended up becoming assassination footage, was a political film from the start, in the sense that the man who made it was motivated by his enthusiasm for the leader he came to honor. But it also can and should be seen as a love film, in the sense that the filmmaker "loved Kennedy" and wished to share or disseminate that love with his loved ones—his family and friends—by making the film. When "Mr. Z.," as he was known, arrived at his office that day, his secretary reminded him that he had forgotten to bring in his camera. To have it available for the big event, he schlepped all the way back to his home in the suburbs—a labor of love, indeed.

A modest and religious man, profoundly committed to his family and temple, Abraham Zapruder was a Russian Jew born in a village outside Kiev in 1905, a time of unprecedented revolutionary upheaval. When sailors on the royal battleship *Potemkin* in Odessa mutinied at the inhumane living conditions imposed on them by their superiors, word of their revolt spread rapidly to shore, igniting a popular uprising that the czar's troops promptly and ferociously extinguished. Authorities blamed the unrest on the Jews and condoned pogroms (officially sanctioned, organized massacres) to punish the ethnic minority for problems facing the nation at large. The period of pogroms against the Jews had actually begun some quarter of a century earlier, in the aftermath of the assassination of Czar Alexander II by an anarchist group, the Nihilists. Hoping to escape forever the political terror to which he and his family had long been subjected, Zapruder immigrated to the United States in 1920, seizing the opportunity provided him by the Bolshevik Revolution.

After two decades of working in the dressmaking trade in New York, Zapruder moved to Dallas in 1941. Eight years later he opened his own business, manufacturing and marketing lines of dresses. Dallas provided a good home for him and his family, and he happily belonged to the city's small but prosperous Jewish community. But he

did not leave antisemitism behind in Russia, for it grew like a bad weed in Dallas, one of the most politically and religiously reactionary cities in Texas. President Kennedy's forthcoming trip delighted Zapruder, who expected it to boost the morale of the city's embattled liberal minority.

The day the presidential visit was announced, Zapruder fell into an informal lunch-counter debate with a stranger on the topic of civil rights. The stranger grudgingly admitted that the president and his attorney general brother, Robert, had the power to force their liberal views on Texans. "God made big people," the man said of the president. "And God made little people," he said, pointing to himself. Then he added, "But Colt made the .45 to even things out." Shocked, Zapruder snapped back, "People like you we don't need."

Hence Zapruder's act of filming the motorcade mixed love and politics. It affirmed his personal commitment to New Frontier liberalism as embodied by the thirty-fifth president. Loving Kennedy, for Zapruder, meant loving liberal America as an alternative to reactionary Russia, of either the czars or the Soviets, and reactionary Dallas. The home movie footage would therefore be his token of respect and love not only for his president but also for his wife and children and grandchildren, who were not at hand to see what he had only to drop down to the plaza below his office to see for himself.

HAVING CHARACTERIZED the Zapruder film as a home movie, I want to consider it now as a Hollywood film. It isn't one, of course, in the sense that it's not a contrivance or fiction produced on an industrial timetable and scale by professional actors, writers, set designers, cinematographers, and so forth. Nevertheless, the Zapruder film resembles the Hollywood studio movies that, at their peak, captivated the American imagination and, even in their decline during the television era, wielded an extraordinary influence on how Americans—and others worldwide—perceived reality.

It's worth noticing, for example, that the internal architecture of the Zapruder film conforms to the three-act structure of mainstream commercial feature film productions, whether comedy, drama, melodrama, action picture, or musical. According to that narrative formula, a relatively brief opening act concludes with a sudden dramatic turn of events, leading to a comparatively long middle act that climaxes in a third and final act. In the Zapruder movie the first "act" shows the president and his entourage proceeding down Elm Street ensconced in a mammoth convertible, beaming and waving at the crowd in a triumphant display of power and glory. This act ends abruptly when they pass behind a large road sign that momentarily blocks them from view. The long, painful middle act begins when they reemerge with the president clutching at his throat. Incredulous and alarmed, his wife gathers him in her arms. The second act

closes with the exploding of his head. In the final act she scrambles onto the trunk, and a Secret Service agent leaps aboard and pushes her back to her seat. The car disappears into a cavernous underpass, and so ends the terrible tale.

Narrative formula aside, the Zapruder film also resembles a Hollywood picture in its reliance on "star power." In fact, if Zapruder had captured the murder of an "unknown" in his home movie, no one besides police investigators or possibly the victim's family would have bothered to look at it again, and it certainly would not be famous today. You would not be reading about it now. But the movie that Abraham Zapruder produced that day in Dallas does have stars in it, and they happen to be two of the biggest ever to pass before the eye of a motion picture camera.

Hollywood invented movie stars as early as the 1910s. Before that, performers in movies were not even identified by name. A star was an actor or actress whose box-office appeal had already been determined by a previous film or stage production. Banks were more willing to lend studios money when these market-tested performers were assigned to productions. As soon as the cash value of name brand performers became clear, Hollywood set about perfecting the art of the star sell. Entire marketing subdivisions were created whose sole purpose was to manufacture stars. Studio publicity departments invented biographical backgrounds and off-camera daily lives for their stars in order to characterize them, in any given instance, as genuinely humble or heroic, exotic or erotic, ordinary or eccentric. Entertainment journalists, voracious for printable copy, eagerly transmitted these fabrications to readers whose own appetite for them was practically boundless.

One of the biggest stars of the silent cinema was Gloria Swanson, who emerged from semiretirement in 1950 to play Norma Desmond in Billy Wilder's acerbic deconstruction of the star system, *Sunset Boulevard*. So successful was Swanson at the peak of her popularity in the mid-1920s that when her contract with Paramount came up for renewal, the studio tried to lure her back into corporate servitude at the then astronomical sum of $17,500 a week. She chose independence instead and formed her own company, Swanson Productions, in partnership with her Irish-American lover, a self-made millionaire from Boston who had bidden a temporary farewell to his wife and children and gone out to Hollywood to make an even greater fortune in the film business. According to Swanson's autobiography, her lover fathered a child by her in 1929 and wanted desperately to leave his wife and children, but as a devout Catholic he couldn't do it. He was Joe Kennedy, the father of the twelve-year-old future president who would someday star in one of the most widely seen films of all time.

WHEN JOSEPH KENNEDY returned to his wife and children in the summer of 1929, he had succeeded in producing no fewer than seventy-six movies. Moreover, through

a series of acquisitions and mergers, he had created a new film company, Radio-Keith-Orpheum. In the 1930s RKO, as it came to be known, produced *King Kong, Little Women, Citizen Kane*, and the Astaire-Rogers musicals. Kennedy no longer ran the company, having liquidated his interests for $6 million before heading home. President Roosevelt returned Kennedy's lavish campaign favors by appointing him head of the new Securities and Exchange Commission in 1934 and four years later naming him the United States ambassador to the Court of St. James.

During the years of his political involvements and ambassadorial duties, Joe Kennedy retained his insider's knowledge of movie stardom as a carefully designed industrial commodity. At the end of World War II he set about manufacturing the greatest star of them all, choosing his oldest surviving son, Jack, for the part. But the senior Kennedy wasn't thinking of a Hollywood career for his boy. He wanted Jack to become nothing less than America's leading man, its president.

Kennedy believed that his scrawny second son had all the necessary raw materials. As he later clarified in an interview just before Jack's presidential campaign in 1960, Jack demonstrated extraordinary public magnetism. "Jack is the greatest attraction in the country today," he crowed. "I'll tell you how to sell more copies of a book. Put his picture on the cover. Why is it that when his picture is on the cover of *Life* or *Redbook* they sell a record number of copies? You advertise the fact that he will be at a dinner and you will break all records for attendance. He can draw more people to a fundraising dinner than Cary Grant or Jimmy Stewart. Why is that? He has more universal appeal."

Joe engineered his son's political career with considerable public relations savvy. Father and son together carefully attended to every detail of the young man's public image, from his expensively tailored clothing to his romantic, unruly haircut to his much-ballyhooed literary finesse. (His books, including *Profiles in Courage*, winner of a Pulitzer Prize, were largely ghostwritten by hired advisers.) In 1946, when Jack ran for Congress, Joe paid for the printing and circulation of a condensed *New Yorker* profile by Jack's friend John Hersey glorifying Ensign Kennedy's wartime adventures as commanding officer of a PT-boat in the Pacific. The former studio lord even sent his son to Hollywood for an extended stay to have a look around and see how stars are made.

Not that Joe foisted the Hollywood mindset on an unwilling participant. All his life John Kennedy was enamored of the movies. John Hellmann points out in *The Kennedy Obsession* that as a sickly, frequently bedridden child the future president ravenously devoured the manly heroics of boys' adventure stories and Hollywood epics and modeled himself upon them.

During his sojourn in the film capital, Jack carefully observed "the blinding magnetism" of male film stars such as Gary Cooper, Clark Gable, and Spencer Tracy. Ac-

cording to one of his close friends, he was "always interested in seeing whether he had it [sexual magnetism] or didn't," continually putting himself to the test with women to prove the potency of his manhood. "To me," said the friend, "that's always accounted for a lot of the numbers [of Jack's sexual partners], if you will. You know, does he have it or doesn't he have it?"

Another of Jack's friends from the 1940s described him as "very narcissistic. . . . I'd say, 'Jack, it's *ridiculous* for you to go out in the sun like that! You just can't wait to get down to Florida to get your tan in the quickest time so you can come back and look so handsome at these parties you go to.' And he'd say, 'Well, Henry, it's not only that I want to look that way, but it makes me feel that way. It gives me confidence, it makes me feel healthy. It makes me feel strong, healthy, attractive.'" Apparently many others, not only his numerous female admirers but also his male friends, and eventually a large segment of the American electorate, fed off the sense of self-confidence and health that Jack exuded.

And so here he comes down Elm Street in Dallas, sitting in the back seat of what surely must have been the world's heaviest, most impressive limousine. The crowds cheer and wave, like fans at a Hollywood premiere. His beautiful co-star, Jacqueline Kennedy, sits beside him, while the tall, movie-star-handsome governor of Texas, John Connally, scrunches into a jump seat, taking a markedly second-banana position.

TO REFER TO Jacqueline Bouvier Kennedy as a co-star understates her importance, for she, not her husband, is the true star of Zapruder's film. It's her show. She's the protagonist, the central consciousness and agent of audience identification. Her husband acts in the movie, but in an unconscious, mechanical way: the deadly bullets, which we cannot see, push at neural buttons and levers, also unseen, in his body and compel him to thrash mindlessly. By the time he comes into view from behind the road sign, he has ceased to be a sentient human being, a man of wit and charm and enormous political self-discipline and libidinal non-discipline. She, however, is altogether human in this extreme moment and thereby elicits our sympathetic response.

Let us stop for a moment and think about Mrs. Kennedy as, metaphorically, a movie star. We can do this by comparing her with actual film stars of the period. According to an annual poll of feature film exhibitors, the biggest box-office star of 1963, male or female, was Doris Day. Doris Day? The biggest draw of the year? Well, yes. She was also number one in 1960 and 1962 and would be again in 1964. In fact, Doris Day was the number one box-office star in America for the entire first half of the nineteen sixties (followed in order by John Wayne, Rock Hudson, Cary Grant, Jack Lemmon, and Elizabeth Taylor). In virtually every way, Jacqueline Bouvier Kennedy was the

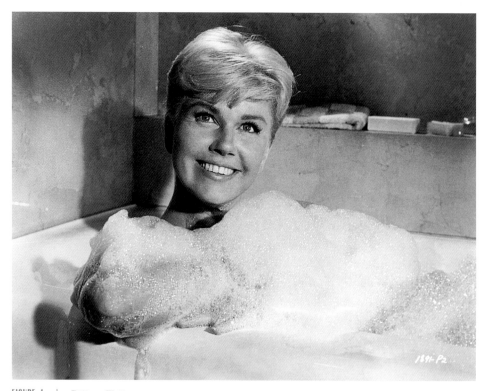

FIGURE 1 | *Pillow Talk*, 1959

antithesis of Doris Day: the one dark and slender, the epitome of boarding school polish and European sophistication; the other blond and cherubic, an embodiment of West Coast sunshine and all-American bounce.

Born in Cincinnati as Doris von Kappelhoff, Day started her show business career as a big-band singer and starred in numerous studio musicals of the 1950s. By the early 1960s, she had perfected the film persona for which she is now remembered: that of an overwhelmingly wholesome, plucky, happy-go-lucky virgin who always manages to resist her suitor's advances until the final fade-out presaging marriage. (Groucho Marx once quipped, "I've been around so long I can remember Doris Day before she was a virgin.") The perky and mildly sexual tone of her movies was conveyed in advance by their titles: *The Thrill of It All, Move Over, Darling, Pillow Talk, The Pajama Game, That Touch of Mink* (Fig. 1).

Despite the clear-cut differences between Jackie Kennedy and Doris Day, they each played a major role in an assassination movie. Jackie starred in Zapruder's, and Doris in one of Alfred Hitchcock's, the 1956 comic thriller *The Man Who Knew Too Much* (a remake of his 1934 British film by that title).

The attempted assassination in *The Man Who Knew Too Much* takes place in London's crowded Albert Hall during a concert performance. At the culmination of the film's major dramatic sequence, Day's character emits a shattering scream that causes the assassin to misfire. A happy ending ensues.

The catchy tune that Day sings twice during the course of the film, "Whatever Will Be, Will Be (*Que Sera, Sera*)," won that year's Oscar for best song, and its cheerfully accepting refrain became a vocal icon of the Eisenhower era. It remained one during the Kennedy years too. The lyrics recount that when the singer, as a child, asked her mother if she would be beautiful, rich, and famous, the mother counseled her, There's no point in worrying about the future. Whatever will be, will be.

American popular culture of the 1950s and early 1960s was filled with such expressions of complacent acceptance. Studied optimism was an official ideology of the times. Frank Sinatra's 1959 Oscar-winning hit, "High Hopes," from Frank Capra's *Hole in the Head*, encouraged the listener to follow the example of "a silly old ant" and persist in expecting good things to happen:

> Once there was a silly old ant
> Thought he'd move a rubber tree plant.
> Anyone knows an ant can't
> Move a rubber tree plant.
> But he's got high hopes,
> He's got HIGH HOPES.
> High apple-pie-in-the-sky hopes.

For the 1960 Democratic primaries, Sinatra's songwriters adapted the hit, making it a campaign anthem for his friend Jack Kennedy:

> K-E-double-N-E-D-Y
> Jack's the nation's favorite guy.
> Everyone wants to back Jack.
> Jack is on the right track.
> And he's got HIGH HOPES,
> High apple-pie-in-the-sky hopes.

For the first eight seconds or so of the Zapruder film, "High Hopes" or "Whatever Will Be, Will Be" might have been appended as sound track. But for the rest of the movie, such bubbly music and pat phrases would be grotesquely inappropriate. They could even seem scathingly comic, along the lines of what Stanley Kubrick achieved at the end of *Dr. Strangelove* (completed shortly after the assassination), when he satirically juxtaposed Vera Lynn's World War II–era hit "We'll Meet Again" with a mon-

tage of mushroom clouds representing a civilization-ending nuclear holocaust. Or think of Alex in Kubrick's *Clockwork Orange* (1971) merrily belting out the lyrics to "Singin' in the Rain" while raping a woman and torturing her husband. Historically and thematically, the Zapruder film marks an almost perfect divide between Doris Day's "Whatever Will Be, Will Be" and Alex's "Singin' in the Rain."

ODDLY ENOUGH, an assassination also marked Elizabeth Taylor's most famous role, that of the Egyptian queen Cleopatra in the four-hour, $44-million epic that, thanks to enormous cost overruns and a scorching and scandalous offscreen romance between the leads, was unquestionably the most talked-about film of 1963 (Fig. 2). Drawn from Plutarch, Suetonius, Shakespeare, and Shaw, as well as various earlier Hollywood costume spectaculars, not to mention Taylor's own tabloid lifestyle, *Cleopatra* purports to tell a story of political and sexual intrigue in the ancient world. Shortly after her magnificent arrival in Rome (the most spectacular set piece in the film), the Queen of the Nile loses her lover Julius Caesar when he is struck down in the Forum by a group of conspirators who fear his imperial ambitions.

The parallels between Caesar and Kennedy, Cleopatra and Jackie, and the Roman Forum and Dealey Plaza are not, of course, exact. Indeed, even to suggest a comparison between real-life tragedy and the commercial extravaganza set forth by Hollywood-on-the-Tiber risks offending. Yet the point of this book is to argue that participants and onlookers alike always and inevitably understand historical events, tragic or otherwise, through culture, high, low, and in-between.

I doubt that anyone in 1963 thought of linking the Kennedy assassination to the assassination sequence in *The Man Who Knew Too Much* or compared Jackie's entry into Dallas with Cleopatra's into Rome. Yet these popular-culture analogues were in the air in 1963, familiar references, however unconscious, that would have given a shocked population some greater conceptual purchase on the otherwise inconceivable occurrences of November 22.

I would even say that the public responded to Jackie Kennedy both before and during the assassination weekend by taking account of the conspicuous ways in which she differed from Liz Taylor but was also like her. The differences were more readily apparent. Though both women were dark-haired, wide-eyed beauties, Jackie was tall, thin, and small-breasted, whereas Liz was diminutive in height and buxom. While Taylor's private life was notoriously public, the first lady's was famously private. (The mass media made much of her yearning to keep her personal life to herself, even as they extravagantly ignored that yearning.) The public viewed Liz as a seductress, a manhunter and home wrecker. By contrast, they regarded the first lady as a homebody, refined and elegant and wholeheartedly devoted to her husband and two small children.

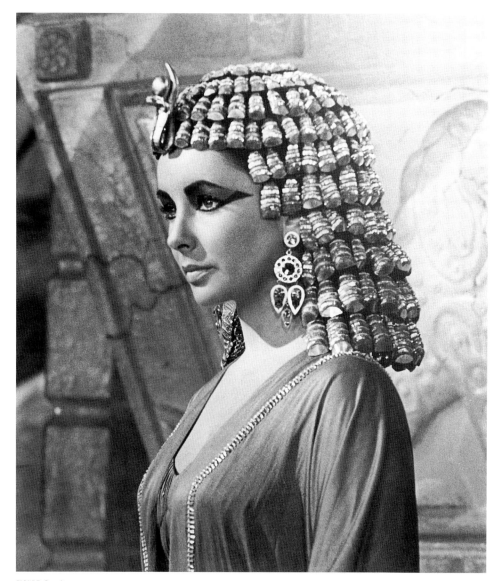

FIGURE 2 | *Cleopatra,* 1963

Liz, everyone knew, had been given a million dollars to impersonate an Egyptian queen, the largest sum ever paid to a single actor in the history of the profession. Jackie, as she was affectionately called by the American people at large, was regarded as a queenly woman who didn't need to impersonate anyone, or be paid exorbitant fees— if any fees at all—to share her beauty with an adoring public. Moreover, she proved herself an even bigger star in the size of the audience she attracted. When she hosted

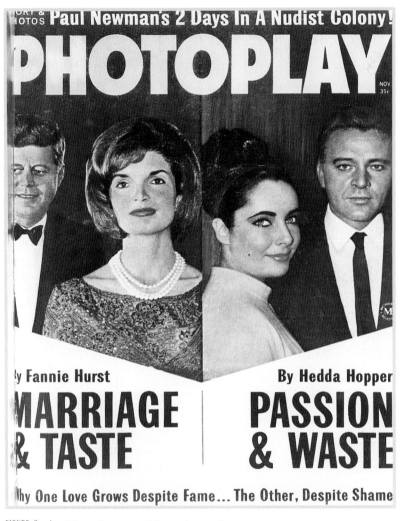

FIGURE 3 | *Photoplay* cover, November 1963

a sixty-minute taped TV program entitled "A Tour of the White House with Mrs. John F. Kennedy," which was broadcast simultaneously on the CBS and NBC networks on Valentine's Day 1962, her performance drew more than 45 million viewers in America and an estimated several hundred million more worldwide.

Whatever their differences, Jackie and Liz jointly ruled the supermarket tabloids of the era. Side by side head-and-shoulder shots of them adorned the cover of the June 1962 issue of *Photoplay*, whose headline promised a story of "AMERICA'S 2 QUEENS! A comparison of their days and nights! How they raise their children! How they treat their men!" The cover of the November 1963 *Photoplay* (possibly still on the stands

 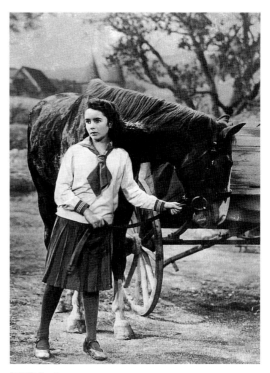

FIGURE 4 | East Hampton, New York, 1934

FIGURE 5 | *National Velvet,* 1944

at the time of the assassination) paired a picture of Jackie and her husband with one of Liz and her paramour, Richard Burton. Beneath the one photo was the caption MAR-RIAGE & TASTE, under the other, PASSION & WASTE (Fig. 3). However differently the tabloid press constructed these two couples in the public imagination, they were surely at that time the two most famous couples on the planet. Which others could even begin to compare? Not Queen Elizabeth and Prince Philip, or the Duke and Duchess of Edinburgh, or Princess Grace and Prince Ranier.

In popular myth, Jackie and Liz (who was three years younger) shared other characteristics. For example, Jackie had been riding and showing horses since she was a child (Fig. 4). Liz, too, was associated with horses, having first achieved fame as the spirited adolescent horseback rider in the 1944 MGM classic *National Velvet* (Fig. 5).

Seven years later, audiences used to Liz's roles as an ingenue were stunned by her sensual beauty in her first adult role, that of a debutante in *A Place in the Sun.* Young Jacqueline Bouvier, whom *Time* named "Debutante of the Year" in 1947, was not yet a striking beauty, but by all accounts she was moving in that direction. Although the 1951 satire of American family life *Father of the Bride* detailed the inherently comic tribulations of mounting a wedding, it nonetheless showed a nation of filmgoers a sto-

rybook wedding, Hollywood style, with Taylor the bride. In 1953, with her wedding to Senator Jack Kennedy in Newport, Rhode Island, Bouvier provided the real thing (if a "storybook wedding" can ever be regarded as a "real thing").

Most of all, the two women shared a tragic aura. When Taylor's (third) husband Michael Todd, a film producer, died in a plane crash in 1958, the widow received over 3,500 telegrams of sympathy, including one from the first lady, Mamie Eisenhower. In 1961 a string of illnesses culminating in a life-threatening double pneumonia necessitated an emergency tracheotomy. The press maintained a vigil at her hospital, while bystanders in the street wept openly and piled up flowers on the hospital steps, as though at a shrine. Jacqueline Kennedy received similar expressions of public sympathy in the summer of 1963 when she gave birth prematurely to an infant, Patrick, who lived just thirty-nine hours. Both women seemed ennobled by their respective sufferings and perilous, unsought intimacy with death.

The point of these comparisons to Doris Day and Elizabeth Taylor is that the female protagonist of the Zapruder film existed in an imaginary realm already populated by those women and the various roles they played in movies as well as in the popular press. Like other film stars I discuss later, they formed an important part of the context that shaped the public's perception of the first lady before, during, and after the assassination weekend. Because the public could not know the first lady except through what they heard and saw of her in the news and in entertainment magazines (or what they thought they discerned beneath the stiff formality of her televised White House tour), they had to rely on her Hollywood surrogates and opposites—Doris, Liz, Audrey, Grace, Marilyn—to find some way into her ordeal and experience it vicariously with all the pain and, yes, pleasure that Hollywood allows.

I HOPE BY NOW to have established that the Zapruder film is more than a forensic or historical document, and more than a home movie. It's also a narrative film, however brief, and in this it resembles the Hollywood feature films that shaped the perceptions, as well as values, dreams, and expectations, of its cast (the Kennedys), production crew (Abraham Zapruder), and worldwide audience.

It wasn't made to be a Hollywood-style movie, any more than the urinal that Marcel Duchamp purchased in 1917, signed, and affixed to a gallery wall with the title *Fountain* was originally made to be a work of fine art. Neither the maker's intention nor the object's initial purpose can limit the meanings it comes to acquire under new, often unexpected conditions of use.

What I'm hoping to get at here is a sense in which the twenty-six-second Zapruder film is one of the most powerful cinematic texts of the twentieth century. Like the

great film classics—*Battleship Potemkin* or *Rashomon*, for example—it has been scrutinized closely, though the frame-by-frame analysis accorded it differs from the shot-by-shot study of those much longer masterpieces. The Zapruder film, like such epoch-defining popular hits as *The Birth of a Nation*, *Gone with the Wind*, and *Star Wars*, has grabbed hold of imaginations across the world, affecting the way that vast numbers of viewers have reconceived power, love, conflict, and history. If major works of cinematic art combine beauty, tragedy, happiness, and horror so as to move and instruct spectators and show them dimensions of reality they have not previously seen or understood, then the Zapruder film may qualify as such a work.

BUT WHERE IS THE ANTAGONIST—or, in pop culture terms, the villain—of this drama? No Aristotelian adversary steps forward directly and visibly to thwart the ambitions of the hero, but Zapruder's film implies the presence of an antagonist, an author of the violence that takes place. The movie creates in the viewer's imagination an angle of vision besides that of the occupants of the car and that of Zapruder on the hillside. It suggests a triangulation of vision: both Zapruder with his movie camera and X with his rifle look through an optical sighting mechanism to "shoot" the president.

In Chapter 8, I'll talk about Lee Harvey Oswald, the man accused of assassinating the president. But for now I want to think of him more abstractly, as a figure of solitude and estrangement, the classic urban "loner" of late-nineteenth- and twentieth-century art, fiction, and film. To borrow the term made famous by Ralph Ellison's 1952 novel about black alienation in white America, the unseen killer in Zapruder's film is an "invisible man." His literary forebears are Dostoyevsky's underground men—Raskolnikov in *Crime and Punishment* and the unnamed narrator in *Notes from the Underground*—or the quasi-rational, quasi-mad protagonists of the turn-of-the-century Norwegian novelist Knut Hamsun.

These are men who wait alone in rooms, peering through windows at the world outside, from which they are detached and estranged. "Oswald"—for let us so designate the unseen antagonist implied by Zapruder's cinematic narrative—is stationed at his window like the figure in an Edward Hopper painting. Sometimes Hopper's men are literally alone, as in *Office in a Small City* (1953), in which a man seen through one upper-story window looks out another at barren rooftops and a bleak sky (Fig. 6). The implacable lines and rectangular planes of urban geometric space imprison him. In other paintings, such as *Hotel by a Railroad* (1952) or *Excursion into Philosophy* (1959), Hopper's men are not physically alone but so enwrapped in their own solitude that their loneliness, and implied impotence, seem all the more pronounced.

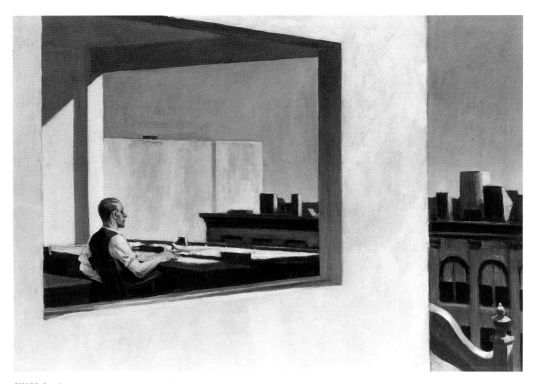

FIGURE 6 | Edward Hopper, *Office in a Small City*, 1953, Metropolitan Museum of Art

HOPPER'S STARK URBAN LANDSCAPES resemble the low-budget Hollywood mystery thrillers of the late forties and early fifties that used to be called B-films and underground movies but now are typically grouped under the rubric "film noir." These made-on-the-cheap movies have a raw, unencumbered artistry and crude energy lacking in glossier studio productions of the early postwar era.

One brilliant (and still overlooked) underground movie of those years is a man-at-the-window picture called *He Walked by Night* (1948). Directed by the B-film master Anthony Mann, *He Walked by Night* was shot by Mann's frequent collaborator, John Alton, surely one of the greatest cinematographers in the history of the medium. The movie, based on a true story from the files of the Los Angeles police, starts off in the pseudo-documentary style fashionable in such postwar crime sagas as *Call Northside 777* and *The Naked City*. The popular radio (and later television) criminal investigation series *Dragnet* came directly out of *He Walked by Night*. But the film quickly turns from police procedure to its true focus, the cryptic title character, a young loner named Roy Morgan (Richard Basehart).

Walking down a suburban street late one night, Morgan peers into an electronic goods shop window, presumably intending to break in. When a suspicious patrolman

pulls over to the curb and asks to see some identification, Morgan draws a gun instead and kills him. He spends the rest of the film trying to elude the dragnet that slowly closes in on him.

Living in a shabby little bungalow apartment, a stranger to his neighbors, who find him weird and remote or don't notice him at all, Morgan is a true outsider. He is indeed one of Hopper's men at the window, except that the window at which he stands is obscured by a closed venetian blind through which he peers surreptitiously. Most of all, he's an underground man, and literally so in the last reel of the film, when he disappears into the L.A. drainage system for a last stand against his pursuers. Alton's expressionistic lighting etches Morgan poised with his rifle in the bowels of the city as police flashlights stab the darkness in search of him. A tear gas canister bursts across the screen with a writhing, curling fog that draws Morgan out of a mammoth drainage pipe and into a hail of police bullets. He dies, and the film ends precipitously, without explaining who he was or what he was after or why he killed a cop in the first place.

An underground movie about an underground man, *He Walked by Night* almost seems, in retrospect, to prefigure Lee Harvey Oswald, another young outsider at a window who, having murdered a police officer who stopped him for questioning, was gunned down before he could testify in court. The Zapruder film doesn't look in any way like *He Walked by Night*, nor does it focus on, or even glimpse, the killer. But in its brevity, muteness, and inscrutability, it too leaves us with no understanding of the individual (or individuals) whose violent action catalyzes the narrative we watch.

After the Kennedy assassination and the investigations into the life of his suspected assassin, it became almost a tenet of our times that sexual frustration or grief or confusion was a major ingredient in the witches' brew that poisoned the psyche of the killer. William Manchester suggested as much in his best-selling history of the Dallas weekend, *The Death of a President* (1967), and Robert de Niro's performance as Travis Bickle in *Taxi Driver* (1976) and Don DeLillo's Lee H. Oswald in *Libra* (1988) made the connection seem all but inescapable.

Even in the years leading up to the assassination, movies such as Hitchcock's *Psycho* (1960) and John Frankenheimer's *Manchurian Candidate* (1962) construed extreme violence in terms of extreme sexual repression. Frankenheimer's film envisions a political assassin brainwashed by Communist agents, including his own monstrous mother (Angela Lansbury), who manipulates him with an array of incestuous seductions. In the climactic scene, the assassin perches with a rifle at an open window high above a political convention hall, poised to shoot down the presidential nominee. At the very last instant he trains his sights on his mother instead and fires away.

Psycho also features a loner by the window. Norman Bates, the character played by Anthony Perkins, seethes with Oedipal hostilities and generalized aggressions that

are only partially masked by his good-looking, boyish exterior. Psychologically tyrannized by his mother (whom it turns out he has murdered), Norman Bates has provided for viewers ever since a figure of murderous derangement in whose archetypal form the plain, boyish, mother-bullied twenty-four-year-old Lee Harvey Oswald can readily be recognized.

Norman peering through a peephole in the motel wall at the young woman he is about to murder; Norman (in the guise of his mother) gazing intently out the upper-story window of his decrepit Victorian house on a hill: these are two of the most chilling images of our time of a human predator waiting to ravage his unsuspecting human victim. In the years since 1963, the imagined (for it was never photographed) picture of Oswald stationed by his upper-story window has taken its place, and in a sense merged, in our vast cultural unconsciousness with its counterpart images in *Psycho*.

An eyewitness in Dealey Plaza, Ronald Fischer, reported to the Warren Commission that ten or fifteen seconds before the presidential motorcade turned onto Elm Street, he was struck by the oddity of a man who stood motionless in a sixth-floor window of the Texas School Book Depository: "He didn't look like he was watching for the parade," recalled Fischer. "He looked like he was looking down toward the Trinity River and the Triple Underpass down at the end—toward the end of Elm Street. And . . . all the time I watched him, he never moved his head, he never—he never moved anything. Just was there transfixed."

Fischer's description calls to mind a small but much celebrated scene from another Hitchcock classic, *Strangers on a Train* (1951). A charming psychopath named Bruno Antony (Robert Walker) stalks the hero, a tennis star. Bruno comes to watch him during a warm-up. While all the other spectators in the stands pivot their heads back and forth from one side of the net to the other, Bruno's gaze remains fixed in a single direction.

HITCHCOCK BASED AN ENTIRE FILM on the theme of fixed vision and antisocial looking. Only in that film, *Rear Window* (1954), the man who gazes is not the villain but the hero. Jimmy Stewart plays L. B. Jefferies ("Jeff"), a photojournalist confined to his one-room Greenwich Village apartment because of a broken leg. Bored and restless, he spends his nights peeping into the windows of apartments across the courtyard, making up scenarios about the lives of the various men and women in his building whom he doesn't know. Eventually he fixates on the odd behavior of a neighbor, Thorwald (Raymond Burr), whose wife seems to have disappeared after a marital quarrel. Suspecting Thorwald of murdering her, the photographer trains a high-magnitude telephoto camera lens on him, as if pointing a sniperscope (Fig. 7).

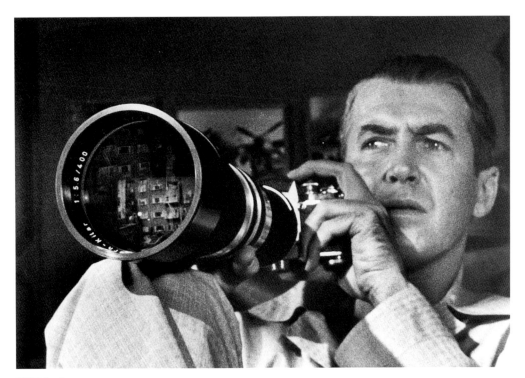

FIGURE 7 | *Rear Window*, 1954

Although Jeff's suspicions prove correct, and Thorwald is apprehended, the movie repeatedly questions Jeff's voyeuristic behavior. Early in the film his visiting nurse rebukes him. "We've become a race of Peeping Toms," she says. "What people ought to do is get outside their own house and look in for a change!" Later, a neighbor whose dog has been poisoned stands in the middle of the courtyard and shouts at the curious but uninvolved onlookers, "None of you know the meaning of the word neighbor! Neighbors like each other. Speak to each other. Care if anybody lives or dies. But none of you do."

Hitchcock, when interviewed, defended Jeff's emotionally detached looking. ("What's so horrible about that? Sure, he's a snooper, but aren't we all?") The film, however, is not so glib. It reflects complexly on voyeurism and on the moviegoer's tacit complicity with it. Jeff, the man at the window, is a modern urban everyman: alienated from his neighbors, fearful of commitment (the subplot of the film involves his resistance to marriage), and hypnotized by the passing spectacle (in his case, what he sees in strangers' windows).

Rear Window provides an intriguing touchstone for the Zapruder film not simply because Hitchcock's film shows a man peering furtively from an upper-story win-

dow through a high-powered lens and Zapruder's predicates the existence of such a man (offscreen). The Hollywood film's two main characters and the stars who played them connected, directly and indirectly, to Jack and Jackie Kennedy at the time of its production.

In the movie Jeff's fashion model girlfriend, Lisa (Grace Kelly), wants to marry him. Jeff resists, adamant about not being pinned down, certainly not by a woman and certainly not by marriage. He wants to roam the world again in search of adventure and photographic subjects. The movie's comic epilogue, however, reveals that now Jeff has broken his other leg (in a climactic fight with Thorwald) and will have to settle in for another prolonged period of recuperation, during which Lisa will contentedly play the role of nursemaid.

In 1953 Jack Kennedy, a freshman senator whose lanky, boyish appeal was often compared to that of a young Jimmy Stewart, resisted the efforts of his father to pin him down in marriage to his beautiful girlfriend, Jacqueline Bouvier. Joe Kennedy seems to have believed that his son needed a wife, and a good-looking one at that, to further his presidential ambitions, but the senator, a committed womanizer, had other ideas. He wanted to roam the world in search of sex and adventure—and indeed, he went off on just such a quest immediately after the announcement of his betrothal. On his return he married Jackie in the decade's most newsworthy storybook wedding, save for that of Grace Kelly three years later.

Rear Window appeared in late 1954, while Jack was recuperating in the hospital from spinal surgery. His solicitous young wife hovered at his bedside, not unlike Lisa over Jeff. One evening Jackie met Grace Kelly at a dinner party and persuaded her to play a practical joke on her convalescent husband. Showing up at the senator's bedside dressed in a nurse's uniform, the actress whispered in his ear, "I'm the new night nurse," and began to feed him. Kennedy was too ill to respond. As she left, Kelly sighed, "I must be losing it." These words are similar to what she says in *Rear Window* when, as Lisa, she fails to arouse Jeff, who is preoccupied with Thorwald. The next morning, when Kennedy learned of the movie star's nocturnal visit, he said he thought it had been a dream.

As in a dream, disparate elements have conflated: reality and fiction, truth and fantasy, phantoms and people. *Rear Window* matches up with the Zapruder film in a series of crossovers: transfixed observer by the window (Jeff, Oswald), photographic on-looker (Jeff, Zapruder), endangered heroine (Lisa, Jackie), fashionable nursemaid (Lisa, Grace Kelly, Jackie), and obscure, indecipherable murderer (Thorwald, Oswald—*Wald*, a dark, impenetrable woods, a forest).

In our contemporary cultural unconscious, our collective postmodern mental archive, the two cinematic texts engage in an implicit cross-communication, each one enriching the meaning of the other. It's difficult, maybe even impossible, to respond

to Zapruder's movie today except as we have been conditioned to respond by Hitchcock's macabre tales of murder from the 1950s and early 1960s and the many novels, movies, TV shows, news accounts, and perhaps even real-life behavior influenced by them. Likewise, it is difficult if not impossible to watch Hitchcock's films without some consciousness of that ambush in the broad daylight of Dallas and Abraham Zapruder's cinematic representation of it.

SO SHARPLY did Hitchcock characterize certain phenomena of modern existence—murder in public places, illicit looking, misattribution of guilt ("the wrong man"), the eroticism of violence, the violence of repression—that our way of experiencing these phenomena through cinematic representation tends to be Hitchcockian whether we're aware of it or not.

Take, for example, one of the most remarked on sequences in all of Hitchcock's body of work, the crop duster episode in *North by Northwest* (1959). A suave and dapper Madison Avenue advertising executive (Cary Grant) in a gray business suit stands incongruously beside a prairie highway, alone in the middle of nowhere. He waits for someone he has never seen to arrive for a prearranged meeting. No one arrives. Silence prevails, save for the occasional rumble of a passing vehicle and the distant drone of an old-fashioned biplane dusting nearby crops. The air hangs heavy. So does the tension. A farmer appears, says little, and departs again. The man continues to wait. He is nervous, apprehensive—and utterly alone. Suddenly the biplane swoops out of the sky and buzzes him, its propeller blades fracturing the air. He throws himself to the ground just in time and then jumps to his feet and sprints toward a nearby cornfield, the only possible cover. The plane veers about and comes after him at full throttle, guns ablaze (Fig. 8). In desperation, he runs to the road and into the path of an oncoming oil truck, which skids to a halt. The crop duster smashes into it and peremptorily explodes.

Hitchcock's handsome star, in his gray suit, manages to elude death from above; Zapruder's does not. Hitchcock's crop duster sequence, moreover, exemplifies sophisticated filmmaking techniques involving multiple camera positions and rhythmic editing, whereas Zapruder's technique could hardly be less sophisticated, with its single camera angle and inept framing. Nevertheless, the power of both scenes (the entire Zapruder film consists of a single scene) resides in their shared metaphoric connotations. Each of them generates an allegorical drama about the postwar American avatar of white, middle-class, suburban normality known as "the man in the gray flannel suit." Men in gray flannel suits were supposed to worry about things like job promotions, long commutes, and two-martini lunches, not crop dusters and sniper bullets, especially not in public spaces at midday. Cops got shot at in broad daylight—cowboys, too,

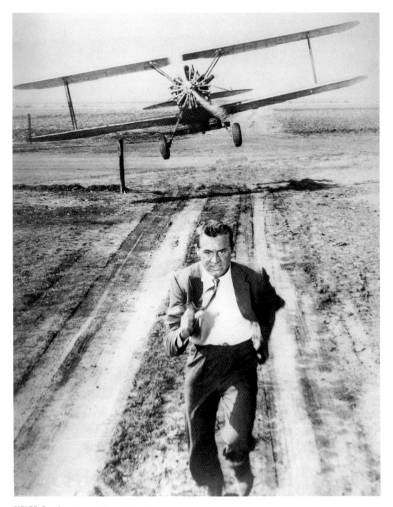

FIGURE 8 | *North by Northwest,* 1959

and gangsters in fedoras or petty criminals—but not Madison Avenue advertising executives or leaders of the free world.

The crop duster in *North by Northwest* amounts to a deus ex machina. The term originally referred to a god in an ancient Greek or Roman play lowered to the stage by a mechanical apparatus, usually to extricate the hero, who could not escape from a tight spot on his own. The sudden dramatic intervention by the god was typically benign. In our time, however, a deus ex machina is any character who appears out of nowhere or any abrupt happening that alters the course of events.

Although such an intervention is still implicitly favorable, it need not be, for the Olympian gods, we have learned, don't always have our best interests at heart. But if

you prefer to reserve "deus ex machina" for happy interventions from out of the blue, let us instead cobble together the term "daemon ex machina" to describe Hitchcock's on-screen crop duster and Zapruder's offscreen assassin.

IN 1963 HITCHCOCK UNVEILED his most unrelenting deus- or daemon-ex-machina movie. Very much like Zapruder's film, *The Birds* is a tale of terror striking unexpectedly from above. A beautiful and sophisticated young socialite, Melanie Daniels (Tippi Hedren), implausibly turned out in a frosty green daytime dress suit and a fur coat, guides a small motor launch across a bay. As she nears shore, a gull suddenly hurls itself out of the sky and pecks her forehead, drawing blood. The attack has no apparent motivation, no provocation. Later, while Melanie is sitting on a bench outside a rustic schoolhouse, crows begin to amass ominously on the jungle gym behind her. When she and her friend the schoolteacher begin to lead the children away from the threatened schoolhouse to the presumed safety of the town, the birds descend violently upon them (Fig. 9).

Despite a publicity extravaganza before the film's release, *The Birds* underperformed at the box office. Audiences generally found it baffling. Apart from the revenge-of-nature theory offered by a quirky ornithologist, who is played as a combination of Rachel Carson and Miss Marple, the movie never explains why the birds attack. And even though Melanie and her newfound family apparently escape at the end of the film, the birds seem to have conquered the town and perhaps will soon take over the world (as happens in Daphne du Maurier's original short story). As one disgruntled viewer complained in a letter to Hitchcock: "Why-y-y-y did the birds attack? Even Dizzy Gillespie and Stravinsky resolve their discords. You have violated one of your fundamental rules. Therefore, I'll seriously consider accepting a refund of the price of admission when you mail me a $.95 check (Either that or answer Why? It's still buggin me. Or is that the sequel?)"

The film's lack of closure, its refusal to interpret its own happenings, has marked it as an art film or, to put this more specifically, as an instance of early-sixties cinematic modernism. In a fascinating study of Hitchcock's role in the making of his own reputation as a master filmmaker, Robert Kapsis shows that with *The Birds* Hitchcock tried to have it both ways: to contrive a popular hit but also win the approval of more intellectually minded viewers, whose taste in movies was being shaped by the nouvelle vague (new wave) filmmakers of France and the Swedish, Polish, and Italian existentialists. Indeed, the old master boned up on the controversial work of the young European filmmakers by arranging private screenings for himself of movies such as *Breathless*, *The Virgin Spring*, and *L'Avventura*—all films, Kapsis notes, "that in different degrees reject the Hollywood conventions of resolution, closure, and an upbeat ending."

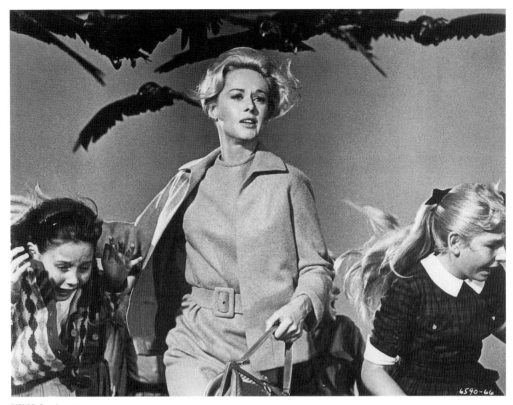

FIGURE 9 | *The Birds*, 1963

If *The Birds* attempted to mix mainstream elements (suspense, horror, violence) and art house signifiers (psychology, ambiguity, thematic suggestiveness), its marketing strategy was hybrid as well. Heavily promoted on television and in popular magazines such as *Life* and *TV Guide*, and armed with Hitchcock's humorously ungrammatical-sounding but arresting slogan, "*The Birds* is coming," the movie was also showcased, thanks to the diligent efforts of Hitchcock's acolytes and publicists, in prerelease screenings at the Museum of Modern Art and the Cannes Film Festival. A reviewer for *Time* commented that "after 38 years and more than 40 films, dealing mainly in straightforward shockery, the Master has traded in his uncomplicated tenets of terror for a new outlook that is vaguely *nouvelle vague*."

THE ZAPRUDER FILM, TOO, combines "straightforward shockery" and "vaguely *nouvelle vague*" characteristics (cinema verité filmmaking; the use of a handheld camera, available light, and nonprofessional actors; lack of closure; and a sad or bleak ending).

The term "nouvelle vague" in *Time*'s review of *The Birds* refers to such French films as Jean-Luc Godard's *Breathless* (1959), François Truffaut's *Jules and Jim* (1962), and Alain Resnais's *Last Year at Marienbad* (1961). More stately, perhaps, in technique but no less controversial on the American art house circuit of the early 1960s were the movies of Italian masters such as Luchino Visconti, Federico Fellini, and Michelangelo Antonioni. A number of such films for the intelligentsia flickered in the dark in the Kennedy White House. Although the president, according to one account, had a "decidedly low-brow taste in movies—Westerns, war films, and action-adventure pictures that were short on dialogue and long on gunplay"—the first lady preferred European art cinema, with its moody tales of alienation, ambiguity, and indecipherability.

No film was ever more about alienation, ambiguity, and indecipherability than Antonioni's *L'Avventura* (1960), which Hitchcock studied before undertaking *The Birds*. And few movies have ever at their time of release been more bitterly derided and passionately defended. Now generally recognized as a cool, elegant, and morally astringent masterpiece, *L'Avventura* depicts a group of rich Italian socialites who come together for a yacht trip in the Mediterranean. Dropping anchor alongside a barren volcanic island, they explore it alone and in pairs. Anna, a bored and beautiful young woman, disappears. The other voyagers scour the island for her, calling her name. She never responds, and they never find her. Did she slip off a rock and drown? Did she throw herself into the sea? Did she accept a ride off the island by someone in an unseen, unnoticed sailboat? Was she abducted? Eventually they leave the island and go their separate ways, except for Anna's lover, Sandro, and her best friend, Claudia (Monica Vitti), who continue to search for her on the mainland and in the process become guilty lovers. Meanwhile, Anna is never found, her strange disappearance never explained.

The Zapruder film is similarly enigmatic and tight-lipped. It no more tells us who shot the president than Antonioni's film tells us what became of Anna. Like *L'Avventura*, it simply shows consequences, examining human behavior in a dry, detached manner. Claudia tries to find her best friend and then mates with her best friend's lover. The president's wife tries to succor him and then tries to scurry off the back of the limousine. End of story. End of movie. But even if the Zapruder film seems a wholly nonpsychological narrative, a mere recording of events without attention to the interior lives of its "characters," it is a profoundly psychological film, after all, in providing a pitiless record of human response under extreme duress. Like *L'Avventura*, it raises questions it is incapable of answering: Not only who shot the president, but also how deep does love go? Why was she scurrying off the back of the car? If the most powerful man in the world can be so vulnerable to violence and death, well, then, where does that leave us? Was Kennedy's mind, so vaunted for its wit and charm, nothing, finally, but a brain stew and his handsome, virile body no more than inert skeleton, muscle, and flesh activated by snapping neurons and synaptic juice? What a piece of work is a man, indeed?

As with *Rear Window*, intriguing biographical connections link the Kennedys to *L'Avventura*. In August 1962, soon after the reported suicide death of Marilyn Monroe, the first lady took her young daughter, Caroline, on an extended holiday in Ravello, a picturesque cliff town on the Amalfi coast. Biographers have suggested that Jackie wished to stay out of the country to sidestep ugly and potentially explosive rumors that the president had been carrying on an affair with the Hollywood star and had broken off with her only days before her lethal overdose.

Yet while vacationing in Ravello, Jackie herself became the subject of gossip and innuendo when she was seen spending a great deal of her time with the notorious playboy Gianni Agnelli, the multimillionaire prince of the Fiat automobile corporation. Was that her way of getting back at her husband for his infidelities? Was she engaging in something of an *avventura* of her own? The paparazzi photographed America's first lady sunbathing with Agnelli on his 82-foot yacht and dancing barefoot on deck. The deputy secretary of state at the time, George Ball, later recounted that CIA agents "were ordered to fetch her diaphragm and send it over to Italy by the next plane." Irate, the president fired off a telegram to his wife: "A LITTLE MORE CAROLINE AND LESS AGNELLI," he admonished.

Over a year later, in October 1963, the first lady again entered *L'Avventura* territory when she accepted an invitation from the Greek shipping tycoon Aristotle Onassis to join him (and others) for a Mediterranean cruise on his yacht. This time she was accompanied not by her daughter but by her jet-setter sister, Princess Lee Radziwill, and other international socialites. Again the president looked askance at his wife's brazen indulgence in leisure-class hedonism, despite—or perhaps because of—his own proclivities toward flirtation and the serial sexual liaisons to which it led. Five weeks after her return, the two of them sat together in the back of an open-air limousine in Dallas. Although the world in general and Abraham Zapruder in particular did not recognize them as characters from an Antonioni film, indeed they were.

THREE YEARS AFTER the Kennedy assassination, another of Antonioni's maddeningly unresolved glimpses of modern life and alienation became a surprise commercial hit internationally. Filmed in English, *Blow-Up* (1966) depicts a series of events both strange and mundane that occur to a trendy London fashion photographer named Thomas (David Hemmings). Meandering through a green and windy park one day, he inadvertently records a murder—or so it later appears—while photographing a pair of lovers from afar. As with *L'Avventura*, the film revolves around the inability of anyone to know anything or anyone for certain.

In a remarkable twelve-minute sequence without dialogue, Antonioni shows Thomas developing the roll of film he took in the park, printing selected images,

FIGURE 10 | *Blow-Up*, 1966

mounting them on his wall, pondering them, returning to the darkroom, blowing up certain details, mounting them too on the wall, studying, reflecting, musing (Fig. 10). An enlargement of the couple embracing reveals the woman to be looking off into the distance in apparent anxiety.

Thomas follows the direction of the woman's eyes and pinpoints an area in the woods that may contain the object of her gaze. Returning to the darkroom, he comes away with a blowup of the spot in question and sees what appears to be a man hidden behind a fence—and a pistol pointed in the direction of the couple. Extreme enlargement of a later photo in the sequence reveals what may be a corpse, possibly the woman's "lover" (for now quotation marks are necessary), stretched out beneath a tree. But the photographic information has been blown up so large, so out of proportion to its original scale, that the image verges on abstraction, and human form becomes almost indistinguishable from the natural forms around it.

Thomas returns to the park that night and does indeed find a corpse beneath a tree, but he leaves without reporting the incident. He goes back again in the morning. The corpse has disappeared. Returning home, he finds his studio has been ran-

sacked and the incriminating negatives and prints have been stolen. The extreme blowup of the corpse is all that remains of the photographic evidence of the murder, but it's far too abstract to be meaningful. Thomas, devoid of affect, an epitome of 1960s anomie, shrugs off the entire incident as one more bizarre happening in a world that makes no sense.

In the history of cinema, *Blow-Up* could be described as *Rear Window* meets *L'Avventura* meets the Zapruder film. For the conceit of close scrutiny of inadvertent photographic evidence of a crime comes not from the Argentine writer Julio Cortázar's source story but from the 1964 Warren Commission Report and issues of *Life* magazine published in 1963 and 1964 that reproduced portions of the Zapruder film in frame-by-frame enlargements. (The Zapruder film itself was shown only in official investigative and courtroom viewings and small private and public screenings of bootlegged prints until ABC and CBS televised it in 1975.)

I don't know that Antonioni and his cowriters reworked Cortázar's story after seeing *Life* magazine or had the Zapruder film and the Kennedy assassination in mind during the production of *Blow-Up*. Nonetheless, both films feature ambush murders committed by unseen, unidentified assassins and recorded inadvertently by men with cameras who happen to be on the spot. Moreover, the outstanding set piece of *Blow-Up*, Thomas's step-by-step investigation of his still photographs, recapitulates the meticulous close analysis of Zapruder's footage performed by forensic experts and conspiracy theorists alike in the months preceding the making of Antonioni's film.

If *Blow-Up* depicts a mid-sixties world devoid of moral norms and political ideals, the Zapruder film and the stunning early-sixties event it records contributed to the dramatic breakdown of those norms and ideals. The young Americans who swarmed to *Blow-Up* in 1966 and identified with its cynical and listless characters inhabited a social space far removed from the utopian landscape characterized by Kennedy's exhortation to "ask not what your country can do for you, ask what you can do for your country."

In *The Conversation*, Francis Ford Coppola's film of 1974, and in Brian De Palma's *Blow Out*, of 1981, both movies about professional soundmen who inadvertently record murder on audiotape, filmgoers immediately recognized tributes to *Blow-Up*. Critics grasped the films' references to recent historical events such as Watergate (the Nixon tapes) and Chappaquiddick (in De Palma's story, a married politician driving at night with a mistress swerves lethally off a bridge). But both movies are more than mere allegories about political scandal. Each self-reflexively examines the manipulation of a technological medium of reproduction—sound recording but also, by extension, film—to extract from it usable evidence of the nature and source of a crime. Both movies also hark back to the Zapruder film and its hyperanalysis by freelance investigators (conspiracy theorists) operating on the social fringe.

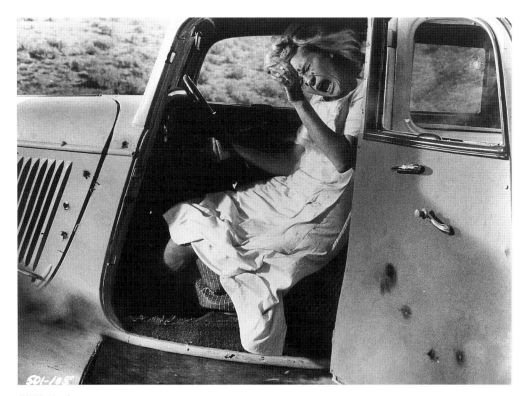

FIGURE 11 | *Bonnie and Clyde*, 1967

WHILE *BLOW-UP* METAPHORICALLY CAPTURED the frustration of deciphering the Zapruder film, *Bonnie and Clyde* built its devastating final scene directly upon it. In the closing sequence of the 1967 box-office hit, two Depression era fugitives from the law, played by Faye Dunaway and Warren Beatty, stop on a country road beside a broken-down farm truck. Clyde gets out to offer a hand. Suddenly, a storm of machine-gun fire engulfs him outside the car and Bonnie within. The Feds have sprung an ambush.

The director, Arthur Penn, resorted to a repertoire of nouvelle vague cinematic techniques, including slow-motion photography and multiple-viewpoint editing, to make the shredding of Bonnie and Clyde's physically beautiful bodies at once excruciatingly violent and spellbindingly beautiful (Fig. 11). Interviewed at the time of the film's release, Penn spoke of striving to convey "the spasm of death . . . the ballet of death" in this final scene. "There's a moment in death when the body no longer functions, when it becomes an object and has a certain kind of detached ugly beauty," he explained. Specifically, he had the Zapruder film stills in mind when devising this scene:

"There's even a piece of Warren [Beatty]'s head that comes off, like that famous photograph of Kennedy."

In another interview Penn explained that he regarded violence as "a part of the character of America. It began with the western, the 'frontier.' America is a country where people realize their ideas in violent ways." Emphasizing the point, he added, "Kennedy was slaughtered. We are in Vietnam killing people and getting ourselves killed."

The connection in Arthur Penn's mind between the "slaughter" in Dallas in 1963 and what was taking place in Vietnam in 1967 goes beyond the slain chief executive's having treated the distant Asian land as a strategic testing point for cold war relations with the Soviets. Kennedy did in fact order the deployment of some hundreds and eventually thousands of U.S. "military advisers" to the Republic of South Vietnam in an effort to prop up the regime of President Ngo Dinh Diem against both internal enemies and Communist invaders from North Vietnam.

Diem's corrupt politics, opposition to land reform, and harsh oppression of the Buddhist majority—he was a Roman Catholic—eventually forced Kennedy to withdraw his support. In early November 1963, the American president authorized his ambassador to South Vietnam to inform the military officers who were planning a coup d'état that the United States would support the new government. Diem was killed in the process. Thus, without calling for the political murder of his counterpart, Kennedy indirectly contributed to it two weeks before his own assassination.

Oliver Stone's movie *JFK* (1991) contends polemically that Kennedy's death came at the behest of high-level Pentagon and CIA hawks who refused to countenance what they saw as an imminent and disastrous military pullout in Southeast Asia. Stone focuses almost entirely on circumstantial evidence and counts on the filmgoer's willingness to see in history the machinations of evil right-wing conspirators. The Zapruder film advances no thesis about political conspiracy and assassination. But it too belongs to the film genre known as the "political thriller." Like *JFK* and other movies of its stripe, such as *Seven Days in May* (in production at the time of Kennedy's death), *Z* (1968), *Executive Action* (1973), *The Parallax View* (1974), *All the President's Men* (1976), and *Winter Kills* (1977), the Zapruder film portrays a specifically political event—in this instance, the unannounced beheading of a chief of state—as raw melodramatic spectacle.

Contrary to popular belief, the Vietnam war was not the first that television brought into the American living room. Documentary footage of World Wars I and II, the Korean War, and various other U.S. military actions appeared frequently on TV in the 1950s and 1960s, and G.I. action movies were a late-night mainstay. The prime-time series *Combat!*, which starred the Method actor Vic Morrow as a U.S. infantryman on the front lines in Normandy, enjoyed a long, healthy run on ABC from 1962 to 1967.

Part of what made the televised coverage of Vietnam seem so powerful and real, especially in the later stages of the war, was that it didn't look or sound anything like the sanitized studio versions of warfare viewers were so used to watching.

As I mentioned above, the Zapruder film did not appear on television until 1975, the year the United States pulled out of Vietnam. Thus its broadcast postdates Vietnam coverage and in fact was made possible by that coverage, which, along with Watergate and other nationally televised traumas, such as race riots, violent political demonstrations, and various assassinations and assassination attempts, revised expectations of what television audiences could see on their living room screens. The Zapruder film, even though it was not shown to the public until these other events had taken the cap off TV, can legitimately be regarded as the first documentary footage of the new era.

THE ZAPRUDER FILM, that is to say, symbolically laid the groundwork for what came to be called the new realism in late-1960s filmmaking and news reporting. In the art world, the term "new realism" originated early in the 1960s. It referred to pop art.

The pop artists were realists in the sense that they worked in a representational mode, unlike the previous generation of artists, the abstract expressionists. They were "new" realists because, unlike the social realists of the Depression era, they chose as their subject matter not the realities of poverty, class warfare, and racism, but the factuality and materiality of everyday life in a modern urban consumer society.

By 1963 the most notorious of the art world's new realists was Andy Warhol. With his deadpan silk-screen reproductions of commodities such as Coke bottles, soup cans, and movie stars (or, more specifically, their publicity photos), Warhol successfully shocked not the bourgeoisie, who were never his target, but rather their high-minded, high-culture art world adversaries, such as the abstract expressionists.

Late in 1963 Warhol extended his range as a pop artist/new realist: he became a filmmaker. In November of that year, a home movie emerged from Warhol's East Forty-seventh Street "Factory" that stunned viewers. Zapruder's film was also stunning, because the event it depicted was so extraordinary. Warhol's film was stunning—or, if you will, numbing—because the event (or nonevent) it recorded was so unbelievably ordinary. Entitled *Sleep*, the movie showed nothing more than a man sleeping on a couch. It showed this for a total of six hours.

Let's think about the Zapruder film in conjunction with *Sleep*. We can begin by cataloging some of the films' conspicuous differences. One is in color, the other in black and white. One runs for 26 seconds, the other for approximately 21,600 seconds. One film comprises a single camera movement—a pan from left to right, with a notorious jiggle or shake in it after the bullets fly—and no change of camera position. In the

other the camera does not move at all; some minor editing accommodates a total of six camera setups during filming. The subject of Zapruder's film, President John Kennedy, didn't know the man who was filming him. The subject of Warhol's film, his lover the poet John Giorno, did. Zapruder recorded history, Warhol nonhistory.

Yet both made history. *Sleep* gave rise to the influential branch of experimental cinema called "structural" or "material" film. The best-known example, Michael Snow's *Wavelength*, from 1967, consists of a single shot lasting forty-five minutes: an agonizingly slow zoom that begins with a full view of the interior of a Manhattan loft and ends with an extreme close-up of a portion of a photograph affixed to the far wall. The subject of the movie is its own cinematic processes and duration. Neither Warhol nor Zapruder set out to make art. Well, not exactly. Zapruder surely did not, and Warhol didn't either, in that his purpose seems to have been to make "anti-art." As the film historian P. Adams Sitney explains, "Warhol turned his genius for parody and reduction against the American avant-garde film itself. The first film that he seriously engaged himself in was a monumental inversion of the dream tradition within the avant-garde film. His *Sleep* was no trance film or mythic dream but six hours of a man sleeping."

Both *Sleep* and the Zapruder film show with implacable silence a man all but stripped of his "daytime" accoutrements of wit, reason, and personality and reduced to his primal, involuntary biological essence. In one case he sleeps; in the other he dies. Both look on the human condition from a cold, mechanical distance (no humanizing close-ups, no heroic lighting, no sweet or stirring music, no sound or sound effects whatsoever). Both films—Zapruder's unintentionally but Warhol's surely intentionally—test the audience as few other films in history have done. They dare us not to avert our eyes or slink or storm out of the screening room in revulsion, dismay, or fury.

And both are home movies. Jonas Mekas, one of the most important supporters and practitioners of avant-grade cinema in the 1960s, thought the term "home movies" best described that cinema. He explained: "Man has wasted himself outside himself; man has disappeared in his projections. We want to bring him home. We want to remind him that there is such a thing as home, where he can . . . be with himself and his soul—that's the meaning of the home movie, the private visions of our movies." Unlike Hollywood movies, home movies "are so personal, so unambitious in their movement, in their use of light, their imagery."

In a very real sense, then, Warhol's home movie, like Zapruder's, is about reaction time, that of not only the films' subjects (how many fractions of a second elapse between the impact of the bullet and the neurological twitch? how many minutes or seconds between the sleeper's shifting of limbs?) but also their viewers. How long can you look at the Zapruder film without shutting your eyes or feeling queasy or laughing nervously—or, perhaps worst of all—not feeling anything? How long can you re-

main lashed to your seat during *Sleep.*) Mekas recounts that at a Greenwich Village screening of *Sleep* in November 1963 he greeted the filmmaker with a rope, led him to a seat in the back of the hall, and tied him down. About halfway through the film, he decided to check on Andy—and found only the rope.

Sleep is a Proustian film, but instead of being a remembrance of things past, it compels viewers to *experience* the passage of time—to suffer it, reflect on it, impatiently measure it, mourn it, or even, perhaps, rejoice in it (as when they think, the more quickly time passes, the sooner this ordeal will be over). The Zapruder film is Proustian in a similar way, for its viewers experience the passage of time in a hyper-aware manner.

Its pulse and rhythms have been measured, timed with a stopwatch, parsed, run forward, run in reverse, sped up, slowed down, frozen. How fast is the limousine traveling between points A and B, when does the president's wife look to her right, how soon do the onlookers fling themselves to the ground? *Sleep* is maximal in length and minimal in action, the Zapruder film the exact reverse, yet both films force viewers to acknowledge a vivid discrepancy between clock time and internal time. Both are movies about duration—that of the event represented and that of viewers' capacity to endure it.

In a certain way, *Sleep* and the Zapruder film both descend from Proust's nineteenth-century predecessor Émile Zola, the pioneer of French literary naturalism. Zola argued that the artist's role, like that of a pathologist or physiologist examining diseased specimens, was to study humankind with clinical detachment. Artists autopsied their subjects, dissecting them and their behavior with a steady hand and cold eye, having first freed themselves of messy emotion or sentimental attachment or melancholy rumination. The paradox of both *Sleep* and the Zapruder film is that although they too are autopsy reports, clinical in their distance and detachment, the experience of watching them nevertheless remains Proustian, thoroughly saturated with subjectivity and an intense awareness of time's finiteness and, ultimately, one's own.

ANOTHER MARCEL BESIDES PROUST links Warhol and Zapruder. Warhol's anti-art filmmaking in the early sixties derived its rationale from the theories of the great dada instigator Marcel Duchamp, whom Warhol, like numerous other avant-garde artists of the time, idolized. Though the French-born artist was a living legend and had been since the 1920s, he did not receive his first museum retrospective until 1963.

Duchamp spurred a reconception, if not a full-scale rejection, of the very notion of art. By taking found and ready-made objects (a shovel, a bicycle wheel, a bottle rack, a urinal) and displaying them in an art gallery setting, he drove home the point that art is never autonomous and self-sufficient but always contextual, relational, contin-

gent. Art is merely what we choose to call art. It's what we're willing to exhibit as such and either praise or condemn, what we're willing to pay money to see or purchase, what we allow to activate our consciousness and spin it in a new direction. Beauty is present or absent not in the thing on display but only in the minds of the widely varied viewers who see it displayed.

In a way, the Zapruder film is even more of a readymade than *Sleep*. Warhol trained his camera on a found object—a man sleeping on a sofa—but in fact the man "posed" on that sofa over the course of several weeks, knowing he was being filmed as he slept (or feigned sleep). *Sleep* is constructed from footage shot from a series of different camera angles and repeated ("looped"). The Zapruder film, in contrast, truly focuses on a found object (a mundane presidential parade that starts off like scores of others), records it in real time, sticks to a single camera position, and relies on a single take.

While *Sleep* adheres to the important dada principle of chance intervention in only a relatively insignificant, staged way (it's not really an accident that the man sleeps in front of the camera), chance intervention defines the Zapruder film. The killing of the president may not have been unplanned, but its filming was. Taking the film out of its official context—as forensic evidence or historical document—and resituating it in the art avant-garde transforms it into an instance of "aleatory" (random, chance-dependent) dada, even as the event it records changes suddenly from presidential motorcade to presidential assassination.

ANOTHER FILM WARHOL MADE late in 1963, the much shorter *Blow-Job*, records the face of a young man as he stands before a wall and experiences the act the title names. Or does he? We as viewers can never know for sure, because the camera remains fixed on the man's face, never once pulling back or cutting away to reveal the stimulus to which he (apparently) responds.

See the film in your mind's eye through this elegantly minimal verbal account:

> The head tilts right. Then left. Then right. The facial muscles tighten. Then relax. The eyes close. The eyes open. The eyes drift off into a glazed stare. For the next thirty-five minutes, the camera keeps an unblinking vigil over its pretty subject. The head tilts right. Then left. Then forward. The eyes close. The eyes open. Then it is over. The eyes narrow to slits. The muscles of the face tighten into a grimace. The head shoots backward.

These short sentences convey the pulsation of pleasure one imagines the young man in front of the camera to have experienced as a result of his encounter with an offscreen mouth. One can go back and reread the passage as a characterization of what's

shown in the Zapruder film. Not beat for beat—too many eye openings and closings, too many head tiltings. But in principle the language of the passage and the clinically detached, monocular scrutiny of the camera it describes are not far afield from a description of Kennedy's mechanistic movements ("the head shoots backward") as seen through Zapruder's lens.

As I noted, we never see an actual fellatio in Warhol's film, at least not at the point of contact. We infer the presence of the fellator (or fellators) from circumstantial evidence: the tilting or lolling head and clenched or relaxed facial muscles. Similarly the Zapruder film bespeaks the presence of an assassin (or assassins) by focusing entirely on the physical reactions of the assassinated. Unlike their Hollywood counterparts, these movies use no reverse-angle shots to show the perpetrator (or perpetrators) of the act whose results we witness.

Both films are thus great teases and, as such, metaphysical exercises. Like St. Paul, they ask us to believe in the evidence of things not seen. They toy with our perceptual processes and suggest, on reflection, how eagerly we use our imaginations, our cravings, our anxieties to fill in the gaps when information lags. That use of the imagination is the core theme that Antonioni essays in his film about the ultrahip photographer who comes to believe he witnessed a murder in the park. *Blow-Up*, meet *Blow-Job*.

IN PASSING, I must mention that the maker of *Blow-Job* and the male lead of the Zapruder film had much in common, at least at the murky, subterranean level of psychobiography. At first glance, they couldn't have been more unlike. John Fitzgerald Kennedy, the scion of one of the wealthiest families in America, was a handsome and virile heterosexual who exuded confidence and, as though by natural right, claimed the role of the most powerful man in the Western world. Andy Warhol (originally Andrew Warhola), the son of working-class Czech immigrants, was a diminutive, unprepossessing, initially closeted homosexual who fretted about his looks and scraped to find a place for himself in the New York art underground.

But today they are two of the most immediately recognizable icons of the 1960s (recognizable, in large part, because of their distinctively profuse hair—Kennedy's abundant, windswept locks, Warhol's mop-top white wig). Both were the children of Roman Catholic mothers, whose single-minded devoutness seems, in each instance, to have left the sons emotionally abandoned and plunged into a vacuum of affect. Both men were sickly as children and had to undergo prolonged periods of recuperation. Each was confined to bed for months at a time, during which he countered boredom with heavy doses of reading and fantasy.

Both grew up obsessed with heroes and movie stars. Their yearning to be emotionally, if not also physically, close to such stars was surpassed only by their longing

to be stars themselves. Both of them, Kennedy first, then Warhol, did indeed become bonafide superstars, to use the term Warhol coined. Although each was exceptionally charismatic and often surrounded by legions of admirers, each exhibited what appears to be an almost pathological aversion to the touch of anyone other than an intimate lover. Both have become forever linked with Marilyn Monroe. And both fell to an assailant's bullets—Kennedy fatally, in 1963, Warhol critically but not fatally, in 1968.

Andy Warhol and Abraham Zapruder, however, would seem to have absolutely nothing in common apart from their connection to the fashion world. Warhol began his career as an illustrator for fashion publications and a shopwindow designer for women's clothing stores and thus indirectly overlapped with Zapruder for a time. But more important, both men with movie cameras made "underground" films. Well into the 1970s almost the only way the public could see the Zapruder film was by way of an illegal copy or copy of a copy made from the original, which was sent occasionally to independent laboratories for scientific analysis. These bootleg dupes, or film stills made from them, were projected in private homes, dormitory rooms, church basements, and other meeting places of those on the radical left, the radical right, or somewhere in between who wanted a chance to determine for themselves who shot Kennedy.

Don DeLillo's 1997 novel *Underworld* describes such a viewing in the early seventies in the studio of a video artist: "People started arriving. There were people already there and others started arriving and there was a pungent trail in the air, the root aroma of marijuana rolled and toked communally, and a sense of some event not unlike the showing of a midnight film. . . . [T]he event had a cachet, an edge of special intensity. But if those in attendance felt they were lucky to be here, they also knew a kind of floating fear, a mercury reading out of the sixties, with a distinctly trippy edge."

The artist shows a bootleg copy of the Zapruder film on several screens in different rooms of his apartment. DeLillo re-creates the twenty-six-second movie and its effect on the audience in a paragraph-long sentence:

> The footage started rolling in one room but not the others and it was filled with slurs and jostles, it was totally jostled footage, a home movie shot with a Super 8, and the limousine came down the street, muddied by sunglint, and the head dipped out of the frame and reappeared and then the force of the shot that killed him, unexpectedly, the headshot, and people in the room went ohh, and then the next ohh, and five seconds later the room at the back went ohh, the same release of breath every time, like blurts of disbelief, and a woman seated on the floor spun away and covered her face because it was completely new, you see, suppressed all these years, this was the famous headshot and they had to contend with the impact—aside from the fact that this was the President being shot, past the outer limits of this fact they

had to contend with the impact that any high-velocity bullet of a certain lethal engineering will make on any human head, and the sheering of tissue and braincase was a terrible revelation.

IT IS TIME TO VIEW the Zapruder film not simply as fortuitous evidence of an infamous, historically significant murder. That it certainly is, no question. It should also be seen, however, as a crucial cinematic text of the twentieth century, one that intersects in myriad ways with myriad other cinematic texts before and after. No, the Zapruder film is not Hitchcock or Antonioni or Warhol or film noir. It's not *Bonnie and Clyde* or *The Birds* or *Blow-Up* or *Blow-Job*, and Jack wasn't Cary Grant; nor was Jackie Doris, Liz, or Grace.

But try considering what has transpired in these pages as a Duchampian art history that places a found object or readymade, the Zapruder film, in a context radically different from the one it normally occupies. Think of this chapter as an exhibition space, a gallery in your head, in which the Zapruder film has run in a continuous loop alongside other movies and the characters in them and the performers who existed outside of them. Think of it as a piece of discourse that we are able to "hear" only because of our extensive culturally imbibed knowledge of other, overlapping cinematic discourses: the documentary, the pseudo-documentary, the art film, the anti-art film, the big-budget thriller, the low-budget thriller, the historical epic, the 8-millimeter home movie, and so forth.

I return to the Zapruder film in Chapter 6. But first I want to go back in time to look closely at a series of photographs of Jack and Jackie Kennedy, from the summer of their engagement in 1953 to their arrival in Dallas ten years later at the intriguingly and appropriately named Love Field.

2

"Gentle Be the Breeze, Calm Be the Waves"

YOUTH, FRESHNESS, TEETH. That's what we see at the beginning. Sunlight too, and slim braided ropes, and curling windswept hair, flapping sunstruck sails, the sea, and the spray of the sea. The seaspray deposits itself on the sleeveless shoulder of her blouse, with its decorative pockets and upturned collar, and on the hem of her Bermuda shorts. It soaks the bottom of his shorts and ricochets off his bare, elegantly slender feet, which carelessly overhang the edge of the sloop (Fig. 12).

How perfectly they smile. She, clinging to the mast for support, beams with giddy delight, her head thrown forward, her eyes scrunched up, perhaps as much in response to the dizzying pleasure of the moment as to the dazzling glare of the sun.

He too leans forward, his boyish head cantilevered over his upraised knees. The sun paints broad squared planes on his face. His arms, one unbuttoned sleeve casually rolled back at the cuff, loop over his knees, his right hand encircling the left, allowing but one finger to dangle free. He squints in her direction, not at her but past her toward the camera. She may be the object of his attention, but so too, implicitly, is the electorate. After all, this is not a private snapshot, even though in its apparent informality it pretends to be. It appeared on the cover of *Life* magazine in the summer of 1953 highlighting a story entitled "Senator Kennedy Goes A-Courting." Featuring a series of photographs of Jack and Jackie cavorting at the Kennedy family compound in Hyannis Port, Massachusetts, and sailing in the bay, the article marked the public announcement of their engagement, though it never actually mentioned marriage.

The photographer, Hy Peskin, specialized in sports photography. Three summers earlier he had taken the now legendary picture of Ben Hogan's perfect follow-through

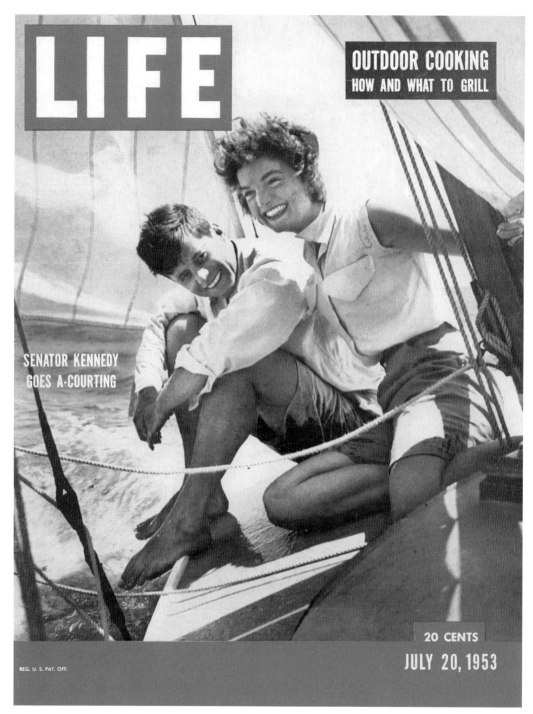

LIFE

SENATOR KENNEDY
GOES A-COURTING

20 CENTS

JULY 20, 1953

REG. U. S. PAT. OFF.

FIGURE 12 | *Life* cover, July 20, 1953 (Hy Peskin, photographer)

with a 1-iron from the fairway on the final hole of the 1950 U.S. Open: a great shot of a great shot. Although the *Life* cover does not similarly record a magnificent athletic accomplishment, Peskin's shot of Jack and Jackie breezing across the waves, like his picture of Hogan, conveys a sense of elegant ease in a pristine natural setting. This was the first of eighteen times, by the way, that Jacqueline Bouvier, soon to be Kennedy, would grace the cover of *Life*—more times than any other individual in the history of the magazine except her husband.

It's certainly a "clean" picture: innocent and full of fun. He might seem to look and smile in the direction of her chest, meagerly endowed by the standards of the film goddesses Jane Russell and Marilyn Monroe, whose hit sex comedy *Gentlemen Prefer Blondes* opened at the Roxy the week that this edition of *Life* went on sale. Her oversize and gratuitous pocket flaps may be shaped like breasts. But there's no sense here that Kennedy's eyes fix on her body parts (or their fetish substitutes) or that his smile hints at lechery.

Still, the photo throws off subtle suggestions of sexuality. The shadow from her arm down to her waist contours her torso, giving her a more curvaceous shape. The way she sits demurely over her folded legs would have been considered appropriate for a twenty-three-year-old who had attended Miss Porter's School and Vassar, but the bare arms and legs add to the pose a hint of the cheesecake that typified the era's calendar girl pinups. And although this pretty brunette is not literally bound by ropes, they cut across her body in a faint reminder of the damsel-in-distress bondage imagery so prevalent in the period's pulp art, fiction, and film.

Her right arm is hidden. Perhaps it grips something stationary, such as his waist. Even if not, she leans toward him—for stability, but also, we might infer, for affection's sake. He, however, does not hold onto her or onto anything other than himself, as indicated by the compression of his torso against his upper legs and the circling of his arms around his knees.

This semiotics of female dependence and male independence would have made intuitive sense to *Life*'s readers. Taken in nature amid the primal elements of sun, sea, and sky, the photograph *naturalizes* the male-female relationship embodied here by the boyish young senator and the girlish young woman whom he has gone "a-courting." If she leans on him, why, that's "natural," given their positions on the deck and the traditional, "timeless" hierarchy of the sexes.

Today the photograph might strike us as a conventional Madison Avenue concoction whipped up to sell a modern pleasure-oriented lifestyle and the commodities associated with quick and easy self-gratification. ("Alive with Pleasure!" we can easily imagine a caption gloating.) Back then the imagery was not so hackneyed. All the same, it did serve as an advertisement, in this case for an emerging post-Depression, postwar

consumerist attitude toward life and for a handsome young politician who brilliantly embodied that attitude.

Part of the "selling" of John Kennedy at this point in his career involved showing him to be, at heart, a young, irrepressible, carefree lad, a barefoot boy. For nearly a century, the barefoot boy had been one of America's most cherished archetypes, a figure of energy, spontaneity, wholesomeness, and honesty (even when, like Tom Sawyer, he occasionally prevaricated in a mischievous but essentially harmless manner). Here, the pairing of Jack's barefoot boyishness and the sun, sea, and sails calls to mind one of the most beloved works in the canon of American art, Winslow Homer's 1876 oil painting *Breezing Up*, a favorite of museum visitors ever since it became one of the founding works in the National Gallery of Art (Fig. 13).

Breezing Up shows three young lads seated or reclined informally on the deck of a sailboat, the *Gloucester*. An adult fisherman controls the rope lines, and the boat bounds over the waves amid sun and spray. Homer's contemporaries lauded "the exulting freedom with which his brush ripples over the canvas" and "in which a fresh sea is cloven by the fisherman's boat, while his little boys drink in the health and breeze of the young day." In terms that might well characterize the barefoot senator, an art critic of Homer's time singled out "the boatman's barefoot boy who sits upon the thwart, and whose bright eye evidently sees such enormous horizons as he looks through the

curl of spray shaved up by the keel." Jack's bright eye also evidently sees enormous horizons through the spray—in this case, the horizons of an impending marriage and perhaps even a future presidency.

Jack's clean and innocent boyishness denies, or at least elides, his sexuality, but we must not assume that Americans in the early fifties took no notice of sex. As a female reader informed *Life*'s editors, "Not only is he 'the handsomest young member of the U.S. Senate,' but he has the prettiest legs." Sex splashed across the nation's movie screens that summer, most notoriously in Hollywood's steamy tale of adultery *From Here to Eternity*. When a half-naked hunk of an army sergeant, played by Burt Lancaster, grapples on the sandy beach with his commanding officer's wife, played by Deborah Kerr, their embrace climaxes unmistakably in the foam of the incoming tide.

Jack and Jackie were no Burt and Deborah. Nevertheless, Jack's sexuality was even then an item on the public agenda. Politically, his persona as a footloose young bachelor with an eye for the ladies had served him well. Not long before he announced his engagement, the *Saturday Evening Post* entitled a profile on him "The Senate's Gay Young Bachelor." In a letter to a friend he jokingly admitted concern that marriage would diminish his political capital. "I gave everything a good deal of thought," he wrote. "I am getting married this fall. This means the end of a promising political career, as it has been based up to now almost completely on the old sex appeal."

Joe Kennedy understood that his son's sexual attractiveness to women had mattered in his election to the House and then to the Senate and would help him when he sought the White House. Thirty or so years earlier, before the passage of the Twentieth Amendment granted women the right to vote, such heterosexual attractiveness was relatively unimportant to a politician. Likewise, during the Depression and the war stability, not sexiness, was a politician's prerequisite. Joe Kennedy sensed that all this was about to change in an era of prosperity and relative security.

He also recognized, though, that Jack's generation was, in the words used to title a popular 1952 movie, "the marrying kind." All over America, his son's contemporaries had returned from the war, married, moved to the suburbs, and started families. But not Jack. Jack was adamant about remaining a playboy, and his biographers concur that he had every intention of remaining one until his tough-minded father insisted on the political expediency of marrying. At age thirty-six the filial bearer of Joe's go-for-it-all political ambitions required a wife (and no ordinary wife, at that, but one with the social standing to offset his own family's Boston-Irish parvenu status).

That's what this *Life* cover photo and the corresponding story were all about: Jack's forthcoming conversion from ladies' man to married man. It's not known if Joe actually paid *Life* for this coverage or otherwise bartered for it with his friend Henry Luce, the publisher of the magazine, but a few years later, when his son appeared on the

front of another Luce publication, Joe boasted over lunch to Francis Cardinal Spellman, "I just bought a horse for $75,000. And for another $75,000, I put Jack on the cover of *Time*."

JACK'S PERSONAL AVERSION to marriage can be (and has been) variously explained as a desire to remain unencumbered in his pursuit of sexual pleasure, a fear of commitment, a recoil from the sham of his parents' marriage, or a recognition of his own inability to experience lasting intimacy with others in general and women in particular. Perhaps even the Arthurian legends he pored over during his sickly childhood came into play. In Sir Thomas Malory's *Morte d'Arthur*, a damsel asks Sir Lancelot why he remains "a knight wifeless." Lancelot replies, "To be a wedded man, I think not; for then I must couch with her and leave arms and tournaments, battles and adventures."

As Jack matured, he quickly realized that to "couch" with a woman did not necessitate marrying her. Sex needn't constitute an obstacle to the "battles and adventures" on which he had set his heart. If anything, it added to their savor. Jack rather precociously rejected the putative chastity of the Arthurian heroes of his boyhood and took a different breed of Englishman as his model, the eighteenth-century rake.

The term "rake" derives from the longer composite word "rakehell"—one who gathers (rakes) sin and immorality (hell). But it also pertains to hunting and hawking, where to rake is to run or fly after game. Jack Kennedy, like eighteenth-century rakes before him, enjoyed nothing more than to pursue, to rake, his chosen game (women in his case; for others it might be drink or cards). Lord Chesterfield, the English earl remembered posthumously for his didactic letters to his grown son, admonished the young man not to become a rake, for such men fall into "the lowest, most ignoble, degrading, and shameful vices; [which] all conspire to disgrace his character and ruin his fortune." Nor would he allow his son's sins to go uncensured, for:

> Nobody but a father can take the liberty to reprove a young fellow grown up, for those kind of inaccuracies and improprieties of behavior. The most intimate friendship, unassisted by the paternal superiority, will not authorise it. I may truly say, therefore, that you are happy in having me for a sincere, friendly, and quick-sighted monitor. Nothing will escape me; I shall pry for your defects, in order to correct them, as curiously as I shall seek your perfections, in order to applaud and reward them.

Jack's father bore little resemblance to Lord Chesterfield. Far from imploring his son not to sin with women, the elder Kennedy liked to impress the younger with dis-

plays of his own extramarital prowess. One summer day in 1929 Joe took his mistress, Gloria Swanson, for a private sail on the *Rose Elizabeth*, the yacht he'd named for his wife. While they were in the midst of making love, they looked up to see Jack, a stowaway, suddenly appear from below deck. Bewildered, the twelve-year-old dove overboard and swam for shore. "Joe wasn't upset," Swanson recalled. "He just laughed, then he just fished Jack out of the water. I was embarrassed, of course, and Jack was shaking, almost crying. He didn't really understand what we had been doing or how to react. Joe thought the whole episode was hilarious."

Let's look again at the *Life* cover. Now some quarter of a century older than when he discovered his father having sex with the film star, Jack is topside again, and again in the presence of a beautiful young woman, only this time his old man isn't around to claim her. Or is he? Joe, after all, owned the boat, it was sailing off his Hyannis Port property, and he had almost certainly arranged the series of photo sessions from which this picture results. Moreover, the engagement itself, which the cover photo publicizes, had come at his insistence. In the *Life* photo, if we return to it with Swanson's troubling anecdote in mind, we might detect in Jack's disconnected gaze the vulnerability of that distant summer's day.

Jackie, too, had been subjected to Joe's exhibitionism. A year earlier, during her first visit to Hyannis Port, she was watching a new Doris Day and Ronald Reagan movie in the basement screening room with various family members when Joe tapped her on the shoulder and beckoned her to come with him. He led her to a room lined with glass cases containing hundreds of dolls garbed in native costumes from around the world. "I used to bring Gloria Swanson to this doll room," he remarked. "She liked to make love here. Let me tell you, that woman was insatiable." He then proceeded to describe to his son's girlfriend and future fiancée Swanson's intimate bodily details, including her genitals and her capacity for multiple orgasm. The twenty-two-year-old's reaction to this bizarre confession/boast has not been recorded, but one of her biographers notes that, "as the daughter of Black Jack Bouvier, Jackie had heard worse."

Called "Black Jack" (also the "Jack the Sheik" and "the Black Orchid") because of his dark, swarthy good looks, Jackie's philandering father enjoyed regaling his daughter with stories of his sexual exploits. And, she, apparently, liked to be regaled. "From the time Jackie was old enough to understand the difference between men and women," according to the biographer Edward Klein, "her father engaged her in sexually stimulating conversations. One of Jackie's favorite stories, which she had heard firsthand from her father, was how he had misbehaved on his honeymoon with her mother. On his way over to England with Janet on the *Aquitania*, he had slipped away from his bride and slept with the tobacco heiress Doris Duke."

Divorced from Janet Lee Bouvier when Jackie was thirteen, Black Jack sought to win and maintain the love and loyalty of "Jacks" and her sister, Lee. Never remarry-

ing, he saw his two girls as often as possible (he lived in New York, they with their mother and stepfather in Virginia and Newport). Courting them with his abundant personal magnetism, he also provided them with monthly allowances and charge accounts and horses to ride, and he paid for their private school education. Doing so drained his limited financial resources. A stockbroker whose fortune disappeared in the stock crash, Bouvier nonetheless liked to live high, or at least appear to do so, especially when his daughters came to visit. Recurrent dependency on alcohol forced him from time to time to undergo clinical treatment. But his girls adored him, and his relationship with the older child was especially close. At a relatively early age she became his confidante, devotedly listening to, and being entertained by, his many tales of sexual conquest and intrigue.

Why these paternal sexual confessions/boasts? Were the two instances I mention here, Joe's and Black Jack's, weird aberrations from the norm, notable precisely because they were exceptions to the rule of fatherly sexual discretion? Probably. Jack Bouvier had fallen on hard times when he began his Scheherazade-like campaign to woo Jackie and forestall her inevitable disappearance from his life. Joe Kennedy, in contrast, was flush with success when he pulled Jackie aside at Hyannis Port to recount his intimate knowledge of his former lover. With their gratuitous disclosures to Jackie, the older men proved themselves manipulative and controlling, and maybe even predatory. But they made themselves pathetic as well, for they disclosed to her not their sexual prowess, as they may have thought, but their insecurity, as evidenced by their compulsion to boast.

Jackie's biographers have often pointed out that after her father died, early in her marriage, the man with whom she shared the closest emotional bond was not her husband but her husband's father. Joe Kennedy, it seems, was willing, indeed eager, to take her into his confidence in a way that Jack Kennedy, with his secretive love affairs and fear of intimacy, never was.

Perhaps we can make better sense of these instances of sexual confession by a father and a father figure by looking at an analogous third instance. In 1976 the distinguished biographer and scholar of early American history Page Smith published an astonishing book-length letter from his father, Ward Smith, written in the first person and filled with graphic detail about the elder Smith's lifelong devotion to extramarital sex. In his introduction to *A Letter from My Father* Page Smith explains, "It was my father's strange conceit to write me a letter, the writing of which extended over a period of more than thirty years, and which, ultimately, reached ten thousand pages in length." Ward never sent Page any portion of the letter, but he told his son of its existence and sometimes read aloud to him from it. He bequeathed it to Page as part of his estate.

Like his contemporaries Jack Bouvier and Joe Kennedy (and Joe's son John), Ward Smith was a dedicated, that is to say, single-minded and hard-working, philanderer for whom the term "labor of love" takes on a special meaning. Trying to make sense of his father's obsessive pursuit of women, Page Smith speculates, "It must be one of the profoundest ego-satisfactions known to man to experience the feminine world as almost totally and constantly accessible. That alone might be enough to make a man an addict." But Smith also notes that his father "failed by virtually every standard that the average American regards as important. He was an absent husband, a nothing father, an inadequate provider, a repeated business failure. In one area only was he an unqualified success—in bed, in sexual exploits. . . . In that field he was, or felt himself to be, unrivaled."

That singular success, Smith concludes, gave purpose to his father's extraordinarily detailed and explicit sexual narrative: "So perhaps his letter to me can be understood as a variation of the great American success story. My father never made it. . . . But while his contemporaries and friends and associates were making it, he was making it with their wives, mistresses, and daughters, as well as any other stray female who wandered into his ambience."

Ward Smith was born poor and never became rich. John Vernou Bouvier III was born rich and became poor. Joseph Kennedy was born poor (or so he claimed) and became exceedingly rich. And John F. Kennedy was born rich and remained rich. Yet all four men seem to have subscribed to the particular cult of success that Page Smith describes, one in which prowess in the bedroom equals, or substitutes for, prowess in the boardroom. The seemingly inappropriate sexual confessions of the three older men may indeed be understood as variations on one of America's most important literary or subliterary genres, the success story, which is nothing if not about the taming of what William James called "the bitch-goddess SUCCESS."

Herein is the subtext of the *Life* photo shoot arranged, and perhaps even paid for, by Joe Kennedy. It testifies not simply to this one senator's youth and freshness and resplendently white teeth but to the dream possibility that in America any barefoot boy could earn the right to sail away with a princess.

IN SENATOR KENNEDY'S OWN MIND, the symbolic meaning of his dalliance with the alluring Miss Bouvier may have had less to do with the assertion of nouveau-riche financial success than with a much older social ideal, as embodied in Lord David Cecil's acclaimed biography *The Young Melbourne*, which Jack, an Anglophile, often reread and quoted. Published in England in 1939, while the Kennedy family resided there (the second volume, *Lord M*, appeared in 1954), *The Young Melbourne* vividly

re-creates the life and times of an English statesman who capped his long political career by serving as Queen Victoria's first Prime Minister. Years earlier, Melbourne had suffered humiliation when his wife, Lady Caroline Lamb, embarked on an outrageously public love affair with the poet Byron.

It remains unclear whether Jack identified primarily with the long-suffering Melbourne, a man who maintained cool detachment and ironic wit under trying circumstances, or with Melbourne's nemesis, Byron, who, like Jack, overcompensated for a sickly childhood with a rakish determination to bed every woman he desired. But it's unnecessary to choose, for given who Kennedy was and aspired to be, probably he would have been attracted to both men and, beyond them, to the aristocratic world of Regency England to which they belonged.

The prologue to *The Young Melbourne* lucidly portrays the Whig milieu that formed men such as Melbourne and Byron: "The Whig aristocracy was a unique product of English civilization. It was before all things a governing class. At a time when economic power was concentrated in the landed interest, the Whigs were among the biggest landowners: their party was in office for the greater part of the eighteenth century. . . . And they lived on a scale appropriate to their power."

Although the wealthiest young men of this social class could afford to live lives of pure indolence, the best of them, such as Melbourne, were "always in touch with the central and serious current of contemporary life. The fact that they were a governing class meant that they had to govern. The Whig lord was as often as not a minister, his eldest son an M.P., his second attached to a foreign embassy. So that their houses were alive with the effort and hurry of politics." That description readily suggests why young Kennedy would have identified with young Melbourne.

His own pursuit of carnal pleasure would surely have been licensed by Cecil's contention that the Whigs' economic circumstances "did not encourage the virtues of self-control. Good living gave them zest; wealth gave them opportunity; and they threw themselves into their pleasures with an animal recklessness at once terrifying and exhilarating to the modern reader. . . . The historian grows quite giddy as he tries to disentangle the complications of heredity consequent on the free and easy habits of the English aristocracy." Far from striking a disapproving tone, Cecil eulogizes the Whigs for their behavior: "Unseemly as some of its manifestations were, one must admit that there is something extremely attractive in this earthy exuberance. . . . For all their dissipation there was nothing decadent about these eighteenth century aristocrats. Their excesses came from too much life, not too little."

In a manner that must have made young Kennedy's heart sing, Lord Cecil concludes, "It was the same vitality that gave them their predominance in public life. They took on the task of directing England's destinies with the same self-confident vigour, that they drank and diced. It was this vigour that made Pitt Prime Minister at twenty-

four years old." Stirring words for a man who dreamed of becoming, and then did become, the youngest president in his nation's history.

From Jack's point of view, the *Life* cover and the feature inside showing his family and fiancée enjoying summer leisure at their country estate would have accorded well with Cecil's idealizing depiction of the Whig aristocracy. A dashing young lord, his pretty consort, casual, unstudied elegance, physical grace, appurtenances of wealth, the open air, a dazzling sun, windblown sails: in a word of Cecil's that Kennedy was to make his own, this photograph is the embodiment of "vigor"—or, as Jack famously pronounced it, "vigah."

The formal qualities of the photo underscore the vigor of its subjects, a handsome young couple enjoying their leisure. Employing a full range of tonal values, it offers the eye a visual playground to skip along, from the inky black cable in the near left to the richly textured shadow on the deck beneath their legs to the white shirts and sails to the sun-drenched sky. Equally rich is the photo's pictorial composition, full of sharp angles, curving lines, shafts and planes of light, and a subtle balancing of interlocked forms. Strength, vitality, force, and energy: Peskin's photograph conveys them all.

By treating its readers to such an appealing, fresh-scrubbed, toothpaste-bright representation of Kennedy vigor, *Life* transmitted Kennedy's Whiggish ideals as well. In the eighteenth- and early-nineteenth-century English context, Whigs were political liberals because they opposed the power of the state over the individual, but in present-day political terms they were conservatives, in that they intensely objected to government intervention in the economy. The Whig aristocrats favored the moneyed and educated classes over what they took to be the rabble; as home secretary, Melbourne ruthlessly suppressed agrarian unrest, in which the poor agitated for government protection. The Whigs embraced the philosophy of laissez-faire, which advocated allowing economic matters to occur without regulation.

Laissez-faire economics, as formulated by Adam Smith and retooled for the industrial era by Jeremy Bentham and John Stuart Mill, advocated free trade and open markets, minimal government regulation, and the removal of artificial barriers to, and restraints on, trade. Such a philosophy held enormous appeal for freewheeling entrepreneurs such as Kennedy's father and his father's friend Henry Luce, the founder of Time-Life. Jack Kennedy, however, was less than wholly committed to economic laissez-faire. After all, he came of age during the New Deal, which sought to mitigate the socially disastrous effects of a laissez-faire economy with government-funded stimulants and safety nets.

In more personal terms, though, Jack was wholly in favor of a laissez-faire approach, at least insofar as he and the ever-multiplying objects of his desire were concerned. America itself in the postwar era was beginning to turn (either too slowly or too rapidly, depending on one's point of view) toward a laissez-faire sexuality. Popular his-

tory and the media today ignore that shift as they mythologize (or demonize) the white middle-class suburban culture of the 1950s as a stronghold of conservative morality, where Mother ceaselessly baked cakes, Father knew best, and "Beaver" was the moniker of an all-American boy, not vulgar slang.

Perhaps the fifties *were* more innocent than our own time, whatever exactly that might mean, but the trouble with such a contrast is that it obscures how highly sexualized life was then for vast numbers of Americans. The real difference between then and now may well lie not in the significance of sex in people's lives but in the mass media's under- or overemphasis of its importance.

DURING THAT SUMMER when Jack Kennedy frolicked with Jacqueline Bouvier on a sloop off Hyannis Port, a young army veteran in Chicago pieced together the layout for the inaugural edition of *Stag Party*, a new magazine he planned to publish. It would, he hoped, magically re-create in its glossy color pages the sweet-nectar fantasies that kept him going through the relentlessly drab days and nights of his life. He drove a clunky 1941 Chevrolet and inhabited a tiny walk-up apartment with a wife who did not share his enthusiasm for sex and an infant daughter whose constant wails invaded the hallowed precincts of his imagination. As a ravenous reader of mass-market magazines who had himself worked for several, he surely scrutinized the July 20 issue of *Life* that summer and envied Senator Kennedy for just about everything one man could envy in another: wealth, power, looks, and, in the single term that seemed to sum up everything else, "women."

With $600 borrowed from the bank, the young would-be publisher drove out to a suburb and negotiated with a calendar manufacturer for the rights to a 1948 color pinup photo of a fetching blond model who posed with her lips invitingly open and her eyelids sensuously lowered. The model luxuriated on a length of red velvet, with nothing on, as she was later to recall, but the radio. This, of course, was Marilyn Monroe, obscure when she posed for Tom Kelley's calendar photo, but now, in 1953, a movie star. Hugh Hefner paid $500 that day for the publication rights to the Monroe pinup (for which she had earned a mere $50). With the rights to the picture in hand, he soon attracted investors to his enterprise. Changing the name of the magazine to *Playboy*, he brought out the first issue in December 1953 with Monroe clothed on the cover and nipple-naked inside. The edition sold out quickly, and Hefner rapidly advanced toward his goal of becoming a millionaire himself and, like Senator Kennedy, a bona fide playboy.

The name *Playboy*, with its connotations of a life comfortable enough to allow the energetic pursuit of pleasure, proved far more appropriate than *Stag Party* for Hefner's magazine. "Stag party" meant a gathering for men only, a revel that excluded women

other than the hired strippers or performers in stag movies that the men bayed and whistled at with raucous displays of virility. That environment was not the one Hefner aspired to in his fantasies. The fervent male bonding of the stag world didn't interest him. He dreamed instead of a world overflowing with women who shared his desire for endlessly inventive and erotic free play and who were either already highly skilled at such play or were more than willing to be instructed.

Nevertheless, *Playboy* was aimed at stimulating the fantasies not of one man only, but of millions. It sought to create a nationwide stag party. A subscriber, by ogling pulchritudinous (to use Hefner's favorite modifier) women in the privacy of his own bedroom or bathroom, became "one of the guys" without actually having to enter into disturbing proximity with other men. *Playboy* thus provided its readers with an abstract and hence nonthreatening form of manly social bonding, an essential element of male heterosexuality.

It's as if Hefner had latched onto the dream of eighteenth-century English aristocratic life that Kennedy embodied and, in the effulgence of American postwar consumer culture, made it accessible to millions of his and Kennedy's less-than-aristocratic male contemporaries. Hefner received his training in the magazine business working for *Esquire*, a publication that during the 1930s and 1940s symbolized male glamour and rakishness. Its name denoted an English country gentleman, a landowner who ranked higher than a commoner but lower than a knight or lord. Hefner's *Playboy* exploited its readers' aristocratic desires and pretensions but democratized them, for the underlying theme of the magazine was that any man, any regular guy, even any barefoot boy, could achieve playboy status for the nugatory price of a newsstand copy.

Thus what *Playboy* sold its readers wasn't imaginary women but rather the gallant lifestyle that real-life playboys, like "the Senate's gay young bachelor," Jack Kennedy, made seem so enviable. The naked pinups were not an end but a means. They promised men the experience, if only in fantasy, of unregulated sexual hedonism and an exhilarating liberation from long-term commitment and marital obligation. That millions of men desperately desired the playmate who seemed to cast her gaze on each reader, and on him alone, only made the psychological pleasure all the more exquisite.

Playboy wasn't the only mass-market magazine in 1953 to invite readers to use its pictures to stimulate sexual fantasies. It was simply more overt than most. "Among other magazines offering masturbatory possibilities," Gay Talese notes in *Thy Neighbor's Wife*, his history of American postwar sexuality, were "such large circulation magazines as *Life* and *Look*, which, in beguiling ways, sometimes surpassed all other publications in presenting sexually arousing photographs."

Talese also notes that President Kennedy's personal popularity was "enhanced by his fashionable young wife, Jacqueline, who became the most photographed woman in the world and, parenthetically, the masturbatory object of numerous male maga-

zine readers. Never before in American history have so many men privately craved a President's wife." Presumably, the photo of her in shorts and a sleeveless blouse in the summer of 1953, while anything but lewd or lascivious, nevertheless inspired in many of *Life*'s male readers a similar private craving.

BUT WHAT ABOUT Jackie's desire? Where was she in all of this? Did she too lust for Jack's looks, wealth, and power, not so much in the way that Hefner and his age cohorts did, but, all the same, to have her own unfettered access to these desirable characteristics? Probably, but who can say for sure? One can only make some statistically informed guesses about it on the basis of the enormously influential sex survey that Dr. Alfred Kinsey published in the summer of 1953, *Sexual Behavior in the Human Female.* A companion volume to his earlier best-seller, *Sexual Behavior in the Human Male,* this Kinsey Report, as it was popularly called, tabulated and statistically analyzed more than seventeen thousand in-depth interviews with American women of differing social class, race, religion, age, geographic region, and sexual predilection. Surely somewhere in the book's five-hundred-plus pages, young Jackie Bouvier would have found some representation of herself.

Kinsey reported that nearly 50 percent of American women in general and 60 percent of those who had graduated from college had engaged in sexual intercourse before marriage (almost half with their fiancés alone; nearly half of the women who had engaged in sex reported having had more than one sexual partner). Over a third of women who were still single at age twenty-five had had sex. As of 1953, 20 percent of married women over the age of thirty-five had been unfaithful to their husbands (and 10 percent of wives under thirty-five). Kinsey found that 62 percent of his female sampling admitted that they masturbated, 65 percent had nocturnal sex dreams, and 13 percent had by age forty-five experienced at least one homosexual contact that resulted in orgasm. While these findings have been questioned in recent years, they shocked Americans at the time by suggesting that sexual desire was more pervasive in the middle class than had been recognized.

As *Life* was quick to point out in an extensive discussion of the new Kinsey Report, more sexual activity among American women did not necessarily mean a greater enjoyment of sex. To the contrary, explained the magazine, Kinsey's study revealed that women were having more sex than before but, if anything, enjoying it less because it had become yet another domestic burden, that of keeping their men content at home. "The new Kinsey book demonstrates," wrote *Life*, "that to the average woman the average man must seem . . . like a 'prancing, leering goat.' To the average man, the average woman must seem . . . disinterested, unresponsive and in fact sometimes downright frigid. So completely different are male and female sexual appetites and tastes,

says Dr. Kinsey, that it is almost a miracle that 'married couples are ever able to work out a satisfactory sexual relationship.'"

Life put it still more bluntly: "The average woman, the figures show without doubt, can certainly take sex or leave it alone." As an approving female reader wrote to *Life*'s editors, "The wishful thinking and vicarious eroticism of psychiatrists (male) in presupposing and encouraging ravening sexuality in women may now, at last, come to an inglorious end. . . . It should by now be sufficiently demonstrated that women will engage in activities they do not particularly enjoy, and which are frowned on by convention, just to escape a status combining the features of household utensil and plaster saint." *Life* told its readers that Kinsey's findings about the innate or deeply conditioned sexual *froideur* of women "will probably be much less surprising in Europe, where many wives have found it quite a relief for the husband to take a mistress, than in the peculiarly superromantic U.S. of 1953," a nation in which "Marilyn Monroe is the most publicized movie star of all because she can convey [the] impression of total passionate surrender."

By "superromantic" *Life* meant saturated with sexual fantasy and sexual exploitation: exactly what Hugh Hefner was eagerly planning to purvey and what *Life*, more coyly, capitalized on in both its Kinsey and Kennedy editions that summer. Marilyn Monroe herself intriguingly poked fun at the sexual saturation of American culture. "I used to wake up in the morning, when I was married," she said, "and wonder if the whole world was crazy, whooping about sex all the time. It was like hearing all the time that stove polish was the greatest invention on earth."

HOWEVER SHE HERSELF FELT about sex, Marilyn embodied one of culture's most tenacious and elusive ideals: pure, happy, undiluted sexuality. Jackie could never compete with her for sheer sex appeal, not in 1962, when the voluptuous film star, in a clinging, diaphanous gown, sang a torrid "Happy Birthday, Mr. President" at Madison Square Garden, or in 1954, when the president-to-be languished in the hospital and had not yet met his mistress-to-be.

During his convalescent stay after back surgery, the same stay during which Grace Kelly visited him in the guise of a night nurse, Jack taped to the door opposite his bed a large movie poster of Marilyn, hands on her hips and legs planted wide, wearing short-shorts, heels, and a tight white sweater. (Marilyn to the troops in Korea: "I don't know why you boys are always getting excited about sweater girls. Take away their sweaters and what have they got?") Kennedy hung the poster upside down, so that Marilyn spread her legs in the air. Jackie did not find the gag amusing. "You know, I have the exact same outfit," she said to her husband. "Why not take that down and I'll have a similar photo made of myself for the same space?" The poster remained where it was.

FIGURE 14 | *The Seven Year Itch*, 1955

Monroe's legs featured prominently in what has surely become the most iconic Marilyn image of them all, the scene from *The Seven Year Itch* (1955) in which she stands over a Manhattan subway grating and squeals with pleasure as her skirt billows upward (Fig. 14). The idea of shooting the scene on location came from Marilyn's friend Sam Shaw, a still photographer hired by the studio to document the making of the Billy Wilder film. Very early one morning on Lexington Avenue the actress struck a variety of poses in front of a crowd of gawking onlookers and assorted photojournal-

ists (among them the subsequently acclaimed street photographer Garry Winogrand). The sequence as it appears in the movie was reshot on a Hollywood soundstage and is far tamer than what transpired on Lexington Avenue. In the pictures taken on location Marilyn's ribbed white halter-top dress flies up over her legs and panties like a foaming wave. It looks like the half shell on which Botticelli's Venus perches, only here it extends above her hips rather than beneath her toes. In each of the many versions of this photo, Marilyn epitomizes pleasure, delight, *fun*. Norman Mailer surmised that having sex with Marilyn Monroe would be as easy as eating ice cream. Well, here she's the one who seems to be relishing the ice cream, and all the way down to the roots of her soul. ("Do I like to be photographed full face or profile?" she once asked rhetorically and then answered, "Profile every time when you have a beautiful profile all the way down.") Yet the subway vent picture should not be regarded as an unambiguously universal emblem of exultant female sexuality.

Whether we take Marilyn's delighted grin at face value or regard it as contrived, manufactured solely to stimulate male fantasy, the photos of her astride the subway grate constitute, collectively, an unforgettable image of urban modernity. In this regard, the subway shots represent the antithesis of the shot of Jack and Jackie on the sailboat, even though their photo too incarnates giddiness and sensual pleasure. The sailing picture is pastoral: anti-urban and antimodern. The Kennedys went to Hyannis Port to escape the city, and in sailing off the coast they partook of age-old premodern rituals. The subway photos, in contrast, pulsate with urban energy and the thrill of modernity.

The city-lust of the subway photos can be glossed by the following passage from Page Smith as he attempts to make sense of his father's serial sexuality:

> The principal riddle of my father's life was his obsession with sex. I always saw it as, in part, a consequence of his life in New York City. To me the city simply was (doubtless because of my association of my father with sex and with the life of the city) a sex-saturated environment. One was surrounded by women out of context, so to speak. They were not perceived, as one brushed past them in the streets, in crowded places, saw them on buses and above all, of course, on subways, as wives or mothers or people imbedded in some particular, defined social situation, but as mysterious, alluring sexual creatures, each seeming to promise a blissful assignation. That my father should have been so eloquent on the subject of what might be called "subway sex" seems significant to me, because of all the places one encountered women in New York, the subway was the most sexually suggestive if only because of the press of bodies stimulated by the motion of the train. It was one of those odd encounters of extraordinary if transient intimacy, in which the modern city abounds; eyeball-to-eyeball contact, body contact, olfactory contact that was at the same time outside of any normal context of social relationship.

Marilyn does not jangle, jostle, and rhythmically rock *on* the subway in this photo series, but she towers over it symbolically, like a mythological goddess. She's a fertility symbol, a latter-day Venus of Wallendorf (the oldest known prehistoric figurine representing a fertility goddess). The subway world, or, if you will, the underworld, that Marilyn presides over is that pulsing, desiring, and dangerous realm of urban transience and anonymity that became in the twentieth century the very emblem of modernity. The subway vent photos take the quintessential late-1940s, early-1950s film noir setting—the mean streets of Gotham in the dark of night—and superimpose on it an ultrablond female fantasy figure dressed, or undressed, all in white and displaying not a lick of shame, guilt, or fear.

Mailer describes the scene thus: "She plays it in innocent delight, a strapping blonde with a white skirt blown out like a spinnaker above her waist—a fifty-foot silhouette of her in just this scene will later appear over Times Square. In Eisenhower years, comedy resides in how close one can come to the concept of hot pussy while still living in the cool of the innocent."

The series of skirt-blowing, underwear-revealing stills from *The Seven Year Itch* appealed irresistibly to viewers—and presumably not only males—because these pictures envisioned the metropolis as a setting emancipated from crime, coercion, and violence, a safe and carefree playground in which sensual impulse can be "vented" without dire consequence. Indeed, Mailer's likening of Marilyn's blowing skirt to a spinnaker conjures her as an urban pleasure schooner, a carefree windjammer not all that different in spirit from Jack and Jackie's sailboat, bounding over the briny waves.

As the Mailer passage indicates, the photos also celebrate the male gaze and women's corresponding self-objectification. Moreover, in subtle or not so subtle ways they suggest that only *whiteness* can transform the city from a jungle to a paradise. Hollywood's reigning blond sex goddess ("goddess" derives from the same root as "goodness") symbolically modeled the universal worth of Caucasian hair color, skin pigmentation, and, ultimately, social identity. Soon after Marilyn famously flashed her white thighs and panties across America's movie screens in the summer of 1955, the Emmett Till murder case stunned the nation. A fourteen-year-old black child from Chicago visiting relatives in Mississippi, Till was accused of whistling provocatively at a white woman in a grocery store and beaten to death by locals who claimed they had acted to defend the honor of white womanhood. Sympathetic jurors set them free. Monroe's billowing skirt photos were remarkably popular then, and still are, not in spite of these additional meanings about the sexuality of modern women and the desirability of whiteness, but in some way because of them.

Jackie would seem in every way Marilyn Monroe's exact opposite, even more than she was Doris Day's or Elizabeth Taylor's. The physical differences are obvious: Jackie more closely resembled Audrey Hepburn—dark, slender, boyishly built—who became

FIGURE 15 | *Roman Holiday*, 1953

the idol of many young women in the summer of 1953 for her performance in *Roman Holiday* as a princess who falls in love with a journalist (Fig. 15). So are the differences in family background, upbringing, schooling, career path, and public persona. Jackie guarded her private life, Marilyn made hers public; Jackie shunned publicity and Marilyn thrived on it. (Try to imagine Jackie Kennedy standing over a subway vent in front of onlookers and squealing with joy as her dress swells up around her. Not possible.) Despite some rumored lapses, never proved, Jackie seems to have remained devoted to her husband during his lifetime, even though he betrayed her constantly, whereas Marilyn, however much she may have wished to be a one-man woman, most decidedly was not.

Yet, oddly, they shared certain intimate qualities (such as high, breathy, how-can-I-please-you? vocal patterns) and, in one notorious instance, people (the president). Attractive women from the start but not knockouts, they made themselves into two of the most celebrated beauty icons of the twentieth century. Both were known across the world during their lifetimes and have since achieved legendary status as two of the most

idolized women of all time. They were intelligent, witty, and well read. Each, in her way, suffered martyrdom. And each was economically dependent on men.

Twice in 1953 Marilyn satirized gold digging, first in a film called *How to Marry a Millionaire*, and then again, brilliantly, when she performed her over-the-top "Diamonds Are a Girl's Best Friend" number in *Gentlemen Prefer Blondes*. In real life, this child of the working class remained ever suspicious of the class superiors on whom she was emotionally and often financially dependent. "I could never be attracted to a man who had perfect teeth," she said. "A man with perfect teeth always alienated me. I don't know what it is but it has something to do with the kind of men I have known with perfect teeth. They weren't so perfect elsewhere."

In September 1953 Jackie, whose father had dissipated his wealth and whose wealthy stepfather, though benign to her, was not planning to will her any part of his estate, stepped up to the altar with one of the richest men in America—a man who did indeed have perfect teeth. Ever since Jackie was a child, her mother had insisted she wed someone "with real money," and now she was fulfilling that admonition. According to Gore Vidal, who knew her then, she responded to a former lover who objected to her involvement with Jack by answering coolly, "He has money, and you don't." Look at the sailboat photo again in this context, and Jackie suddenly seems like a fetching brunette variation on Marilyn, whose *Gentlemen Prefer Blondes* was showing in movie theaters across the country the week the *Life* issue appeared: how to marry a millionaire, indeed.

EARLIER IN 1953 Marilyn, having bagged her first film lead, played a wife who conspires to murder her husband, Joseph Cotten. It was the studio press photo from this thriller, called *Niagara*, that Andy Warhol used as the starting point for his famous *Marilyn* silk screens of the early 1960s. Ian Fleming described the same publicity shot in his 1957 James Bond novel *From Russia with Love* (which JFK later identified as his favorite of the series). In the chapter entitled "The Mouth of Marilyn Monroe," a giant advertising poster from the film covers the side of a building in Istanbul. A villain tries to escape through a hidden trapdoor: "Out of the mouth of the huge, shadowed poster, between the great violet lips, half-open in ecstasy, the dark shape of a man emerged and hung down like a worm from the mouth of a corpse." Bond and an ally, lying in wait, shoot the man from a distance with a telescopically sighted rifle. Fleming's metaphoric use of Marilyn's face as both an icon of lust and a site of death parallels her role in the movie being advertised.

In that film, when Cotten, as an emotionally troubled and sexually insecure war veteran, discovers that his wife is not only cheating on him but also conspiring to have him killed, he turns the tables and kills her instead. He does so inside an enormous (and

FIGURE 16 | *Niagara* advertisement, 1953

enormously phallic) bell tower at the base of the famous falls. He himself dies when his escape boat runs out of power and the torrent sweeps it over the edge into oblivion.

From start to finish, the film equates Niagara Falls with marriage (honeymooners and honeymoon motels), marital dysfunction (the marriage breaks apart at the falls), and unleashed sexuality (the continual roar of the water, the framing of Monroe's overtly sexual body by the curvature of the falls, the violent current against which men are powerless [Fig. 16]). *Niagara*'s popularity with audiences—it recouped six times its cost at the box office and made Monroe a star—suggests that the archetypal sexual symbolism of man, woman, and water would not have been entirely lost on readers of

Life. Those same readers, however, probably would not have noticed that the magazine's picture of Kennedy's boat as it heels through the waves provides an ominous trope for that oftentimes wild and jouncing ride known as marriage.

If sailing works as a figure of speech (or a visual trope) for marriage, it does so for sex as well. Jack Kennedy recognized the metaphoric relationship, first drawn by Lord Byron, between lovemaking and sailing. Two years earlier, in the summer of 1951, he had confided to a friend, "I don't want to marry a girl who's an experienced voyager. And I'm not referring to travel on land and sea. I mean, I don't want to marry a girl who's traveled sexually—who's sexually experienced." Revealing a masculine insecurity not unlike that of Joseph Cotten in *Niagara*, but without the murderous paranoia, he added, "There are too many complications with a girl who's an experienced voyager. They make comparisons between you and other men. I want someone young and fresh. I want to marry a virgin."

MARRYING AN EXPERIENCED voyager was not, apparently, a problem for Jackie. She knew that the man she had chosen for herself had been sailing, so to speak, all his life. That's how men are, she might have thought. The Kinsey Report suggested that this is how most American women of the period regarded men. "Kennedy men are like that," she explained to the woman who would marry Jack's brother Teddy in 1958. *Così fan tutti*, the Italians say: they're all like that.

Fluent in Italian and a lover of classical music, Jackie might even have phrased her comment thus. In so doing she would have been alluding to Mozart's 1790 opera *Così fan tutte*. In an acclaimed new production starring Eleanor Steber, Roberta Peters, and Richard Tucker, *Così* was a glorious hit at the Metropolitan Opera in the early 1950s. The feminine ending for *tutte*—an "e" rather than "i"—indicates that it's women, not men, who are "all like that." Like what? Perfidious, inconstant, two-timing. Not to be trusted. Here in the radiant work of Mozart is the quintessential theme of a late-1940s, early-1950s film noir such as *Niagara*—you can't trust a dame—but with a radically different, eighteenth-century, sensibility. Female fallibility is accepted as part of the human condition, even embraced good-naturedly, rather than decried.

The slight story of *Così fan tutte* goes like this: When a pair of Neapolitan naval officers brag that the two women to whom they are betrothed could never possibly be unfaithful to them, an acquaintance wagers otherwise. He bets he can prove before the day is out that even these women are as fickle as any others. In the opera buffa that ensues, the officers mislead their respective lovers into believing that they have gone off to war and then return, in disguise, to seduce them, each man pursuing the other man's sweetheart. The plot succeeds, and all is revealed in the end, but no one seems

to mind, and the two couples, having switched partners, proceed together to the altar in a triumphant finale.

In proclaiming that women are "all like that"—fickle and untrustworthy—Mozart and his librettist Da Ponte make it strikingly clear that men are "like that" as well, for they're shown to be every bit as inconstant as the women and even more duplicitous. The ladies' maid, Despina, addresses this very point in an aria:

> In men, in soldiers
> You expect to find fidelity?
> (laughing)
> Don't let anyone hear you, for goodness' sake!
> They're all made of the same stuff.
> Quivering leaves
> And fickle breezes
> Are more steadfast than men.

She holds no romantic illusions about members of the opposite sex and their gambits of love:

> All that men care about
> Is having their way with us.
> Then they despise us and
> Deny us affection.
> It's not worth asking barbarians
> To show mercy.

Women have but one response to the tyranny of men, and that is to beat them at their own game:

> Come now, ladies, let's pay back
> These indiscreet and selfish creatures
> In their own coin;
> Let's love them purely
> For our own pleasure
> And vanity!

Unsentimental sentiments such as these would have made sense to young Jacqueline Bouvier, who was an ardent admirer of eighteenth-century history, culture, and sensibility. The chapter that follows has more to say on this subject. But the Mozartian

outlook was not restricted to the opera stage. From time to time it appeared on Broadway as well, as in Frank Loesser's *Guys and Dolls*, which became one of the longest-running musical-comedy hits of the 1950s, with over twelve hundred performances.

Once again the plot hinges on a sexual wager. Can the handsome hero, Sky Masterson, convince a chaste, right-minded Salvation Army worker named Sarah Brown to accompany him on a romantic getaway to (pre-Castro) Cuba? He can: "If I were a bell," Sarah sings after an evening with Sky in Havana, "I'd be ringing!" But at the end of the show, she hasn't been able to wean him away from his propensity to gamble. An acquaintance, Adelaide, a stripper, offers Sarah this comically cynical advice:

> Marry the man today,
> Trouble though he may be.
> Much as he loves to play,
> Crazy and wild and free.
> Marry the man today,
> Rather than sigh and sorrow.
> Marry the man today—
> And change his ways tomorrow!

Sarah quickly cottons to this idea, and soon the two women sing in soaring harmony:

> Marry the man today,
> Give him the girlish laughter.
> Give him your hand today
> And save the fist
> For after.

Is that "girlish laughter" we see Jackie giving Jack? Poised on his sailboat, leaning toward him in a gesture of feminine dependency, she may indeed be an experienced voyager, after all. Perhaps not in the way that Jack used the term, yet it would be wrong to think that she's simply a passenger here. She may not be steering the boat, but in a sense she's steering him. Or at least imagining that this is what she's doing and would continue to do once they were married.

Sadly, the illusion didn't last long. At the time the *Life* issue appeared on the stands, Jack was sailing again, but not with Jackie. Leaving his fiancée behind, he and another bachelor, a college buddy, chartered a yacht on the French Riviera. Senator Kennedy's office announced that he had traveled to France to confer with government officials about the situation in Indochina. The debonair playboy from America was spotted night after night in the hot spots of Cap d'Antibes with a succession of beautiful women, none of them bearing any resemblance to French government officials.

WHEN I LOOK at *Life*'s picture of the handsome young couple metaphorically sailing off into their future on a gently breezy day, I am reminded of a contrasting image of an older, plainer couple limping into their final harbor. This is the famous wire service photograph of the convicted Communist espionage agents Julius and Ethel Rosenberg, seated side by side but separated by a steel-mesh grille in the back of a police van taking them to the death house. The Rosenbergs attracted far greater notice than Jack and Jackie during the summer of 1953 because of the controversy leading up to and following their execution on June 19. To sympathizers across America and in other countries throughout the West, the evidence mustered against the couple was disturbingly suspect and the sentencing unjustifiably harsh. International pleas for executive clemency failed to delay their appointment with the electric chair.

The Rosenberg execution brought into high relief a chasm in the country between those who insisted Communism must be stamped out at any cost and those who believed anti-Communist witch-hunting had finally gone too far. Photographs of the condemned couple's two young sons, aged ten and six, the elder in a Brooklyn Dodgers baseball cap comforting the younger in tears, stirred powerful sentiments, much as images, a decade later, of the two even younger Kennedy children, suddenly rendered fatherless and forlorn, intensified and personalized onlookers' emotions.

Kennedy steered clear of the Rosenberg case, publicly neither supporting nor opposing the penalty meted out to them. Indirectly, though, he shared accountability for their fate. First as a congressman and then as a senator, Jack allied himself with Senator Joseph McCarthy, a close friend of his father's and a figure of great popularity with the Irish-American voters of Massachusetts. During the first six and a half months of 1953, Jack's brother Bobby worked zealously on McCarthy's staff, quitting only when McCarthy foolishly slandered the United States Army with charges of Communist infiltration. Though Jack never took on "Communist infiltration" with the ardor or flamboyance of his colleague from Wisconsin, he stood by McCarthy as long as it was politically expedient to do so. When the Senate voted to censure McCarthy in December 1954, Jack's office let it be known that he was unable to take part in the proceedings because he was convalescing from surgery.

He predicted jokingly to a friend that when he was released from the hospital, "Those reporters are going to lean over my stretcher. There's going to be about ninety-five faces bent over me with great concern, and every one of those guys is going to say, 'Now, Senator, what about McCarthy?' . . . Do you know what I'm going to do? I'm going to reach back for my back and I'm just going to yell, 'Oow,' and then I'm going to pull the sheet over my head and hope we can get out of there." This was at the time when Kennedy was beginning work, along with his ghostwriters and editors, on his Pulitzer Prize–winning book about principled moral leadership, *Profiles in Courage*.

The blacklisted screenwriter Dalton Trumbo aptly called the McCarthy era "the time of the toad."

No, Jack Kennedy didn't throw the switch on the Rosenbergs. Nor did he do anything to prevent it from being thrown or, more generally, to lower the level of anti-Communist hysteria bewitching the nation. It would be wrong to suggest that Jack was indifferent to Communism, for that was not at all the case. He opposed it and believed America needed to be steadfast in resisting the Soviet Union on every front. One of his most formative experiences had been living in England and traveling through Europe on the eve of World War II. He had arrived at the conclusion—unlike his father, who favored appeasement—that only military preparedness and a willingness to engage in armed conflict could prevent the illegitimate territorial incursions of a Hitler or Stalin. That was the premise of *Why England Slept*, his Harvard senior thesis of 1940, which, rewritten in 1946 with the help of ghostwriters supplied by Henry Luce, became a best-seller. (It was reissued in 1961, the year of the Berlin Crisis.)

All the same, Jack was never much troubled by a fear of Communist infiltration of the United States, the so-called "invasion from within" that fueled McCarthyism and led to the execution of the Rosenbergs. Ironically, while he forcefully condemned the "let sleeping dogs lie" policy that had been extended to Hitler in Munich, in 1953–54 he seems to have adopted precisely that policy with regard to McCarthy. To borrow a period term that referred to a person indulgent of the Communists who did not actually join the party, Jack was a "fellow traveler" of the right-wing anti-Communists without being one himself.

A NOVEL PUBLISHED IN ENGLAND in 1963 by a then obscure American expatriate captures the mood of a decade earlier as seen by someone who could not stomach the tenor of the times. "It was a queer, sultry summer, the summer they electrocuted the Rosenbergs, and I didn't know what I was doing in New York," the narrator recalls. "I'm stupid about executions. The idea of being electrocuted makes me sick, and that's all there was to read about in the papers—goggle-eyed headlines staring up at me on every street corner and at the fusty, peanut-smelling mouth of every subway. It had nothing to do with me, but I couldn't help wondering what it would be like, being burned alive all along your nerves." What a different take indeed on the subway city that supercharged Ward Smith's erotomania and puffed Marilyn's dress up above her waist.

The account is Sylvia Plath's, in her autobiographical novel, *The Bell Jar*, a grueling and acidic account of a clever college student, Esther Greenwood, who wins a writing contest that brings her to New York to work on the editorial board of a fashion magazine. Unable to tolerate the continual slights and domineering behavior of the various men with whom she comes in contact and the many women who provide them

left margin running header

with unquestioning moral support, Esther free-falls into depression and a mental break-down. She attempts suicide on several occasions and lands in a psychiatric hospital.

Aside from the reference to the Rosenbergs at the start, the novel would seem to be entirely personal and apolitical. But increasingly in the sixties the personal *was* the political, at least in the minds of social progressives. Plath's novel, published only weeks before she committed suicide, became a landmark of the new feminist movement—and Plath one of its outstanding martyrs. Esther's nemesis is not only her marriage suitor, Buddy Willard, but Buddy's conventional mother. Mrs. Willard favors platitudes: "What a man wants is a mate and what a woman wants is infinite security" and "What a man is is an arrow into the future and what a woman is is the place the arrow shoots off from." Esther can't abide such sentiments. "The last thing I wanted was infinite security and to be the place an arrow shoots off from. I wanted change and excitement and to shoot off in all directions myself, like the colored arrows from a Fourth of July rocket." Marriage strikes her as a euphemism for servitude. "And I knew that in spite of all the roses and kisses and restaurant dinners a man showered on a woman before he married her, what he secretly wanted when the wedding service ended was for her to flatten out underneath his feet like Mrs. Willard's kitchen mat."

When Esther, concerned about the impending execution, says to one of the other students working on the magazine, "Isn't it awful about the Rosenbergs?" her co-worker misunderstands and replies vengefully, "Yes! . . . It's awful such people should be alive." In Plath's book, Rosenberg-hating connects with what Esther calls "woman-hating" (which is not exclusively the province of men), and the moral decadence she sees all around her characterizes the political decadence of McCarthyism.

In her search for infinite (financial) security and her willingness to be the place Jack's arrows shoot off from, did Jackie flatten out under his feet like Mrs. Willard's mat? And in so doing, in acquiescing, like millions of other women, did she contribute to the social and sexual inequity that *The Bell Jar* decries? From this later, feminist, point of view Jackie, like Marilyn with her dress swirling up about her waist, was complicit with the male oppressor, making herself not only an experienced voyager but also a fellow traveler.

Sylvia Plath and Jacqueline Bouvier were close in age (Jackie the elder by three years). Plath attended Smith, Bouvier, Vassar. Plath won a writing contest that brought her to New York to work for *Seventeen*. Bouvier won a writing contest that would have brought her to New York to work for *Vogue*, except that she turned down the offer under pressure from her mother, with whom she had a difficult relationship. Plath too was dominated by her mother and suffered a rancorous relationship with her. Plath married a handsome young poet (Ted Hughes) who philandered.

Plath killed herself, in large part, some of her devotees believe, because of her husband's excessive infidelities. Jackie did not kill herself. She may not have liked her cir-

cumstances, and her biographers say she considered divorce more than once in the early years of her marriage, but she stuck with it. Her heroines were not women like Sylvia Plath but eighteenth-century French figures such as Madame Récamier, who was renowned for her literary salon, and Madame de Staël, the brilliant memoirist. Either by innate predisposition or rational, calculated choice, she decided to accept her husband's promiscuity and move on from there. She chose, that is, to remain onboard rather than jump ship. Or, heeding the words of another hit song from *Guys and Dolls*, she sat down so as not to rock the boat.

HOWEVER DIFFERENT SHE and her husband were, and in many ways they were radically so, they shared a passion for the eighteenth-century Enlightenment, its wit, and its pleasure-loving mores. Looking at the sailing photo one last time, we can almost hear *Così fan tutte* in the background. It's one of the most sweetly beautiful pieces of music ever written, so turn up the volume. A trio of singers, two women and a man, bid farewell to a boat that flies away with the women's betrothed aboard. The orchestral accompaniment is fluid and liquescent and throbs with feeling. *Soave sia il vento, Tranquilla sia l'onda*, are the phrases that the singers, their voices intertwined, cast out to the sea as a blessing and a prayer for the voyagers on the boat:

> Gentle be the breeze,
> Calm be the waves.
> And may every element
> Kindly answer
> Your desires.

This comes at an early point in *Così fan tutte*, before the farce truly begins and the betrayals multiply. Later in the opera, music this piercingly hopeful would seem out of place, foolish and naive. It would not suit Jack and Jackie, either, once their marriage dropped anchor. But here, so early on, while it's still midsummer 1953, the trio from *Così* makes sense. We know that the breeze will not be gentle, nor the waves calm, and every element will not kindly answer their desires. Yet if we close our eyes and listen to the music, it's possible to believe otherwise.

3

A Marriage like Any Other

"SHE IS JACKIE KENNEDY, the cameo-faced wife of the presently front-running Democratic candidate, Senator John F. Kennedy." Donald Wilson, the Washington correspondent for *Life* magazine, wrote that description in a feature entitled "John Kennedy's Lovely Lady" that ran in the summer of 1959, a year before Kennedy did indeed win the presidential nomination at the Democratic National Convention in Los Angeles.

"Until recently," the story continued, "Jackie was seldom on public display, a comparative stranger to the Washington round of dinners and receptions. She continues to prefer dinner for four on the patio of her Georgetown home to an embassy ball. She is happier in an art gallery than at a cocktail party." Wilson in this piece limns the essential persona of Jacqueline Kennedy that all her subsequent public personae—fashion maven, protective mother, tragic widow, gold-digging jet-setter, trade book editor—could never erase or obscure.

Mrs. Kennedy, "who dazzles the voters' eyes, is a sensitive, individualistic young woman." Note how Jackie's physical beauty ("cameo-faced," "dazzles"), though acknowledged and granted due importance, is secondary. Intellect and culture, perhaps surprisingly, seem to matter more here, in the pages of the most influential American middle-class family magazine of the time, if not also the one with the largest readership: "She is an amateur scholar of 18th Century Europe ('I love and know the most about the 18th Century'). She speaks Spanish, French and Italian fluently. Her interests run, as her husband puts it, 'to things of the spirit—art, literature and the like.' When the senator lost the notes for a speech that he had planned to end with a quote

FIGURE 17 | Hyannis Port, August 1959 (Mark Shaw, photographer)

from Tennyson's 'Ulysses,' Jackie bailed him out of trouble by quickly reciting the appropriate lines."

A photo of Jackie and Jack relaxing in the garden at Hyannis Port, taken for the *Life* feature but not used in it, unerringly conveys the eighteenth-century esprit that Jackie and, in a less scholarly fashion, her husband so highly prized (Fig. 17). Forget for the moment, if you can, who these two people are and look at the photograph, which was shot in color but published only years later, in black and white, in a Jacqueline Kennedy Onassis memorial edition. Two figures, a woman in the foreground, a man stationed behind her, sit outdoors on a sunny day. She wears a white blouse (sunstruck yellow in the color original), a crocheted sun hat, and tight-fitting pants. He wears a narrow-collared pale gray polo shirt. The camera focuses with great precision on her face, while the magazine that juts into the foreground, the man beside her, and the blossoms behind her head progressively soften in focus and finally evaporate into a blur.

Smiling, she glances down at the magazine folded open in her lap. Her eyes may actually have been caught closed, either from laughter or the sun. The man, squinting, looks toward her with a laugh, presumably responding to some witty comment she's made about the magazine. Because no written text is visible to us on the glossy page that curls over her upraised leg, we might assume that whatever witticism is in the air at this moment originated from her, not the magazine, which remains tantalizingly unidentified. (*Vogue* or *Harper's Bazaar* would certainly fit the bill.)

Both figures are not only dressed casually but seated that way, too. He leans forward as he chuckles, arms angled outward at the elbows, hands joined at his interlacing fingers, which are mostly blocked from sight by her knee. She leans back in her cushioned wicker chair, legs askew, the magazine spanning the gap between them. Shade darkens his face, save for a triangle of bright light on his nose, a sliver of it at his left temple, and a dusting on his wavy hair. Her face is shaded by her sun hat and her own thick, dark hair, but light bounces up from her blouse to highlight her nose, her chin, her cheeks, the arches beneath her eyebrows, and the wide expanse between them. Her eyes do indeed look closed against the intensity of the midday glare.

The sunlight here enacts the figure of speech the *Life* article uses to describe Mrs. John Kennedy: she is someone who "dazzles" the eye.

EIGHTEENTH-CENTURY AMERICAN PAINTING typically portrayed colonial women with accoutrements of fruit and flowers, conventional symbols of female fecundity. Their husbands, just as typically, were visually associated with such inorganic and, yes, phallic objects as swords, staffs, and telescopes.

Here the woman's male admirer is narrowly contained, on one side by a wrought-iron railing and on the other by her erect knee, which, purely in terms of composition, thrusts up and out from the implied space of his lap. Her own genital area is at once open, thanks to the parting of her legs, and closed off by the magazine, so that she appears both available and unavailable to him in a coquettish and tantalizing manner that would have made perfect sense to eighteenth-century sophisticates, libertine or otherwise. His squinting gaze takes in her body appraisingly or appreciatively, but in either case, something more than her wit elicits his flashing grin.

The marital esprit of the Hyannis Port photo reminds me of my favorite husband and wife double portrait of eighteenth-century America, *Mr. and Mrs. Thomas Mifflin*, painted by John Singleton Copley in 1773 (Fig. 18). If we compare it to the photo of Jackie and Jack in the garden at Hyannis Port, we encounter a number of outstanding similarities (as well as differences too obvious to detail). A gentleman seated behind his handsome dark-haired wife gazes at her appreciatively, a smile enlivening his face. Elbows out and hands close together, he is the passive figure in the composition while she, hands apart and engaged, lights up with animation. Sarah Morris Mifflin, though to modern eyes less attractive than Mrs. Kennedy, is similarly "cameo-faced," with delicate features, porcelain skin, widely spaced eyes, heavy eyebrows, and thick, dark hair.

Humor or wit enlivens both women. Mrs. Kennedy crinkles up her eyes in laughter (if not also to stay the glare of the sun) and smiles as broadly as an ancient comedy mask. Mrs. Mifflin peers in the viewer's direction with understated irony and a smile of equanimity conveyed by the slight upward turn of her lips and an adjacent dimple. Even elements of their apparel bear similarities: one wears a sun hat, the other a cap, and both, lustrous V-necked blouses.

The double portrait of Mr. and Mrs. Mifflin, though certainly tamer, less erotically spirited, than the double portrait of Mr. and Mrs. Kennedy, also depicts domestic intimacy. Both images show a man looking appreciatively at his sharp- or quick-witted wife. The eighteenth century prized wit as a virtue—both these women embody it—and the smile as its signal attribute. Note how the folds and creases of Mrs. Kennedy's blouse reflect her smile. Like waves on a placid pond, they ripple outward rhythmically from the core event, her laugh.

Whatever Mrs. Mifflin may actually have been like, Copley's painting characterizes her by her mental acuity. The handloom she works serves as a metaphor (or perhaps, more properly speaking, a metonym) for her mind, as in Copley's famous earlier *Paul Revere* (1770), where the Boston silversmith's precision hand tools, laid out before him on a reflective mahogany surface, bespeak his precise intellect. Here is a woman, the painting seems to say, who weaves her thoughts as self-assuredly as the yarn at her fingers.

FIGURE 18 | John Singleton Copley, *Portrait of Mr. and Mrs. Thomas Mifflin (Sarah Morris)*, 1773, Philadelphia Museum of Art

Mr. and Mrs. Mifflin is not, however, without an erotic charge of its own. His hand hovers just above hers, almost, but not quite, duplicating the position of her fingers and almost, but not quite, touching. The gesture is loving, playful, synchronized, and sexual in the sense of flesh enveloping flesh or body part molding itself to body part. His other hand wields a narrow book that points knifelike at her banded throat; his finger plunges deep into its crevice and she smiles, as though from some internal pleasure to which he too is privy. Let's put aside for the moment that we know almost nothing about the private workings of the Mifflins' marriage and all too much about the Kennedys'. Both of these images convey a sense of marital affection and hint at shared pleasures of mind, if not body as well.

ALTHOUGH LITTLE IS KNOWN TODAY about Sarah Morris Mifflin, her husband is a well-documented historical figure. Like Jack Kennedy, he was a political creature, the scion of an elite family. A radical Whig (meaning, in this context, that he opposed British rule over America), Mifflin served as a delegate to the Continental Congress of 1774, a representative at the Constitutional Convention, and Pennsylvania's first governor. He seems to have recognized the political capital to be gained from effective picture making; he had himself painted by every important American artist of the era: Benjamin West, Charles Willson Peale, Gilbert Stuart, and John Trumbull in addition to Copley.

Much has been written about Joseph Kennedy's instinct for public relations. He understood the uses of glossy photojournalism in the picture magazines, and he was one of the first modern figures to see how an aspiring politician might turn it to his advantage. From a historical perspective it's good to recognize, however, that long before photography, not to mention the Kennedys, came on the scene, the visual arts had been used for precisely that purpose. Indeed, many an illustrious artistic monument was created to bestow a transcendent radiance on some earthly mortal who either sought or already wielded extraordinary political power. The sculptural effigies of Egyptian pharaohs, the portrait busts of Roman emperors, Hyacinthe Rigaud's giant oil portrait of Louis XIV, Jacques-Louis David's "action" painting of Napoleon crossing the Alps on a charging steed: all of these works gave imposing visual treatment to an imperial ruler's claim to legitimacy, if not also to absolute power.

In a democracy, however, political imagery must make candidates appear human and approachable, not like kings, emperors, and gods but like men and women one could actually sit down and talk with. The leaders of the early American Republic understood as much, hence the success of artists such as Peale, Trumbull, and Stuart—particularly Stuart—gifted at making these leaders look like normal flesh-and-blood human beings.

But no one of the era could compare to Copley when it came to investing powerful men and their wives with warmth, dignity, and deep-seated humanity. Properly speaking, Copley was not an artist of the early Republic. He left Boston for London on the eve of the Revolution and never returned, his father-in-law, a wealthy royalist and importer of luxury goods, having unwillingly provided the tea for the Boston Tea Party. But Copley's pre–Revolutionary War portraiture of the wealthy Massachusetts elite (and occasionally of others, such as Mr. and Mrs. Mifflin of Pennsylvania) is the true art-historical source of twentieth-century pictures such as the one of Senator and Mrs. Kennedy in the garden.

The acclaimed fashion photographer Mark Shaw took the picture. Among his other

famous subjects were Pablo Picasso, Marc Chagall, Elizabeth Taylor, Grace Kelly, Audrey Hepburn, Cary Grant, and Pope Paul VI. Although it would be too much to call him a latter-day Copley, Shaw shared with the eighteenth-century painter a knack for creating portraits that strike the viewer as intimate, casual, and unstudied. In a sixteen-year span, he worked on over a hundred features for *Life*, and his work made the cover twenty-seven times. Following this assignment for *Life*, he became one of Jackie Kennedy's favorite photographers. He died in 1969, at the age of forty-seven, from a heart attack related to his addiction to amphetamines supplied by a New York physician named Max Jacobson.

Known by his patients as "Dr. Feelgood," Jacobson also supplied amphetamine injections to President and Mrs. Kennedy before the drug was classified as a controlled substance. Jack was first introduced to this magic elixir in September 1960 by his close friend Chuck Spalding, who recalls noting that Jacobson's waiting room was always filled with entertainers such as Eddie Fisher, Johnny Mathis, Zero Mostel, and the lyricist Alan Jay Lerner, whose Broadway musical *Camelot* opened in December of that year.

According to Spalding, Dr. Feelgood injected Kennedy with an amphetamine and vitamin cocktail on the eve of his first TV debate with Vice President Richard Nixon. Jack recommended Jacobson's services to his wife, who may in turn have been the one to introduce the doctor to Shaw. Shaw's 1964 best-seller, *The John F. Kennedys: A Family Album*, which put before the public a number of the Hyannis Port photos that hadn't appeared in the August 1959 *Life* story on Jackie, closes with a fond dedication to this impresario of instant energy, "My friend and companion, Dr. Max Jacobson."

ONE PHOTO IN SHAW'S BOOK that had also featured prominently in *Life* showed Jackie, legs set wide apart, standing up to her knees in water and swinging her two-year-old daughter Caroline by her arms (Fig. 19). The little girl, plump as a cherub in her striped bathing suit, appears to be shrieking with terror or pleasure or both as she flies through the air with a trail of spray flung from her heels like a comet's tail.

No amphetamines needed here. This is a picture of pure, unadulterated energy. The little girl's natural high spills off onto her mother, as well as the viewer, like the ocean spray. And talk about a primal scene: mother, child, ocean, air, and nothing else apart from a scattering of half-submerged rocks safely distant. Earth, wind, water, and fire—the fire conveyed figuratively by the girl's shrieking excitement.

Compare Jackie bestride the sea in Shaw's photograph to one of the most famous bathers of art, Galatea in Raphael's magnificently manic fresco on the walls of Rome's Farnesina pleasure palace (Fig. 20). Raphael depicts the naked sea nymph of Greek

FIGURE 19 | Hyannis Port, August 1959 (Mark Shaw, photographer)

mythology cavorting in the ocean with nymphs and satyrs, the bright red cloak that swirls around her resembling the curving comet's tail of water flung off by little Caroline. Galatea stands on an oversize seashell that a team of capering dolphins draws across the waves. Burly Neptune, mounted on a steed, blows a conch horn; winged cherubs, pudgy like Caroline, with legs likewise cast apart, fly through the air with Cupid's bows poised to release arrows of love.

Galatea was a favorite subject with artists, among them the Carracci, Nicolas Poussin, and even the teenage John Singleton Copley, affording liberal opportunities to depict sun, sea, and female flesh. Although Jackie appears fully clothed in Shaw's photograph, wearing the same slacks as in the garden photo and a similar blouse, she's a modern Galatea all the same. We cannot assume that *Life*'s readers recognized the art-historical provenance of the photo, but like the viewers of Raphael's fresco, they would surely have experienced the picture's surging energy.

Galatea aside, Shaw's photo portrays Jackie as a colossus who straddles the water and towers against the horizon. It's a good and positive image of female strength, and it ripples with maternal power. But in that power lies a potential threat. Those rocks

FIGURE 20 | Raphael, *Galatea*, 1513, Villa Farnesina, Rome

off to the right—logically we know that Jackie does not hurl Caroline toward them, either literally or symbolically. Yet they loom, hard, cutting, partly submerged. They darken the picture and suggest the presence of a force, a disquiet, maybe even latent aggression, that Jackie's exuberant play does not entirely efface.

"THE CHILDREN APPEARED before her like antagonists who had overcome her; who had overpowered and sought to drag her into the soul's slavery for the rest of her days."

The words are those of the narrator of *The Awakening*, Kate Chopin's 1899 novella that languished in obscurity until literary historians rediscovered it in the

1950s. It has since come to be regarded as an American classic. *The Awakening* tells of Edna Pontellier, a middle-class New Orleans housewife relegated, like other wives of her social rank, to a hollow round of parties, chatter, and tiresome afternoons at the seashore with her children. Edna tries mightily to engage herself in that existence, but it leaves her feeling empty, as though life must have something more to offer a woman, something true and impassioned that she has somehow failed to detect amid the daily tedium and the occasional excitement of love affairs. Gazing at the sparkling Gulf of Mexico or immersing herself in its waves, she experiences a sense of awakening from her torpor: "The voice of the sea is seductive, never ceasing, whispering, clamoring, murmuring, inviting the soul to wander in abysses of solitude," Chopin explains.

At the end of the book Edna, despondent, forsakes husband, children, and lover in a suicidal submission to the sea. First she removes all her clothes: "How strange and awful it seemed to stand naked under the sky! how delicious! She felt like some new-born creature, opening its eyes in a familiar world that it had never known." Edna as Botticelli's Venus, as Raphael's Galatea. Or even as Shaw's Jackie: "The foamy wavelets curled up to her white feet, and coiled like serpents about her ankles." Edna proceeds farther out into the water. "The touch of the sea is sensuous," notes Chopin, "enfolding the body in its soft, close embrace." Edna goes out still farther, her arms and legs yielding to fatigue. "She thought of Léonce [her husband] and the children. They were a part of her life. But they need not have thought they could possess her, body and soul."

Here Chopin writes the sentence quoted at the beginning of this section that shocked her turn-of-the-century readers but resonated powerfully in the feminist 1960s. Edna's only alternative to "the soul's slavery" was the sea, the endless sea. "The water of the Gulf stretched out before her, gleaming with the million lights of the sun," recounts Chopin, repeating her earlier comment with poignant effect: "The voice of the sea is seductive, never ceasing, whispering, clamoring, murmuring, inviting the soul to wander in abysses of solitude."

The situation in Shaw's picture of Jackie, Caroline, and the sea is a far cry from that in Kate Chopin's account of a woman deprived of meaningful work and relationships by the rigid social norms of her time so that she prefers death at sea to being at sea in her life. ("A Creole *Bovary*," Willa Cather dubbed the work in a hostile review.) Yet we must never take Shaw's photograph, or any other, at face value, presuming that what it tells us about its subject is self-evident and all we need to know. *Life*'s job in this photo feature was to portray a happy family—not any old happy family but one that clearly defied Tolstoy's claim in *Anna Karenina* that all happy families resemble each other, for this one was exceptional: beautiful, polished, and perfect.

But the second part of Tolstoy's dictum, that all unhappy families are different from one another, holds true here.

For this was an unhappy family. Jackie K., although not an Edna P., Emma B., or Anna K. (a nineteenth-century literary triumvirate of despondent bourgeois housewives), suffered from frequent spells of depression in the early years of her marriage. It wasn't simply her husband's compulsive philandering that sent her into her tailspins, although that was surely reason enough, but also the lack of a meaningful career for her beyond that of housewife, mother, and beauty object whose chief function, in *Life*'s terms, was to dazzle the voters' eyes. Jack's political career, particularly when he barnstormed in the thick of a campaign, left Jackie frequently alone. She despised the obligations of a political wife, the glad-handing of delegates and lobbyists, the small talk with other Senate wives, the tedious luncheons, the innumerable cocktail parties where people come and go, speaking of anything but Michelangelo.

In late October 1959 the photographer Jacques Lowe snapped a stunning picture of the Kennedys breakfasting in an Oregon diner (Fig. 21). They sit across from a man, his back to the camera, who holds up a morsel of toast as if for inspection. Jackie, wearing a dark hat and peering down into her coffee cup, turns away from her mate, whose face, hands, and shoulder the fierce shadows of a venetian blind slice to black-and-white ribbons. Jack, the weary campaigner, looks almost prayerful, his hands folded over the lower part of his face. "Good" and "Year," part of a tire company logo, hover over his head like the words of a thought bubble summing up his hopes for the twelve months of arduous campaigning still ahead. Outside the diner, behind the couple, a pile of used and cast-off rubber tires provides a gritty ambience.

Lowe's photo invokes the moody and alienated imagery of Edward Hopper's *Nighthawks*, an unforgettable painting of a man and woman seated together in an isolated diner on an empty city street (Fig. 22). Hopper's influence permeates Lowe's picture—the psychological separation, the bleakness, the downscale setting. The photograph also draws on film noir, for example, the opening of *The Killers* (1946), where hit men enter a diner in search of their victim, or the noir masterpiece *Out of the Past* (1947), where Nick Musuraca's haunting cinematography ensnares the lonely, yearning characters in webs of patterned light. In film noir, men and women are always irredeemably estranged from each other, their married lives soured by perpetual anxiety, boredom, and mistrust. Just as Mark Shaw's photo of the Kennedys in a Hyannis Port garden blithely incarnates the Enlightenment ideal of marital conviviality, Jacques Lowe's shot of them in a Portland diner recalls film noir's bleakly modern imagery of social isolation.

FIGURE 21 | Portland, Oregon, October 1959 (Jacques Lowe, photographer)

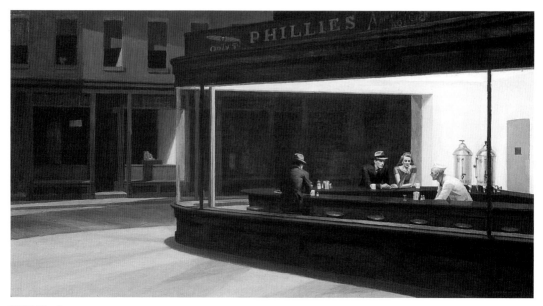

FIGURE 22 | Edward Hopper, *Nighthawks*, 1942, Art Institute of Chicago

JACKIE TRIED TO BE the perfect hostess, the perfect housewife, the perfect politician's mate. To that end, she enrolled in political history courses at Georgetown University and took up the new fad called gourmet cooking (which by her own admission she never mastered). She signed up for volunteer work and dutifully frequented coffee klatches for Senate wives. Yet she was also desperately unhappy.

"My mother thinks that the trouble with me is that I don't play bridge with my bridesmaids," she remarked wryly in 1957. If her mother's assessment of her difficulties seemed to speak from another era, Jackie might have gained more acute insight into what was going wrong with her life by reading a book that had first been published in France in 1949, while she was studying in Paris at the Sorbonne. When translated into English in 1953, the year of her marriage, the book received much attention, at least in the intellectual circles that attracted her. Written by the existentialist philosopher and novelist Simone de Beauvoir, it was called *The Second Sex*.

De Beauvoir's book is an extensive yet pungent historical survey and philosophical analysis of women's long-standing social inequality. True to her Marxist roots, de Beauvoir stressed that women have traditionally participated in their own domination, acceding to their second-class status rather than struggling to overthrow it, having been bought off by the false promise of comfort and security. "It must be admitted," she writes, "that the males find in woman more complicity than the oppressor usually finds in the oppressed."

According to de Beauvoir, men need women not merely to do their housework, bear their offspring, and gratify their senses, but also to permit them the cherished fantasy of being "male, important, superior." And it is primarily women who indoctrinate themselves in this responsibility. From earliest childhood, girls are trained by their mothers, sisters, aunts, and schoolmistresses to dedicate themselves to stimulating and satisfying male fantasies of superiority:

> We have seen that all the main features of her training combine to bar her from the roads of revolt and adventure. Society in general—beginning with her respected parents—lies to her by praising the lofty values of love, devotion, the gift of herself, and then concealing from her the fact that neither lover nor husband nor yet her children will be inclined to accept the burdensome charge of all that. She cheerfully believes these lies because they invite her to follow the easy slope. . . . So she readily lets herself come to count on the protection, love, assistance, and supervision of others, she lets herself be fascinated with the hope of self-realization without *doing* anything.

In 1957, the year that Jackie managed to joke that the trouble with her was that she didn't play enough bridge, a journalist named Betty Friedan set out to discover

why so many middle-class housewives across the land experienced gnawing dissatisfaction with their lives but couldn't say why. Friedan came to call this "the problem with no name," and she titled her 1963 best-seller on the topic *The Feminine Mystique*. The title referred to the vast array of cultural messages informing women that their essential nature required them to achieve ultimate satisfaction in life as wives and mothers; if they found themselves unhappy in those roles, it was only because they had allowed themselves to entertain selfish and unnatural impulses.

> Millions of women lived their lives in the image of those pretty pictures of the American suburban housewife, kissing their husbands goodbye in front of the picture window, depositing their stationwagonsful of children at school, and smiling as they ran the new electric waxer over the spotless kitchen floor. They baked their own bread, sewed their own and their children's clothes, kept their new washing machines and dryers running all day. . . . Their only dream was to be perfect wives and mothers; their highest ambition to have five children and a beautiful house, their only fight to get and keep their husbands. They had no thought for the unfeminine problems of the world outside the home; they wanted the men to make the major decisions. They gloried in their role as women, and wrote proudly on the census blank: "Occupation: housewife."

Jackie tried to play the role. Apparently, even though she didn't bake her own bread and had servants to wax the floors and fold the laundry, she believed in it wholeheartedly. In October 1953, a month into their marriage, when she and Jack were interviewed live by Edward R. Murrow for a broadcast of his popular nationally televised show *Person to Person*, Jack talked about international affairs and Jackie about home furnishings. She even interrupted her husband's discourse at one point to show off with wifely devotion a commemorative football that Jack had received from Harvard. Nine years later when the first lady invited forty-five million American TV viewers into her newly redecorated home, it was basically the same performance on a grander scale, with presidential flatware and china now taking the place of the Harvard pigskin.

Whether the problem gnawing at Jackie in the early years of her marriage was the one with no name—suffocation in the feminine mystique—or her husband's lack of emotional and sexual commitment, or both, her spirits faltered. In late summer 1956, rumors circulated that Jacqueline Kennedy wished to divorce her husband. Similar rumors had made the rounds the previous summer, but this time they were taken more seriously. The syndicated columnist Drew Pearson mentioned the rumor first, then *Time* supposedly printed a story that Joe Kennedy had met with Jackie and offered her a million dollars not to leave his son. The Kennedy camp denied this, but Joe's friend Igor Cassini (the older brother of Jackie's future fashion designer Oleg Cassini) con-

firmed it, in which case, technically speaking, Elizabeth Taylor was not, as I stated in Chapter 1, the first actor in history to receive a million dollars to play a part.

Earlier in the summer of 1956, Jack and Jackie were interviewed for an NBC news program called *Outlook*. When the interviewer turned to the senator's wife and said, "You're pretty much in love with him, aren't you?" she replied, "Oh, *no*," and then stared into the camera, smiling. After a prolonged silence, she added, "I said no, didn't I?" Bewildered, the interviewer tried again: "You *are* pretty much in love with him, aren't you?" Jackie paused at length and then replied, wanly, "I suppose so. . . ." The entire segment was edited out of the final broadcast. A few days later, Jack flew off to the Riviera for a Mediterranean cruise with his brother Teddy and his friend Senator George Smathers, leaving behind his wife, who was eight months pregnant.

While Jack was still away, indulging in the pleasures of what amounted to a floating bordello, Jackie awoke in pain. She was bleeding internally. Rushed to the hospital, she had an emergency cesarean section to save the baby, but that failed. She lost the infant, an unnamed girl.

When Jack, off the Italian coast, heard the news, he telephoned Jackie in the hospital. He told her he had no intention of cutting short his cruise. He changed his mind only under pressure from his fellow playboy Smathers, who told Jack, "If you want to run for president, you'd better get your ass back to your wife's bedside, or else every wife in the country will be against you."

THREE YEARS LATER, in the summer of 1959, when Mark Shaw went to Hyannis Port to photograph Jack and Jackie, the biggest change in their marriage was Caroline, aged two and a half. In two of the Shaw photographs, one of which appeared in the *Life* story, the family of three occupies a stretch of sandy beach. Jackie's feet are bare. Jack wears Top-Siders with white crew socks.

In one shot, he balances Caroline above his head, while Jackie, hands clasped demurely in front of her, stands aside and gazes down at the pair, a happy grin on her face. Father and daughter form an intricate geometric unit, a whirligig of arms and legs, with outstretched fingers braced on shoulders and hips as if they were a duo of circus acrobats—and Jackie the bemused spectator. In the other shot, Jackie sits directly behind Jack on the sand and purses her lips as if cooing to the little girl cantilevered over her father's shoulder. Both are wonderfully happy pictures, brimming with the glories of parenthood and the beauty of the 1950s nuclear family. Yet in both Jackie is set off from the other figures, physically and psychologically separate.

In another photo from that session on the beach, a telephoto close-up, Jackie, alone with Caroline, embraces her (Fig. 23). Caroline's striped swimming suit is off now, and her mother presses a terrycloth towel against the naked baby flesh, the two of them

FIGURE 23 | Hyannis Port, August 1959 (Mark Shaw, photographer)

calling to mind the Madonna and child of an Ivory Snow laundry soap box, but also much more than that. The daughter symmetrically mirrors the mother, her forearm laid on Jackie's upper arm, her elbow fitting into the crook of Jackie's elbow. With the father out of the picture, the two females look particularly close and in tune.

Caroline's hair is wet and coiled, Jackie's windswept and tousled. Jackie's lips press against Caroline's ear, her nose against the back of Caroline's head. One eye, partially covered by a wayward strand of hair, gazes directly, even provocatively, at the camera, the other eye hides, or is hidden, behind her daughter. Jackie's white blouse blends in with the sand. The picture is a study in textures and tones: the terrycloth towel, the crisp cotton blouse, the folded-back sleeve, Jackie's thick hair, Caroline's damp locks, her plump, volumetric baby flesh, her mother's lips, her mother's lashes, the grainy sand.

It is also a study in the bond between mother and infant. Again the artistic touchstone is Raphael. *Madonna of the Dunes,* this picture might be called, in homage to Raphael's beloved *Madonna della sedia (Madonna of the Chair)* from about 1514. (Fig. 24). In that work, Raphael inscribes a vigorously beautiful young mother, her infant son, and a praying John the Baptist within a perfect circle, its arc rhythmically repeated in the mother's halo and silk turban, the faces, the turnings of the chair post, and the

FIGURE 24 | Raphael, *Madonna della sedia*, 1514, Pitti Palace, Florence

curves of shoulders and limbs. Centuries after the Renaissance master painted it, the Victorians venerated this painting, which embodied for them a "separate sphere," an ideal of hermetically sealed domesticity—apart from male acquisitiveness and conquest—that underpinned their social and political economy by offering a safe haven from the depredations of the outside world.

Mark Shaw's photo of Jackie and Caroline on the beach alludes to the *Madonna della sedia*, whether or not Shaw had Raphael's work in mind. Eliminate the chair post and John the Baptist, Christ's gold robe, and the Madonna's elaborate costume and draw an imaginary circle around the beach photo, and you have essentially the same elements in both pictures. Each depicts a chubby young child with a head of curls gathered up in a mother's arms, and in each the beautiful young mother, her pretty lips pursed into the trace of a smile, fetchingly peers over her shoulder not at the child but at the viewer.

FIGURE 25 | Jean-Auguste-Dominique Ingres, *Odalisque,* 1814, Louvre, Paris

The Victorians, who frequently painted or sketched the *Madonna della sedia* on their pilgrimages to Florence, would most likely have mentally blocked out the sexiness, the come-hitherness, of Raphael's Madonna—unlike either Raphael himself or his contemporaries. Indeed, the model for the painting was probably the artist's mistress, Margherita Luti, the baker's daughter known to posterity as La Fornarina (the woman baker).

In Renaissance Italy motherliness and female sexuality were not so strictly segregated from each other as in the Victorian era and such neo-Victorian periods as 1950s America. To be sure, Renaissance Italy too exemplifies a patriarchal society where women were either virgins or whores. But the Renaissance masters liked to paint the Madonna with an effulgent physical attractiveness gratifying to the spirit and the senses and capable of inspiring in male beholders a desire not entirely religious.

Jackie's sexiness in the Shaw photo recalls another world-famous work of art, by an artist whose own artistic hero was Raphael: Ingres's *Odalisque* (also known as the *Grand Odalisque*) of 1814 (Fig. 25). The word "odalisque" derives from the Turkish term for a female slave or harem girl. Ingres and his contemporaries in Napoleonic France were drawn to such exotic subject matter, which corresponded to their nation's imperialist and colonialist desires.

As Edward Said has shown, "Orientalism" in art, literature, history, and other forms of humanistic knowledge has both masked and exacerbated the Western impulse to dominate the East by treating it as a fantasy land of indolence, barbarity, and libidi-

nal excess. Ingres's odalisque, with her peacock feathers, bracelets, and turban, her acres of naked flesh, and the long-stemmed pipe at her feet, epitomizes Orientalism in the visual arts, even though the model herself looks European.

Note how much Ingres borrows here from, of all places, the *Madonna della sedia:* the turbans are nearly identical, the hairstyles too, and the faces similarly shaped. In both cases the model looks provocatively over her shoulder, gazing directly at the viewer. Shaw's Jackie is herself something of an odalisque, with that fetching, peek-a-boo glance, the disheveled hair (a turban of sorts), the long, sensuous, white expanse of back, and the nakedness of flesh that the photograph strategically displaces from the sexy young mother to the innocent babe in her arms.

LET'S GO BACK to Jackie's hair. Hair, when you're talking about the Kennedys, is significant. Jack and Jackie both were all about hair. Each was graced with copious amounts of it. As first lady, Jackie kept her hair carefully under control, but not in this earlier seaside photo. Here she is haloed by dark locks that coil this way and that, as free from restraint and premeditation as the ridges and pockets in the sand behind her. Jackie's longtime hairdresser Kenneth Battelle recalls first meeting her in the early days of her marriage: "In those days women were running around with their hair sprayed to a fare-thee-well. I used to go out on the road with the magazines, and we'd do makeovers, and I'd say, 'What's your hair problem?' And they'd say, 'Oh, my hair blows in the wind.' You can laugh at that, but in those days, it wasn't supposed to blow in the wind."

Jack's hair also played an important symbolic role when he delivered his inaugural speech in a globally televised broadcast from the steps of the Capitol. Pointedly forgoing the protection of a hat or coat, the forty-three-year-old president-elect showed off his youthful vigor—and by extension that of his nation—on a 22-degree winter day chilled by sharp, piercing winds.

Flowing and unbound hair has long been a conventional sign of unconventional freedom and creativity. The Romantic poets and pianists—Byron and Shelley, Chopin and Liszt—demonstrated by their loose locks their rejection of cultural and social orthodoxy. In the Victorian era women were expected to keep their hair as tightly secured as their chastity. But not all Victorians approved of the plastered-down look. The hair of beauties painted by Pre-Raphaelite artists such as William Holman Hunt and Dante Gabriel Rossetti tumbled down the canvas in undulating waves.

The Pre-Raphaelite photographer Julia Margaret Cameron, a friend of Tennyson and other luminaries of the age, was particularly given to photographing beautiful young women with long, flowing hair. (Their youth was essential: "No woman," Cameron remarked when she herself was advanced in years, "should ever allow herself to be photographed between the ages of eighteen and eighty.") She posed them

FIGURE 26 | Julia Margaret Cameron, *The Kiss of Peace*, ca. 1865, University of Michigan Museum of Art, Ann Arbor

(usually they were her servants or nieces) as chaste Madonna figures holding nude or seminude young children in their embrace (Fig. 26).

Sometimes the Madonna in question in Cameron's photographs looks toward the camera, and at other times she looks away, but unlike Shaw's Jackie, she never smiles fetchingly or gives the viewer a come-hither look. Moreover, Cameron avoided sharp focus and was more than willing to allow her prints to be smudged, blotched, or otherwise technically compromised, considering such flaws evidence of her artistic integrity. In this her photographs bear little resemblance to Shaw's technically flawless glamour shots. Still, the typical Cameron Madonna, like Shaw's, exudes sensuality.

For Cameron, physical sensuousness, far from canceling out the spirituality of her photographic subject, was the best means to convey it. Shaw can be understood as an heir to Cameron inasmuch as his photograph of Jacqueline Kennedy embracing her half-naked daughter, Caroline, combines Cameron's adulation of famous contemporaries with her exultation of the sensual Madonna of loose and free-flowing locks.

FIGURE 27 | Dorothea Lange, *Migrant Mother*, 1936, Library of
Congress, Washington, D.C.

SHAW'S JACKIE and the dustbowl Madonna known as the *Migrant Mother* belong
to two very different worlds.

In Dorothea Lange's classic 1930s photograph, a gaunt young woman, forehead
creased with worry, eyes narrowed in pain, the fingers of her hand pressing absently
into her cheek and tugging at her weathered flesh, peers off into a bleak and uncertain
future (Fig. 27). Two ragamuffin children (with disheveled hair that might have
pleased a Pre-Raphaelite) hide their faces behind their mother, as though unable to
look at what she sees, while a sleeping infant streaked with dirt nestles against her breast.

In the worried expression and telling gestures of the haggard Madonna, Lange
served up to Depression era viewers a searing portrait of poverty and maternal anxi-
ety. She took the photograph (and five others of the same woman) at a squatters' camp

in Nipomo, California, at the edge of the pea fields. As she explained in a detailed caption for another image in the series, "The crop froze this year and the family is destitute. On this morning they had sold the tires from their car to pay for food. She is thirty-two years old."

Lange's *Migrant Mother*, when published, stirred readers from around the country to mail in contributions for the relief of migrant workers. It has continued to exert an impact ever since. In the early 1970s, for example, the *Black Panther* newspaper in Oakland, California, printed a pencil drawing of *Migrant Mother*, captioned "Poverty Is a Crime, and Our People Are the Victims."

That's precisely the effect Lange was after. A childhood victim of polio whose father had abandoned her family, she exhibited a lifelong concern for the disabled and disadvantaged. Taking up photography at age seventeen, she determined to use her camera as a social witness. When the Great Depression struck, she set off across the country under the sponsorship of a government agency, the Farm Security Administration (FSA), to document rural poverty. *Migrant Mother* is but the best-known of Lange's many powerful photographic images from a remarkable career that ended when she succumbed to cancer in 1965 at the age of seventy.

Migrant Mother puts the photo of Jackie and Caroline to shame. Shaw's picture, next to Lange's, seems coy, even silly—the epitome of shallow glamour photography. Shaw's Madonna was a young mother married to an exceptionally wealthy man who occupied a seat in the United States Senate and was about to begin a run for the presidency. Shaw photographed her on assignment for a *Life* cover story spun from fluff. Lange's Madonna was ragged, prematurely aged, a woman utterly without social standing. The photographer who took her picture never even bothered to learn her name.

"I saw and approached the hungry and desperate mother, as if drawn by a magnet," Lange recalled. "I do not remember how I explained my presence or camera to her, but I do remember she asked me no questions. I did not ask her name or history." Many years later, the woman was identified as Florence Thompson, an Oklahoma native of Cherokee descent, who went on to have ten children and a middle-class life near Modesto, California, where she died in the early 1980s.

AND YET IT'S TOO SIMPLE to censure Jackie for being rich, pretty, and pampered, or to find Shaw's photo meretricious because of that. The fact is that poverty didn't exist in America in 1959—or so most Americans believed. As *Life* boasted in its year-end issue, "For the first time, a civilization has reached a point where most people are no longer preoccupied exclusively with providing food and shelter." As evidence, the magazine pointed out that over 175,000 U.S. households were equipped with swimming pools.

Poverty was America's most closely guarded secret. The government, the media, and the middle class in general did their best to keep it not only from the nation's cold war adversaries, who would most certainly have gloated, but also from Americans themselves. That is, unless you yourself were poor in America at this time, or had relatives who were, you would most likely believe that poverty was a thing of the past in the United States, although census figures reveal that 18.5 percent of all American families qualified as poor in 1954 and 22.4 percent of the population fell below the poverty line of $1,467. Poverty was treated in the middle-class press as nothing more than an evil demon that had been exorcised by good government, the generally happy marriage of labor and capital, and a robust postwar economy.

If you lived in suburbia, as most Americans did by 1959, you saw no evidence of poverty, unless perhaps in the man who mowed your lawn or the cleaning lady who waited for the bus to take her elsewhere when her workday was done. If you watched television, as most Americans did by 1959, you saw no evidence of poverty there, either. To be sure, television had its poor people. But popular daily fare such as *Queen for a Day* or prime-time dramas such as *The Millionaire* hammered home to vast numbers of willingly gullible viewers the irresistible message that poverty was being eliminated in case after case after case. All it took was the wave of a game show host's wand or the stroke of a pen in a philanthropist's checkbook.

President Kennedy is said to have been shocked to discover poverty in 1962 when he read *The Other America* by Michael Harrington, which laconically, unemotionally, and with devastating power revealed the extent of poverty across the country. Kennedy gave copies of the book to his domestic policy advisors and, with the avid consent of his brother Robert, the attorney general, nudged the alleviation of poverty onto the White House agenda.

In 1957 *Fortune* listed Joe Kennedy as one of the sixteen wealthiest individuals in America, with a net worth of $200 to $400 million. By 1960 the various trust funds he had set up for his wife and seven surviving children were worth an estimated $10 million each, providing Jack with an annuity of approximately $500,000 at a time when, as I note above, nearly a quarter of the population earned less than $1,467 a year. Like no other twentieth-century president before him aside from Franklin Roosevelt, Kennedy appears to have been stung by poverty once his eyes were opened to it. Perhaps Roosevelt and Kennedy, both born to wealth and privilege, were able to muster a concern for the poverty of others because, never having remotely experienced it themselves, they found the sight of it appalling.

That is but speculation. Who can say if Kennedy would have mounted the "war on poverty" that preoccupied his successor, Lyndon Johnson, for an all-too-brief period before the war in Vietnam superseded it? Significantly, Kennedy's first item of business on assuming power (more than a year before he read *The Other America*) was to

issue Executive Order No. 1, instructing the secretary of agriculture to double the surplus food rations provided to some four million needy Americans. One of the most cogent lines in his inaugural address spells out the matter thus: "If a free society cannot help the many who are poor, it cannot save the few who are rich."

Nonetheless, Mark Shaw's Madonna of the Kennedy Compound was far more in keeping with the general taste, ideals, and fantasy identifications of most Americans in 1959 than Dorothea Lange's Madonna of the Pea Pickers from a quarter of a century earlier. One month before the *Life* edition featuring Jackie appeared on the stands, Vice President Richard Nixon had trumpeted the glories of American material abundance in, of all places, Moscow, where the United States was about to open an exhibition as part of a cultural exchange.

Engaging Soviet Premier Nikita Khrushchev in what the press dubbed the Kitchen Debate, Nixon led the way through a replica of a modest middle-class American kitchen and extolled its conveniences: hot and cold running water, full-size refrigerator-freezer, stove and oven, automatic dishwasher, roomy cabinets, spacious counters. When the premier sounded off about American decadence and capitalist greed, the vice president chuckled, "Isn't it better to be talking about the relative merits of our washing machines than of the relative strength of our rockets?"

Pretty Jacqueline Kennedy, with her knowing smile and rumpled hair, was the honorary Madonna of this world, not that of the sad old migrant workers' camp in California. I suspect that most Americans, shown a print of *Migrant Mother* in 1959, would have assumed it a picture of a downtrodden Soviet peasant rather than of a fellow countrywoman.

THAT SUMMER THE BEST-KNOWN young mother in America was not Jacqueline Kennedy but the TV mother played by the actress Donna Reed on the situation comedy named for her, *The Donna Reed Show*. Although this was not the most popular program on television, *TV Guide* reported in a cover story in August that it was steadily gaining a fan base after a sluggish start the preceding September, when it premiered opposite *The Millionaire*. The weekly nonadventures of a Wonder Bread family consisting of a small-town pediatrician, Dr. Alex Stone; his wife, Donna; and their teenage daughter and adolescent son, the show always focused on the headliner, the mother (Fig. 28).

Donna Stone was neither a ditzy clown like Lucy Ricardo (Lucille Ball), nor a vacuous smile in high heels and an A-line skirt like other sitcom moms. She was the brains as well as the heart of the Stone family and its driving force. In most episodes, the handsome man of the house, Dr. Stone (Carl Betz), was but a supernumerary. Reed teasingly referred to her show as *Mother Knows Best* to distinguish it from the more typical sitcom of the 1950s, *Father Knows Best*.

FIGURE 28 | *The Donna Reed Show*

Reed came to her television "momhood" by way of a career in the movies, where typically she played a hometown sweetheart, as in Frank Capra's 1946 Christmas parable *It's a Wonderful Life.* Her film career peaked with her best-supporting-actress role as a "nightclub hostess" (prostitute) in *From Here to Eternity*, and now in her thirties, she recognized that her days in Hollywood were numbered. Deciding, in her words, to "take control of my career," she formed a production company with her real-life husband and created her own television show. The program ran for eight seasons before Reed retired from the role to devote more time to her real-life family. The show went to syndication heaven.

Critics complained that Reed and her TV family were too perfect to be believed. The New York talk show host David Susskind called *The Donna Reed Show* "pure drivel" and suggested that it be retitled *The Madonna Reed Show.* Significantly, the series itself sometimes took its star's new superfrau persona as a subject of inquiry. In

an episode from the first season entitled "The Ideal Wife" (perhaps in homage to Oscar Wilde's ironic study in marital hypocrisy *The Ideal Husband*), Donna grows alarmed at the praise she constantly receives as a flawless mother, spouse, and suburban housewife.

Over coffee during a small dinner party hosted to perfection by Donna, a guest with an edge of superiority in her voice lauds her hostess's remarkable abilities, concluding with the observation, "Any mother who can get through a day without screaming at the children is a saint." Donna makes light of the comment ("I don't believe in screaming. A rubber hose is just as effective and it doesn't leave any marks"), but the flinty look in her eyes conveys her displeasure. More praise the next day from her husband, children, and even the deliveryman further unsettle her, confirming her suspicions that she is universally admired because universally perceived as subservient. She begins testing out her anger, losing her temper at strangers and intimates alike, causing them to cower in her presence. Her experiment in self-assertion proves successful, but only up to a point, because she doesn't like the new persona that results. At the end of the half-hour episode, she returns to her characteristic sweetness. ("The Revolution is over," says her husband at breakfast. "The people can go back to their peaceful lives.") Yet her family has also been chastened and enlightened by her short-lived rebellion.

Jackie Kennedy was never a TV housewife, aside, perhaps, from her televised tour of the White House. But whatever her true private sentiments may have been, she publicly espoused complete devotion to her children and husband. Readers of *Life* praised her for her straightforward child-rearing values: "Rearing children," she is quoted as saying, in a caption beneath a photo of her playing with Caroline and a handful of young Kennedy cousins, "I believe simply in love, security, and discipline." In a JFK memorial edition of *Look* issued a year after the assassination, she says, "I never had or wanted a life of my own. Everything centered around Jack. I can't believe that I'll never see him again. Sometimes, I wake in the morning, eager to tell him something, and he's not there. . . . Nearly every religion teaches there's an afterlife, and I cling to that hope."

In our own cynical era, long after the killing in Dallas and assorted other shocks, scandals, and disturbing revelations about the private lives of public figures have sharpened our distrust of sentiments such as these, Jackie's words might strike many as phony, if not downright dishonest. How could she have said such things, some have wondered, when she well knew that her husband was chronically unfaithful to her during the ten years of their marriage? Was she trying to fool the public, or herself?

Perhaps neither. Perhaps she uttered those words in good faith—religious faith, in this instance. For all Jackie Kennedy's admiration of the French eighteenth century and her desire to live by its liberal codes, she seems equally to have been molded by the Roman Catholic medievalism that her beloved eighteenth-century Enlighten-

ment struggled to overturn. In other words, Jackie not only modeled *as* a Madonna, she modeled herself *on* the Madonna.

Enlightenment wit and cynicism might have allowed her to cope with the day-to-day stresses of life and marriage. But the medieval cult of the Virgin and its latter-day manifestation in the feminine mystique may well have provided her with a stable sense of self when her world came flying apart.

SURPRISINGLY, MARK SHAW'S IMAGE of Jackie as Madonna was not included in the *Life* feature story for which it was taken. Why not? Possibly the editors thought the picture too sexy. The mix of the sacred and profane that was good enough for Raphael or Julia Margaret Cameron might have been judged inappropriate for the mass-market readership of 1959. Remember, Doris Day reigned at the box office that year and "Madonna" Reed on TV.

Another reason for *Life*'s decision to omit the photo from its spread is that Madonna images smack of Catholicism, whatever the creed of the artist or Madonna figure. The relevance here is that John Kennedy was launching a bid for the White House. America had never had a Catholic president. The only Catholic who had previously competed for the office, the Democrat Al Smith, in 1928, got thumped at the polls in large part because of his religion. Joe Kennedy, to make sure the same obstacle would not derail his son, determined to keep his family's Catholicism out of the public eye, and apparently with good reason. Political historians believe that Jack's religion nearly cost him the election.

A campaign speech he made before a gathering of Protestant ministers in Houston, Texas, in September 1960 may well be the reason it did not. When asked whether he would feel compelled to take orders from his "hierarchical superior in Boston," Cardinal Cushing, Jack replied courteously, "I am the one that is running for the office of the Presidency and not Cardinal Cushing." Then came the speech itself. In what sounds almost like an anticipation of the "I Have a Dream" speech that Martin Luther King, Jr., gave three years later, Jack declared:

> I believe in an America where religious intolerance will some day end, where all men and churches are treated equal—where every man has the right to attend or not attend the church of his choice—where there is no Catholic vote, no anti-Catholic vote, no bloc voting of any kind. . . . This is the kind of America I believe in—and this is the kind I fought for in the South Pacific and the kind my brother died for in Europe. No one suggested then that we might have a "divided loyalty," that we did "not believe in liberty," or that we belonged to a disloyal group that threatened the "freedoms for which our forefathers died."

Such eloquence, along with his personal charm and lovely, visibly pregnant wife (and the benefit of illegal votes in Chicago), sent John Kennedy to the inaugural stand on January 20, 1961. There he electrified Americans with his resounding appeal to the chivalric ideals of bravery, piety, sacrifice, and honor that came in time to be designated by a catchword: Camelot.

A WEEK AFTER THE ASSASSINATION, the president's widow granted an interview to the newsman and presidential historian Theodore H. White, who was writing a piece for *Life*. The nation was still very much in shock from the events of the previous weekend, and millions of Americans wanted to look in on the former first lady, as much out of a need for guidance in their own tribulation as out of sympathetic concern for her. During the interview, Jackie recalled that before going to bed each night the president liked to put on the original cast recording of *Camelot* and had more than once expressed the hope that his era would be remembered like King Arthur's. It's easy for us today to lampoon what looks like crude mythmaking and to remark snidely on Jack's actual bedtime proclivities, but I think the analogy is on the money, nevertheless—so long, that is, as we recognize that the apt comparison is to both Camelot and *Camelot*.

Alan Jay Lerner and Frederick Loewe's musical play opened on Broadway December 3, 1960, six weeks before the Kennedy inauguration. In its finale, moments before a great battle is to begin, Arthur knights a lad who aspires to join the Round Table. Sending him off the field of battle to safety, he implores the youth ("Don't let it be forgot") to tell future generations of the "brief, shining moment" that was Camelot.

Kennedy, in his inaugural address, charged his listeners in language of greater complexity but similar import. "Let the word go forth from this time and place, to friend and foe alike, that the torch has been passed to a new generation of Americans." The concern with posterity also calls to mind Lincoln's Gettysburg Address: "The world will little note nor long remember what we say here, but it can never forget what they did here."

The operative word in the Kennedy speech is "Let." He uses it a full dozen times in an address that, at a mere 1,365 words, is one of the briefest in the history of presidential inaugurations. "Let" is the perfect Kennedy verb, a liberal's term, a predicate of permissiveness. It does not command, urge, or beg. Instead it engages agreement. It is a term of consensus: we're all in this together, and I'm speaking to you as an equal and an ally. "Let every nation know," he says; "let us begin anew"; "let us go forth." He uses the term to kick-start one of the overriding doctrinal ideas of his foreign policy: "Let us never negotiate out of fear. But let us never fear to negotiate."

The boldest statement of the address carries a brass-knuckle punch gloved in the

velvety smoothness of the Kennedy *let*. "Let every nation know, whether it wishes us well or ill, that we shall pay any price, bear any burden, meet any hardship, support any friend, oppose any foe to assure the survival and the success of liberty." With this paean to self-sacrifice and national resolve, Kennedy echoes Churchill during the Battle of Britain. It's pure drama, the way his extended series of verb phrases ("pay any price, bear any burden") builds to a crescendo, concluding with the drums and trumpets of "oppose any foe."

"This much we pledge," he says. That's the language of chivalry, and the whole short speech is cast in it. This, more than Jackie's retrospective tale of bedtime listening to Lerner and Loewe, makes Arthurian romance central to the Kennedy thousand days. In his ingenious analysis of the Gettysburg Address, Garry Wills writes, "And therein lies the greater power of the Address. It is made compact and compelling by its ability to draw on so many sources of verbal energy—on a classical rhetoric . . . , on a romantic nature-imagery of birth and rebirth . . . , on biblical vocabulary . . . on a 'culture of death' that made mourning serve life."

Kennedy's address similarly amalgamates various puissant languages of suasion. Its stirring effect on listeners derived, in no small measure, from its ability to invoke, without actually naming or imitating them, such inspirational leaders of the past as Pericles, Lincoln, Roosevelt, Churchill, and the fabled King Arthur.

THE TRADITION OF MULTIPLE inaugural balls began with Eisenhower in 1953, when two large gala events constituted the festivities. (A CBS radio announcer made communications history that year when he told a national audience, "And now we take you to Washington, where both presidential balls are in full swing.") Kennedy assumed office in a flurry of inaugural balls—no fewer than five.

The photographic image that for me best captures the underlying medievalism of the Kennedy inauguration was taken at one of those galas by a photographer named Paul Schutzer, who later lost his life covering the 1967 Israeli-Arab war. Schutzer had already snapped some of the most vivid images of Kennedy's presidential campaign, catching the excitement of the crowds that gathered to see him. One Schutzer photo of Kennedy campaigning in Los Angeles in 1960, reaching out to touch a sea of outstretched arms and hands, resembles Roger Marshutz's classic photo of Elvis in Tupelo, Mississippi, in 1956, leaning from the stage like a faith healer to run his hand across the forest of fans' fingertips.

Now, on this celebratory night, Schutzer photographed the Kennedys from above and behind in the presidential box (Fig. 29). Jackie, who had given birth two months earlier to John junior, sits in the lower left corner of the picture looking up adoringly at John senior. She wears a silver-and-white gown that she herself designed, with the

FIGURE 29 | Inaugural Ball, Washington, D.C., January 20, 1961 (Paul Schutzer, photographer)

help of her friend Diana Vreeland, the editor of *Vogue*. Her chiffon overblouse shines in the light, as do the contour of her arm and the length of her neck and upturned face. But in this picture Jackie is only an appendage to Jack. The light that strikes her is borrowed from him.

Standing, he is transfigured by the light. It showers down on him from above, or, alternatively, it emanates from him. In contrast with his dark-clad body, his face glows, his teeth gleam, and the line along his arm glimmers. He emits an aura. Here King Arthur (good government) and Sir Lancelot (youthful romantic ardor) merge with Galahad, the holiest of knights.

Jackie had encountered Jack's inaugural address "in bits and pieces many times while he was working on it." But earlier that day was the first time she had heard it as a whole. As she was later to comment, "It was so pure and beautiful and soaring that I knew I was hearing something great." Astutely, she compared it to the Funeral Oration of Pericles, the famed leader of ancient Athens who presided at the birth of its greatest period of art, philosophy, and democracy. Paul Schutzer's photograph actually alludes to the classical world, whether Schutzer, Kennedy, or anyone else intended that allusion or recognized it as such.

Compare the president's form to that of the magnificent bronze youth from about 340 B.C. found in the sea off the Greek island Antikythera: captivating elegance, strength, and beauty embodied in the "soaring" gesture of the extended arm (Fig. 30). Or compare Kennedy with a more regal figure, the marble statue of Caesar Augustus from the imperial villa of Prima Porta. Like Schutzer's photograph some twenty centuries later, the *Augustus of Prima Porta* (ca. 20 B.C.) blends elements of the real and the ideal so as to blur the line between human and god (Fig. 31). No doubt Schutzer snapped numerous photographs that night, as did plenty of other press photographers, but this one clicked with viewers and entered the canon—not because it echoed classical sculptural prototypes but rather because, like them, it strikingly summarized Western culture's most deeply ingrained notions about youthful grace, leadership, and nobility.

In the Christian era, artists depicting Christ triumphant looked to ancient Greek and Roman statues like these as a template for the gesture of power and benediction. The photo of Kennedy at the inaugural ball plays upon this centuries-old Christian tradition, endowing him with a Christly charisma. The term "charisma," so closely linked with John Kennedy during his administration and in the eulogies ever after, derives from the Greek word for divine gift. In Christian theology, the word refers to a divinely inspired grace or talent for prophecy or healing. Schutzer's photo gives the word an unforgettable visual definition. To use Jackie's comment about the address itself, Jack, in this photo, is "pure and beautiful and soaring."

Gazing up at him devotedly, she is the consummate 1950s housewife, a picture-perfect embodiment of the feminine mystique. But more than that, she is once again

the Madonna. Except now the golden child whom she adores is not a babe in arms but rather a grown man and the newly minted leader of the Free World. She is also his Guinevere and, in a different mythic context, his Penelope—the patient, long-suffering wife of Ulysses who sat home weaving while he sallied forth to war, intrigue, and adventure. No wonder the Kennedys both loved Tennyson, who produced an epic romance about Arthur as well as a poetic monologue about Ulysses.

Tennyson wrote "Ulysses" in 1833, shortly after learning of his best friend's death. As he himself said, the poem revolves on "the need of going forward and braving the

FIGURE 31 | *Augustus of Prima Porta*, ca. 20 B.C., Vatican Museums

struggles of life." It's written from the perspective of the Homeric adventurer in his old age, long after his return to Ithaca. Now, as death beckons, he prepares for his final voyage—"To sail beyond the sunset, and the baths / Of all the western stars, until I die."

As a widow, Jackie recalled some of Jack's favorite lines from the poem, such as "I am a part of all that I have met" and "How dull it is to pause, to make an end, / To rust unburnished, not to shine in use!" She didn't explicitly draw the connection, but it seems to me that the poem's famous final line, "To strive, to seek, to find, and not

to yield," may have inspired the cadence, if not also the determination, of Jack's defiant assertion in the inaugural address, "We shall pay any price, bear any burden, meet any hardship, support any friend, oppose any foe."

Given John Kennedy's own gargantuan appetite for adventure, sexual or political; his dire experiences in World War II; his loss of a brother, a sister, and several children, newborn or miscarried, how can he not have identified with the following stanza from "Ulysses"?

> I cannot rest from travel: I will drink
> Life to the lees: all times I have enjoyed
> Greatly, have suffered greatly, both with those
> That loved me, and alone; on shore, and when
> Through scudding drifts the rainy Hyades
> Vext the dim sea: I am become a name;
> For always roaming with a hungry heart
> Much have I seen and known; cities of men
> And manners, climates, councils, governments,
> Myself not least, but honoured of them all;
> And drunk delight of battle with my peers,
> Far on the ringing plains of windy Troy.

SOME TODAY REGARD JACK KENNEDY as a presidential lightweight, all flash and style, charm and wit, a pretty boy lacking in the mettle and vision of truly extraordinary leaders. Kennedy did not possess a great oratorical style. His delivery of formal addresses (as opposed to his informal press conferences) was stiff, even awkward. Jackie, it is said, coached him in his speechmaking, teaching him gestures, vocal inflections, and other techniques to make his points more forcefully and persuasively.

Watching footage of the inaugural address, we see a man who punches out some of the most eloquent words in American political history with an odd grimace on his face. As he appears in the inaugural ball photo, however, he's an entirely different man. If he had none of the evil genius of his century's political demagogues, he has here nevertheless the magnificence of Il Duce surveying the crowds from his balcony in Piazza Venezia or the electricity of Lenin in Red Square in pitch-perfect combination with the relaxed self-assurance of a TV talk show host.

Kennedy at the inaugural ball matches up best with a fictional politician, Charles Foster Kane, as depicted in *Citizen Kane* appearing in a convention hall before throngs of admirers (Fig. 32). Orson Welles's camera takes us in over the heads of the assembled spectators (an optical simulation of thousands) to a low-angled shot of Kane at

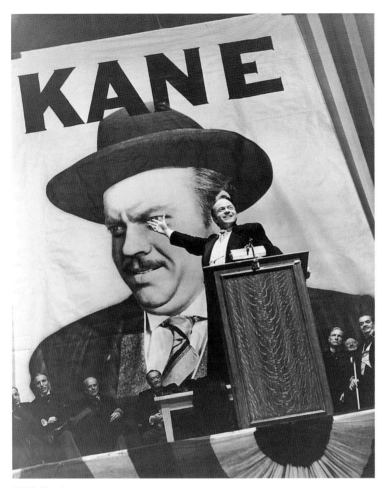

FIGURE 32 | *Citizen Kane,* 1941

the podium, where, with a self-enchanted grin on his face, he gestures to a giant-size campaign picture of himself.

Welles uses this shot not to adulate his antihero but to underscore his essential shallowness. Kane's political convictions, we soon learn, are as thin and flat as that campaign poster, and in this context the duplication of the politician by his larger-than-life image suggests his duplicity. Garry Winogrand's photograph of Jack addressing the Democratic National Convention in 1960 (Fig. 33) rhymes with Welles's picture of a "two-faced" politician addressing a crowd, though with a number of intriguing twists: here the politician turns his back to us (a motif of Kennedy photography discussed in Chapter 7), his hand gestures toward himself rather than toward his photographic image, the other figures visible in the shot are not party dignitaries on the

FIGURE 33 | Garry Winogrand, *Democratic National Convention*, *1960*, Fraenkel Gallery, San Francisco

dais but photographers in the press stands, and the wry doubling of the orator does not make him larger than life but smaller, cozily downsizing him to the dimensions of a portable TV screen.

Surely the most penetrating political film ever made in America, *Citizen Kane* is also one of the most profoundly cynical, tracing a leader's loftiest ideals to his private fears and insecurities. The movie sees political ambition, left or right, liberal or conservative, as a symptom of a personal (albeit socially representative) neurosis.

The conservative media tycoon William Randolph Hearst provided the real-life model for Charles Foster Kane, but Kane shows surprising similarities to John Fitzgerald Kennedy, whose own political career would not begin until five years after the film's release in 1941 (by RKO, as it happens, the studio formed by Joseph Kennedy). Like Jack Kennedy, Charlie Kane was a remarkably rich, gregarious, quick-witted, romantically dashing youth with high ambitions, an oversize ego, and a roving eye. Like Jack, as detailed by numerous biographers, Charlie suffered from and overcompensated for an emotionally cold mother. Charlie's legal guardian, like Jack's father a financier of great wealth and domineering power, masterminded his ward's future as Joe Kennedy did his son's.

With an eye on the White House, Charlie married a president's niece, the elegant Emily Norton, to whom he was unfaithful, just as Jack, with an eye on the White House, married the elegant Jacqueline Lee Bouvier, to whom he was prodigiously unfaithful. Charlie, like Jack, wanted to be a liberal political reformer, but entanglements of all sorts prevented him from staying his course. And both Charlie Kane, the tabloid newspaperman, and Jack Kennedy, the president, opportunistically sanctioned an ill-considered invasion of Cuba.

A reporter inquiring into the life of the late Charles Foster Kane asks Jed Leland, once Kane's closest friend and subsequently his enemy, about Kane's first wife. "She was like all the other girls I knew in dancing school," Leland answers. "They were nice girls. Emily was a little nicer. She did her best—Charlie did his best—well, after the first couple of months they never saw much of each other at breakfast." A slow dissolve takes us to the breakfast room in Kane's turn-of-the-century home while Leland concludes his commentary with droll irony: "It was a marriage just like any other marriage." The sequence that follows acerbically represents the Kane marriage by a rapid series of breakfast scenes in which the husband and wife grow increasingly distant from one another, literally as well as figuratively. The setting remains the same, but mentally and emotionally they inhabit separate worlds.

By all accounts, that description fits the Kennedy marriage too, at least before the White House years. After moving to the White House, Jack and Jackie seem to have become closer, perhaps because now they had to work as a team. She became an extremely important player in his administration, second in importance, in the public's eye, only

to the president himself. She was the cultural czarina of the New Frontier, and the diplomatic influence she proved capable of wielding was an enormous asset. Whatever marital tribulations she continued to endure because of her husband's compulsive infidelities, Jackie in the White House no longer suffered the problem with no name. She was no longer a supernumerary—no longer simply John Kennedy's Lovely Lady.

In her expanded role she inspired a new generation of girls and young women. The media historian Susan Douglas credits the first lady with doing her part to dismantle outdated gender stereotypes: "Jackie had these traditionally 'masculine' qualities—she was smart and loved intellectual pursuits, she was knowledgeable about history and the arts, she wore pants, and she had big feet—yet she was still completely feminine, a princess, a queen. She knew how to take charge, and yet she also knew how to be gracious and ornamental." The first lady's serious commitment to historic preservation and the flourishing of the arts, along with her beauty, fame, and glamour, made her "the most charismatic woman in America, possibly in the world, and she was critically important to baby boom culture because of the way she fractured the old fairy tales." American baby boomers weren't the only observers to appreciate Jackie as a positive and influential representative of changing times. Commenting upon her triumphant state visits to Paris, Vienna, and London in 1961, an English newspaper wrote, "Jacqueline Kennedy has given the American people from this day on one thing they had always lacked—majesty."

This chapter, which began with Jackie and Jack in the sunlight, ends with them in the spotlight. The two images are opposite in so many ways. One is neo-Enlightenment, the other neo-Gothic. One emphasizes male-female conviviality and the play of wit and manners, the other male magnificence and female adoration. She dominates in one, he in the other. While neither picture tells the whole story of the Kennedy marriage, both convey essential aspects of the Kennedy myth and in so doing characterize the values of American society during that time.

With both pictures in mind, let us now proceed toward a third image of togetherness and separateness or, if you will, of a marriage like any other. This one shows the arrival of the Kennedys in Dallas, Texas, on a sparkling morning in late November 1963.

4

Blue Sky, Red Roses

THIS WAS THE LAST TIME they would see blue sky together. What a lovely day it had turned out to be. When they awoke that morning in Fort Worth, the sky was seeping rain. Not pouring, mind you. It wasn't a hard rain that fell in Fort Worth, only a drear November rain that now seems an omen of tears to come. Everything always looks different in retrospect, and never more so than with the Kennedy assassination.

Had the rain continued, for example, the president's Secret Service agents would have shielded the passenger compartment of the presidential limousine with a protective glass covering that was used to keep rain off the first couple. It wouldn't have stopped an assassin's bullet, but it might have obscured his view. Even if the rain had not subsided, the president would most likely have waved off the bubbletop, had he been on his own. He thrived on direct contact with the crowds that turned out to see him and would not have minded a drenching if it granted him more eye-to-eye engagement.

It would not do, however, for the first lady to get soaked. Spectators who turned out for the presidential motorcade, as eager to gape at her as at her husband, would have been disappointed if she were partially hidden from sight by the rain-deflecting bubbletop. But Jackie's hair, her makeup, her elegant clothing—in a word, her image—were not meant for inclement weather. Or so, apparently, the president thought, and thus, had the rain continued, he probably would have agreed to the use of the bubbletop.

By the time they got to Dallas, the sky had dried its eyes. The day smiled upon them.

THEY FLEW INTO LOVE FIELD at 11:40 in the morning. They'd left Fort Worth a mere thirteen minutes earlier. Understand, Fort Worth and Dallas neighbor each other on the Texas plain, a mere thirty miles apart. The Kennedys could have gotten from one town to the other more rapidly and efficiently by car than by airplane. But neither speed nor efficiency was the primary consideration. Jack Kennedy grasped the importance of ceremony in public life. The arrival of the people's leader needed to be grand and majestic, an occasion of fanfare and spectacle. As I've noted, Kennedy was nothing if not a manager of image—his own, his wife's, his nation's. No president before him, with the possible exception of Franklin Roosevelt, had demonstrated such a gift for shaping his image, parceling it out, honing it, making it shine. Jack Kennedy got to the top by making himself *visible*, the object of the people's admiring and desiring gaze. His insistence on maximizing his visibility that day is what got him killed.

He knew the dangers. The Secret Service agents were continually urging him to remain behind cover—that of the bubbletop or their own protective ring of bodies—but Jack had too much at stake in living dangerously to acquiesce. Some men only affect a devil-may-care attitude about their own personal safety, determined, in reality, to keep out of harm's way. Kennedy seems to have been the opposite. While his public persona was that of a calm man guided by reason and circumspection, in fact he had a gambler's compulsive attraction to risk.

America had prevailed during the Cuban missile crisis, it was widely believed, because the president remained cool when others, his generals, for example, were inclined to be precipitate. But in private Jack courted danger, as if its adrenaline rush granted him the strength—the "vigah"—that his cortisone treatments for various physical ailments (and Dr. Jacobson's amphetamine cocktails) provided less reliably.

One day, for example, when sailing off Palm Beach with the fashion designer Oleg Cassini, a family friend, he decided to go for a swim, even though the Secret Service warned that sharks had been reported in the area. "The President jumped in, however, and it was quite a sight: the coast guard boats circling in close, creating almost a swimming-pool-sized protective circumference in the ocean, and there, in the middle, the President, treading water and puffing a cigar. He loved the grand gesture, the successful gamble. That morning, he had played against the sharks and won—and, signaling for a line, he allowed himself to be pulled back onto the yacht, triumphantly puffing all the while."

Jack's bravado was that of a man who, his biographers concur, believed he should already have died from childhood illness, war injuries, life-threatening spinal surgery, or their lethal combination. As a conspicuously underweight member of Harvard's football team, he had thrown himself into the roughest possible situations to prove him-

self, getting knocked flat time and again by beefier players and always pulling himself up off the turf to embrace more punishment. Not long after college, he became a bona fide war hero. No one has ever suggested that during the war he deliberately placed himself in danger, but when he faced it, he seems almost to have relished the experience. The patrol torpedo (PT) boat he commanded in the South Pacific split in two when rammed in the middle of the night by an unsuspecting Japanese destroyer. Jack swam alongside his men to the nearest island, several miles away, towing, with a cord held between his teeth, a badly wounded sailor. On subsequent nights, he swam off to surrounding islands until finally he made contact with friendly islanders and through them got a message to headquarters that led to the rescue of his stranded contingent.

Some of Kennedy's critics charged that the PT-109 episode was embellished by journalists looking for a good story and made too much of by Joe Kennedy when his son ran for a seat in Congress. Jack, however, never boasted about the incident. When asked how he became a war hero, he replied, "It was involuntary; they sank my boat."

That has the laconic sound of something Jack's movie star hero Gary Cooper would have said, but it's witty too. "He appeared to be beautifully on to himself," Gore Vidal later remarked. "As a result, there were few intellectuals in 1960 who were not beguiled by the spectacle of a President who seemed always to be standing at a certain remove from himself, watching himself with amusement at his own performance. He was an ironist in a profession where the prize usually goes to the apparent cornball."

THE ENGLISH HEROES of Jack's childhood, such as the Knights of the Round Table, talked in flowery language, but those of his early adulthood, such as Lord Byron, taught him the pleasures of understatement. Kennedy's "It was involuntary; they sank my boat" exhibits the same wry eloquence as Byron's recollection of how he became a literary celebrity: "I awoke one morning and found myself famous." Given his own nature and aspirations, how could young Kennedy not have sought to model himself on an ironist who lived like an aristocrat, loved like a libertine, died like a hero?

Another of Jack's idols was the English aristocrat Raymond Asquith, a prime minister's son who was killed in action in World War I. Kennedy read about Asquith in one of his favorite books, *Pilgrim's Way*, by the Scottish historian, diplomat, and spy novelist John Buchan (his 1915 book *The Thirty-nine Steps* gave rise to the modern espionage thriller). Appearing in 1940, at the start of World War II, *Pilgrim's Way* celebrated the bravery and self-sacrifice of the generation that had fought in the previous war. According to Buchan, who had been close to Asquith, his "debonair and brilliant and brave" friend readily put his life on the line for his country but never made a show of it, preferring instead to hide "his devotions under a mask of indifference."

A year after the assassination, Jackie recalled Buchan's elegant formulation about Asquith, which she thought applied equally well to her slain husband: "He disliked emotion, not because he felt lightly but because he felt deeply."

Buchan's verbal portrait of Asquith calls upon a classical rhetoric of patriotic obligation that Kennedy himself invoked, to great effect, during his presidency. "Our roll of honor is long, but it holds no nobler figure," Buchan writes of the fallen warrior. "He will stand to those of us who are left as an incarnation of the spirit of the land he loved." Buchan's parting remark about his friend—"He loved his youth, and his youth has become eternal"—might well have been in Jackie's mind when she requested that Jack's grave in Arlington National Cemetery be marked by an "eternal" flame.

"In the early deaths of war heroes in *Pilgrim's Way*," John Hellmann writes in his examination of literary and cinematic influences on the president, "Kennedy could see male beauty preserved by death, a narcissistic, much admired masculine image ennobled by self-sacrifice for a great cause." He continues:

> On his way to the South Pacific, Kennedy was in a somewhat different situation from most of the men around him. While he enjoyed enormous advantages of wealth, he journeyed toward war with considerable reason to believe that an early death, or perhaps a debilitated life, awaited him if he survived to return home. Kennedy was hardly suicidal in his intent, but his recommendations of *Pilgrim's Way* to his fellow officers reflected his love of a book that depicted suffering and death in war in achingly beautiful, even homoerotic, terms—as an achievement of a masculine nobility that could never be lost.

Hellmann concludes that John Kennedy consistently, if unconsciously, courted danger as a response to his lifelong life-threatening physical infirmities and to the overweening political ambition fanned in him by his father. His ongoing sexual and political adventurism, his obsession with proving himself extraordinary "both in bed and on the podium," grew directly out of his self-perceived inadequacies.

JFK's identification with Byron and other heroes of English history drew him to a corollary idea—of America as "legitimate successor to the Empire as defender of freedom in the world." In his quest to achieve personal glories similar to theirs, JFK imbibed the ethos of eighteenth- through early-twentieth-century British imperialism and reinvented it for the new cold war era.

IN THE 1950S IAN FLEMING joined John Buchan and David Cecil on the list of authors whose books Kennedy enjoyed. Fleming's suave hero James Bond was in certain essentials a cold war counterpart to Richard Hannay, the protagonist of Buchan's ear-

lier spy novels. At home in elite society and able to maneuver through it with finesse, but not at all "unmanly" or effete, both characters could adapt to any situation and meet any challenge. Jack encountered the first of the Bond novels, *Casino Royale* (1953), when Jackie brought him a copy during his hospital stay after spine surgery in 1954.

The 007 ethos appears to have influenced not only Kennedy's private but also his political intrigues. At a Georgetown dinner party with Ian Fleming in 1960, he listened seriously to Fleming's schemes for sexually embarrassing Castro or even assassinating him with a poison pen or an exploding cigar. After the Bay of Pigs fiasco, in which he had relied on bad advice from the Central Intelligence Agency, Jack ruefully remarked, "It would have been better if we left it to James Bond."

Bond was a fantasy figure for those like Jack Kennedy who had the wherewithal to emulate his social and sexual savoire-faire and for a wide range of other men during the cold war era. The Bond movies (*Dr. No* came first in 1962, followed by *From Russia with Love* in 1963 and *Goldfinger* in 1964) extended the impact of the imaginary secret agent on run-of-the-mill male fantasy, setting the hearts of boys and men aflutter with Bond on-screen (as embodied by the darkly handsome and debonair Sean Connery) as well as on the page (Fig. 34).

Take Lee Harvey Oswald, for example. In the summer of 1963, recently fired from his job as a maintenance mechanic at a coffee warehouse, he found himself with nothing but time on his hands. He used it to read, among other books, a biography of Mao Tse-tung, a diatribe on Communism by J. Edgar Hoover, a biography of John Kennedy, and four James Bond thrillers. While it remains a matter of speculation whether Oswald was an operative for the CIA, FBI, KGB, none of them, or all them, his credentials as an admirer of 007 are indisputable.

A 1964 reader's guide to the Bond novels extols the fictional character's sexual prowess:

> Almost every personable female he meets seems more than ready to hop into bed with him at his merest nod. Waitresses brush against him provocatively, married women appear to be his for the asking, other men's mistresses forget their lovers when they see him, and even expensive whores are willing to bestow their favours pour amour. . . . Occasionally, though, he meets a girl who has no immediate intention—or eventual intention, for that matter—of copulating with him. More often than not he wins her over. This is usually accomplished by derring-do.

"Derring-do." The very term connotes something archaic, primitive, premodern. It comes from the Middle English verb phrase *derrynge do,* meaning "daring to do," but Sir Walter Scott popularized it as a noun in his chivalric novel *Ivanhoe.* It thence

FIGURE 34 | *Dr. No*, 1962

came to mean daring, even foolhardy, action or reckless courage. The Romantics cherished derring-do because it showed an exhilarating carelessness toward circumspection and other middle-class conventions of behavior.

James Bond comes from a long line of male Romantic heroes who inspire ardor in readers by their nonchalant acceptance of extreme personal risk in the quest for some great, hallowed goal. Such a goal might be protecting Her Majesty's commonwealth from nefarious enemies (007), or launching a secret invasion of "freedom fighters" against Cuba (JFK), or gunning down the "treasonous" president of the United States (LHO).

AN UNSIGNED HANDBILL circulating in Dallas during the days leading up to the president's arrival featured front and side mug shots of Kennedy with the words "Wanted for treason" printed in bold type. Beneath them the handbill continued, "This man is wanted for treasonous activities against the United States." It accused him of "betraying the Constitution," "turning the sovereignty of the U.S. over to the Communist controlled United Nations," and (among other sins) lending his "support and encouragement to the Communist inspired racial riots." Whether Oswald ever saw this circular is unknown, but he certainly would have heard of such charges against the president.

My point is not Kennedy's treason or Oswald's guilt. It is that both men, along with millions of other readers who admired the Bond adventure tales, swilled the Romantic ideology of derring-do as a confirmation of potency, sexual and otherwise. That one man possessed it in exceptional, almost superhuman, abundance, and the other lacked it, almost pathetically, yet both were fans of Bond suggests how deep-seated this ideology is across the board, regardless of social standing or historical epoch. As the eighteenth-century London periodical the *Adventurer* asserted, "It is the ADVENTURER alone on whom every eye is fixed with admiration, and whose praise is repeated by every voice."

Jack's arrival at Love Field is thus emblematic of his adventurousness, his derring-do. When shown a reactionary diatribe against him in a Dallas paper earlier that morning, he had shrugged it off, saying, "Oh, you know, we're heading into nut country today." The crowds who came out to greet him and his wife at Love Field and on the motorcade route were unaware that he had maligned them, or that he was knowingly subjecting himself to risk by reducing his security among them to make himself more visible. But even if they did not understand that his coming to Dallas involved personal bravery—or, more accurately, disdain for personal safety—he embodied for many of them an up-to-date ideal of masculine courage, potency, and attractiveness.

IN THE FALL OF 1963 the title character of the unexpected box-office hit *Tom Jones*, winningly played by the young English actor Albert Finney, offered another embodiment of the masculine ideal. A spirited adaptation of Henry Fielding's eighteenth-century picaresque novel, the movie recounts the bawdy exploits of a handsome youth possessed of a genuinely sweet and guileless nature.

Finney's Tom is also unabashedly sexual. He hops from bed to bed with a zest matched only by that of the filmmakers, who avail themselves of a wide array of unconventional cinematic devices to record his romps and convey his joyful gusto. The only villains of the piece are the prudes who primly regard Tom as a depraved scoundrel.

FIGURE 35 | *Tom Jones* advertisement, 1963

Rejected by many studios before it was finally produced and went on to win the Best Picture Oscar, *Tom Jones* amounted to one of the most critically acclaimed and financially profitable early sallies in the sexual revolution of the 1960s (Fig. 35). The movie depicts free love as healthy, happy, and natural, and sexual repression as sick, twisted, and unnatural. And it does so in such a fun-loving way that despite its assault on traditional sexual and behavioral codes, legions of viewers who might otherwise have stood firm against its libidinal implications thronged to see it.

As a masculine ideal Tom Jones, like James Bond, exemplified a guilt-free attitude toward sex, a handsome, rugged manliness, and an insouciant wit and charm. Emerging from Air Force One in Dallas, John Kennedy was somewhat jowly, thanks

to the cortisone he was taking for his Addison's disease. Still, with his smartly cut suit and princely bearing, he looked every bit as much a hero of the era as the Bond of fiction or the Jones of film. The shape of his face and cut of his hair even resembled those of Albert Finney's Tom, and his toothsome grin was equally endearing.

The public at the time, not privy to Kennedy's extramarital "adventures," might well have turned on him had they known. Jack, after all, was a married man, whereas James and Tom were not. Spared such revelations, however, many Americans, both male and female, were captivated by his appearance, style, and youthful freshness, and they responded to him with ardent affection similar to that bestowed on the two imaginary heroes. Tennessee Williams was clearly mistaken when, after meeting Jack in Florida in 1958, he predicted that the senator could never get elected to the White House because he was "far too attractive." ("Look at that ass," he commented when Kennedy walked in front of him.)

Whether Jack himself identified with Tom, as he did with James, we do not know. But if he did catch the movie at one of Jackie's White House screenings in that final fall of his life, he would surely have found in the title character yet another English hero to list with his others, real and mythical—Lancelot and Arthur, Byron and Melbourne, Asquith and Bond.

ONE LAST ENGLISH HERO, or in this case antihero, needs to be added to the mix: T. E. Lawrence. An Oxford-trained archaeologist who served with British intelligence in the Great War and organized Arab tribesmen for a successful guerrilla campaign against the Turks, "Lawrence of Arabia" was one of the most enigmatic figures of the early twentieth century—a brilliant writer, a closeted homosexual, an antisemite with fascist leanings, and a leader of extraordinary charisma.

Lawrence, as his friend John Buchan wrote of him in *Pilgrim's Way*, "had a magnetic power which made people follow him blindly, and I have seen that in his eye which could have made, or quelled, a revolution." Buchan admitted to puzzlement at Lawrence's many contradictions. "I do not profess to have understood T. E. Lawrence fully, still less to be able to portray him; there is no brush fine enough to catch the subtleties of his mind, no aerial viewpoint high enough to bring into one picture the manifold of his character."

In 1963 David Lean's visually stunning desert epic *Lawrence of Arabia* provided an "aerial viewpoint," literally as well as figuratively, on the British warrior. The movie opens with an overhead shot of a young man striding across the pavement to a motorcycle awaiting him in the upper left corner of the Panavision screen. While the credits roll in the empty space to the right, the young man, Lawrence, played by Peter O'Toole, readies the machine for what soon turns out to be his final journey. Speeding

FIGURE 36 | *Lawrence of Arabia, 1962*

off on a narrow English country lane, he swerves to avoid two bicyclists in his path and flies over an embankment to his death. Abruptly the movie cuts to St. Paul's Cathedral, where Lawrence's remains have been interred in state, and then to Cairo two decades earlier, where the story of the Arabian campaign begins.

The first half of the film exults in Lawrence's youthful impetuosity and brash idealism (Fig. 36). It also portrays him as taking an almost masochistic pleasure in subjecting himself to physical discomfort, even pain. When someone asks him how he "does that trick" of extinguishing a match flame by allowing it to burn down to his fingertip, Lawrence answers, "The trick is not minding that it hurts." In effect, that was Kennedy's own approach to the often excruciating physical pain and fatigue in his life, as well as the fear. He would have preferred not to come to Dallas in the first place, but political protocol necessitated the journey, and, despite the ominous hostility man-

ifest in the right-wing local press and the "wanted for treason" circulars, he fully intended to soldier on.

The second half of the movie devolves into a dark and at times nearly incoherent account of Lawrence's deepening self-conflicts, his earlier exuberance and straightforward heroism now clouded by sadistic and masochistic impulses. In the concluding sequence, set in Damascus, he loses control of his men and comprehends fully how his dream of a united Islam has failed. Jack Kennedy, unlike the T. E. Lawrence of either history or Hollywood, was not given to depressive self-hatred, and he seems to have maintained a largely unflagging confidence in himself and his ability to better the world. If he was an idealist, he was, even more, a toughened political compromiser who recognized, and fully accepted, that any victory comes sown with the seeds of defeat. That, to him, was simply the way things were.

It's easy to imagine Jack's seeing himself narcissistically in 1963 as a latter-day Lawrence of America, dauntlessly uniting warring factions in his own party (the purpose of his stop in Dallas) and commanding the love and respect of the plebeians through his charisma. It's impossible to imagine him identifying with Lawrence in the second half of the movie, a leader who falls into confusion, depression, and self-loathing.

Perhaps, had Kennedy remained in office longer, he too would have become irreparably scathed, suffering his own series of diplomatic debacles. What Damascus was for Lawrence, Saigon might have proved for Kennedy—the symbol of his ultimate political failure. As it happened, he reached Dallas before he ever got to his own version of Lawrence's Damascus. In Jack's case, the film ended before intermission.

LIFE'S FULL-PAGE COLOR PHOTO depicting the presidential couple arriving at Love Field opens the magazine's coverage of the assassination. The rest of the pictures in the report are in black and white, as if the very colors of human life, not to mention happiness, had bled out of them. Blurry enlargements from the 8-millimeter Zapruder film, they look like smudges on the page.

In contrast, the Love Field arrival shot, taken by the veteran *Life* photographer Arthur Rickerby, seems larger than life—vividly colored, crisply focused, it fills the page (Fig. 37). The Kennedys look tall and vibrant. They come so close to the photographic picture plane that they seem within our reach, giants among us. *Life*'s editors clearly intended Rickerby's photo as a resplendent, magical, wonderful *before* to the drab, dismal, and violent *after* in what turned out to be the best-selling issue of the magazine in its fifty-some-year history.

It is impossible to look at this image with a historically innocent eye. It comes to us today, as it did to viewers in 1963, replete with the poignancy of the conditional. The principals in the photograph, frozen in history, are forever poised on the precipice,

FIGURE 37 | Love Field, Dallas, November 22, 1963 (Arthur Rickerby, photographer)

about to suffer—he to die, she to scream—and Lyndon Johnson, that minor bumbling character who can be seen bending over behind Jackie, about to become the most powerful man in the world.

The photograph has the formal density of a carefully constructed painting. It is filled with intriguing visual symmetries and repetitions. Consider, for example, how the notched lapel of the first lady's suit echoes that of her husband's, but more loosely and expansively, or how the stripes of his shirt connect to the broad blue stripe on the jet and the stripes of the flag, as well as to the piping on her suit and the subtle striped pattern in its warp and weft. Note, too, how the geometric pattern of his necktie, with its neat rows of rounded rectangles, harmonizes with the bouclé fabric of her wool jacket as well as with the row of porthole windows on the jet and the three zeroes of the plane's call number lined up beneath the flag. The president's pocket handkerchief, the vice president's white carnation, and the first lady's white glove form an inverted triangle, compactly framing her. Particularly delicate is the way husband and wife fleetingly touch arms, his hand going one way, hers the other. Regardless of its original journalistic purpose and subsequent historical significance, the Rickerby photograph stands on its own as a richly complex visual artifact.

The accompanying text from *Life* commences, "Now in the sunny freshness of a Texas morning, with roses in her arms and luminous smile on her lips, Jacqueline Kennedy still had one hour to share the buoyant surge of life with the man at her side." Here is that sense of the conditional I mentioned that is the staple of legends about heroes, saints, and martyrs. *Life*'s designers laid out the opening two pages of the report so that Jack, on the far left, seems almost to look past Jackie to the facing page, on which an uncaptioned black-and-white photo shows a bouquet of white roses abandoned on the back seat of the vice president's car. The direction of his gaze, as in Renaissance paintings, establishes a before-and-after narrative: triumphal entry of the hero on one side and on the other, as if he alone foresees it, a melancholy emblem of his imminent martyrdom.

Mrs. Kennedy carries a bouquet of red roses. Apparently all the local florists were sold out of yellow roses because of the many Democratic festivities planned. (The yellow rose is popularly associated with Texas, though the state flower is the bluebonnet.) Red was the next-best color available for welcoming the first lady. Lady Bird Johnson, the vice president's wife, and Nellie Connally, the governor's wife, according to William Manchester, received white roses. *Life* shows one of those bouquets left behind in the vice president's car; the other (whose roses look yellow, not white, despite Manchester's account) can be seen in the Zapruder film flying out of Mrs. Connally's arms when the president's head shatters.

Red roses have a long-standing tradition, which I take up in Chapter 5. Since the Middle Ages they have signified the spilling of holy blood, the martyrdom of a saint.

Although it was pure happenstance that Mrs. Kennedy received red roses instead of yellow, and though no one at Love Field, including the photographer, had any idea what was to take place a mere eight miles away, in retrospect—the only way in which anyone has *ever* viewed this photo—it prophesies death to come. It is a modern-day equivalent to a late Gothic or early Renaissance painting such as Stefan Lochner's *Madonna in the Rose Garden* (1450) or Martin Schongauer's *Madonna and Child in a Rose Arbor* (1473), both of which count on the viewer to invest the lovely red flowers on display with a sense of the mortal tragedy to unfold. Although the roses in the photograph in no way predicted the assassination, they have given that photo a sense of ineluctable tragedy, conferring on John Kennedy, whose political ratings were slipping, a beatific aura he did not possess at the time of his death.

Indeed, under normal circumstances an alternative cultural signification would have emerged from the photo. From ancient Rome to the Tournament of Roses parade in Pasadena each New Year's Day, roses have also been a sign of victory, pride, and triumph. That meaning is still visible in the Love Field photograph but inevitably tinged with a sad or bitter irony.

ROSES ARE NOT THE ONLY richly meaningful signifiers in the Love Field photo. The pages that follow examine three others: the first lady's garment, the president's body, and the airplane in the background.

Jackie's Chanel suit has become a legendary piece of clothing in American history, for even after it was soaked in her husband's blood she refused to change out of it for the long flight with his body back to Washington. When Lady Bird delicately suggested she might feel more comfortable in a fresh outfit, the newly made widow fiercely refused, explaining, "I want them to see what they have done to Jack." The suit features prominently in the photograph, to be examined in Chapter 7, in which she stands beside Lyndon Johnson aboard Air Force One as he takes the oath of office. In that picture the photographer cropped out the bloodstains, but they conspicuously appear in the press photos of her departing from the presidential plane at Andrews Air Force Base later that day (see Fig. 73). Viewers were startled.

Startled, because it was presidential blood and because first ladies had seemed until now to exist in a world magically sealed off from the messy stains of daily life and suffering—but also because in 1963 the item of apparel known as the Chanel suit was just about as solid a symbol of bourgeois female chic as could be found anywhere in the Western world. By wearing a Chanel suit, a woman gave notice that she was smart, classy, and independent. No one would have expected to see such a garment bloodied like a butcher's apron.

Even before the martyred president's blood was spilled on the suit, making it a holy relic (one kept locked in storage at the National Archives), Jackie's Chanel suit came with a great deal of twentieth-century history attached to it. The brand name Chanel belonged to one of the most impressive and influential women of that century, Gabrielle "Coco" Chanel.

Born in France in 1883 and reared as a poor orphan in a convent, Chanel had become Paris's leading fashion designer by the end of World War I. Like her friends Igor Stravinsky, Pablo Picasso, Jean Cocteau, and Sergey Diaghilev (the Russian ballet impresario whom Jackie, in her youth, had idolized), she was a modernist. And she, more than any other individual, liberated women from the tight restrictions of belle epoque fashions and offered them the comfortable alternative of modern styles.

Her designs offered women the relaxed freedom of movement previously reserved for men. Eliminating stays, bustles, and corsets and substituting silk, cotton, or wool jersey for satin, Chanel introduced loose-fitting sweaters, blazers, pleated skirts, trench coats, and the trademark "little black dress." By the 1930s she was the world's most famous clothing designer.

Arrested as a collaborationist at the conclusion of World War II and set free thanks to the intervention of her friend Winston Churchill, she departed for Switzerland and retirement, living off the revenue of her patented perfume, Chanel No. 5. In 1954, however, at the age of seventy-one, she threw herself back into the fashion business in vexation at the regression of women's fashions, as she saw it, toward a socially conservative and physically restrictive style. In particular, she took aim at Christian Dior's "New Look," which the couturier introduced in the early postwar era in an avowed attempt to make women feel feminine and glamorous again after the prolonged period of drab functionality that had characterized the war years. "Dresses must have a soul," said Dior. "In an age of machines, dressmaking has come to be the final refuge of all that is human, all that is personal, and all that can never be imitated."

Chanel accused Dior of treating women like armchairs to be upholstered: "He puts covers on them," she sneered. Her goal was to dress women as real-world beings who reasonably wished to combine elegance and functionality, practicality and chic, old-fashioned femininity and up-to-date independence. By the early 1960s the Chanel suit had become a wardrobe staple of the upwardly mobile American female. A Chanel suit fit almost every daytime occasion that required a woman to dress stylishly.

It was thus the perfect outfit to choose for riding in a presidential motorcade.

OR WAS IT? From the beginning of her husband's campaign for the White House, Jacqueline Kennedy's preference for clothing of French design provoked controversy.

Why weren't American-made clothes good enough for her, the critics demanded? Stung by such charges, Jack insisted that Jackie henceforth wear American-designed and American-made garments for her public appearances. One of the first steps she took after Jack's election was to engage the services of Oleg Cassini, an American-born fashion designer whose grandfather, a Russian count, had been an ambassador to Washington at the turn of the century.

Cassini had designed costumes for Hollywood, was once engaged to Grace Kelly, and was an old crony of Joe Kennedy's. He also had European mannerisms and taste, so for Jackie he was ideal, perfectly understanding and appreciating her taste for French couturier fashion but also meeting Jack's requirement that she wear American-made designs.

The national origins of Jackie's fashion wardrobe were not the only point of controversy during the 1960 campaign. Critics accused her of squandering indecent amounts of money on her clothes. In July of that year *Women's Wear Daily* reported her clothing expenses, which amounted to $15,000 a year (equivalent to $100,000 today)—potentially ruinous news for Jack, not because he couldn't easily foot such bills but because he could. His Roman Catholicism was one thing, and, as we've seen, he handled it well, but the vast wealth of the Kennedy family, and Jackie's sumptuous wardrobe, were another matter.

No one expected Jack to hide his wealth, but it wouldn't do to rub it in the voters' faces, either. That's when Joe Kennedy stepped in and told Jackie that from now on he, not Jack, would cover the bills. This arrangement would spare the new president further embarrassment about his wife's extravagance while enabling her to look as ravishing at state events as a fairy-tale princess gone to the ball. Joe understood that in the era of television, the taxpayers didn't want a dull-looking first lady in the White House. They wanted a living doll. But they wanted someone else to pay for her costumes, not their elected president and, by implication, themselves.

This was not the first outcry in recent years resulting from the cost of clothing a politician's wife. The most notorious example had occurred about a decade earlier, on September 23, 1952, to be exact. That was the evening that Senator Richard Nixon, who was then the vice presidential nominee for the Republican Party, appeared on national TV, immediately after an episode of *I Love Lucy*, to fight for his political life.

Newspaper stories had revealed that the senator was the beneficiary of a "slush fund" established for his "financial comfort" by a "millionaire's club" of California businessmen. Nixon's opponents demanded his resignation from the Senate and called on General Eisenhower to drop him as his running mate. Instead of rushing to Nixon's defense, Eisenhower left him dangling. In desperation, Nixon agreed to go on coast-to-coast radio and television, live, to answer the charges against him.

At the start of his allotted time, Nixon explained that the money set aside in the

fund wasn't for his own personal benefit but for the war that he was waging against Communist infiltration. He then devoted the remainder of his thirty minutes to an account of himself as an ordinary man from an ordinary background, blessed with an ordinary American family, shared with his wife, Pat. He wore ordinary suits, drove an ordinary car, and amassed ordinary debts.

Nixon did confess that he had accepted a gift from a supporter, a black-and-white cocker spaniel that his daughters named Checkers. "And you know the kids, like all kids, love the dog, and I just want to say this right now that regardless of what they say about it, we're going to keep it." He finished his apologia by proclaiming, "Pat and I have the satisfaction that every dime that we've got is honestly ours. I should say this—that Pat doesn't have a mink coat, but she does have a respectable Republican cloth coat, and I always tell her that she'd look good in anything."

The Checkers speech, as it came to be known, was a smashing success for Nixon. General Eisenhower put his arm around him and said, "You're my boy"; Checkers became the most famous pet in America, and the phrase "respectable Republican cloth coat" entered the language.

That is what Jack Kennedy was up against when he opposed Nixon for the presidency eight years later. On the campaign trail Jackie wore a bright red cloth coat designed by the French couturier Hubert de Givenchy that was passed off by the Kennedy press people as an inexpensive Ohrbach's copy, a claim *Women's Wear Daily* tartly disputed.

NOW IN DALLAS SHE WORE a bright pink Chanel suit. Whether it was an authentic Chanel (it was) or an American copy, costly or inexpensive, it was rife with class connotations and international implications unlikely to be missed in Dallas, a citadel of right-wing isolationism and populist anti-elitism. In 1960 Jackie would not have dared to dress in an article of clothing so conspicuously French or French inspired, but now, in 1963, she could get away with it, even in Dallas, because in general the American public was proud of her stylish elegance.

The turning point had come during Jackie's triumphal visit to Paris and Vienna in 1961. The crowds in those cities clearly adored her, and such rebarbative figures as the French president, Charles de Gaulle, and the Soviet premier, Nikita Khrushchev, whom she met in Vienna, were visibly enchanted by her. It was during this European tour that President Kennedy sardonically introduced himself as "the man who accompanied Jacqueline Kennedy to Paris." The American public basked in the reflected glory of its first lady (Fig. 38).

After that, Jackie had much more leeway to flaunt her French taste. "Until Paris," Oleg Cassini has noted, "Jackie was nothing but a little housewife. But then, she single-

FIGURE 38 | Elysée Palace, Paris, June 1961

handedly began to create Camelot. The furniture, the ideas, the cooks, food, the fantastic people she invited to the White House—Casals, Bernstein, Frost. And she did it all herself. While Jack was busy with the presidency, Jackie was creating Versailles."

So when Jackie sat at her dressing table in the presidential hotel suite in Fort Worth the morning of her short flight to Dallas, her decision was not whether to wear her

Chanel suit but which of two pairs of white gloves to wear with it. She also kept checking the weather and hoped that the rain would continue so that the bubbletop would be necessary and her coiffure thus protected from the wind. It all sounds silly now, but that's how the past always looks when viewed through the windowpane of tragedy.

JACK MAY HAVE GRUMBLED about the inordinate amount of time and money his wife spent on her clothes and appearance. But he himself was always visibly pleased by the results, and, like his father before him, he came to realize what an asset her beauty was to his political and diplomatic career. The grumbling may even have been for show, to make him seem like a regular guy, an ordinary American husband (well, not as ordinary as Nixon) like the long-suffering comic strip husband Dagwood Bumstead, from *Blondie,* or TV's humorously impatient husband Ricky Ricardo, from *I Love Lucy.* When Jack spoke from the back of a flatbed truck at an early morning rally of union workers outside the hotel in Fort Worth, he answered shouts of "Where's Jackie?" by pointing to her eighth-floor window. "Mrs. Kennedy is organizing herself," he explained. "It takes her a little longer, but, of course, she looks better than we do when she does it."

Later that morning, when she finally made her entrance at a breakfast for two thousand cheering Texans, Jack remarked, "Two years ago I introduced myself in Paris by saying that I was the man who had accompanied Mrs. Kennedy to Paris. I am getting somewhat the same sensation as I travel around Texas. Nobody wonders what Lyndon and I wear." The comment elicited a wave of laughter from the crowd. One cynical journalist turned to a Kennedy advisor and asked, "When are you going to have her come out of a cake?"

Jack Kennedy bought into the same assumptions as his audiences in Fort Worth, and throughout America, about the immutable differences between men and women. *The Feminine Mystique* was a best-seller in 1963, but so was Ian Fleming's *Spy Who Loved Me,* whose female narrator (scripted, to be sure, by a man) observed:

> All women love semi-rape. They love to be taken. It was [Bond's] sweet brutality against my bruised body that had made his act of love so piercingly wonderful. That and the coinciding of nerves completely relaxed after the removal of tension and danger, the warmth of gratitude, and a woman's natural feelings for her hero. . . . [A]ll my life I would be grateful to him, for everything. And I would remember him forever as my image of a man.

Tom Jones, the movie, also featured "semi-rape" but treated it comically rather than heroically—as did the Broadway hit *Camelot,* in the "Fie on Goodness!" number. A

lusty chorus of knights, oppressed by the high morality of the king's regime, longs for the good old days and rues the present, when "virgins may wander unmolested." Not everyone in 1963, however, considered "semi-rape" and male sexual prerogative either sexy or funny.

In Sylvia Plath's *Bell Jar*, published in London early that year, the month before the author's suicide, the narrator, Esther, tells of nearly being raped by her date to a country club dance, a tall, dark, and handsome Latin American. She describes him as "a woman-hater" and explains, "I began to see why woman-haters could make such fools of women. Woman-haters were like gods: invulnerable and chock-full of power. They descended, and then they disappeared. You could never catch one." But *The Bell Jar* was not a best-seller, and the early reviews were not favorable. The author was called "neurotic" and her views deemed aberrant, far from the mainstream.

The stereotypical notions of innate sexual difference that were advanced in the media—in popular fiction, movies, television, comic strips, advice columns, marriage manuals, and so forth—also emanated from the political realm. Jackie's beautification of herself and Jack's "good-natured" jokes about it were important symbolic features of the political landscape—as central to it finally as the president's economic, diplomatic, and legislative initiatives. Jack's attempt to "take" Cuba in 1961 and his patient refusal to "back down" or "wimp out" against the Soviets during the missile crisis in 1962 implicitly demonstrated the behavior that, as most Americans learned from popular culture, was manly in the bedroom.

THE PRESIDENT AND HIS WIFE used to joke about the young females who mobbed his campaign appearances. They called them "jumpers" because, on what turned out to be the eve of the Beatles' invasion of America (launched some three months after Dallas), they were always hopping up and down with excitement to catch a glimpse of their idol as he passed by. In more ways than one JFK cashed in on that delirium. He not only exploited it for his own off-the-record sexual advantage but also used it to hot-wire his political life. It gave him the appearance of being adored by the crowds, and in American presidential politics that translates into clout with voters, legislators, corporate executives, union leaders, foreign heads of state, and everyone else with whom the president breaks bread.

A photograph of Jack at Santa Monica in August 1962, emerging from the surf with soaking wet trunks, underscores his sexual charisma (Fig. 39). At the time this picture was taken, Jackie and Caroline were on holiday in Italy. Jack was spending a long weekend at the beach house of his sister Pat Lawford. Three weeks earlier, in a nearby bungalow, his spurned mistress Marilyn Monroe had died from an overdose of sleeping pills.

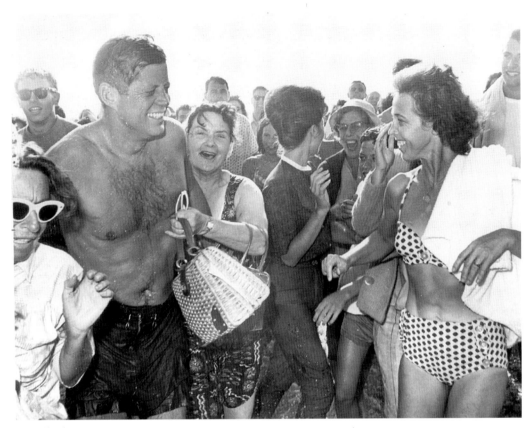

FIGURE 39 | Santa Monica, August, 1962 (Bill Beebe, photographer)

In this picture, Kennedy does a Marilyn. This is his subway-grate photo, in which, like Monroe, he exudes primal sexuality and feeds off the onlookers' rambunctious response to it. The presidential body is muscular and all but hairless, save for a square patch in the center of his chest. His shoulders, broad and powerful, are those of an avid swimmer, which he was. He smiles happily, his eyes scrunched tight, like a child too long cooped up in the classroom and now at last free to romp. Women mob him. A few men appear in the crowd, but they remain in the background, looking on amused or admiring (or perhaps with Secret Service attentiveness).

This is a female moment, the picture seems to say. Jack stands at the far left of the image, as in the Love Field photo, but a female admirer squeezes into the narrow space between him and the picture's edge. She appears to be an older woman, considerably older than Jack. Because of the cropping, we catch only a glimpse of her. Dark glasses framed in flaring white plastic hide her eyes.

Nonetheless, she looks ecstatic, her glee at finding herself beside the president

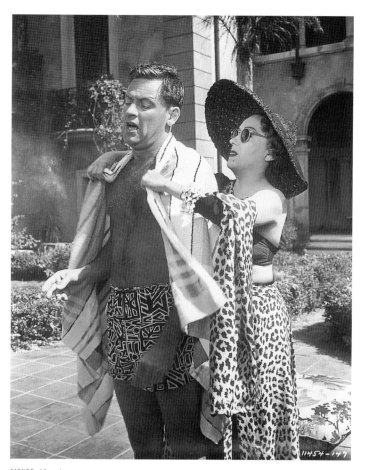

FIGURE 40 | *Sunset Boulevard,* 1950

conveyed to us by her foreshortened arm and half-clenched fingers. She's Norma Desmond and he Joe Gillis, from *Sunset Boulevard,* the Hollywood exposé movie of a decade earlier that starred Joe Kennedy's former mistress, Gloria Swanson, as the older woman ready to seize in her clutches the young hunk of meat played by William Holden (Fig. 40).

In one sense, the photo seems brimming with joyous innocence, a snapshot of happy days when a politician could go out in public and literally "press the flesh" without fear of either assassination or sexual allegation. Yet it's also a macabre image. The older woman with a handbag seems almost to clutch his chest. The aligning of Jack's squinting gaze with that of the trim, well-toned woman in a polka-dot two-piece swimsuit would seem sexually meaningful in another context, but here we recognize her as his sister-in-law Ethel Kennedy.

The photo captures the crazy-carnival atmosphere of Federico Fellini's internationally acclaimed satire *La Dolce Vita* (1960), which outrageously draws comparisons between movie-star worship and religious hysteria. It's one of the few "art" films Jack is known to have liked. The Santa Monica shot, with its pack of predatory fans swarming after a handsome young man, also invokes the notorious climactic sequence of *Suddenly Last Summer*, Gore Vidal's screen adaptation of a Tennessee Williams one-act play that was being filmed in Florida when Kennedy and Williams met. In the movie's denouement, shown in flashback through the eyes of an emotionally devastated Elizabeth Taylor, whose aunt wants her lobotomized, cannibalistic Sicilian urchins swarm after Taylor's traveling companion, a homosexual predator who has been exploiting them, mob him, tear him to pieces, and devour him.

Suddenly Last Summer actually figures in an anecdote about Jack told by his friend Ben Bradlee. On the night of the West Virginia primary in 1960, Jack and Jackie nervously waited out the results in Manhattan with their good friends Ben and Tony Bradlee. (Ben, who worked for *Newsweek* at the time, later became the *Washington Post* editor who se reporters initiated the unraveling of the Watergate affair.) The two couples decided to relieve the pressure by taking in a movie. The picture that the Bradlees and Kennedys attempted to see was *Suddenly Last Summer*, but they didn't make it.

As Bradlee explains: "It was a film with a surprise ending, whose publicity included a warning that no one would be admitted after the show had started. And no one included the next president of the United States. No manner of identification could change the usher's instructions." That was that, so they crossed the street to another theater, one that specialized in porn:

> This wasn't the hard-core porn of the seventies, just a nasty little thing called *Private Property*, starring one Katie Manx as a horny housewife who kept getting raped and seduced by hoodlums. We wondered aloud if the movie was on the Catholic index of forbidden films (it was), and whether or not there were any votes in it either way for Kennedy in allegedly anti-Catholic West Virginia if it were known that he was in attendance. Kennedy's concentration was absolute zero, as he left every twenty minutes to call Bobby in West Virginia. Each time he returned, he'd whisper "Nothing definite yet," slouch back into his seat and flick his teeth with the fingernail of the middle finger on his right hand, until he left to call again.

I've not been able to find a copy of *Private Property* anywhere (Fig. 4.1). It seems to be a lost and forgotten film, but the little I've turned up in Internet research suggests it offered a protofeminist and anticapitalist critique of bourgeois marriage. Don't laugh. Its writer-director, Leslie Stevens, the son of a naval vice admiral who invented the gear deployed to halt incoming planes on aircraft carriers, started his writing career as a prodigy who contributed material to Orson Welles's left-wing Mercury

FIGURE 41 | *Private Property*, 1960

Theatre. After the war Stevens attended the prestigious Yale School of Drama. In the mid-1950s, Joanne Woodward starred in one of his off-Broadway plays that transferred to Broadway, and he wrote teleplays that appeared on such well-regarded live network series as *Playhouse 90* and *Kraft Theater.*

Stevens's claim to cult status today is due solely to the pathbreaking TV science fiction series *The Outer Limits* that, as an executive producer and sometimes writer-director, he unveiled in 1963. Like its rival series, *The Twilight Zone, The Outer Limits* brought to weekly prime-time television an often thought-provoking critique of mainstream norms and values, albeit in the form of quirky, edgy, or trashy tales of shock and horror. ("There is nothing wrong with your television. Do not attempt to adjust the picture.") Thus *Private Property* may have had more substance to it than Ben Bradlee deigned to notice. The title seems a deliberate amalgamation of Noël Coward's *Private Lives* and Friedrich Engels's *Origins of the Family, Private Property, and the State.*

Even if no one in the Kennedy party was paying attention to *Private Property* that night, its "nasty" saga of the sexual exchange of women, together with the super-charged homophobic sexual psychosis of the gothic film playing across the street, *Sud-*

denly Last Summer, indicates that the Kennedys, Catholicism, the West Virginia primary, Jack's emergence from the Santa Monica surf, the erotic feeding frenzy surrounding him on that occasion, and *Life*'s droll appreciation of his well-toned middle-aged physique (the caption notes that "he still has only a modest displacement" in the water): all of these loosely linked elements reveal the pervasiveness of culture (movies, sex, and magazines) in mid-twentieth-century politics and of politics in mid-twentieth-century culture.

CASTING OUR EYES BACK NOW to Love Field, 1963, we see none of the hysteria, the confusion, the animal sensuality, the implicit violence of Santa Monica, 1962. Decorum prevails. The only woman pressed close to Jack is his wife, and she's young, beautiful, radiant, and perfectly dressed. And he's all buttoned up in his natty lightweight wool suit with its neat little pocket kerchief, chalk-striped shirt, and geometrically patterned blue silk tie.

In seventeenth-century Dutch memento mori paintings, a human skull can sometimes be found on or near a banquet table that overflows with material abundance. It is there to remind the viewer that death lurks close at hand for everyone, no matter how successful or rich. The Love Field photo, in conjunction with the Santa Monica picture, has a similar memento mori effect. Beneath these fine clothes strode that fine body; within the hour both would be awash in his blood.

Jack's face, you will notice, is full, even jowly. In his youth, Jack Kennedy had been almost painfully thin. At the time he graduated from Harvard, he was six-foot-one but weighed only 145 pounds. Biographers have suggested that when he first ran for public office as a congressman from Massachusetts, his gangly, underweight form made female voters want to take care of him and feed him a good home-cooked meal.

By the time he arrived at Love Field seventeen years later, he had fattened up. Age had done it—he was now well into his forties. But so had the cortisone he was taking to control his Addison's disease, a life-threatening glandular affliction. A side effect of the steroid replacement treatment was facial puffiness. Surely he also gained weight thanks to the round of state dinners that had become a fixture of his administration.

Jack was unhappy about putting on extra weight. "Few things interest him more than a discussion of his own weight," Ben Bradlee noted in his diary after an intimate dinner party at the White House during which the president indulged in two helpings of a rich dessert and bemoaned the extra pounds he was carrying of late. On another occasion JFK recoiled from a snapshot of himself in a bathing suit. "It shows the Fitzgerald breasts," he explained to his friends, adding, "Better get rid of that." In 1962, along with millions of other middle-aged American men, Jack began using a new product on the food market known as Metrecal. Produced by the Mead Johnson

Company, Metrecal was the first liquid dietary meal substitute to be sold nationally, and it was an instant best-seller on supermarket shelves. A can of Metrecal supposedly supplied all the daily vitamins and nutrients a person needed, with few of the calories that normally came along with them.

Metrecal appeared at about the same time that low-calorie soft drinks were introduced onto the market: Diet Rite Cola in 1962 and Tab in 1963. The first meeting of Weight Watchers, organized by a dieting housewife in Queens, took place in May 1963. Meanwhile the President's Council on Physical Fitness gave official encouragement to the exercise craze that was taking hold throughout the land. Toning up the muscles and eliminating excess pounds was now a matter not simply of narcissism but of patriotic duty, for a nation of fit citizens was a nation fit to combat foreign enemies. The Santa Monica photo shows the president leading the way, and the trend continued right up to the doorstep of Dallas.

Life describes him: "Vibrant with confidence, crinkle-eyed with an all-embracing smile, John F. Kennedy swept his wife with him into the exuberance of the throng at Dallas' Love Field." The photo, in emphasizing Kennedy's "vibrant" physical appearance, enhanced by the way his sun-burnished hair stands out against the deep blue sky, gave visual form to the word he had made a keynote of his presidency, "vigor."

The presidential historian Theodore White recounts that when he interviewed the president's widow for *Life* a week after the assassination and she relived her traumatic memories of it, she recalled, almost as in a reverie, "His head was so beautiful . . . his mouth was so *beautiful.*" As we look again at the Love Field photograph, we can see how Jackie, in her serene proximity to the handsome, charismatic, vigorous presidential body, must have served as a fantasy stand-in, a surrogate, for millions of other American women, like those two middle-aged sea nymphs in Santa Monica who clung adoringly to the dripping wet surfside Adonis whose Metrecal- and exercise-regimented forty-five-year-old body sizzled with male pinup beauty.

RED, WHITE, AND BLUE predominate in the Love Field photo. The colors of the American flag that the presidential jet bears on its tail are also those of the French flag. France as a nation and, even more, as a cultural concept manifests itself in this photograph, and not merely in the cut of the first lady's clothes.

As I have noted, Jacqueline Kennedy, to many Americans, signified cultural sophistication—more specifically, *French* sophistication. Her preference for the French pronunciation of her first name ("Zhack-leen") and her birth name, Bouvier, were themselves continual reminders of Frenchness. So too were the many gala Washington dinners over which she presided, their menus prepared by the White House master chef, the Frenchman René Vedon. The night the world's most celebrated cellist,

Pablo Casals, performed in the East Room, dinner consisted of *mousse de sole, filet de boeuf, galantine de faisan au porto,* and *sorbet au champagne.*

That same year, 1961, a former State Department employee turned housewife, Julia Child, published her first cookbook, *Mastering the Art of French Cooking.* It quickly became a national best-seller. In 1963 Child introduced her now legendary TV cooking show, *The French Chef.* For a certain middle-class segment of the population, preparing and eating French food and drinking French wine became a means of achieving liberal sophistication—what the French sociologist Pierre Bourdieu, in another context, calls distinction, the means by which a social group attempts to link itself to higher-status social entities and distinguish itself from groups of lower status.

At the time, America was well on its way to becoming a "fast-food nation." McDonald's started up in 1954; Burger King in 1957; Domino's, Hardee's, Kentucky Fried Chicken, and Pizza Hut all in 1960. TV dinners, frozen foods, and Jell-O were ubiquitous at mealtime in suburbia. Despite, or perhaps because of, this burgeoning of convenience foods geared to a hypermobile, hyperactive middle-class society, Jackie Kennedy epitomized an aristocratic "slow-food" ideal to which many Americans, at least in their dreams, aspired.

IN A MANNER OF SPEAKING, the presidential jet that stretches, white, blue, and silver, behind the heads of the first couple was French in origin. That's because it bore the markings of one of the world's leading industrial designers, Raymond Loewy.

Born in Paris in 1893 and trained as an industrial engineer, Loewy served in the French army in World War I before immigrating to the United States in 1919. He arrived in New York expecting to find an advanced industrial civilization and was rudely disappointed. "I was amazed at the chasm between the excellent quality of much American production and its gross appearance, clumsiness, bulk, and noise," he later recalled. "Could this be the leading nation in the world, the America of my dreams? I could not imagine how such brilliant manufacturers, scientists, and businessmen could put up with it for so long."

Loewy set out to remedy the situation, and, in so doing, he became one of the inventors of a new profession called industrial design. The idea was to take the bare bones of industrial products and give them an attractive, user-friendly flesh; to create, that is, a desirable (and desire-inducing) exterior for commercially manufactured products. One of his early successes, for example, was the 1934 Coldspot refrigerator that he designed for the Sears, Roebuck Company. Refrigerators until then were perfectly functional but unsightly machines, boxy and awkward. Loewy transformed them into white, gleaming, hygienic-looking totems of curvilinear modernity—a design concept that remained basically untouched for the remainder of the twentieth century. (Not inci-

dentally, the modern style of American appliances helped Vice President Nixon to "win" his Moscow kitchen debates with Premier Khrushchev in the summer of 1959 by underscoring Nixon's claims for American advancement.)

Loewy and his staff went on to design the exterior look of General Electric toasters, Remington electric shavers, Coca-Cola fountain dispensers, Greyhound buses, Studebaker automobiles, the Lucky Strike package, the Shredded Wheat cereal box, the Shell gas station sign, and the universally recognized corporate logos for Exxon, TWA, United Airlines, Canada Dry, Nabisco, and innumerable other brand-name consumer products. Loewy developed streamlined styling for locomotives, automobiles, and luxury liners. In his later years he designed the living quarters for the astronauts aboard NASA's Skylab.

To be sure, Raymond Loewy wasn't the only American industrial design giant of the twentieth century. Others include Norman Bel Geddes, Henry Dreyfuss, Harley Earl, Charles and Ray Eames, Paul Rand, and Walter Teague. But Loewy was the most famous of the lot. In 1949 *Time* ran a cover story on him, and his witty 1951 autobiography, *Never Leave Well Enough Alone*, swiftly became an international best-seller.

Given his world renown and his unabashedly lavish and hedonistic lifestyle, Loewy would seem to have been an obvious choice for Jack Kennedy when he decided to redesign the look of Air Force One. Moreover, Loewy's French origin and his claim to have received much of his inspiration from such creative geniuses as Picasso, Diaghalev, and Chanel would have made him attractive to Jackie as well. (When she was twenty-one, she had written, "The three men I should most like to have known were Charles Baudelaire, Oscar Wilde, and Diaghiliff." She added, "If I could be a sort of Overall Art Director of the Twentieth Century, watching everything from a chair hanging in space, it is their theories of art that I would apply to my period.")

"*Air Force One* was Kennedy's baby," Loewy recalled years later:

> He and I discussed what it should look like, and he asked me to come back soon with some sketches. A week later I showed him four different versions, large color drawings about thirty inches wide, of the exterior markings. In every case I had replaced red [the color then in use on the presidential aircraft] by a luminous ultramarine blue. There were also various versions of simple classic typography. Kennedy became increasingly interested and suggested slight modifications. For our appointment, I brought along sheets of colored paper, scissors, razor blades, and rubber cement. Since his desk in the Oval Office was relatively small, we just sat on the floor cutting out colored paper shapes and working out various ideas.

According to Loewy, "JFK enjoyed his plunge into industrial design so much that he told his secretary, Mrs. Lincoln, that we were not to be disturbed while we were

'working.'" After the Air Force One redesign was completed, the president suggested that they develop other projects together. "My view was that industrial design principles could be applied nationally; the physical appearance of the country could be aesthetically upgraded, but only with government leadership. The task represented an enormous project, aborted by JFK's assassination."

What this may suggest is that Kennedy saw the nation's aesthetic style not as something frivolous and inconsequential but as integral to its cold war initiative. He had good reason to do so. Early in 1960, when the Republicans still controlled the White House, Stuart Symington, a high-ranking Democrat (and incidentally a friend and patron of Loewy's), declared in the Senate that the United States had fallen behind the Soviet Union in nuclear armaments, resulting in a potentially dangerous "missile gap." When Kennedy's presidential campaign took up that theme, urging greater military preparedness and a determination to close the gap, Republicans insisted that no such gap had emerged during the Eisenhower-Nixon tenure in the White House. No one, however, denied the existence of another, truly stupendous, gap between the Americans and the Soviets—in consumer goods. In this cold war campaign the Americans triumphed easily, with Raymond Loewy, as it were, one of the five-star generals.

In 1990, four years after Loewy's death (at age ninety-three) and six months after the fall of the Berlin Wall that had been erected during Kennedy's watch, the International Design Center in Berlin mounted a large retrospective exhibition of Loewy's work as an industrial designer. (Interest in Loewy had been evident decades earlier: the first German edition of *Never Leave Well Enough Alone* in 1953 had sold out in four weeks!) The organizer of the exhibition explained that the many American industrial products with which Loewy was so intimately associated—"from the toothbrush to the locomotive, from the lipstick to the ocean liner"—had an almost magical appeal in Europe after World War II.

> We had hunger, but [Americans] had superfluidity, our cities had been bombed to rubble, theirs were flourishing metropoles. Then the Marshall Plan not only helped the reconstruction of the West German economy, it also brought a hitherto unknown flood of American goods to Europe, and for a short time it really looked as if the so envied American way of life could become a European reality as well. . . . Up to the mid-sixties American product culture influenced the whole of Western Europe, and the lifestyle of the masses followed its model.

SIX YEARS AFTER KENNEDY'S DEATH, his friend and aide Theodore Sorensen countered those who belittled the former president as the epitome of style over substance, someone who ruled by smoke and mirrors, a man who was all flash, a handsome face

with a winning smile, a clever line, and a beautiful wife but no moral depth. "There is a tendency now to separate the style from the substance—to regard the 'Camelot' flavor of elegance and sophistication as a world of glittering parties, pageantry, and press repartee wholly apart from the grim world of international crises and the daily grind of political campaigning." They were not in fact separate, Sorensen maintained. But by 1969 few readers were likely to believe him.

How many times have we been told that Jack won the election in 1960 only because he looked better and had a smoother presence on TV than Nixon did and because his father bought up needed votes in places like Chicago? We are constantly reminded that, despite all the idealistic talk and noble rhetoric, he sent Green Berets to Vietnam and propped up antidemocratic regimes simply because they opposed the Communists. That he or his minions plotted Castro's assassination, allowed anti-Castro "freedom fighters" to be hung out to dry at the Bay of Pigs, and played a form of Russian roulette with the Soviets during the Cuban missile crisis. That he provided little real support to the emerging civil rights struggle and associated himself with black leaders such as Martin Luther King, Jr., only when circumstances made it politically impossible not to do so. That he preyed upon any woman, available or otherwise, who struck his fancy, including one thought to be a Soviet spy and another who was a mobster's girlfriend, and that no place on earth, including his wife's bedroom in the White House, was off-limits for his adulterous escapades.

Neither condemning Kennedy nor rushing to his defense interests me here. I want to point out, however, that the debate about style versus substance, which has preoccupied JFK observers since the scandals of the late sixties (Chappaquiddick) and the early seventies (Watergate) made high-level political demystification a national obsession, was already part of the national *aesthetic* discourse. Here, too, Raymond Loewy is apposite. Style over substance was the very complaint Loewy's critics brought against him. They accused him, along with his fellow industrial designers, not to mention legions of Madison Avenue advertisers, of littering the visual landscape with tawdry deceptions, the moral equivalent of lies.

From the lofty heights of design modernism, inspired by the Bauhaus School dictate that form follow function and its latter-day manifestation in the architecture of the International School of Mies van der Rohe, Le Corbusier, and Eero Saarinen, Loewy's product design seemed reprehensibly commercial. In the eye of purists, the man was not really a designer but a stylist.

Loewy claimed that his work was truly modern and not marred by an overemphasis on style. Thus he objected when a friendly interviewer used the term "sheathing" to describe the machine exteriors he was so famous for creating, because Loewy thought the word suggested casing that is in some sense superfluous to the machine within, a mere adornment, rather than an integral expression of it. He insisted, that is, that the

outer styling of his toasters and trains, his locomotives and lipsticks, was always a truthful visual expression of their inner content.

He also attributed some of the disparagement of his work to jealousy. "I'm sure my life style was an easy target for other designers," he said. "It probably made some of them resentful and critical, because luxurious living didn't seem to interfere with the firm's increased reputation and large output. But a good life has been as important to me as my work; *in fact, the two of them are bound up in each other for me*, and I hope that my work in industrial design, that industrial design itself, has made life better for others as it has for me" (emphasis added). The point is that for Loewy, and I think the same may be said of John F. Kennedy (and Jackie as well), style, including lifestyle, far from being extraneous, manifested inner content. That notion would have been familiar to Jackie from the writings of one of her cultural heroes, the British aesthete Oscar Wilde.

To this way of thinking, Kennedy's wit and charm, his handsome face and sexy body, his aura of wealth and hedonism, his devil-may-care insouciance—all these were in fact the true substance, the true meaning, of his presidency rather than phony packaging. Let's go back to the material and symbolic object that kicked off this discussion, Air Force One in the Love Field photograph. Kennedy seems to have understood that it was as much a vehicle for ideas as for people and that the bundle of ideas it conveyed were those of American newness, elegance, speed, comfort, and global reach.

Cynics might say, and I would concede, that Kennedy was advertising himself by way of Air Force One. But Air Force One was also advertising America to Americans (and to the rest of the cold war world), providing a symbolic self-image. It amounted to a looking glass that showed them their own dazzling and glamorous future. That's what it's doing there in that photograph, the American flag proudly affixed to its tail. Chapter 7 describes its return to Washington three hours later with that tail between its legs, but even then Air Force One continued to function as Kennedy had foreseen, as a flying symbol of modern America.

IN THE EARLY 1960S the greatest intellectual proponent of the notion that style is substance, or at least inseparable from it, was the controversial Canadian media philosopher Marshall McLuhan. I suspect that Kennedy never read a word of McLuhan in his life, yet he was the McLuhanesque president par excellence. *Understanding Media*, McLuhan's then baffling but now prophetic-seeming tome of 1964, introduced into discourse our present usage of the term "media" and such now commonplace concepts as "global village" and "information age."

It was McLuhan who advanced the notion that Kennedy had triumphed over Nixon in the televised debates because his relative casualness and nonchalance were so much

easier for viewers to watch—that is, to invite into their living rooms—than his rival's overinsistent, almost hectoring, style of debate. But what really made Kennedy a McLuhanite was his instinctive grasp and thoroughgoing demonstration of McLuhan's overarching precept, "The medium is the message." (An analogue can be found in the contemporaneous principle governing the New Criticism in literary circles, that a poem's form is its content and not a mere container—"sheathing"—for some other and more important interior meaning. New critics were fond of citing the paradox posed by Yeats, "How can we know the dancer from the dance?")

McLuhan subtitled his book *The Extensions of Man*, arguing that every medium of communication—handwriting, print, radio, television, and movies—is a tool or device to extend us out into the world beyond our own bodies. Air Force One was a means of transportation but also of communication, its Loewy-and-Kennedy-designed exterior bearing its "message" of sleek and beautiful American modernity to the public as it carried the passengers inside to Dallas.

It also functioned as both a symbol and an actual producer of the global village that McLuhan subsequently described. It took Kennedy to Berlin. Nine years after Kennedy's death, it transported President Nixon to Beijing.

JET TRAVEL WAS A NEW, thrilling experience for most Americans in the early 1960s. Today's travelers take the jet airplane for granted or, worse, put up with it while fearing or loathing it: the noise and pollution, the crowded seating, the lost baggage, the annoying delays, the vulnerability to terrorism, the catastrophic disasters that could happen to any of us or our loved ones next time around. But in 1963 jet travel seemed at once chic (the term "jet set" was popularized in 1960 by Oleg Cassini's gossip columnist brother, Igor) and futuristic (as spoofed in the animated TV show *The Jetsons*, which premiered in prime time in 1962).

Even then, however, jet travel could seem alarming, as in two memorable episodes of the hit TV series *The Twilight Zone*. In "The Odyssey of Flight 33," broadcast on February 24, 1961, a jet airliner en route from London to New York encounters a freak tailwind that causes it to accelerate to an unprecedented speed. The crew lose radio contact with Idlewild (later renamed Kennedy) Airport, and when they look out the window at the isle of Manhattan, they see dinosaurs instead of skyscrapers. Flight 33, having broken the sound barrier and the time barrier, has inadvertently flown into the Earth's prehistoric past. It never manages to return to the present.

"Nightmare at 20,000 Feet," broadcast on October 11, 1963, tells of a salesman flying home from the sanitarium where he was treated for a nervous breakdown. Looking out his window, he spots a furry, man-sized creature that lands on the wing and stares in at him. He realizes that the gremlin means to sabotage one of the engines. When

the salesman's repeated attempts to alert the crew meet with no success, he pulls out a pistol and shoots the gremlin, who sweeps off the wing into the night. The plane lands safely and the salesman is carried off in a straitjacket, grinning with satisfaction because he has saved the lives of everyone on board.

For most Americans airplane travel itself was exotic. More than 80 percent had never flown, and those who had were unlikely to have flown by jet. America's first coast-to-coast air service was introduced in 1929. With numerous stops along the way, the trip took forty-eight hours to complete. By 1934 propeller-driven aircraft could ferry passengers from New York to Los Angeles in a mere thirteen hours, with three or four stops. Only a quarter of a century later, in 1959, did regularly scheduled jet passenger service begin between those two cities, reducing the time involved by nine hours and eliminating all stops in between. The age of jet travel had arrived.

The public's romance with the passenger jet was still in full bloom when Air Force One touched down at Love Field. That is why it made perfect sense for Kennedy to *fly* rather than drive the thirty miles from Fort Worth to Dallas. He was staging a grand theatrical entrance that was about much more than his own godlike prowess (though it was certainly that too). It was about the prowess and modernity of America and its ability to soar powerfully and gracefully into the future.

The presidential plane also beckoned respectfully toward the past, because America had been settled by pioneer families who crossed the continent in their own horse- or mule- or ox-drawn wagons. That, in any event, has been the long-standing myth and rugged-individualist ideal that Kennedy's arrival on Air Force One—his personal intercontinental jet—amply reinforced. At the very least, it promoted the American travel business, which had been moribund and was suddenly growing apace into one of the nation's most profitable capital industries.

Even the name of the jet, or lack thereof, contributed to its aura. Earlier presidents had given their planes homey monikers: "Sacred Cow" (FDR), "The Independence" (Truman), "Columbine" (Eisenhower), but Kennedy never named this one, so by default it was called Air Force One, the radio control tower name the air force used to designate *any* aircraft that carried the president. The press loved the sound of it, and so did the public, because it symbolized the burgeoning military technology (and terminology) the nation embraced and the Space Age (and space race) on which it was eagerly embarking.

In 1959 the popular historian of rocketry and aeronautics Martin Caidin published a book-length paean to civilian jet travel, *Boeing 707*. He recounted the extraordinary thrill awaiting every passenger: "Up, up . . . soaring into the deepening blue, scorning the cloud mountains, gaining mastery of them all." Empyrean realms, hitherto the exclusive playground of the gods and, only more recently, of fighter and test pilots, were now accessible to anyone with the price of a ticket. Caidin pitied those who would elect

not to experience this wonder for themselves as "people who have never lived . . . trapped in a two-dimensional world, blind to the beauty which soars about their heads."

COMPARE CAIDIN'S PANEGYRIC with a sour commentary published by one of his contemporaries:

> Recently I boarded a plane at Idlewild Airport in New York at 6:30 one evening. The next morning at 11:30 I was in Amsterdam. The flight was routine, at an altitude of about 23,000 feet, far above the clouds, too high to observe landmark or seamark. Nothing to see but the weather; since we had no weather, nothing to see at all. I had flown not through space but time. My only personal sign that we had gone so far was the discovery on arrival in Amsterdam that I had lost six hours. My only problem en route was to pass the time. My passage through space was unnoticeable and effortless. The airplane robbed me of the landscape.

That is Daniel Boorstin writing in *The Image*, his full-scale attack on modern American culture, mordantly subtitled *A Guide to Pseudo-Events in America*. Published in 1961 and often reprinted since, Boorstin's book is worlds apart from Caidin's. But Boorstin is after much bigger game. His book needs to be seen as the era's most sustained criticism of the value system that Raymond Loewy and John F. Kennedy vigorously represented and Marshall McLuhan conceptualized. That is, to use a term derived from McLuhan's phrase "the global village," Loewy and Kennedy both devoutly believed in and championed globalization, whereas for Boorstin the "shrinking" of the globe signaled the modern individual's loss of self and authenticity.

The Image insists that Americans—or, more generally, inhabitants of the modern era—finding it increasingly difficult to know who they are, also find themselves unable to distinguish readily between truth and falsehood, reality and hype, history and legend, travel and tourism, heroism and fame. *The Image* introduced the concept of "the pseudo-event," a commercial celebration or political happening (a supermarket opening, a campaign rally) planned so that it seems to occur spontaneously, as though generated by the will of the public itself. The book defined the celebrity as a pseudo-hero, "a person who is known for his well-knownness." A hero, according to Boorstin, is distinguished by brave or important achievements, whereas the celebrity's greatest accomplishment is simply to have become the focus of media attention.

Hence the saga of Charles Lindbergh, the first man to fly across the Atlantic solo, who thereby became the most recognized individual in the world: "Lindbergh's singularly impressive heroic deed was soon far overshadowed by his even more impressive publicity. If being well-known makes a person a celebrity, here was the greatest.

Of course it was remarkable to fly the ocean by oneself, but far more remarkable thus to dominate the news. His stature as hero was nothing compared with his stature as celebrity."

Boorstin distrusted style and anything that smacked of it. Style itself was "pseudo." *The Image* doesn't single out Loewy by name, but it is generally scorching in its attitude toward product design and packaging as well as advertising and celebrity endorsements. As for Kennedy, the political stylist par excellence, Boorstin tars him along with Nixon in a passage ridiculing the 1960 presidential debates:

> These four campaign programs, pompously and self-righteously advertised by the broadcasting networks, were remarkably successful in reducing great national issues to trivial dimensions. . . . Public interest centered around the pseudo-event itself: the lighting, make-up, ground rules, whether notes should be allowed, etc. Far more interest was shown in the performance than in what was said. . . . Of course, a man's ability, while standing under klieg lights, without notes, to answer in two and a half minutes a question kept secret until that moment, had only the most dubious relevance—if any at all—to his real qualifications to make deliberate Presidential decisions on long-standing public questions after being instructed by a corps of advisers. . . . This greatest opportunity in American history to educate the voters by debating the large issues of the campaign failed.

The Image abhors image making and image selling, at least insofar as they falsify everyday reality and distract an all-too-easily distractible public. Jack Kennedy—assisted by his father and wife and some brilliant photographers and a willing public—was the great modern master of the art (or pseudo-art) of making and selling an image.

RECALL MARTIN CAIDIN'S HYMN to the glories of jet travel: "Up, up . . . soaring into the deepening blue, scorning the cloud mountains, gaining mastery of them all." Isn't that what Kennedy's own personal Boeing 707—and, by extension, the Kennedy presidency itself—were all about: offering the earthbound folk of America an exciting and inspiring, if perhaps only fantasy-based, excursion into the stratosphere, scorning the cloud mountains and gaining mastery of them all?

To be in love with John F. Kennedy in 1963—whether as his wife, one of his mistresses, an American voter, or even, let's say, a citizen of postwar, cold war Berlin—must have been a way of accompanying him, imaginatively and emotionally, into that sky and feeling the supercharged oxygen of life hurtling through one's veins.

Here, in *Life*'s full-page color photo, on a resplendent autumn day in Dallas, the sleek light-blue Boeing jet that measures the distance between the president and first

lady but also unites them in its expansive reach bespeaks the dreams and promises of that now long-vanished moment in modern history. The vivid hues of the red roses, the pink suit, the blue necktie, the blue sky, the white gloves, the blue-and-white striped shirt, and the white and blue stripes along the fuselage all come together in a single compact geometric unit affixed high on the tail of the jet, the U.S. flag, as if to stamp this glorious day with an affirmation of patriotic pride in America.

As a patriotic icon, the Love Field photo might be called *American Modern* in contrast with the famous Grant Wood painting of three decades earlier, *American Gothic* (Fig. 42). Wood's painting portrays an Iowa farmwoman and her husband or father (in truth the artist's sister and his dentist), rigidly posed in front of a neatly kept farmhouse marked by a pair of Gothic Revival upper-story windows. By the late 1950s it symbolized, with tongue-in-cheek irony or otherwise, depending on the viewer, quintessential plain, upstanding, hardworking American folk. As the art historian Wanda Corn has amply demonstrated, "a virtual torrent of takeoffs of *American Gothic*" began to appear in the 1960s, often with famous heads, including those of presidential couples, grafted onto the bodies of the two farm folk. In this instance, however, the upright presidential couple does not parody Wood's neo-Victorians but rather replaces them as archetypes of national identity.

The Kennedys are no farmers. Jack glows with a movie star's mien and is clad in Brooks Brothers, not overalls. Jackie, dressed in Chanel, looks like a million bucks, with her luxuriant hair and radiant smile. The key object in the foreground of the picture is not an old-fashioned pitchfork but an armload of roses, which, despite their earlier-noted iconographic suggestion of martyrdom to come, in this context bring to mind a victorious beauty pageant queen or a diva cradling flowers at her curtain call. The Victorian Gothic farmhouse window in the background of Wood's painting reappears as a row of jet portholes.

Wood's couple warily guards America's past, but this one strides confidently into its future. The Love Field photo thus provides a snapshot of Kennedy era modernity and an emblem of that era's aspirations.

If in Caidin's terms those who had yet to fly in a jet were "people who have never lived . . . trapped in a two-dimensional world, blind to the beauty which soars about their heads," JFK had not only lived but had offered others, symbolically and poetically, the opportunity to live free and soaring, released from the iron cage of the two-dimensional world of cold war dichotomies, style-versus-substance antinomies, or merely the dull prose of daily life.

AIR FORCE ONE WASN'T SIMPLY an airplane, it was a Boeing 707 that had coursed like Apollo's chariot through the blue sky over Dallas, and Kennedy wasn't simply a

FIGURE 42 | Grant Wood, *American Gothic*, 1930, Art Institute of Chicago

celebrity but, to those transfixed by him, a genuine hero, part 007, part Lawrence of Arabia, part Tom Jones.

We shouldn't forget that in 1963 those figures were primarily inventions of the mass media and thus, in Boorstin's terms, pseudo-heroes. Nonetheless, they galvanized the imagination of millions of spectators worldwide, and to minimize the social and political importance of that mythmaking would falsify modern history. As the editor of the *Shinbone Times* says at the end of John Ford's 1962 western elegy *The Man Who Shot Liberty Valence*, "When the legend becomes the fact, print the legend." I take his words to mean not that we must accept the legend as truth but that we must seek the truth in the legend, especially as it was understood at the time.

The movie *Tom Jones* comes to a rousing and rollicking end in rhymed couplets urbanely measured out by a deep-voiced narrator:

Happy the man, and happy he alone,
He who can call today his own,
He who, secure within, can say,
Tomorrow do thy worst, for I have lived today.

Those lines might well have served as a motto for Jack Kennedy. Except that there was no need to wait for tomorrow to do its worst.

That was coming within the hour.

<div style="text-align: center; font-size: 2em;">**5**</div>

Hit the Road, Jack

JACK KENNEDY LOVED TO DRIVE. He loved cars for their raw power and speed. In his youth, he was notorious among his friends and dates for being wild behind the wheel. One friend recalled: "Jack drove pretty fast. We drove a lot around the Cape. You couldn't get arrested too many times without having trouble with your license. One night, we were riding along. I remember a cop was coming up behind us—another ticket would have cost Jack his license. While the car was still moving, we changed places, which is a very tough operation to do. . . . I don't know how we did it, but we got away with it and, of course, I got the ticket!" When Jack, in his early twenties, was touring the Riviera with another friend, he took a turn too fast and rolled the car into a ditch. Jack's manner of driving epitomizes what one of his biographers aptly terms his "reckless youth."

In that regard, Jack was a man of his times. Although by the 1950s he wasn't often able to climb behind the wheel because of his back ailment, he shared a speedster's sensibility with the hot-rodders and joyriders of the younger generation. One suspects that he would have gotten along perfectly well with James Dean, who raced to his death in 1955 on a country road in a Porsche Spyder pushed to its maximum speed. And even though Jack would at first seem to have had nothing in common with Jack Kerouac besides the first name, in a way he resembled the Beat characters in *On the Road*.

Kerouac described the heroes of his 1957 picaresque novel as "mad to live, mad to talk, mad to be saved, desirous of everything at the same time, the ones who never yawn or say a commonplace thing, but burn, burn, burn like fabulous yellow roman

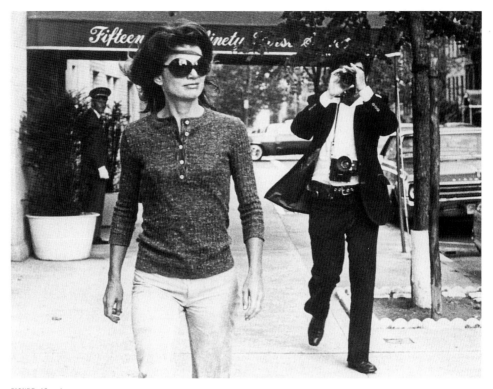

FIGURE 43 | Madison Avenue, October 7, 1971 (Joy Smith, photographer)

candles exploding like spiders across the stars and in the middle you see the blue cen-
terlight pop and everybody goes 'Awww!'" Less poetically, the newspaper columnist
Joseph Alsop recalled of his friend Kennedy: "He was snobbish about courage, and he
was snobbish about experience. He didn't want us to be ordinary and routine. . . . He
wanted experience to be intense. I don't know how to put it quite. To my way of think-
ing he really wasn't like an American. He wasn't a foreigner, either, but the normal,
successful American view of life was not really his view at all."

On the Road recounts the many, often frantic cross-country road trips taken by the
first-person narrator, Sal Paradise, and his beautiful, godlike, almost superhumanly
energetic friend Dean Moriarty. Dean is an all-night man: he can talk all night, drive
all night, screw all night. An unabashed hedonist, with a wife, a mistress, and several
girlfriends scattered from coast to coast, he adores women as much as they adore him.
Men find his company inspiring, exhilarating, irresistible. Dean can be cruelly un-
sentimental about both his female sexual partners and his male traveling companions,
a paragon of selfishness, yet still they are drawn to him, captivated by his golden ra-
diance. In all these qualities Jack Kennedy was a real-life Dean Moriarty.

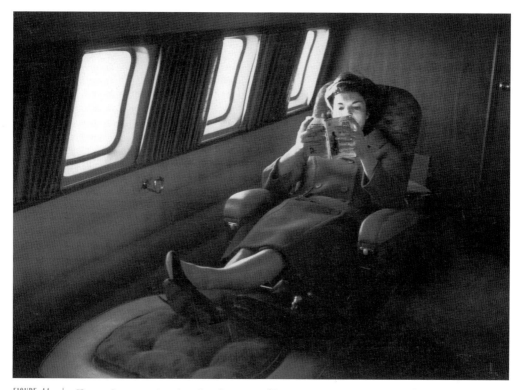

FIGURE 44 | Kennedy campaign jet, October 1959 (Jacques Lowe, photographer)

Still, no one could have seemed less Beat in the 1950s than Jack and Jackie. El-
egance, taste, and class were too much of what they were about for them to have
made sense in a Beat (shorthand, according to Kerouac, for downbeat or beaten-down,
but also upbeat or beatific) universe. Decades later, the president's widow, in her
Jackie O and Studio 54 phase, would be known for wearing dark glasses and sexy
skintight jeans (Fig. 43), but in the late 1950s Jackie in jeans was virtually unimag-
inable.

There's a wonderful shot of her in the fall of 1959 reading *On the Road* on the ten-
seat aircraft the Kennedy family purchased for Jack's presidential campaign (Fig. 44).
Her prim leather handbag on the floor beside her, Jackie reclines all the way back, her
legs stretched out for comfort. Daylight streams in from a pair of passenger windows
and illuminates her face. She holds the paperback aloft in her hands and appears to
be deeply immersed in the story. She wears a coat designed by the Parisian couturier
Hubert de Givenchy. How out of place Kerouac seems here, in this setting, with these
trappings, these clothes.

Yet who can say what the book might have meant to Jackie at that point in her life,

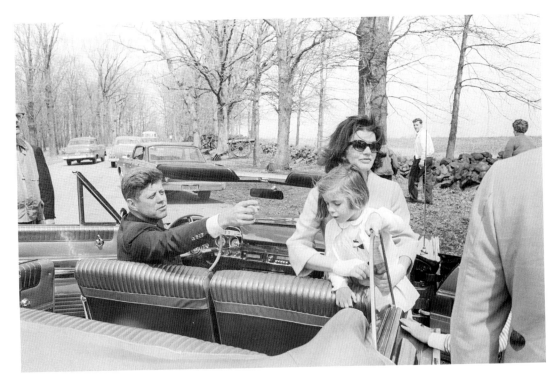

FIGURE 45 | Gettysburg, March 31, 1963

when she and her husband were continually on the road? Or what insight it might have given her into her husband's incandescence, and his blithe unfaithfulness?

I'VE LOOKED THROUGH HUNDREDS, maybe thousands, of photos of Jack, but I recall only one, from the spring of 1963, that shows him seated behind the wheel of a car (Fig. 45). Impeccably dressed, he occupies the heavily upholstered front seat of a convertible sedan parked by the side of the road. Jackie, looking glamorous, like an Italian film star, stands at the passenger-side door with dark glasses, windswept hair, and white gloves. Caroline, about six, makes her way into the car with a certain amount of distracted help from her mother.

The setting is a public park, not any old park but the National Battlefield at Gettysburg in the centennial year of the cataclysmic Civil War battle. A period artillery piece, with a pyramid of cannonballs stacked beside it, guards the low stone wall that stretches across the fringe of space above the car's sun visors. A man in a lightweight jacket strolls along the wall, a cigarette cupped in his hand. His son, only partially vis-

ible above Jackie's shoulder, walks beside him but at a slight distance that suggests a ritual balancing of dependence and independence.

Jack, swiveled toward his wife and child, points his finger off-camera at someone— or something—we can't see. Let us imagine (for this is what the photo asks of us) that here is a young father sightseeing with his family, calling his wife's attention to a monument or historical marker at the side of the road. If we judge only from the photo itself, the setting need not be Gettysburg but could be any one of a number of public sites in the eastern United States. Have they come from church? Are they on their way to Sunday lunch? This man may be commander in chief of the armed forces, but he's also commander of the family car, like any other all-American dad in the spring of 1963. The public admired him in this pater familias role, as the political scientist David Sears informally observed some twenty-five years later:

> He's the only president I can remember who had children while he was president, had babies while he was president—certainly one of the most emotionally evocative events in one's life—and the American people shared all of that. . . . [H]e was able to bring the public into the orbit of a tight family life and all the emotions that go along with a family relationship. Of course, his own sexual behavior wasn't public at that time, so that the image that was given was that of quite a strong family, and I don't think other presidents have been able to capitalize on that.

Certainly there are other, more sentimental photos than this of Jack as presidential dad; the final chapter will look at some of them. But this one is unique in that it almost succeeds in making him an ordinary guy out for a Sunday drive with the wife and kid.

But even if this particular mother and father weren't world-famous, the mom is still too glamorous and the dad too sartorially perfect for them to be believable as ordinary Americans. ("What do the simple folk *do?*" a baffled Arthur and Guenevere muse in *Camelot*.) There's Kennedy pointing again: he did it at the inauguration, he did it at the inaugural ball (in the photograph examined in Chapter 3), and he did it in numerous speeches, so much that it became his trademark gesture, as much a part of the JFK persona as his squinting eyes and toothy smile (Fig. 46). No, he's no more a typical American dad out for a drive than Jackie, with her well-thumbed paperback edition of *On the Road*, was a Beat chick. Still, the car, the road, the other cars on the road (including a VW bus, the quintessential hippie vehicle of the later sixties that was first imported to America in 1963), the push-button AM radio, the suburban white nuclear family: the photograph is a bright, shining icon of auto America and, in effect, an advertisement for it.

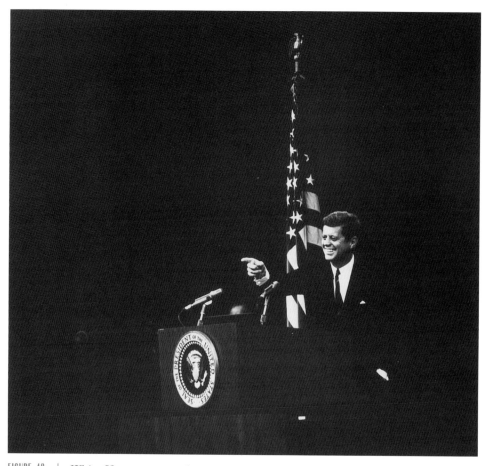

FIGURE 46 | White House press conference

A MAN'S NUMBER ONE JOB, according to deeply entrenched American beliefs, is to protect his family. Everything else he might accomplish in life comes second to that. Interesting, then, that JFK's outstretched hand seems almost to wave into existence that old-fashioned cannon and pyramid of cannonballs, time-hallowed insignias in America of "the defense of liberty," so that the photo links national defense with defense of the family unit. Kennedy may appear almost comically out of place here—what is *he* doing driving a car at the peak of his presidency, and why so overdressed if he's simply out touring? Yet the photo nevertheless draws into an ideologically unified package three elements crucial to the JFK administration's "New Frontier" as well as to the frontier of old: the father-driven family, a strong national defense, and a road full of cars (including a VW bus, a modern-day equivalent of the pioneer's wagon).

In 1956, at the close of Eisenhower's first term, Congress passed the landmark National Defense Highway Act, which authorized the construction of a nationwide interstate highway system, with some forty thousand miles of new high-speed, limited-access roadways. Legislators justified the enormous cost of the undertaking by portraying it as a strategic necessity: in times of national emergency, the armed forces might need such roads to transport troops and matériel expeditiously from one region of the country to another. But no one was foolish enough to believe that military reasons alone prompted the passage of the act. As Douglas Miller and Marion Nowak comment in their history of America in the 1950s:

> The automobile industry had the world's most powerful lobby. Not only were they the biggest fish in a corporate sea of big fish, but they also spawned hundreds of other profit-making businesses. The steel, rubber, petroleum, and construction industries all grew rich and dependent on cars. Add to this motels, garages, automobile dealers, drive-ins, car-hops, and tourism generally, and one begins to see the power of the auto lobby. In 1958 receipts for some 56,000 motels and cabins reached $850 million. That same year 85,000 automobile dealers employed over 700,000 persons; 206,755 service stations gave 465,500 persons jobs and did over $14 billion worth of business; highway construction and maintenance costs that year alone came to $5.3 billion.

The cement industry was another beneficiary of the legislation. A summer 1963 advertisement for the Portland Cement Association, like the photo of the Kennedys at Gettysburg, links family unity, masculine strength, automotive freedom, and national glory. It shows a drawing of a family of four (plus dog) in a gleaming convertible sedan zipping along an interstate highway through a magnificent forested landscape. Dad at the wheel looks ahead at the road while Mom, a benign smile on her face, glances back at the children and shares their joy at the comfort of their travel, as well as its speed, which is indicated visually by parallel lines emerging like rocket exhaust from the tail of the car. The caption reads, "The strongest pavement assures the smoothest ride. CONCRETE brings continuing pleasure and safety to your travel." The text that follows explains: "Your new Interstate highways are a modern engineering wonder. So are the concrete pavements. Their remarkable riding smoothness gives you new comfort, a feel of sure control of your car that means safer driving. And concrete keeps this riding smoothness over the years. The reason is simple: *strength*. It's the strongest pavement there is."

The ad's concluding flourish—"Because there is no substitute for *strength*, there is no substitute for concrete"—translated standard cold war rhetoric to the domestic front. Nothing can substitute for strength, but any reader of the time might easily, if unconsciously, have substituted other terms for "concrete"—"B-52 bombers," for example, or "Intercontinental Ballistic Missiles," or a standing peacetime army.

The forceful figure who shepherded the interstate highway act through Congress was President Eisenhower's crusty and quotable secretary of defense, Charles E. Wilson. Wilson has achieved lasting notoriety for stating in his testimony before a Senate committee, "What's good for General Motors is good for the country." He was misquoted, and his statement to the committee was more temperate: "What was good for our country was good for General Motors, and vice versa." But the press preferred the condensed present-tense statement, which was widely taken to represent what he truly believed, for Wilson had been CEO of General Motors before becoming defense secretary.

Wilson's successor at Defense under Kennedy and Johnson, Robert S. McNamara, was the major architect of the U.S. involvement in Vietnam. As it happens, McNamara also came to Washington via Detroit, where he ran the Ford Motor Company.

AND THUS WE FINALLY ARRIVE at the Ford Motor Company's Lincoln Continental limousine in which Jack and Jackie ride through the streets of Dallas. This car is surely the most famous and controversial automobile in modern history. Long retired from government service, it now occupies a parking place of honor in the Henry Ford Museum in Dearborn, Michigan. Web sites are devoted to it. Conspiracy theorists scrutinize period photographs of it, looking for telltale signs of bullet marks that would prove the existence of a cover-up by the Warren Commission, the Secret Service, the FBI, or some other government agency. It even appears in a lame-brained but persistent urban legend listing the "amazing" coincidences linking America's two most scrutinized presidential assassinations: Lincoln was killed while seated in the Ford Theater, Kennedy while seated in a Ford Lincoln.

Painted dark blue at the time of the assassination, the SS-X-100, as it was officially designated, was sent back to the factory on orders from President Johnson for extensive modifications, including armor plating and a repainting from blue to black. With the original vehicle thus existing only in modified, rebuilt form, accusations of tampering with evidence have naturally arisen. The JFK limo, big as a barge, lumbering down Main Street USA with Jack seated in its commodious rear as if in a Roman bath and Jackie, later, scrambling onto the trunk, has become an unforgettable icon of sixties America.

And it was indeed JFK's limo. He had taken a personal interest in its design. Ike had driven about in a bulbous black 1950 Lincoln Cosmopolitan, but, as with Air Force One, Jack discerned the need for a presidential automobile that would embody the fresh new style and civic ideals of his administration. Lincoln Continentals first appeared in 1961. Before that Lincolns and Continentals were distinct, though similar, models, high off the ground and heavily sculpted. The new model line emphasized a smaller, sleeker design with slab sides. Gone were the outrageous tail fins and baroque

chromium grilles that characterized fifties auto design but all of a sudden seemed vulgar and retrograde. The Lincoln Continental's styling was of a piece with the lean, clean lines of Bauhaus modernism found in Skidmore, Owings and Merrill "glass box" business towers, Knoll furniture, Eichler houses, and the Cassini dresses and suits Jackie wore.

Delivered to the White House garage on June 15, 1961, after months of production and modification, the X-100 influenced the look of car design in the early sixties. (Among its immediate offspring were the 1963 Pontiac Grand Prix, the 1963 Buick Riviera, and the 1964 Chrysler Imperial.) It weighed four tons and stretched twenty-one and a half feet in length, but because of its smooth design it seemed stylishly elegant. Powered by a giant 430-cubic-inch V-8 engine that purred rather than rumbled and roared, the president's Lincoln traveled down parade routes with an aura of flawless grace.

Its greatest moment of triumph came during Kennedy's state visit to West Germany in June 1963. The president flew over on Air Force One, his car on an air force transport plane. In Cologne, Frankfurt, and Bonn, the Lincoln Continental glided through streets full of cheering crowds. In West Berlin it carried Kennedy, Chancellor Konrad Adenauer, and the city's popular mayor Willy Brandt along a thirty-one-mile parade route lined with chanting admirers waving American and West German flags. At one point along the way, two starstruck women broke through the lines to give Kennedy a personal welcome, to the amusement of the three leaders. So much confetti rained down that the president's military aide, a major general, had to stand on the front seat of the Lincoln and rake it off the windshield so the driver could see.

After stops at the Brandenburg Gate and Checkpoint Charlie, where the president left the car to inspect the Berlin Wall, erected virtually overnight two years earlier, the X-100 brought him to the city hall, where an immense crowd had gathered. There he delivered one of the most stirring speeches of his career, declaring, "All free men, wherever they may live, are citizens of Berlin, and therefore, as a free man, I take pride in the words '*Ich bin ein Berliner*'"—I am a citizen of Berlin. The crowd roared with approval. This was one of the defining moments of his presidency and of postwar geopolitics, symbolizing the complete cessation of enmity between the World War II adversaries Germany and the United States and the rising strength of international capitalism in the ongoing conflict with Soviet Communism.

NOW, FIVE MONTHS LATER, Jack sat in the back of the X-100. That his wife sat beside him was in itself a source of satisfaction, for he knew how intensely she disliked participating in such public rituals as presidential motorcades and political campaigns (Fig. 47). She had graciously agreed to accompany him on this trip to Texas, her first major outing since the death of their prematurely born son, Patrick, in August. It

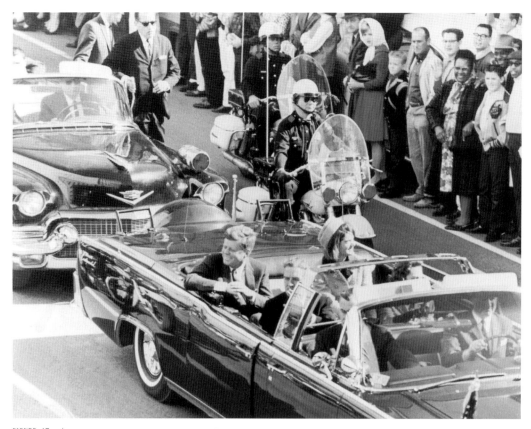

FIGURE 47 | Dallas, November 22, 1963 (Walt Cisco, photographer)

seems he appreciated Jackie's still-fragile emotional health, but also recognized that her presence constituted an enormous political asset. She fascinated the public, which was more sympathetic than ever because of the family tragedy suffered only three months earlier.

With her bouquet of red roses, Jackie looked more like a homecoming queen or a beauty pageant winner than the first lady of the land. All across America that autumn, as so many autumns before, students had voted to elect popular young women to represent their high schools and colleges at the special football match of the season called homecoming. Homecoming weekend for much of the twentieth century was a hallowed tradition of American middle-class life—it's still a tradition, though now less hallowed. The yearly ceremonial combined age-old agrarian harvest celebrations with modern sentimentality about the home (the return of alumni to alma mater), democratic process (an election), and a displaced reverence for—or, at times, mockery of—monarchical rule (the queen).

Food, drink, sports, dancing, and dating (with or without sex) were also part of homecoming. One of the essential events of the weekend was the homecoming parade, during which the queen and her "court of maids" (runners-up) rode down Main Street on a decorated float, cradling bouquets of flowers and waving to the crowds who turned out to see them.

The most venerable of all such parades in America is not actually a homecoming event but is nonetheless associated with a once-a-year football match. It is the Tournament of Roses, held annually in Pasadena, California, on the first morning of the year, before the Rose Bowl game. The tournament was created in 1890 by members of the Valley Hunt Club in Pasadena to promote California sunshine and agricultural productivity. (Football became a regular feature of the event only in 1916; the bowl was constructed in the 1920s.) "In New York, people are buried in snow," announced one of the tournament's founders. "Here our flowers are blooming and our oranges are about to bear. Let's hold a festival to tell the world about our paradise." The first Rose Queen was elected in 1905. She was admired as an embodiment of the Southern California fertility and fecundity that the parade had been invented to advertise.

By 1963, the Rose Bowl Game and the Rose Parade had been nationally televised for years and broadcast to a large number of foreign countries with American contingents. Thus many observers would have understood the iconography of an attractive young woman clutching roses and waving to a friendly crowd from a slow-moving open-air motorized vehicle. Jackie's ride through the streets of Dallas in the X-100 was a variation on that tradition.

Not that anyone watching the motorcade would have mistaken her for a homecoming or Rose Parade queen, even if her pink pillbox hat did resemble a crown. Still, the smiles of the onlookers lining the sidewalk suggest that they were in effect trained extras, lifelong watchers of the ritual genre of public processions—homecoming parades and the nationally televised Rose Parades. Our daily and public lives break down into genres, or narrative categories, similar to those of film, literature, and art. In this sense homecoming parades are a genre, and we come to them with a prescribed set of physical and emotional responses.

Whereas the American public was fully versed in what to feel and how to respond during parades and motorcades, few would have had more than a passing familiarity with the panoply of meanings accumulated over the centuries by a visual and literary symbol as complex as the rose. Nonetheless, rose symbolism has so deeply permeated cultures both East and West that such meanings are inescapable. A glance at any dictionary of symbols and images shows that roses are symbolically important in Hebrew, Hindu, Islamic, and ancient Roman traditions. In ancient Greece, they were said to have originated in the tears shed by the goddess Aphrodite when she pressed her face to the head of her dying lover, Adonis, a beautiful young mortal who fell victim to a

wild boar he had been cautioned not to hunt. In Christianity, white roses stand for purity and chastity, and red roses, since the Middle Ages, have signified the shedding of holy blood, the martyrdom of a saint.

Roses have also traditionally been connected with the female generative principle, youth, spring, love, and romance. Shakespeare's Sonnet 54 observes that roses smell even sweeter when they are about to die—"Of their sweet deaths are sweetest odours made." Thus Jackie clutched in her arms not merely roses but a wealth of symbolic meanings. Had her husband not been assassinated moments later, those meanings would have remained largely unnoticed, but precisely because of the assassination, they are now uncannily appropriate.

One witness of the assassination, recently interviewed on syndicated radio, noted the red roses specifically in recalling the moment of the killing. He was six at the time; it was his mother's birthday, and his father had taken the day off from work:

> As [the presidential party] started coming down the hill, they slowed a little bit. And you could hear a loud pop, which to me at the time sounded like firecrackers. . . . And there was another pop of firecrackers. And this one—there was a great deal of what I thought at the time was confetti, just exploding from the car. I subsequently learnt, much later, that this was obviously President Kennedy being shot, and the confetti was actually his head—the front of his skull and the brains, in retrospect, going up into the air. . . . [The president's wife] was dressed in a very bright pink dress, and she had a lot of red roses in her lap, too; which was also confusing, because it was a mixture of the President and the blood and all the mess and then her pink dress and the flowers . . .

The six-year-old child didn't need to know the long-standing association of red roses with beauty, femininity, pain, death, and martyrdom to experience viscerally the bundling of those various connections in a thorny bouquet of their own.

154

"THE SUBLIME and the ridiculous are often so nearly related that it is difficult to class them separately," wrote Thomas Paine in *The Age of Reason*. "One step above the sublime makes the ridiculous, and one step above the ridiculous makes the sublime again." I mention Paine's words to bring up another cultural coordinate for the JFK motorcade, one that, especially in light of the horror and mayhem about to occur, does indeed seem ridiculous. The pictures of the Kennedys and Connallys riding through Dallas in the X-100 bear a strange but striking resemblance to the title sequence of the weekly TV series that was then watched by more Americans than any other, *The Beverly Hillbillies*.

FIGURE 48 | *The Beverly Hillbillies*

At the beginning of every episode of this show, audiences were greeted by the twanging banjos of Flatt and Scruggs playing a rollicking bluegrass ballad that started thus:

> Come 'n' listen to my story 'bout a man named Jed
> Poor mountaineer barely kept his family fed
> An' then one day, he was shootin' at some food,
> An up thru the ground came a bubblin' crude.

In the accompanying montage Jed Clampett, the poor backwoods patriarch, stumbles onto a fortune in oil in his worthless bramble patch and gathers his family for a move to California. The iconic image from the program shows the Clampetts in country garb, driving with all their possessions in a 1920s flatbed jalopy, down a palm-lined avenue in swank Beverly Hills. ("Loaded up the truck, and they moved to Beverly. / Hills that is! Swimmin' pools, Movie stars!") (Fig. 48). The image provided a sight gag on

FIGURE 49 | *The Grapes of Wrath,* 1940

The Grapes of Wrath—John Steinbeck's book but, even more, John Ford's movie, in which the Dust Bowl Joad family piles into a similar jalopy to make their epic, and much less fortuitous, journey west (Fig. 49).

Those are Kennedys, not Clampetts, riding high into Dallas, and no one would mistake one family for the other. But weren't the Kennedys, in a way (admittedly, only one way), like the Clampetts? Both were originally poor American families that struck it rich. Nouveau riche, that is. Swimmin' pools, Movie stars! Parvenu Joe, like his counterpart Jed, even settled down for a time in Southern California. If the Clampetts, to use present-day Hollywood lingo for one tried-and-true comedic formula, were "fish out of water" in Beverly Hills, so too were the Kennedys in Dallas.

That minor resemblance may seem to offer little reason to bring up *The Beverly Hillbillies* at a time like this, when the bullets are about to fly. But I want to persist in the reference, because in 1963 the only programming on television with a larger audience was the coverage of the assassination and funeral. *The Beverly Hillbillies* was so popular that year, and in the years to come (the series ended after the 1971 season but has run in syndication ever since), that the audience for certain episodes when those were first shown exceeded that of several Super Bowl games. Why was

the series so inordinately popular, and what made it relevant to the social concerns of the sixties?

The Beverly Hillbillies was a new kind of situation comedy, what critics called "the idiotcom" to distinguish it from the more refined, genteel, middle-class sitcoms of the fifties such as *Father Knows Best, The Donna Reed Show,* and *Leave It to Beaver.* Created, written, and produced by the Missouri-born-and-raised comic mastermind Paul Henning, *Hillbillies,* like the later hit spinoff series *Green Acres,* reveled in barnyard humor, lowbrow puns, tall-tale exaggeration, and outlandish country mouse–city mouse contrasts.

In short, the program tapped into a resurgent vein of populism that had been dormant during the fifties, or at least ignored by the mass media. Folk music revived in the early sixties, and bluegrass and country-and-western music suddenly became popular on mainstream radio. The shift in popular culture, combined with the political excitement of the New Frontier that infected a swelling generation of Americans wary of Eisenhower era complacency, made the program's tweaking of stuffy authority figures and the rigid moral order they guarded a source of popular delight. The *Saturday Evening Post* played to this point when it mockingly re-created *American Gothic* on its February 2, 1963, cover with a deadpan Granny (Irene Ryan) and Uncle Jed (Buddy Ebsen) standing in for Grant Wood's straitlaced Iowa farm couple.

That is, the object of satire in *The Beverly Hillbillies* was not the Hillbillies but Beverly Hills or, more generally, the consumer culture for which it stood. The Clampetts elicited laughs because of their rustic naïveté, but from week to week it was clear that the fools were the phony rich people—the jet-setters and country-clubbers—not the Hillbillies. In one episode Elly May dresses up in ball gown, tiara, and white gloves and learns to say "enchantée" so she can impress some fancy folks in her new neighborhood. Like Eliza Doolittle from *My Fair Lady,* she fools them for a time into believing she is an old-world aristocrat. Thus the show entertains the viewer by providing at once a fantasy of unimpeded class mobility and a reassuring reminder that the rich and educated can be even greater boobs than the poor and ignorant.

The Kennedys were rich and educated. They were authority figures. Who could be more authoritative than the nation's president and first lady? Yet the great winning paradox of the first couple—and a central premise of this book—is that they somehow managed to be exceedingly popular with the American public (especially in rural poor, industrial working-class, and minority communities), even though they were also members of a rarefied elite. In fact, their elite status was a crucial element of their popularity. They appeared to retain their ordinary humanity and embrace communal values despite their wealth, which they could easily have used to wall themselves off from the people.

"The people" is a term that takes us back to *The Grapes of Wrath*. At the conclusion of Ford's harrowing movie, in which one disaster after another has assailed the Joads, Ma rallies her forces with an optimistic vision of the future: "Rich fellas come up an' they die, an' their kids ain't no good, an' they die out. But we keep a-comin'. We're the people that live. Can't nobody wipe us out. Can't nobody lick us. We'll go on forever, Pa. We're the people."

Hollywood lore has it that the movie mogul Darryl Zanuck wrote those words after filming had wrapped, called back the cast and crew, and directed the scene himself without informing Ford. Whether he did remains a matter of scholarly dispute, but consensus holds that however it got there, the "We're the people" speech, adapted from a middle chapter in the novel, was transposed to the end so that audiences would leave the theater feeling hopeful about the future of America rather than despondent or militant. Yet even if it was meant to mitigate the anger aroused by Steinbeck's story, the speech was unusual for thirties Hollywood in according some measure of dignity and respect to the unwashed masses.

Despite its populist aura, *The Beverly Hillbillies* might easily be considered a cruel travesty of such Depression era sentiments, and that judgment would not be unfair. One of the most effective sequences in the movie shows the Joads' overloaded truck rattling and rumbling along the dusty road through a cramped migrant-worker Hoovertown, whose denizens eye the newcomers suspiciously as competitors for the limited amount of work-for-hire available. The corresponding shot from *Hillbillies* shows the Clampetts cruising in their truck down a spacious boulevard in Beverly Hills as if they owned it. Ma Joad, despite the destitution of her own family, struggles to feed the starving children who gather around her stew pot. Granny, the Ma Joad counterpart in *Hillbillies*, evidences no such concern for the less fortunate, enjoying herself with her family in a suburban mansion equipped with a "ce-ment pond" (swimming pool).

In that attitude too *The Beverly Hillbillies* was tuned to the times. For whereas New Deal liberalism sought to alleviate poverty during the Great Depression by distributing food and creating jobs, New Frontier liberalism, which developed in prosperous years, spread the ethos of consumerism to every sector of society. The Kennedys swept into Dallas as walking, talking, hand-shaking advertisements for Boeing jets, Lincoln Continentals, Chanel suits, and unspecified brands of hairspray, toothpaste, underarm deodorant, and other grooming products that they made seem essential to the good life. The Clampetts, too, though in a different way, were model consumers— model in enacting each week, in a hilarious and exaggerated fashion, an allegory of modern American consumption, confronting the "latest" and "most revolutionary" new products on the market and being educated to their purpose and use.

Not that the commodity in question was always new. In one episode Jed and his

nephew Jethro are invited to a posh country club to play a round of golf. They eagerly accept, having heard talk of "shooting birdies"—which they figure means they'll be hunting fowl. At the end of the day they come home with a rucksack full of other players' golf balls, which they harvested from the fairways. Granny boils these up and serves them to her kin, complaining that they're the darned hardest eggs she's ever tried to cook.

In that same episode as originally broadcast, Jethro and Elly May, the Clampett young-uns, dash into the kitchen and pour themselves bowls of Kellogg's Corn Flakes. As the dialogue quickly reveals, they've entered the parallel world of a product advertisement without leaving character or costume behind. Only when the commercial concludes does the banjo picking of Flatt and Scruggs signal the end of the show. In what appears to be a sheer non sequitur, a sign comes on-screen urging viewers, "Give to the college of your choice."

BUT IT WAS NOT A NON SEQUITUR. Those who disapproved of *The Beverly Hill-billies* for what they reviled as moronic humor often shook the term "vast wasteland" at it. That phrase quickly became and probably remains the most withering in television criticism. In a now famous speech to the National Association of Broadcasters in May 1961, the newly appointed head of the Federal Communications Commission (FCC), Newton Minow, reminded his audience that the American public owned the airwaves. Hence broadcasting licenses could (and would, he threatened) be revoked if programming failed to serve the public interest. "When television is bad," he said, "nothing is worse."

> I invite you to sit down in front of your television set when your station goes on the air and stay there without a book, magazine, newspaper, profit-and-loss sheet or rating book to distract you—and keep your eyes glued to that set until the station signs off. I can assure you that you will observe a vast wasteland. You will see a procession of game shows, violence, audience-participation shows, formula comedies about totally unbelievable families, blood and thunder, mayhem, violence, sadism, murder, Western badmen, Western good men, private eyes, gangsters, more violence and cartoons.

Minow's voice was only one of many objecting to the excessive physical violence on network television in 1961. In response, network executives ordered a redistribution of the fare on prime-time TV. They sought to reduce the amount of "blood and thunder, mayhem, violence, sadism, [and] murder" and increase the number of "formula comedies about totally unbelievable families."

The Beverly Hillbillies, which premiered on September 26, 1962, was one such comedy—and a most influential one, given its astonishing success. Within weeks it was garnering ratings more than twice those of its competitors in the same time slot. The wasteland became no less vast, only less violent. Or as one detractor wrote at the time, "If television is America's vast wasteland, the 'Hillbillies' must be Death Valley."

Four weeks after its premiere, *The Beverly Hillbillies* became the highest-rated show in television. That same week, President Kennedy made a TV appearance of his own that attracted a large audience. On October 22, 1962, he informed the public that the Soviet Union was installing missile bases in Cuba. Until November 2, when he announced that the bases were being dismantled, many Americans feared the outbreak of nuclear war. In that context surely the down-home humor, folksy wisdom, and heck-who-cares silliness of "Jed and all his kin" held an almost magical appeal. With the real world in danger of going up in flames, the world of the Clampetts was, for millions, mighty appealing:

> You're all invited back again to this locality,
> T'have a heapin' helpin' of their hospitality.
> Hillbilly, that is. Set a spell, Take your shoes off!
> Y'all come back, now, y'hear!

Some thirteen months later, in the weeks following the Kennedy assassination, the Clampetts pulled in higher ratings than ever before.

I WANT TO MENTION one other link between JFK and *The Beverly Hillbillies:* the explicit push by the president and his administration to meliorate the dire living conditions of real "hillbillies" and their lowland counterparts. Rural poverty, which included chronic unemployment or underemployment, malnutrition, and illiteracy, as I noted in Chapter 3, was a mounting concern of Jack's during his time in office, and his first action as president, taken on January 21, 1961, the morning after the inauguration, was to issue an executive order doubling the amount of food given by the federal government to the nation's four million needy families. That order came in direct response to his campaign visits to the West Virginia coal country the previous autumn, where he had witnessed the misery of the rural poor firsthand and had been genuinely moved by what he saw. He returned to West Virginia again on September 27, 1962—coincidentally, the day after the premiere of *The Beverly Hillbillies*—to pledge his support to the poor of the region. Earlier that day in Washington he had signed into

law the Food and Agriculture Act, aimed at protecting farm incomes against catastrophic market fluctuations.

I have already mentioned that Michael Harrington's *Other America*, which appeared in 1962, also heightened Kennedy's awareness of the acute poverty beneath the nation's conspicuous prosperity. The country's entrenched pockets of economic hardship were virtually unknown to anyone who did not live in them. Harrington pointed out that although more Americans were better off than ever before, one in four was trapped in poverty from which escape was all but impossible. "The millions who are poor in the United States tend to become increasingly invisible," he wrote. "Here is a great mass of people, yet it takes an effort of the intellect and will even to see them." He added, "Poverty is often off the beaten track. It always has been. The ordinary tourist never left the main highway, and today he rides interstate turnpikes."

The interstate highways, the flight to suburbia, and the dream worlds of television, movies, and consumer advertising had indeed hidden poverty from the view of most Americans who were not themselves victims of it. In the early 1960s middle-class efforts to *see* poverty in order to ameliorate it divided the new object of scrutiny into two types: the urban poor, thought to be mostly northern and black, and the rural poor, stereotyped as southern and white. The catchall term for rural southern white poverty was Appalachia.

The Appalachian Mountains stretch from the southeastern United States north into Canada, but the region called Appalachia is more confined, centered in the hill and mountain country of West Virginia, Kentucky, Tennessee, and North Carolina. The popular imagination conflated Appalachia and the Ozarks of the western states Arkansas and Missouri. The Clampetts came from that broad imaginary territory. The term "hillbilly," meaning a rustic hill dweller in the South, a person from the backwoods or a remote mountain area, locates them in a landscape but not on a map.

The Beverly Hillbillies was not the first mass-media entertainment set in mythical Appalachia. John Ford's 1941 movie *Tobacco Road*, based on Erskine Caldwell's earthy novel about "poor white trash" in Georgia, laid out a set of hillbilly stereotypes (lazy, dirty, slovenly, oversexed) that has remained in place ever since. Al Capp's long-running comic strip *L'il Abner*, transferred to the Broadway musical stage in 1956 and later made into a lackluster Hollywood film, played up the comic lovability of the hillbilly, portraying the folks of Dogpatch as good-natured, fun-loving, uninhibited innocents. The weekly TV series *The Real McCoys* (1957–63), which drew high ratings until *The Beverly Hillbillies* came along and made it seem too serious and genteel, depicted a farm family from West Virginia that emigrates to California and must learn to adapt to postwar suburbia without abandoning its homespun values, as embodied by crusty but adorable Gramps, played by Walter Brennan.

During the later fifties, a predominant hillbilly stereotype was a lone man or woman with a shotgun who stands (or, more typically, sits in a front-porch rocker) in defiance of the federal government that wants to build a highway or a dam on the hillbilly's land. In the musical production *L'il Abner*, the government wants to use Dogpatch as an atomic bomb test site. In Elia Kazan's *Wild River* (1960), an agent from the Tennessee Valley Authority struggles to persuade an old woman to abandon her cherished family home on an island in the river before the TVA floods it to provide hydroelectric power to the region.

The counterpart stereotype was the hillbilly who discovers oil on his dirty patch of land and transforms himself overnight into a conspicuously consuming multimillionaire, a primitive in a Cadillac, a barefoot Croesus.

> An' then one day, he was shootin' at some food,
> An' up thru the ground came a bubblin' crude.
> Oil that is! Black gold! Texas tea!

We're back in Texas. Dallas, to be exact. Dallas, the oil capital of the nation. Dallas in those years was to oil what Detroit was to cars, Pittsburgh to steel, and Beverly Hills to movie stars. Here come the president and his lady, the first lady, in the back of an enormous Ford motorcar, with the governor of Texas and his wife seated humbly at their feet like poor relations.

The Clampetts riding into Beverly Hills offered millions of Americans the fantasy of possessing phenomenal wealth while remaining firmly rooted in traditional, down-home values. The Kennedys riding into Dallas afforded a similar thrill. Rolling through the streets of the legendary oil capital, rich, powerful, and famous, they appeared to be adored by everyone in sight and thus epitomized nothing less than the American dream. Instants later, the dream shattered.

6

Kennedy Shot

AT THE VERY MOMENT the assassin was shooting JFK with a Mannlicher-Carcano carbine rifle loaded with 6.5-mm shells, Abraham Zapruder was shooting the president with a Bell and Howell movie camera loaded with 8-mm color film. The light waves that registered on that chemically treated film over the course of twenty-six seconds have provided the basis for the public's visual imagery of the assassination.

Only amateurs photographed the event (the professionals lagged behind in press cars), and only Zapruder was using a state-of-the-art home movie camera, which spat out some 480 continuous still images of the X-100 and its imperiled passengers. Besides, he filmed from an elevated vantage point—a concrete balustrade on the so-called Grassy Knoll that rises gently above Elm Street—and used a zoom lens.

As I noted in Chapter 1, the Zapruder film constitutes not one single entity but many. It's a home movie but also a micro version of a Hollywood film; a private artifact of one man's affection for a leader he never met but also an eyewitness account of a public political event; material evidence of a crime scrutinized by investigators but also an endlessly chewed-over bone of contention between warring sides in the ongoing debate about government conspiracy and cover-up. In addition, the Zapruder film, from the start, has been a lucrative commodity.

Immediately on learning of the film's existence, various news agencies tried to buy it. Richard Stolley, a representative from *Life*, got to Zapruder first and eventually offered him the most—an estimated $150,000—for exclusive rights to the film. The dress manufacturer expressed qualms about making blood money, and so much of it, from the Kennedy tragedy, yet he had his own family's well-being to look after. Here

was an opportunity not only to do that but also to get the potential hot potato out of his hands and into those of a reputable news organization, one that might even be considered a twentieth-century American institution. (Zapruder donated $35,000 of the payment he received to the family of J. D. Tippit, the police officer murdered while questioning Oswald.)

Life zealously guarded the original print of the film in its New York vaults. The FBI, the Warren Commission, and other official investigative bodies had to rely in their efforts on the two copies of the movie that were made when the photo lab in Dallas processed Zapruder's negative. Multiple copies of those copies, in turn, were made in the years that followed.

In the first issue of *Life* to appear after the assassination, November 29, 1963, several pages of blurry black-and-white frame enlargements (thirty-one in all) showed the editors' selection of highlights from the film in sequential storyboard fashion. Apart from six black-and-white frames released to the American press by courtesy of Time, Inc., and nine large vivid color frames published for a special undated *Life* memorial edition in early December, the two double-page spreads in the November 29 issue gave the public its only glimpse of the Zapruder film until September 1964, when the Warren Commission issued its eight-hundred-page report on the assassination with twenty-six volumes of supporting documentation. Volume 18 contains black-and-white enlargements, two per page, of nearly all the film's frames. A handful were omitted, however, apparently because of lab damage, but the Report did not call attention to the omission or even acknowledge it, thus providing fuel for subsequent charges of cover-up.

More suspicious, in the view of critics, was the Report's reversal of the two frames that immediately follow number 313, which is the frame depicting the moment of the fatal head wound. Opponents of the commission's findings have argued that the order of these two frames is absolutely crucial to determining whether the president was initially thrown forward at the bullet's impact or thrown back against his seat, information they allege would indicate whether the fatal bullet came from behind (that is, from Oswald in the School Book Depository) or from the front (from a second sniper positioned somewhere above the Grassy Knoll).

The public's first view of the Zapruder stills in color, apart from those nine enlargements in the December 1963 special memorial issue of *Life*, came in the magazine's October 2, 1964, cover story on the findings of the Warren Commission. Congressman (and ten years later, President) Gerald R. Ford provided the accompanying text. Ford was a member of the commission and thus a defender of its controversial finding that a lone gunman shot JFK. The magazine printed eight frame enlargements, which, at approximately 8 by 5 inches each, had a more visceral impact than the multitude of black-and-white enlargements in the November 29, 1963, issue, most of which were only 3 by 2 inches in size.

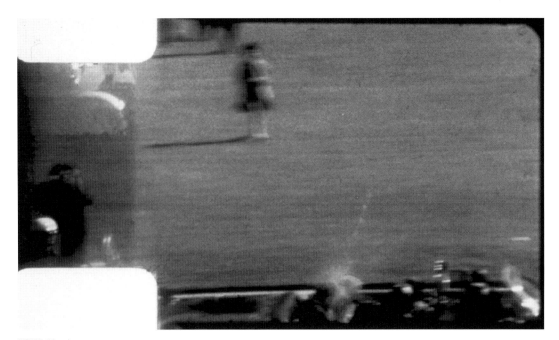

FIGURE 50 | Zapruder frame 313 enlarged, with sprocket holes

Of the eight reproductions in the October 2 issue, one was an enlargement of frame 323, which shows the president slumped back in his seat with a gaping wound in his head, but after thousands of copies of this issue were mailed to subscribers, *Life* replaced 323 with the far more shocking 313, the frame showing the moment of impact with liquid brain matter streaming skyward (Fig. 50). The last two reproductions in the sequence, which reveal Jackie's horror and her desperate scramble onto the back of the Lincoln, may have been even more disturbing to viewers (see Fig. 56).

Life maintained a close guard on the rights to the film and would not honor requests by other news media to broadcast it or reproduce parts of it. The public next glimpsed it in the issue marking the third anniversary of the assassination, published November 25, 1966. In a cover story entitled "Did Oswald Act Alone? A Matter of Reasonable Doubt," *Life* surveyed the growing controversy over the Warren Report. This time around *Life* lavishly illustrated its coverage with partial and full-frame enlargements, each numbered and showing for the first time the visual information contained between the sprocket holes to the left of the main images.

The magazine asked Governor John Connally, who had been wounded in the sniper attack on the president, to review color transparencies made from the original film. Connally is shown carefully examining these to identify the exact frame—the precise moment—when he was hit. He concludes that the Warren Commission was flat-out

wrong in claiming that the bullet that struck him had already passed through the flesh of the president (hence its derisive designation by critics of the commission as the magic bullet). *Life* concurs, ending its report with the following statement printed in bold type: "Conclusion: the case should be reopened."

The editors enlarged some of the details from individual frames to a mammoth 10 by 10 inches, a size that all but filled a page of the large-format magazine. The resulting images were so grainy that they might have reminded filmgoers of *Blow-Up*, which had opened earlier in 1966 and similarly demonstrated (as I note in Chapter 1) the photographic medium being pushed to its limits as a conveyor of information.

NEITHER THE SELECTED STILLS from the Zapruder film shown in *Life* nor those reproduced in volume 18 of the Warren Report gave the public the opportunity to see the film in motion or in its entirety and judge for itself what was revealed. By the late sixties, however, the situation began to change.

When *Life* sent the original Zapruder print to a photo lab in New Jersey in 1968, a technician named Robert Groden covertly made a copy and placed it in a bank vault for safekeeping. Then, when the coast was clear and he could see that no one from *Life* was coming after him, he retrieved the duplicate and optically enhanced it, producing a clearer, more reliable study tool than the FBI and Warren Commission copies or even the *Life* original.

The following year the New Orleans prosecutor and conspiracy theorist Jim Garrison managed to subpoena the original print from *Life* for the trial of Clay Shaw, a suspect who was eventually acquitted, but not before the movie had been screened in the courtroom a full ten times, and on one occasion frame by frame. While the film was in Garrison's possession, numerous copies were pirated, with an estimated hundred of those bootleg prints distributed to college and university groups around the country.

In 1973 Groden showed his enhanced print of the film in Boston at a well-attended research conference, and *Life* chose not to prosecute. The Boston-based Assassination Information Bureau initiated a lecture series in which prints of the Zapruder film were shown to some 600 audiences in 45 states over the next three years. The film finally appeared on television in April 1975, when Groden took it on the nationally televised *Goodnight America* show with Geraldo Rivera. By now the horse was out of the barn and *Life*, unable to maintain the copyright, returned it to the Zapruder estate (Zapruder having died in 1970) for a token price of one dollar.

The mood in America had changed drastically since the publication of the Warren Report. The commission had never satisfactorily explained the assassination of JFK and faced merciless criticism for its numerous gaffes and procedural errors. Growing

distrust and skepticism emerged out of the Vietnam imbroglio; the assassinations of Martin Luther King, Jr., and Robert Kennedy; the inner-city riots; the college sit-ins; the police brutality against demonstrators outside the Democratic National Convention in Chicago; the Kent State killings; and, finally, the Watergate affair. The Zapruder film had come to signify a whole range of disparate meanings. It was at once a holy relic of presidential martyrdom, a document of the last moments of American idealism and innocence, and a testament to governmental ineptness at best, nefarious conspiracy at worst. When the Zapruder estate proceeded to maintain as tight a grip on the film and its reproduction as *Life* had done, suspicion only increased that information was being withheld from the public.

In response, Congress named the House Select Committee on Assassinations to reopen the JFK investigation and conduct a second investigation, into the murder of Martin Luther King. During the three years (1976–79) that the committee performed its job, the Zapruder film was examined and reexamined from every conceivable angle and subjected to a battery of scientific tests, optical enhancements, and forensic studies, all of which aimed to wrest from its crucial 348 frames the secrets that had eluded all previous investigations. In the end, the best the committee could do with the available evidence was state that "President John F. Kennedy was probably assassinated as a result of a conspiracy."

Oliver Stone's *JFK*, released in December 1991, stirred the pot once more, charging that a "shadow government," existing alongside the elected government at the time of the assassination, had conspired to dispose of Kennedy when it became clear that he intended to end America's nascent involvement in Vietnam. The movie's hero is Jim Garrison (Kevin Costner), the New Orleans prosecutor who failed to win a conviction against Clay Shaw but successfully subpoenaed the Zapruder film in the process.

At the climax of the three-and-a-half-hour movie, Garrison projects the Zapruder strip, eliciting cries and gasps from the courtroom audience, stunned by what they see now for the first time. Many in the audience for *JFK* in the early 1990s had a similar reaction. A generation of moviegoers too young to have witnessed the Zapruder film when it was shown on TV and the college lecture circuit in the mid-1970s now had the opportunity to view it, albeit in the charged, melodramatic context of Stone's film.

IN 1999 THE UNITED STATES government sought to purchase the original of the Zapruder film for the National Archives, which had been keeping it in protective cold storage since 1975. The estate asked for $30 million, maintaining that the twenty-six-second footage was a priceless document in the history of the nation and should be valued in the same league as art by Vincent van Gogh, whose *Sunflowers* sold for

nearly $40 million in 1987, or Andy Warhol, whose *Orange Marilyn*, a silk screen of Marilyn Monroe, sold for $17.3 million in 1998. The government countered with an offer of $1 million.

An arbitration team stepped in and set the transfer price at $16 million, with the Zapruder family retaining the film's copyright. Government representatives squawked that even the lesser amount, although just over half what the family had asked, was still wildly extravagant, for without projection the Zapruder film is nothing more than a "tiny strip of celluloid tightly wound on a plastic reel."

By the same logic, the Mona Lisa is nothing more than a swatch of painted canvas twill tightly stretched on wooden bars and covered by glass. Difficult as it may be to assign a value to an artifact so famous and so frequently reproduced as this film—which was never brought to market after its initial sale to *Life* magazine—it is preposterous to estimate value based on the materials of its construction.

Zapruder's "tiny strip of celluloid," because of the circumstances of its production, immediately acquired commodity status and has maintained it ever since. Abraham Zapruder made money selling it to *Life*, *Life* made money selling special issues of the magazine to its readers (and space in those issues to advertisers), the conspiracy theorists made money (though surely not a lot) from lecturing and selling publications with bootleg Zapruder images, the Zapruder estate made money from its copyright ownership and transaction with the government, and Warner Brothers (a subsidiary of Time-Warner, the corporate owner of *Life*) made money from Oliver Stone's movie, which, thanks to the controversy it engendered, fared very well at the box office and in its various TV broadcasts and video, laser disc, and DVD permutations. The Zapruder film is currently available for rental or low-cost purchase at video shops nationwide or on the Internet.

In its 1964 issue on the Warren Report *Life* makes evident the alchemy by which Zapruder's home movie of a horrific event was transformed into a commercial property. On the last page of the story a large black-and-white photo shows mourners gathered at Dealey Plaza nearly a year after the assassination. The caption reads, "Here the people who still flock to the scene day and night have made a makeshift memorial of a flag-decorated stand where they leave their tributes of flowers with notes that say 'We love you,' and 'Lest we forget.'" On the facing page, a large brightly colored ad for Pepsi-Cola features a fetching blond, blue-eyed baby boomer raising a liquid-filled bottle and enticing the reader, "Come alive! You're in the Pepsi generation!" (Fig. 51).

Drab black and white shifts to color; sad, faceless mourners give way to a pretty young model with fabulous hair, flawless skin, and dazzling teeth; and the lugubrious tones of "Lest we forget" disappear in a hallelujah chorus of Pepsi's "Come alive!"

The text for the ad continues: "This is the liveliest, most energetic time ever . . . with the most active generation living it. You're part of it. Pepsi-Cola is part, too. Pepsi is the

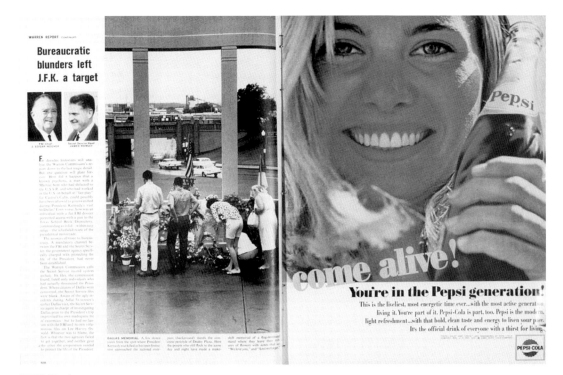

FIGURE 51 | "Come alive!" *Life*, October 2, 1964

modern, light refreshment . . . with that bold, clean taste and energy to liven your pace. It's the official drink of everyone with a thirst for living!" Because Jack Kennedy was always prized for his "thirst for living," as we have seen from the time of the 1953 sailing picture right up to the day of his death ten years later, it's almost as if the juxtaposition in *Life* reassuringly declares that although he is dead, his spirit lives on in "the Pepsi generation" and in the carbonated sugar water that constitutes its "official drink." Moreover, it's not JFK but the consumer of the aptly named *Life* who is resurrected by this relatively routine shift from reporting to advertising. Talk about subliminal suggestion. Momentarily deflated, experiencing pangs of loss and intimations of mortality, and possibly even beset by guilt at the sight of other, more loyal, mourners still holding vigil for the slain president, the reader is summarily restored—brought alive again—by feel-good signifiers: youth, beauty, zest, sexual desirability, and even patriotic loyalty (as encapsulated in the company's red, white, and blue logo), with all of these attributes further attainable, if only in the consumer's imagination, by the simple removal of a bottle cap.

In a neat irony, Richard M. Nixon, having returned to his law practice after two failed campaigns—for the presidency in 1960 and for the California governorship in 1962—represented the Pepsi-Cola Corporation and attended a Pepsi convention in Dallas the

day before the Kennedys arrived. The next morning he boarded a flight that left from Love Field while preparations were under way for the arrival of the presidential jet. On the plane, Nixon recalled years later, "an associate mentioned to me that for want of a few thousand votes here and there it might have been me coming into Dallas that day." Although Nixon earned a good living as Pepsi's hired representative, clearly it was his old political rival who continued to embody the spirit of the Pepsi Generation.

If the "Come alive!" Pepsi ad doesn't seem oddly placed, following so swiftly on the heels of the pious "We love you" and "Lest we forget," a turn of the page reveals an even greater surprise. Coming immediately after several pages of large-scale color frame enlargements of Jack and Jackie writhing in their limo of death, a two-page color layout trumpets the glories of "America's most distinguished motorcar," none other than the Lincoln Continental.

Here the Lincoln is a 1965 model instead of a 1961, it's gray rather than navy blue, and it's a hardtop sedan rather than a limousine convertible. But it is ominously parked beside a grove of trees that stand like sentinels in an eerie mist, and a sign reading "private road," nailed to a white stake in the ground, resembles a simple wooden cross in a military graveyard. The placement of this advertisement immediately after the lurid frame enlargements from the Zapruder film strikes this present-day reader as surreal, though presumably no one at the time found it odd or objectionable.

I suspect that that's because the conceptual borders between "news content" and "ad content" were more solidly defined then than they are now, and thus readers were less likely to notice the spillover from one to the other. Our own view may also be ideologically blinkered, but yesterday's blinders differ from today's. It may no longer be possible now, some four decades later, to discover which advertising agency copywriter conceived the Lincoln ad or which magazine layout editor placed it immediately after the frame enlargements illustrating the story on the Warren Commission's findings, so we may never know what these image professionals were thinking. Even so, the ad and its placement give evidence of the political unconscious at work, in a signal instance of images determining other images in modern image culture.

The slender brunette model poised beside the new Lincoln Continental wears a Chanel suit. Not only that, it's unmistakably pink. All that's missing is the pillbox hat and the armful of red roses.

SO AGAIN WE RETURN to the Lincoln. It moves down Elm Street at an average speed of 11.2 miles per hour. The calculation derived from the Zapruder footage, filmed at 18.3 frames per second, which showed the X-100 taking precisely 8.3 seconds to cover the 136-foot stretch of road from the start of the clip to the moment of the fatal head wound.

Note the mathematical language. The existence of the Zapruder film, plus photo-

graphic evidence assembled from various witnesses, immediately gave rise to a scientific or pseudo-scientific discourse about the assassination. The rhetoric of quantification became an inseparable part of it. Velocities, trajectories, refractions, logarithms, and algorithms entered the lingua franca of the Kennedy killing.

That was the period, after all, of the space race. With the launch of Sputnik in the late Eisenhower years Americans had realized how far they lagged behind the Soviets in the exploration of outer space. A national determination to catch up in all matters of physics and space technology grew feverish. JFK boldly announced America's intention to place a man on the moon by the end of the decade; Congress funded engineering and scientific research; and the population in general was smitten with an ardor for science-speak, even when much of it was incomprehensible to all but specialists.

When *Life* analyzed the Zapruder film a third time, in November 1966, it unequivocally declared its faith in the veracity of camera vision. (That faith is not surprising, given the raison d'être of the popular picture magazine since its inception three decades earlier.) "Of all the witnesses to the tragedy," it wrote, "the only unimpeachable one is the 8-mm movie camera of Abraham Zapruder, which recorded the assassination in sequence. Film passed through the camera at 18.3 frames a second, a little more than a 20th of a second (.055 sec.) for each frame." And here's the key assertion, which I italicize: "*By studying individual frames one can see what happened at every instant and measure precisely the intervals between events.*"

Josiah Thompson, a special consultant for *Life* in its microanalysis of the film, produced his own detailed study, *Six Seconds in Dallas*, which relied on amazingly accurate charcoal sketches of individual frames, his former employer, *Life*, having refused to grant him rights to reproduce from the original. Although Thompson severely criticized the Warren Commission, he shared its conviction (as did *Life* and the general public) that *the* truth about the assassination could be ascertained by a careful scientific investigation of the photographic documents:

> Abraham Zapruder's movie served as a major piece of evidence for the Warren Commission, and it has become a crucial historical document for independent researchers ever since. To an untrained eye it appears to be only a silent, hurried, somewhat blurry view of the President's limousine. Yet if it is studied with the utmost care and under optimum conditions, it can yield answers to enormous questions. Where did the shots come from, and when were they fired? Limited in scope though it is, the Zapruder film is capable of answering these questions.

Or, as Jim Garrison assured the New Orleans jury, the Zapruder film is the "one eyewitness" that is "totally indifferent to power" and incorruptibly "tells what happens as it saw it happen."

Thus the Zapruder film's status as a modern Rosetta stone needing only to be scientifically decoded to unlock the mysteries of the past. The Rosetta stone is an ancient slab of black basalt found at the mouth of the Nile in 1799 during the occupation of Egypt by French revolutionary forces under the command of young Napoleon Bonaparte. An international team of linguists set out to decipher the stone's parallel inscriptions in ancient Greek, Egyptian demotic, and Egyptian hieroglyphics and thus acquire the key to ancient texts that had been impossible for modern readers to understand. The effort took twenty years.

In the meantime, Napoleon abruptly ended the first French republic, declared himself emperor, and embarked on a series of military campaigns that unleashed the agonies of war, famine, and disease on millions of Europeans, Russians, and North Africans. Those celebrating the decipherment of the Rosetta stone in the decade following Waterloo and the Congress of Vienna believed that it boded the subordination of both the ancient past and the recent tumultuous past to the rule of reason. Investigators of the Zapruder film have similarly dreamed of the triumph of reason.

YET THE ZAPRUDER FILM has proved less a Rosetta stone than an illustration of the Heisenberg uncertainty principle. In 1927 the German theoretical physicist Werner Heisenberg, a founder of quantum mechanics, showed that subatomic particles cannot ever be accurately observed because the very act of observation necessarily displaces the particle being observed. That is, empirical physicists cannot "see" a subatomic particle without bombarding it with other subatomic particles, thereby altering its pre-bombardment molecular position.

The uncertainty principle, also called the principle of indeterminacy, made intuitive sense to nonscientists in a world that had recently suffered the certainty-defying ravages of World War I, the Russian Revolution, and, in 1929, the stock market crash. The novels of Joyce, Proust, and Woolf; the poetry of Eliot and Pound; the art of Braque, Picasso, and the surrealists; the music of Bartók, Schoenberg, and Stravinsky; and the relativist theories of Boas in anthropology, Freud in psychoanalysis, and Heidegger in philosophy all seemed to demonstrate in one way or another Heisenberg's disavowal of purely objective knowledge of reality.

And here comes the X-100, ambling down Elm Street for the ten-thousandth or ten-millionth time over the past forty years—twice the time it took to decipher the Rosetta stone—and still uncertainty reigns. Optically enhanced, digitized, computerized, holographed, and even examined by scientists at Los Alamos, the Zapruder film repeatedly fails to divulge the truth.

Or, to the contrary, divulges so many "objective" truths, so many "indisputable" proofs, so many "authoritative" interpretations of who fired the bullets and from where

that anyone who is not a die-hard believer of one particular theory or another faces an array of conclusions so bewildering that choosing among them seems all but impossible. Richard Stolley, the shrewd journalist who bought Zapruder's home movie for *Life*, said of the film clip: "Depending on your point of view, it proves almost anything you want it to prove."

The first paradox of the Zapruder film is that it is a *motion* picture that requires examination as a sequence of *still* pictures. As soon as the movie is freeze-framed or converted into motionless frame enlargements, it ceases to be a movie. Numerous still photographs of the assassination exist, as do other home movie fragments, but the Zapruder film provides by far the greatest continuity of events during the six or so seconds of killing. Yet even this "unimpeachable witness" is impeached by the quality of the camera Zapruder used, the magnification power of the lens, the speed of the film stock, the angle of view and the off-center framing, the location of the sun during filming, and the absence of sound (which was only partially rectified in the late seventies by the discovery of an unnoticed audio recording of a motorcycle cop's radio transmission from the scene of the crime).

The motion picture as motion picture has never told investigators enough. Like Heisenberg's subatomic particle, Zapruder's film (or the X-100 in it) cannot be seen without its first being altered, in this case either by slowing it or by bringing it to a dead halt. When the film has run at its native 18.3 frames per second, it has proved useless forensically unless modified by enhancements, reframings, or computerizations.

The limitations of motion picture equipment make fractional gaps inevitable even in continuous filming. Although each frame represents a mere twentieth of a second, crucial occurrences escaped, unrecorded. In frame 312, for example, Jack is wounded but alive; in frame 313, only .055 of a second later, his brains are flaring toward the sky; the fatal bullet is never in sight. And then there's the matter of the Stemmons Freeway sign, which blocked the camera's view of Jack between frame 193, when he is seen waving to the crowd, and frame 225, less than two seconds later, when he is visible again, now clutching at his throat.

Freud's theory of repression, in its heyday during the Kennedy era, though repudiated by opponents of psychoanalysis in recent years, holds that individuals cannot bear to look back on a traumatic primal scene (such as sexual intercourse by their parents or a personally experienced instance of sexual abuse). They therefore edit it out of their consciousness by an unconscious act of screening. With all its gaps and uncertainties, its occlusions and obscurities, the Zapruder film, like an inscrutable dream narrative written up by Freud, needs to be understood as a modernist text, regardless of the filmmaker's original intentions or the subsequent efforts of scores of investigators who have striven to treat it as an "unimpeachable" witness of history.

To invoke a metaphor that became common in the Kennedy years, the Zapruder

film proved to be less a Rosetta stone than a Rorschach test—less an objective key to reality than an ink blot lending itself to infinitely variable subjective interpretation.

WHEN FRAMES FROM the Zapruder film have been enlarged and cropped to focus the eye on the violent effects of the shots fired into the passenger compartment of the Lincoln, the dark blue horizontals of the car command the bottom portions of the picture while the upper half to two-thirds of the image becomes an almost abstract swath of green. In some instances the green is interspersed with the blurred silhouettes of bystanders, but that depends on the particular frame selected for enlargement and the tightness of the cropping.

In those isolated frame enlargements that leave the green grass of the city park devoid of bystanders, Kennedy dying in the back of his convertible eerily resembles the most famous assassination painting in the history of art, *The Death of Marat*, which was made 170 years before Dallas in a very different time and place—Revolutionary France (Fig. 52).

Its painter, Jacques-Louis David, had been an acclaimed master artist before the Revolution and had enjoyed the patronage of the king himself. But the favor of Louis XVI and his queen, Marie-Antoinette, did not prevent David from staking out for himself a prominent place on the revolutionary councils and voting to imprison and execute the royal couple (as well as some three hundred other aristocrats and opponents of the Revolution). The painter had become a zealous member of the Jacobin party and an intimate associate of Robespierre, the militant instigator of the Reign of Terror. Another of David's dear friends was Jean-Paul Marat, the chief propagandist of the Terror.

Marat was a doctor turned newspaper editor. His publication *L'Ami du peuple* (The friend of the people) launched inflammatory attacks on those he deemed counterrevolutionary. In particular, Marat wished to scuttle the bourgeois faction known as the Girondins, a group from the north of France that espoused moderate views and held large amounts of land and property. Marat detested the Girondins and railed against them in the name of the angry impoverished masses, nicknamed sansculottes (without knee breeches). Because of a skin disease contracted years earlier, when he had been forced into hiding in the sewers of Paris, Marat needed to spend hours of every day soaking in a cool bath with a vinegar-soaked turban wrapped around his head.

It was there, in his bath, that Marat accepted a visit one evening from a twenty-four-year-old woman from the north of France, Charlotte Corday, who claimed that she had secret information about the Girondins to pass along to him. Pulling out a bread knife she had purchased that morning as a murder weapon, Corday stabbed him to death, believing she was doing her part to save France from tyranny. Four days later

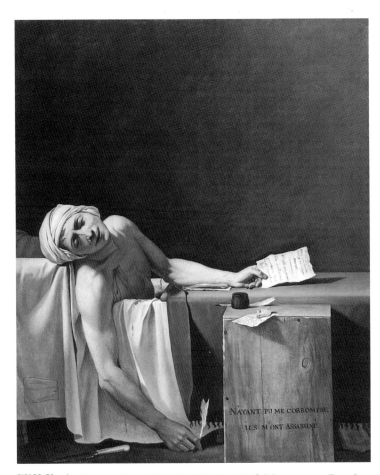

FIGURE 52 | Jacques-Louis David, *The Death of Marat*, 1793, Royal
Museums of Fine Arts of Belgium, Brussels

she climbed to the guillotine and died calmly, a beautiful and virginal martyr in the
eyes of the Girondins, an ugly virago in the view of the Jacobins and sansculottes.

In David's estimation, the true martyr of the affair was Marat, and he set about to
paint a memorial image of his friend that would pay him homage and elicit the rev-
erence of the masses to whom the editorialist had devoted his pen. The picture, because
of its exquisitely simple coloring and architectural design, has often been regarded as
an inaugural work of modernism.

Modernism's first theorist, Charles Baudelaire, wrote a paean to the painting in
1846, calling it "David's masterpiece and one of the great curiosities of modern art."
Guillaume Apollinaire, the modernist poet and friend of the cubists, said in 1912,
"David is the preferred master of certain young painters of the most daring school.

For my own part, I believe *The Death of Marat* is a masterpiece, and one which could have been painted today." Seurat, Braque, Picasso, and Magritte were all conspicuously influenced by David's strict geometry, heroic figuration, and careful superimposition of one plane on another.

The stark simplicity of the picture is the key to its modernist appeal. Working in an era when academic taste extolled painting filled with anecdotal details of important historical events, David revolted. His *Marat* is stripped of all such trappings. It sternly rejects aristocratic folderol and bourgeois clutter, presenting precisely the image of Marat the writer himself had projected: that of a man whose unyielding dedication to truth freed him from the need for material possessions.

Yet David's Marat is no fanatic. Instead, he is a serene, almost angelic figure, his head haloed by his golden white turban and his muscular, perfectly formed arm falling away toward the ground like that of Christ in a Renaissance Pietà or deposition from the cross. (Such religious overtones troubled some of the painting's original sansculottes viewers, given their fervent hatred of the Church.) Marat's bath, draped in white and green cloths, stretches across the bottom half of the rectangular image, while the upper half contains nothing but a color field of richly painted green that represents a wall raked by light.

Marat assassinated while seated in his bath, Kennedy, in his Lincoln. Marat's head, swathed in a turban, lolls to one side, Kennedy's, to the other. (His wife, in her pink pillbox hat, is the one wearing the turban.) Marat is a Pietà figure even though he lacks a Mary to cradle him in her arms; Kennedy too is such a figure, in this instance complete with a Mary. Above the dying Marat appears an abstract dark green wall, above dying Kennedy, an abstract bright green field of grass. Such are the formal, art-historical similarities of the two images. But they are historically similar as well.

David painted his *Marat* in the immediate aftermath of the assassination and submitted it to the people as a form of reportage. In fact, he had called on Marat the day before the murder and could thus lay claim to scrupulous accuracy in rendering the setting of the crime. But those were perilous times, filled with rancor and death, war and confusion, charge and countercharge. David the fire-breathing revolutionary activist seems to have impelled David the visionary revolutionary artist to record Marat's death with a schematic clarity and simplicity that would banish any doubts about who was right and wrong in the conflict between Good and Evil.

The painting received its first exhibition on the day that Marie-Antoinette was driven to the scaffold. David even took time from his busy schedule to knock off a cruelly unflattering ink sketch of her awaiting the blade, haggard and missing her false teeth, wig, and regal attire. The Jacobins and sansculottes regarded *The Death of Marat* as an "unimpeachable" truth-telling document, and the murdered Marat himself as a genuine martyr. (The death of Marie-Antoinette, in contrast, was a case of just

desserts.) The revolutionaries regarded David's depiction of Marat's assassination as virtually an eyewitness account.

Marat is staged, *Zapruder* (to assign a title to the Kennedy assassination footage) is not. *Marat* is theatrical, *Zapruder* cinematic. *Marat* synthesizes events and condenses them into one matchless, formally perfect unit. *Zapruder* allows events to run unsynthesized, one after the other in the order of their unfolding, with no editorializing, no mythmaking, no sanctifying, and certainly no formal perfection and meticulous visual clarity. Still, *Zapruder* is America's *Marat*, the definitive and indelible image of assassination as rendered at the time and place of the tumultuous event that transpired.

WHEN KENNEDY DIED, relatively few well-educated Americans would have known of Jean-Paul Marat, but that was soon to change. In November 1963 an obscure West German playwright named Peter Weiss was writing an avant-garde theater piece that achieved international notoriety some five months later. Weiss provocatively entitled his play *The Persecution and Assassination of Jean-Paul Marat as Performed by the Inmates of the Asylum of Charenton under the Direction of the Marquis de Sade.*

Called *Marat/Sade* for convenience, it premiered in West Berlin in April 1964 and came to London that summer in a controversial hit production by the Royal Shakespeare Company. This RSC production moved to New York at the end of the following year (Fig. 53). *Time*'s review described the production as "a hypodermic needle plunged directly into the playgoer's emotional bloodstream. It hypnotizes the eye and bruises the ear. It shreds the nerves; it vivisects the psyche—and it may scare the living daylights out of more than a few playgoers."

Weiss based *Marat/Sade* on historical fact. It takes place in 1808 in a madhouse near Paris, where the Marquis de Sade, infamous philosopher, pornographer, and libertine, lived out his last years in court-ordered confinement, writing theater pieces for his fellow inmates to perform. Weiss envisions the staging of one such (imaginary) play, on the subject of the Marat assassination of fifteen years earlier. The lunatics impersonate the historical personages of the affair. The role of Marat is played by a delusional paranoiac. Over the course of the play-within-a-play, he and the marquis engage in a series of debates about the meaning of life, death, and revolution.

The resurrection of Marat from the dustbin of history was timely. Weiss wrote his play in West Berlin two years after the erection of the Wall and about six months after Kennedy's visit there set the glories of consumerism (epitomized by the X-100) against the drabness of state socialism. *Marat/Sade* highlighted divided consciousness

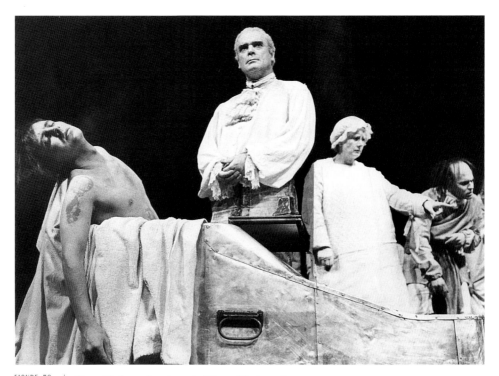

FIGURE 53 | New York production of *Marat/Sade*, 1965

and divided history in a city, a nation, and a world that was then divided, politically, economically, and ideologically, into East and West.

One might even envision the slash of the abbreviated title as a typographical allegory of the Berlin Wall, which itself was a geographical allegory of the various ways in which the world of the early sixties was divided. *Marat/Sade* represents the conflict between socialism and individualism, communism and capitalism, idealism and nihilism, or any other such pairing of incompatible but inseparable opposites. *Time* called *Marat/Sade* a "conservative v. liberal" duel, in which Sade articulates the view that "man's nature is the chain he cannot break and that revolution is futile" and Marat "argues that social injustice demands action, and that man is a creature born to challenge and change nature."

The play's Sade is a radical, pleasure-seeking individualist who declares, "For me the only reality is imagination / the world inside myself / The Revolution no longer interests me." Its Marat, in contrast, frets over the failed promise of the Revolution. He complains, "We're all so clogged with dead ideas / passed from generation to generation / that even the best of us / don't know the way out / We invented the Revolution / but we don't know how to run it."

In the play's schematic logic, the cold war West would certainly be more on the side of Sade than Marat, and Jack Kennedy, with his very public, proto-Pepsi "thirst for living" and private thirst for women was unquestionably more self-gratifying Sade than abstemious Marat. Although it's Marat, not Sade, whom history associates with the tub, recent unconfirmed claims about Kennedy's sexual exploits in the bath portray him as a man of markedly sadistic appetites. Gore Vidal writes, "I remember that he liked sex in a hot bath, with the woman on top, favoring his bad back. Once, with an actress I know, he suddenly pushed her backward until her head was under water, causing a vaginal spasm for her and orgasm for him. She hates him still." Elsewhere, Vidal reports that when the president engaged in bathtub sex with a prostitute and was ready to climax, he'd signal a Secret Service agent to slip up behind her and shove her head underwater, again for the same reason of involuntary vaginal contraction. Vidal muses, "All men—and women, too?—have a streak of sadism. But mine was plainly narrower than Jack's."

As for Kennedy and Marat, it seems they had in common only that both of them suffered from a debilitating chronic illness and was assassinated by a deranged twenty-four-year-old. Yet each of them worked zealously and with undeniable intelligence to present himself (accurately or falsely, depending on the observer's political point of view) as "the friend of the people." Marat was the self-appointed champion of the sansculottes, Kennedy the elected champion of the rural poor and the nation's underprivileged black and Hispanic urban populations.

A photograph that inadvertently conveys the Marat-Sade, Jekyll-Hyde, Dorian Gray duality of Jack Kennedy shows his handsome young face, reflected upside down in the rooftop of a car, transformed into the visage of a gross sensualist (Fig. 54). Jack's inner monster became widely known only after his death, but now it lives on in the public imagination in a complementary relationship—a cold war–style "peaceful coexistence"—with his idealized princely identity.

The monstrosity of the reflection looks like something out of the work of the British postwar expressionist artist Francis Bacon, whose paintings of mangled, tortured, or demonic male heads were lauded in a major retrospective at the Tate Gallery in 1962 and the Guggenheim Museum the following year. Perhaps it is not surprising that the Zapruder film fascinated the artist, for its imagery so strongly resonates with his own. An inventory of papers and effects left in his small London studio at the time of his death in 1992 indicates that for over a quarter of a century he held onto old clippings from *Life* showing frame enlargements from the Zapruder film. Even though he completed his ghoulish triptych *Three Studies of the Human Head* a decade before the assassination, its left-to-right sequence of a man in a necktie being assaulted by an invisible torment looks like a series of Zapruder film stills cropped close on Jack as he takes the lethal bullet's impact and slumps to his side (Fig. 55).

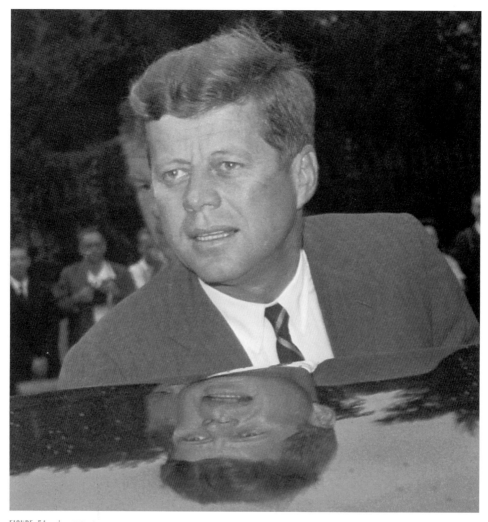

FIGURE 54 | Washington, September 14, 1962

Above I likened Zapruder's film to David's painting inasmuch as each representation documented for its contemporaries the assassination of the people's friend. But in some ways the film has more in common with Peter Weiss's play than David's painting. *Marat/Sade*, successor to Bertolt Brecht's socialist avant-garde plays and Antonin Artaud's experiments in the "Theater of Cruelty," writhes with cryptic lunatic ravings and bacchanalian song and dance performed by half-naked madmen and madwomen who jump and howl and throw themselves about the stage in an orgy of senselessness. In its microcosm of ongoing social conflict and instability, it completely rejects the serene certainty of David's depiction of revolutionary times.

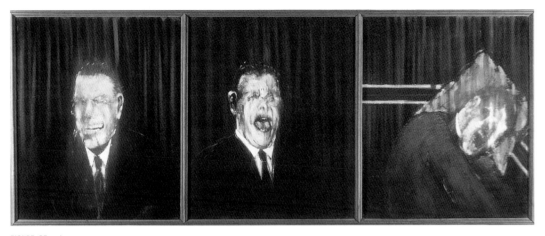

David painted *The Death of Marat* to shed light on the murky political situation of his day, enabling viewers to draw clear, definite conclusions about right and wrong at a moment of mass bloodletting, when warring factions fought literally to the death to assert their legitimacy. It offered a supremely partisan clarity, to be sure, but clarity nonetheless. In this regard I disagree with the art historian T. J. Clark, who calls attention to the semi-illegible portions of the painting (for example, the handwritten letter atop the wooden box and the green background that only partially resembles a wall) to affirm David's status as a founding figure of modernism. Far from offsetting, subverting, or otherwise deconstructing the picture's overall clarity, such contrasting passages increase it. Indeed, few images in the history of art have seemed to viewers as radiantly, luminously perspicuous as *The Death of Marat*.

And in that sense, *The Death of Marat* is the Zapruder film's opposite, whereas *Marat/Sade*, with its hysterical, uncontrolled violence and utter lack of clarity and resolution, is *Zapruder*'s true soul mate, a parallel document of lunatic times and overlapping or crisscrossing dementias.

"THE COLORS ARE BEAUTIFUL. The ever-familiar hues of the tragedy—the pink of the first lady's outfit, the red of the wounds, the green of the grass, the bluish-black of the presidential limousine—would not have been better if selected by Warhol or Matisse." That is how a professional appraiser hired by the Zapruder family described the film in 1999, when he arrived at a suggested selling price of $33.8 million.

The argument seems as specious as the one I noted earlier in this chapter, in which the government denigrated the film as a "tiny strip of celluloid." The original labo-

ratory print of a movie, no matter how beloved, unique, or historically important, belongs to an order of reality different from that of an original oil painting, and displaying that original print in a locked glass case would not, for most viewers, be equivalent to hanging a great painting on a museum wall. Nonetheless, it's valid to consider the Zapruder film as an aesthetic object that bears formal resemblance to the work of certain canonical artists of the twentieth century. The specific painters who come to mind as I screen and rescreen my video copy of the film include not only those mentioned by the appraiser but others as well.

Before I name them, I want to acknowledge that some readers may find offensive the purely formal discussion of a moment of genuine personal horror. I don't wish to aestheticize Kennedy's death or to treat his wife's unimaginable and heartrending dismay as an art-historical text, the occasion for an exercise in source hunting. Still, the Zapruder film has in fact been worked over by analysts of all stripes and intentions, viewed in slow motion by them and subjected to frame-enlargement, color enhancement, forward and reverse projection, and digital manipulation so that it has become a work of artistic abstraction.

Like the American flag that Jasper Johns repeatedly painted in the late fifties and early sixties, the Zapruder film metamorphoses from a strictly political icon into a stunningly beautiful piece of art when it is worked over, played with, stretched and pulled and pushed, retaining its base materiality yet giving way to an ineffable splendor of color and form. And like Johns's flag paintings, the Zapruder film finally refuses to take us where we want to go; no matter how worked over it may be, it does not produce the information we seek. It unlocks no mysteries but only creates more of them. Under "scientific" analysis and technological reconstruction, it ends up as blobs of color, not revelation.

As a principal precursor of pop art in America, Jasper Johns is an appropriate name to invoke in this context, for the Zapruder blowups in *Life* resonate with the early-sixties work of pop artists such as Andy Warhol, who, learning from Johns and Marcel Duchamp, appropriated mass-produced and mass-distributed photographic imagery as the starting point for his artistic explorations. Warhol in particular painted modern life by appropriating and reworking wire service photographs and headlines about contemporary disasters—plane crashes, fatal traffic collisions, suicides, executions, and race riots. Although he did not draw from the *Life* enlargements when producing his "Jackie" silk-screen paintings of the Dallas weekend (see Chapter 9), it makes sense that the appraiser invoked Warhol's name in describing the home movie as a work of art.

For all of its connections to neodada and pop art (traced out in Chapter 1 and returned to in Chapter 9), the Zapruder film also reminds me of an alternative artistic movement of the 1960s, especially when we examine individual frames, enlarged and color-enhanced. This movement goes by the name color-field painting. Rejecting the

gestural brushwork of the abstract expressionists who preceded them, color-field painters like Helen Frankenthaler, Morris Louis, and Jules Olitski applied large swaths of pure color to blank canvas, sometimes by staining or spray-painting, to suggest that the clouds or rivulets of color spanning the width of the canvas were but a detail, a slice, of some larger field of reference that extended beyond the limits of what could be seen.

The hypermagnified and color-enriched frames of the Zapruder film exude the same saturation and ineffability. The color-field painters attempted to produce the apotheosis of paint by turning a viscous liquid medium into pure spiritual atmosphere. Olitski once said that his aim was to capture forever the look of spray paint as it hung weightless in the air. The Zapruder film, technologically reconstituted for forensic investigation, achieves this same apotheosis. An extreme close-up of frame 313, reproduced in color in *The Killing of a President* by the conspiracy theorist and Zapruder film bootlegger Robert Groden, looks strikingly like an Olitski painting: the blue of the president's jacket, the pink of the first lady's suit, the green of the grass, and the fine rusty red spray of the exploded head mingle in delicate abstraction. Attempting to prove conspiracy rather than make art, Groden nonetheless converts the film's basest moment of morbid materiality into a spiritual aerosol.

As Jasper Johns preceded the pop artists, so Mark Rothko, the abstract expressionist, came before the color-field painters. And if enlarged frames of the Zapruder film resemble the work of the color-field artists, they look even more like a sequence of Rothko paintings. During the 1950s Rothko pioneered color-field painting by producing large-scale two-dimensional objects drenched in vaporous clouds of solid yet luminescent tints that seemed to hover over or emanate from vaster regions of pure color. Rothko's paintings, although they are completely non-narrative—they unfold no story, tragic or otherwise—have a haunting, apparitional quality that makes them eerily moving, especially when arranged in a sequence. They are moving in an optical as well as a figurative sense.

The critic Robert Goldwater wrote of the major Rothko retrospective that opened at the Museum of Modern Art in New York days before the Kennedy inauguration (which Rothko attended as a guest of honor), "These are motionless pictures: but despite the repetition of the horizontal—line or rectangle—they are not pictures at rest. The floating shapes convey no sense of relaxation." The German art historian Werner Haftmann noted that in a typical Rothko painting, "The picture became a screen, illuminated by dark light, articulated only by a few colored fields which rise from the ground and sink back into it. These screens of light have nothing more in common with framed pictures."

Rothko's art, this is to say, shares characteristics with motion pictures: the imagery appears to move, to extend beyond the frame, and to be lit from within rather than

applied by brush to the surface, as is the case with most painting. (Rothko's works, in this regard, are even more like TV or computer screens than like movie screens.) Rothkos are especially cinematic when hung in a sequence, as in the Rothko Chapel in Houston, where the color field of one tall canvas seems to seep into that of its nearest neighbor, much as the contents of one frame in a celluloid filmstrip give way to those of the next so that the essential similarities of form create a fluid sense of continuity and the small differences from one frame to another become noticeable only over the sequence.

Zapruder's film, optically enhanced and shown in slow motion, resembles a multitude of Rothko paintings, one following the other. The dense, heavy rectangle of color at the bottom of the picture (the Lincoln) stretches beneath a much larger, considerably lighter color field (the grass). When Abraham Zapruder pointed his Bell and Howell home movie camera at the president, exposing a strip of Kodak color reversal film in a continuous pan lasting twenty-six seconds, he created an artifact that soon took its place in a complex visual—and philosophical—world already populated by the likes of Rothko and his followers. To be sure, Zapruder was not an abstract artist. But then, neither was Mark Rothko, by his own account: "I'm *not* an abstractionist. . . . I'm interested only in expressing basic human emotions—tragedy, ecstasy, doom, and so on—and the fact that lots of people break down and cry when confronted with my pictures shows that I can *communicate* these basic human emotions." Rothko, in a word that came into general use in America in the early 1960s, was an existentialist.

"LIKE IT OR NOT, we are all consumers of existentialism," said *Life*, "buying it in all kinds of packages—novels with faceless characters, plays without exits, nouvelle vague films, whose common perceptible message we already know: human existence is absurd."

This is a surprisingly bleak rumination for a mass-circulation family magazine. What prompted it was a special report on existentialism ("Dealing with Earthly Hells") in November 1964, occasioned by the news that the French philosopher Jean-Paul Sartre had refused the Nobel Prize in literature that had been awarded him. Sartre's audacious gesture shocked many observers; it seemed especially incomprehensible to the bourgeois class he had made a lifelong career of despising, but it caught the rising anti-establishment mood of the times. *Life* gamely tried to explain to its readers what was going on.

Human existence is absurd. That was *Life*'s catchall answer to the meaning of existential meaninglessness. The article, citing Kierkegaard, Heidegger, Rimbaud, Mallarmé, Beckett, Ionesco, Genet, and numerous other continental writers in addition

to Sartre, acknowledged that although artists and philosophers articulated the modern concept of absurdity, modern history promulgated it. The world wars, the death camps, the bomb, all of these brought absurdity to the fore, the ultimate absurdity being that human existence, individual or collective, could be "canceled" without a moment's notice.

As an example of inexplicable cancellation, the magazine singled out JFK's death, representing it not with a photo from Dallas but with an extreme close-up of a *New York Post* front page "extra" in Times Square, with its headline in bold block letters: "JFK SHOT." Above it, in the background, a little girl appears distraught, on the verge of weeping, her trembling fingers pressed against her mouth. *Life* points out that she is part of a billboard display advertising cold medicine. Though she appears to react to the assassination news, she actually has nothing to do with it, aside from sharing photographic space with the headline.

But if *Life* really wanted to get at the heart of absurdity, all it needed to do was reprint the two Zapruder frames reproduced at the end of its Warren Commission issue of four weeks earlier (Fig. 56). One of these, the upper frame of the pair, shows the first lady swiveled about and rising from her seat, pushing off against the inert body that an instant before had been her husband, the president of the United States. A strand of her perfectly coiffed hair lashes her cheek as she clambers from the killing pit. A man in a dark suit is starting to climb onto the shiny limo, which is labeled "Continental" in elegant cursive strokes.

Behind her, three men in suits and ties, frozen in asymmetrical stances, seem to parody the famous garden scene from *Last Year at Marienbad*, Alain Resnais and Alain Robbe-Grillet's enigmatic 1961 art-house movie that the *Life* article cites as an instance of existential indecipherability in cinema (Fig. 57). Of those three men, the one closest to the limousine wields a camera but does not look through the viewfinder. It's as if the scene that unfurls before him defies him to snap its picture. A fourth man, zigzagging horizontally through the air like a Marvel Comics superhero, dives toward the grassy green carpet where his elongated shadow waits.

The lower picture in the sequence appears even more absurd. While an all-American family—father, mother, child—look on, the first lady does an *I Love Lucy* routine, crawling on all fours onto the back of the suddenly accelerating vehicle, looking for what?—Ricky's paycheck that she accidentally tossed into the garbage? Ethel's house keys? Jack's brains? And there's that man again, stepping up onto the rear bumper of the Lincoln like a commuter trying to hop aboard a moving train. If she's ditsy Lucy, he's rubber-limbed Dick Van Dyke, the comic hero of a popular TV sitcom and, in 1964, the creator of Bert, the chimney sweep, in the Walt Disney hit *Mary Poppins*. Van Dyke's physical style of comedy was the sixties' best answer to Buster Keaton, the

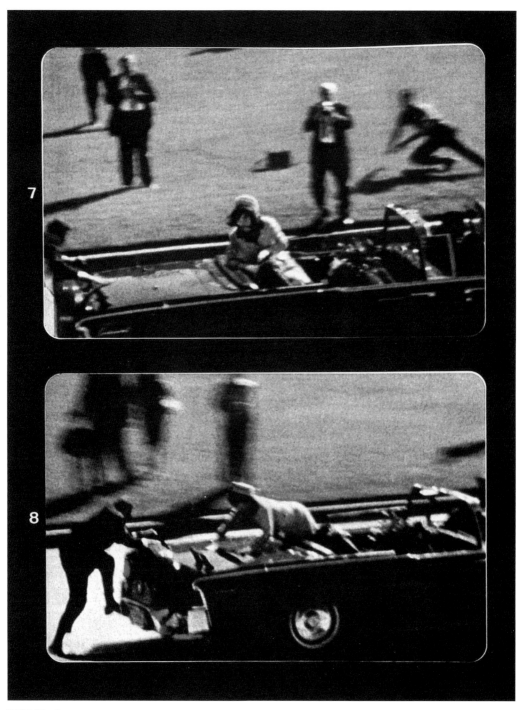

FIGURE 56 | Zapruder film frame enlargements, *Life*, October 2, 1964

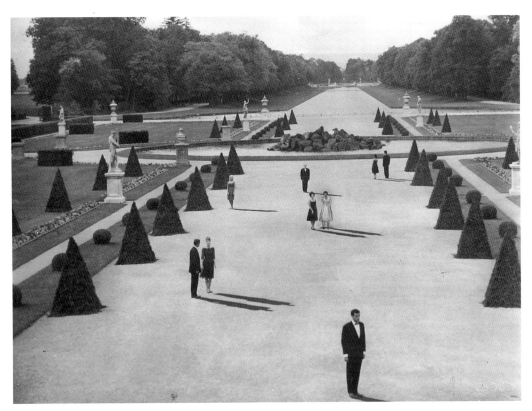

FIGURE 57 | *Last Year at Marienbad,* 1961

silent-era comedian whose acrobatic humor has never been surpassed (not even by his only rival, Charlie Chaplin).

What we have here looks almost like a scene from Keaton's 1927 masterpiece *The General.* Set during the Civil War, the film unfolds the adventures of a woebegone but exceedingly plucky Confederate train engineer who single-handedly chases down his locomotive, "The General," which Yankee spies hijacked from him. His unrelenting pursuit of the powerful machine, which he eventually manages to catch and climb onto despite the obstacles thrown in his path, amounts to one of the most inventive comic sequences in the history of cinema (Fig. 58).

Keaton's comedy and its latter-day derivatives often dramatized a perilous encounter of man and machine, wherein frail but determined humanity (in the case of the Zapruder film, Secret Service Agent Clint Hill) attempts to subdue or at least coexist with inexorable technology (the accelerating Lincoln). Keaton, known as "the great stone face" because of his stoic, imperturbable expression, became a cult figure among six-

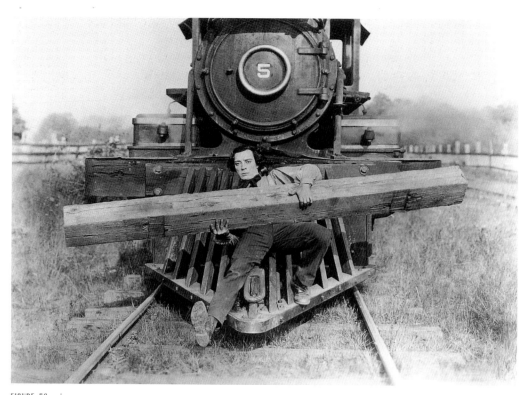

FIGURE 58 | *The General*, 1927

ties artists and intellectuals impressed by what they saw as the surrealist and meta-physical properties of his movies, which were shown on television, in movie house re-vival, and in retrospective at the 1965 New York Film Festival. In 1964 Keaton was even drawn out of semiretirement to appear in an avant-garde film (entitled *Film*) written expressly for him by Samuel Beckett, the master playwright of the Theater of the Ab-surd who is rumored to have had Keaton in mind when he wrote *Waiting for Godot*.

Keaton's movies typically subjected the protagonist to a series of physical humili-ations. In this regard, Jackie on her hands and knees, not agent Hill, is Keatonesque. There she is, one of the most elegant women in the world, climbing out onto the back of a speeding automobile in an act of confusion that would be comic were it not so tragic. In revolutionary France, satirical illustrations mocked the king and queen by showing them in awkward physical positions, out of control of their own digestive and excretory functions (as in David's ink sketch of a toothless Marie-Antoinette). The sans-culottes would find those depictions hilarious. Jackie too is out of control, but only the most extraordinary bitterness toward her and what she represented could make a viewer find her posture, under the circumstances, comically amusing.

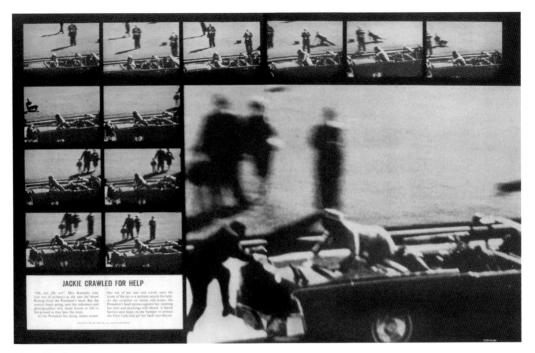

FIGURE 59 | "Jackie Crawled for Help," *Life*, November 29, 1963

PRECISELY SUCH BITTERNESS fueled the notorious "hauling ass to save her ass" routine of the stand-up comic Lenny Bruce in early 1964, at a time when his performances were banned in cities throughout the country and he was continually threatened with prosecution on charges of obscenity. Bruce angrily denounced *Life*'s benign interpretation of Jackie's climbing onto the back of the limo: "As the President lies dying, Jackie scrambles out of her seat and crawls onto the trunk of the car in a pathetic search for help" (Fig. 59). "That's bullshit!" he insisted:

> Why this is a dirty picture to me, and offensive, is because it sets up a lie: that she was going to get help, and that she was helping him [Clint Hill] aboard. Because when your daughters, if their husbands get shot, and they haul ass to save their asses, they'll feel shitty, and low, because they're not like that good Mrs. Kennedy who stayed there. And *fuck it, she didn't* stay there! That's a *lie* they keep telling people, to keep living up to bullshit that never did exist. Because the people who believe that bullshit are foremen of the juries that put you away.

Bruce's biographer contends that "as best as anyone can tell, the single most damning bit of evidence in the subsequent prosecution of Lenny was what his critics felt

was his cruel and angry indictment of Mrs. Kennedy." Over the course of the ensuing years, however, the stand-up comedian's outrageous reading of the *Life* photo went mainstream, especially among college and university students turned cynical by Kent State, the Pentagon Papers, Watergate, and, at a more personal, gossipy level, Jackie's marriage to Onassis and mounting revelations about Jack's extramarital affairs.

Sneering at Jackie for crawling onto the back of the Lincoln—or, more specifically, at the official explanation of why she did so—became a quick and easy way to denote one's independence of the web of lies perpetuated by the corrupt Establishment and its powerful organs of propaganda, such as *Life*, network television, and the Warren Commission. Even today, one's response to the picture of Jackie on all fours is a litmus test of one's political worldview, for the emotion it engenders is likely to indicate sympathy or antipathy toward a range of social values, including early-sixties liberalism, "stand by your man" prefeminism, and Hemingwayesque codes of grace under pressure.

The picture she presents is absurd, a nightmare reenactment of the Reign of Terror. The dainty pink suit, the crownlike pillbox hat, the gawking bystanders: revolutionary Paris has farcically reappeared in Dallas, with the king's widow groveling unceremoniously atop the moving scaffold represented by the Lincoln Continental.

EARLIER I MENTIONED a man on the grass holding a camera. He was James W. Altgens, a photo enthusiast who held a desk job at the Associated Press office in Dallas. Altgens took his lunch hour that day with the intention of photographing the motorcade. As the X-100 slowly approached, he lifted his Nikon and was about to snap a shot when, fifteen feet in front of him, the fatal bullet struck. "Fragments of his head fell right at my feet," Altgens recalled. "I had prefocused, had my hand on the trigger, but when J.F.K.'s head exploded, sending substance in my direction, I virtually became paralyzed. This was such a shock to me that I never did press the trigger on the camera. The sight was unbelievable, and I was surprised I recovered fast enough to make the picture of the Secret Service man aiding Mrs. Kennedy."

Altgens's telephoto image of agent Hill leaning onto the gleaming Lincoln as it angled away toward the light of the underpass made the front page of thousands of newspapers around the globe and won him a World Press Photo award (Fig. 60). What a sorry sight it is.

And what a contrast with the photo, taken a minute or so earlier, with which I ended Chapter 5, showing the Kennedys—the president and his homecoming queen—poised and happy as their imperial chariot, the pride of Detroit, glides slowly, glacially, down the road. Now the Lincoln was at last gathering speed, all of its V-8 power urgently summoned for the futile race to Parkland Hospital.

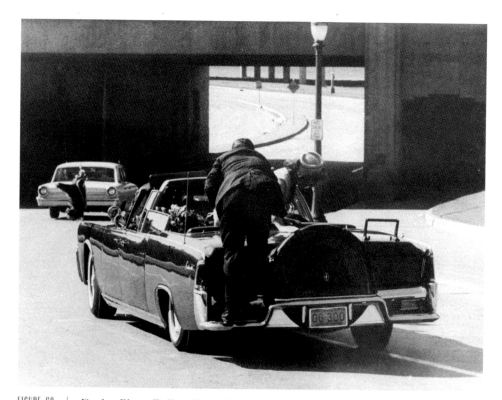

FIGURE 60 | Dealey Plaza, Dallas, November 22, 1963 (James "Ike" Altgens, photographer)

Special Agent Hill told the Warren Commission, "Mrs. Kennedy had jumped up from the seat and was, it appeared to me, reaching for something coming off the right rear bumper of the car, the right rear tail, when she noticed that I was trying to climb on the car. She turned toward me and I grabbed her and put her back in the back seat, crawled up on top of the back seat and lay there." Jackie had no recollection of climbing onto the car, but she did tell the Warren Commission that a moment earlier she had cried (in what must have been less stilted language than the official transcript provides), "Oh, my god, they have shot my husband. I love you, Jack."

It's difficult to believe that she actually uttered those words, even in a more informal version. Under such extreme conditions, she probably didn't think them, either. But that's not to say she didn't feel them, or something equivalent, at the time or in the tranquillity of recollection. I'll admit, this is sentimental of me, a projection of my own music-, film-, and literature-induced preference for a tragic love story, but the historical record provides enough evidence to indicate that she may well have come to love her husband, and he her. One of the most endearing photos of them as a couple shows them in the back of a presidential convertible—not the X-100, but a family car

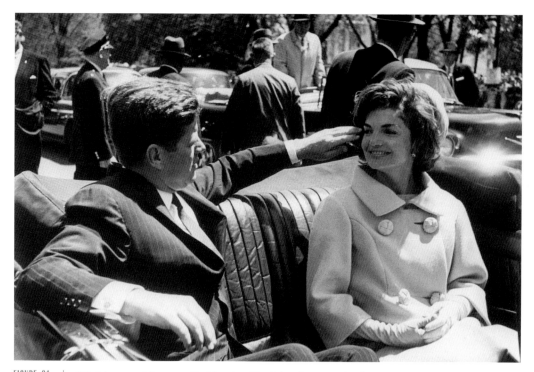

FIGURE 61 | Washington, May 4, 1961 (Stanley Tretick, photographer)

similar to the one of the Gettysburg outing (Fig. 61). She looks radiant, and he, reaching out to touch a wayward strand of her hair, seems to be truly enamored of this queenly woman to whom he is wed.

Think back to the photo of Jack and Jackie sailing joyously ten years earlier. What a long way they have voyaged. The ride in Dallas was not to be their final trip together. Another would begin some two hours hence, when the widow, stained with her husband's blood, saw his body back to the city they'd called home, and the last, three days later, when she accompanied his flag-draped body to the national cemetery.

7

The Loneliest Job in the World

MUCH AS "THE DEATH OF KENNEDY" appears as a latter-day version of David's *Death of Marat,* "The Oath of Johnson" (Fig. 62) seems a modern parallel to the same painter's *Oath of the Horatii* (Fig. 63).

Like Cecil Stoughton's Air Force One photograph, David's masterwork portrays a time of crisis, a swearing of allegiance that takes place moments before a hasty departure. According to ancient legend, three warrior brothers, the Horatii, agreed to fight a duel with three brothers of Rome's enemy Alba to determine the outcome of a war between the two neighboring cities. David shows the Horatii raising their arms in a sacred oath to their father, vowing that they will fight to the death to defend the honor of the republic. Behind the father three grieving women counterbalance the three stalwart men. One of them is their sister, who is engaged to an Alban warrior; another, the Alban wife of one of the brothers. The Horatii's rectitude, confirmed by their swords, lances, legs, and arms and by the unadorned architecture itself, contrasts powerfully with the mournful women's curving femininity. Schematically, the painting pits male valor against female compassion.

Painted on commission from the king some five years before he was overthrown, *The Oath of the Horatii* came to be seen as a prophetic rendering of the revolutionary spirit that swept across France in the aftermath of the American Revolution. Some observers even interpreted the painting as an allusion to the young United States, with its inspiring patriotic self-sacrifice, rejection of monarchy, and dedication to republican virtue. In the Horatii legend Alba, the enemy of republican Rome, was a king-

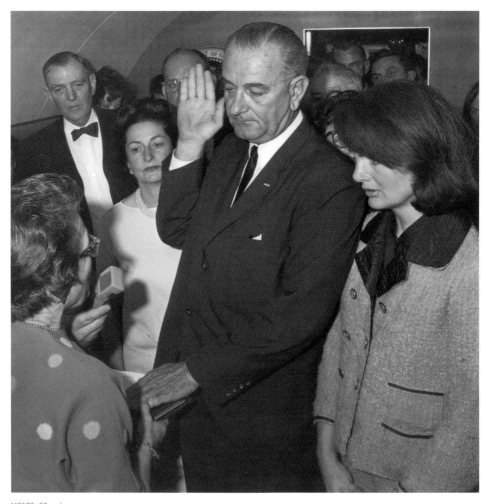

FIGURE 62 | Air Force One, November 22, 1963 (Cecil Stoughton, photographer)

dom. David's French contemporaries, viewing the work in a political context, might thus even have understood Alba to stand for Albion, the ancient name for England.

Stoughton's photograph makes similar points. It shows Lyndon Johnson raising his hand to become the thirty-sixth president of the United States. Three women surround him: the "outgoing" first lady, the incoming first lady, and the government official who administered the oath, Federal Judge Sarah T. Hughes. Johnson stands straight and tall, towering over the women. Lady Bird Johnson, the new president's wife, looks mournful and sad, Jacqueline Kennedy, a bit disheveled and dazed. Yet the widow clearly subordinates her grief to the exigency of history, lending her presence to the occasion to sanction the legitimacy of her husband's successor. While Lyndon Johnson echoes

FIGURE 63 | Jacques-Louis David, *The Oath of the Horatii*, 1784, Louvre, Paris

the unflinching Horatii warriors in this photograph, Jacqueline Kennedy transcendently embodies both the feminine *and* masculine roles laid out by David's painting, a figure simultaneously of stunned grief and of patriotic self-sacrifice.

She hadn't wanted to be there. She had wanted to remain in the back of the plane, alone with the coffin and her husband's closest friends, the so-called Irish mafia of advisors he had kept with him since his early days of politicking in Boston. But Johnson needed her. He understood that the ceremony, without her presence, would lack legitimacy in the eyes of the public.

To that end Stoughton wedged himself against the bulkhead as far forward as possible, and a phalanx of witnesses squeezed into every available spot in the cramped, overheated 16-foot-square stateroom of Air Force One (which sat on the runway sealed tight and without air conditioning), while crew and passengers waited for Mrs. Kennedy to appear. Earlier that day—what already seemed like several lifetimes ago— Jack had joked with the crowd in Fort Worth about her tardiness, excusing it by saying that the end results, her loveliness, made up for the lateness. But now, according to accounts, Jackie was not late because she was making herself lovely. To the contrary,

she explicitly rejected loveliness. Someone had carefully laid out for her on one of the beds in the presidential suite the white dress and white jacket she had been planning to wear in Austin. But when she finally did show up in the packed and sweltering stateroom—saving Johnson the awkwardness of having to go to the rear of the plane to get her, which he was at the point of doing—she was still wearing the blood-stained suit and the bloody white gloves.

Lady Bird Johnson took special note of the gloves: "I looked at her. Mrs. Kennedy's dress was stained with blood. . . . and her right glove was caked, it was caked with blood—her husband's blood. Somehow that was one of the most poignant sights— that immaculate woman, exquisitely dressed, and caked in blood." No wonder Lady Bird focused on this particular accessory. Years earlier she had pithily characterized Mrs. Kennedy as "a girl who was born to wear white gloves." Gloves signaled class. The fashion expert Geneviève Antoine Dariaux, in her 1964 volume *Elegance*, a book club selection, characterized them as "a relatively expensive accessory which require a classic style, an excellent quality, and immaculate freshness." She advised her readers, "Gloves are one of the most unobtrusive accessories when you are wearing them, but their absence is glaringly apparent when you have left them at home!" And she counseled, "You should train your daughter to wear gloves as soon as she is old enough to walk."

Lady Bird was not herself an instinctive wearer of white gloves. Born and raised in the hill country of Texas, equally at home on the ranch and the campaign trail, the owner of several television stations and the manager of Lyndon's senatorial office when he was recovering from a heart attack, she was decidedly not the white-gloves type. "She had always envied the way Jackie wore gloves," reports William Manchester. "She herself usually felt awkward in them and couldn't wait to take them off."

Jackie's gloves were thus not accoutrements that she simply happened to wear on this tumultuous occasion but potent symbols, conveying a world of meaning: elegance and social distinction as well as refinement. The filmmaker Jean Renoir illustrates the social significance of white gloves in his World War I drama *Grand Illusion* (1937), which in the early 1960s ranked in international polls among the greatest motion pictures of all time. Just before embarking on a dangerous mission, Boeldieu, an aristocratic prisoner of war in a German camp, rinses his gloves. "I must admit," comments a fellow officer, "that it wouldn't occur to me to put on a pair of white gloves for this sort of job." Boeldieu shrugs, "Each to his own taste." His comrade observes, "I've been with you every day for eighteen months, and you still say *vous* to me." To which Boeldieu nonchalantly replies, "I say *vous* to my mother and my wife."

Jackie too had been raised with a sense of decorum. In William Manchester's apt phrase, she was bred "to be courteous in adversity."

THE SCENE STOUGHTON CAPTURED with his camera was packed not only with people but also with tension. Lady Bird was appalled at her own remark to Jackie when first seeing her on the plane earlier in the afternoon: "I don't know what to say," she had sobbed, groping for words. "What wounds me most of all is that this should happen in my beloved State of Texas." The Johnson aides were wary of the Kennedy men, who in turn resented their president's plane being commandeered by this new president, for whom they had no respect and who, moreover, had Air Force Two at his disposal. Even the pilot of Air Force One felt the sanctity had been violated. "I just didn't want to be in the [oath-taking] picture," he later recounted. "I didn't belong to the Lyndon Johnson team. My President was in that box." Meanwhile, the Secret Service men, distraught over their failure to protect one president and fearful of an attack on his successor, urgently wanted the plane to take off for the relative safety of the sky and the full-scale security of the White House.

Much to their frustration, the commander in chief refused to depart until he had been properly sworn in *and* the photographic documentation of the ceremony was on its way to the wire services that would transmit it around the globe. Kennedy's men, like the Secret Service staff, were desperate to be airborne, because Dallas officials, governed by local statutes on capital crimes that required a thorough autopsy before a body could be removed from the city, had threatened to impound the president's corpse. Johnson would not leave unless Mrs. Kennedy remained aboard the plane, and she clearly would not remain if her husband's body were taken back to the hospital.

Even Cecil Stoughton was tense during the ceremony he recorded. He recognized that this was the most important photo shoot of his life—not only would the photograph he made show history; it would also *be* history, inseparable from the event that occasioned it. Yet when he first pressed the release of his ever-reliable Hasselblad, before Jackie arrived, the flash failed to operate. Anxiously, he jiggled a small connector wire and tried again. This time his equipment worked. He fired off a series of shots, taking extra care to crop the camera's field of view so that the bloodstains on Mrs. Kennedy's outfit would not appear in any of the negatives.

The judge's reading of the typewritten oath and Johnson's repetition of her words lasted twenty-eight seconds—two seconds longer than Zapruder's home movie. Hastily, the photographer, the judge, and a handful of others who were to remain in Dallas made their way to the exit and down the stairs to the runway while the captain revved the engines. Moments later Air Force One, the sleek and glorious aircraft that had landed only three hours earlier, retreated into the sky.

Judge Hughes, seen administering the oath in Stoughton's over-the-shoulder shot, went on to have a distinguished career as a federal judge. A decade after the swear-

ing in, she once again put her mark on history when she presided in the case of *Roe v. Wade.*

Captain Stoughton, an officer in the Army Signal Corps, continued as the official White House photographer until the summer of 1965, when he applied for permission to attend the dedication of a Kennedy monument in England, at Runnymede. It would mean a great deal to him to go, he explained, since he had been so close to the president's family. A week after his return he received orders transferring him out of the White House. He was reassigned to an obscure Pentagon office.

One year after the ceremony on Air Force One, Lyndon Johnson savored a landslide victory over his Republican opponent, Barry Goldwater. It was the most lopsided decision in presidential history, and this time Johnson was duly inaugurated on the steps of the United States Capitol, with the chief justice of the Supreme Court, Earl Warren, presiding. Four years later, a defeated man who had withdrawn summarily from the race for his party's nomination after a disappointing showing in the New Hampshire primary, he stood on the reviewing stand witnessing the inauguration of his successor, Richard Nixon.

In taking the oath of office, the president accepts the mitigated powers of the chief executive and abjures those of an unlimited monarch. The oath compels the new American president to swear solemnly, in public, that he will not usurp the prerogative of the people embodied in the Constitution, but rather will subject himself to their will. Taking the oath in public is a formality, but not a mere formality. Tocqueville explains that formalities provide necessary and effective constraints on power: "Men living in democratic centuries do not readily understand the importance of formalities and have an instinctive contempt for them. . . . Formalities become more important in proportion as the sovereign is more active and powerful. . . . Thus democracies by their nature need formalities more than other peoples, and by nature have less respect for them."

Jacqueline Kennedy grasped the importance of formality, especially in the midst of crisis, and that is why she consented to stand beside Lyndon Johnson as he raised his hand in oath. She lent a dignity to the occasion that could not have obtained without her. Lyndon Johnson also understood the need to take the oath in the most formal possible manner, despite the radical informality of the setting and the circumstances.

Again, the art of Jacques-Louis David provides an iconographic antecedent for the historical document made by Cecil Stoughton. The Air Force One photo falls between two polarities of David's painting, as represented by the austere neoclassical masterpiece *The Death of Socrates* (Fig. 64) and the grand opera spectacle known as *The Consecration of Napoleon* (Fig. 65). The earlier painting depicts the martyrdom of the Athenian philosopher who, according to legend, died for his adherence to the democratic principles of truth telling, free inquiry, and independent thought, all highly

prized during the Age of Reason that spawned the American and French Revolutions. In an austere chamber marked by a Doric arch like those in the *Oath of the Horatii* (arches echoed in the curving walls of the stateroom on Air Force One) Socrates raises his hand to affirm his beliefs before accepting the fatal cup of hemlock. His somber disciples gather about him in a frieze of figures who bend this way and that while he, the tallest and most upright of the group, radiates light, authority, and solemn majesty.

Johnson, of course, is not preparing to die, nor are his disciples/aides weeping at his imminent demise, although he too is about to raise a most bitter cup to his lips. Paramount in both images are the stark mood, the humble setting, the sense of urgency, the historical significance, and, above all, the notion of supreme dedication to civic and republican virtue.

By the time David painted *The Consecration of Napoleon*, republican virtue in his homeland was a thing of the past. Napoleon crowned himself emperor in an overwhelming display of spectacle that he asked David to re-create in paint. Employing a canvas of superhuman dimensions, David, with a corps of assistants, portrayed the scene that took place in Notre-Dame Cathedral in December 1804. Of the multitude of portraits in the painting, only those of Napoleon and Josephine are vastly idealized. Napoleon refused to pose. "Why do you need a model?" he asked the artist. "Do you think the great men of antiquity posed for their portraits? Who cares whether the busts of Alexander the Great look like him? It is enough that we have an image of him that conforms to his genius."

Stoughton's Air Force One photograph is strangely like and unlike *The Consecration of Napoleon*. Like, in that it captures an important historical moment—an inauguration of great international significance—and does so by detailing the diverse attitudes and expressions of the assembled witnesses. Like also, in memorably portraying the leader in an image that, in Napoleon's words, "conforms to his genius," which is to say, embodies him for posterity. But these similarities pale compared with the differences between the black-and-white photograph and the gargantuan color painting. The differences are evident not only in size, medium, and the compositional rendering of space but also in meaning. The swearing-in photo *renounces* the imperial opulence of the coronation painting; it is, in effect, anti-Napoleonic. It strives to express republican simplicity, plainness, and virtue. It is a humble document and, as such, a document of presidential humility.

Even the extreme compression of space in the photograph conveys the underlying meaning of the presidential oath: that the president swears not to expand his personal and political powers beyond the strict boundaries laid out in the Constitution. Johnson's arm, pressed unnaturally close to his body in the tight space, suggests the binding nature of his oath.

FIGURE 66 | Air Force One, November 22, 1963 (Cecil Stoughton, photographer)

BEFORE, DURING, AND IMMEDIATELY AFTER the ceremony, Captain Stoughton fired off a total of thirteen shots with his 35-mm camera and eight with his 120-mm Hasselblad. All but two of the twenty-one original negatives are now preserved in the Lyndon Baines Johnson Library in Austin. One of those two is a shot of the ceremony, the other a glimpse of relaxed tension once it had ended. The photo historian Richard Trask surmises that the second negative, next-to-last in the series, was withheld from the Johnson Library collection (and probably destroyed, although a print of it survived) because it "may have been construed" as showing an indiscreet gesture.

This picture has come to be known as "the wink photo" (Fig. 66). President Johnson has turned away from the camera with what appears, from the contours of his profile, to be a smile on his face. Directly in his line of gaze is his friend Congressman Albert Thomas, the man at far left with the bow tie. Solemn to the point of being lugubrious in the previous shots, Thomas now appears to be winking.

Conspiracy theorists have seized on this picture as evidence of a plot against

Kennedy by his successor, their speculation all the more persistent because the original negative was pilfered or destroyed. But two conspirators would have refrained from exchanging congratulations in the airplane's close quarters, in full view of everyone else, including the photographer of record. If Thomas is indeed winking, that overt gesture of solidarity with the new president hardly suggests secretive complicity. It may not even be a wink, but rather a blink, that involuntary closing of the eyelids that typically occurs in any candid group photo.

Whether "the wink photo" is innocent or sinister, the original negative is gone, probably because someone in the Johnson White House thought better of entering into the historical record any hint of levity that might compromise the integrity of the presidential succession.

"THE LONELIEST JOB IN THE WORLD" graphically conveys the immense burden that rests on presidential shoulders (Fig. 67). It originally appeared in a *New York Times Magazine* picture essay entitled "A Day with John F. Kennedy" that inventoried the new president's typical workday in mid-February 1961, a few weeks after his inauguration. In its original context the picture illustrated not the transcendent but rather the more mundane side of the presidential occupation.

George Tames, the *Times* photographer granted access to the Oval Office and Cabinet Room, snapped away as the president met throughout the day with members of his staff, cabinet advisors, government officials, and even a local beauty queen and her court. The resulting four-page spread contained twenty-one photographs showing the president at his job from 10:25 in the morning to 7:38 in the evening, with the precise time of each activity specified in the captions. At the bottom of the third page was an image of Jack at 5:01, catching respite from his many face-to-face encounters. The caption reads, "Awaiting the arrival of French Ambassador Hervé Alphand, the President—as is his habit—snatches a moment to read an official document, leaning over the table."

Years later Tames explained that the president, because of his bad back, had a habit "of carrying his weight on his shoulders, literally, by leaning over a desk, putting down his palms out flat, and leaning over and carrying the weight of his upper body by his shoulder muscles, and sort of stretching or easing his back. He would read and work that way, which was something I had seen him do many times."

Although the *New York Times Magazine* caption says that the president is reading an official document, the photographer recalls that he was actually reading an editorial in the *New York Times* by Arthur Krock. Noticing that Tames had slipped into the room, Kennedy looked over at him and said, "I wonder where Mr. Krock gets all the crap he puts in this horseshit column of his."

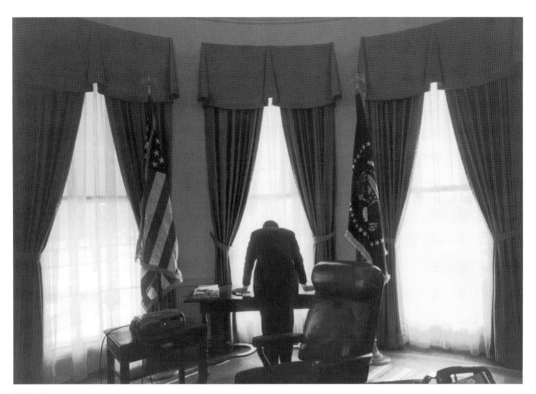

FIGURE 67 | "The Loneliest Job in the World," Oval Office, February 10, 1961
(George Tames, photographer)

A week later, when the president flipped through a copy of the magazine before it appeared on the stands, he singled out the picture of himself with his palms on the table. According to Tames, "When he got to the third page and his eyes were wandering down he spotted this picture. It was a small size, right in the center, looked like it was three inches by four inches, or something like that. He put his finger on it, and looked over at me and said: 'This should have been on the cover.' It struck him right off that he knew that was an important picture and that it was not being played properly."

Regardless of its original context, the photograph is a masterpiece of Davidian gravity and drama. Its overall mood, however, is not neoclassical but neo-Gothic. Think back to *The Oath of the Horatii*, with those three massive Doric arches that dominate the figures and give the scene a steady, drumlike rhythm. Now eliminate all but one figure, transform the arches from rounded to peaked, and replace their dark, heavy shadows with diaphanous white light. Turn the one figure to face into the setting, lean him forward instead of back, and center him within the middle arch. Lower his head, bow his shoulders, silhouette his form. Place him midway between two spearheaded

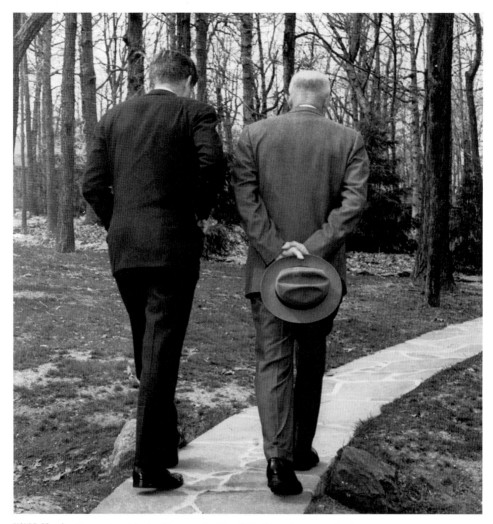

FIGURE 68 | Camp David, April 22, 1961 (Paul Vathis, photographer)

flagpoles bearing the presidential and American flags. Swivel the leather armchair away from the desk, as though its occupant has had to vacate it—the place of business-as-usual—to contemplate matters of grave national importance (hinted at by those otherwise ceremonial flags). In the lower right foreground, almost cropped from the picture yet intrusively present, rests the presidential telephone, which at the height of the cold war inevitably symbolized the global thermonuclear destruction that for the president of the United States was but a phone call away.

A second photograph from Kennedy's first months in office similarly captured the seriousness of presidential responsibility (Fig. 68). Like "The Loneliest Job," it pic-

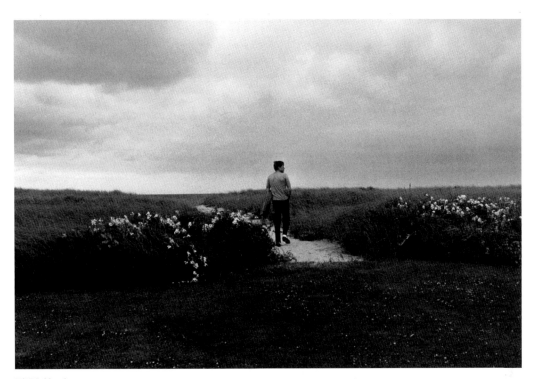

FIGURE 69 | Hyannis Port, August 1959 (Mark Shaw, photographer)

tures the chief executive turned away from the camera, and like Cecil Stoughton's shot of the swearing in aboard Air Force One, it portrays a scene of presidential succession. This photo was thought to be so striking and to say so much about the tenor of the times that it won a Pulitzer Prize for the man who took it, the Associated Press photographer Paul Vathis. It seemed to capture a moment of transition that was at once historical and archetypal.

Along with Garry Winogrand's photograph of Kennedy accepting the presidential nomination in Los Angeles (see Fig. 33) and Mark Shaw's picture of Jack, turned away from the camera, walking alone on the dunes near Hyannis Port (Fig. 69), which *Life* poignantly used to close its November 29, 1963, special issue on the assassination, the Tames and Vathis pictures of JFK with his back to the camera contributed immensely to his romantic aura. Shaw's photo in particular embodies an observation that Norman Mailer makes in "Superman Comes to the Supermarket," a profile he wrote on the Democratic candidate during the 1960 presidential campaign: "Kennedy's most characteristic quality is the remote and private air of a man who has traversed some lonely terrain of experience, of loss and gain, of nearness to death, which leaves him isolated from the mass of others."

Together, these various pictures draw, however unknowingly, on the visual motif of the *Rückenfigur*, the figure seen from behind, so evocatively employed by the great German Romantic painter Caspar David Friedrich. In early-nineteenth-century masterpieces such as *Two Men Contemplating the Moon, Woman at the Window, Wanderer above the Sea of Fog*, and *Moonrise at Sea*, Friedrich arouses complex emotions in viewers by enjoining them to gaze at the backs of figures who, standing, sitting, or walking, face away into the distance.

The Vathis photograph appeared across the country in morning editions on Sunday, April 23, 1961. It shows President Kennedy and his predecessor, Dwight D. Eisenhower, walking side by side on a flagstone path through the woods of Camp David, their backs to the camera. Earlier in the week a secret invasion of Communist Cuba by Cuban exiles had gone terribly awry at the Bay of Pigs, and military disaster had ensued. Outraged, the world demanded to know the extent of the U.S. government's involvement. Kennedy requested help from Eisenhower, who flew to Camp David to join him for discussions. After the two men had finished posing for photos, Eisenhower said to Kennedy, "Come on up here, I know a place where we can talk." As they turned away, the AP's Vathis snapped his photograph, later commenting, "There were just the two of them, all by themselves, their heads bowed, walking up the path. They looked so lonely."

Perhaps Kennedy's hands, dipping shallowly into his tailored coat pockets, convey something of his eagerness to please his elder, or at least defer to him. Eisenhower's hands, in contrast, are fully visible, neatly folded and centered behind him, holding his fedora. Eisenhower here, true to his public persona as an evenhanded, foursquare, straight-shooting man, is a study in balance that is physical and, by extension, moral.

Whatever the subtle differences between the leaders—in their bodies, postures, and apparel, and in the larger political and generational differences those elements signify—the overall feel or subliminal message of the photograph is one of harmony and grace. Two men walk musingly, shoulder to shoulder, along a curving path, their upright bodies in accord with the rhythmic curtain of tall trees across the upper half of the picture.

The photograph purveyed an image of presidential stability and humility during a time of national crisis. The new, youthful leader walks humbly beside his wise elder and takes counsel in the ways of good governance. The scene has a vaguely Shakespearean quality, from the bare, ruined choirs of the trees that have not yet shaken off winter to the implicit characterization of Kennedy as Prince Hal, prepared at last to assume the mantle of leadership from his kingly elder.

The viewer came to the photo knowing that the man on the left was the commander in chief of the United States armed forces—the one who could dial up nuclear annihilation from his desktop telephone. It was on his watch that the Cuban counter-rev-

olutionaries had launched the ill-supported invasion of their homeland. So if he embodied youthful humility here, he also embodied physical force. The man on the right no longer wielded the power he once had, first as chief of the D-Day invasion and then as the thirty-fourth president of the United States, but, as the picture seems to attest, his stature, far from diminishing, had increased. Kennedy's calling him to Camp David implied at least that much. The men's bowed heads soften the aura of great power about them, as does the serene natural setting, where bleak winter gives way to spring, the archetypal season of renewal.

Though the trees at Camp David are naked, they, like Kennedy and like the nation itself, are in the midst of transition. That analogy alone might have suggested to viewers that Kennedy and the nation would right themselves in the end. Thus does the news photograph, which illustrates an informal political discussion at a time of international turmoil, superimpose on its timeliness a reassuring grid of timelessness—the eternal cycle of nature on the cusp of spring and the archetypal encounter of sons with fathers, youth with age.

BUT IT WASN'T SPRING on Air Force One. In Stoughton's photo Lyndon Johnson is the man in the crowd, part of it yet apart from it. The picture shows him at the moment that he becomes the new and sole occupant of "the loneliest job in the world."

In 1963 many Americans looking at that news photo might have been reminded of one of the great mythic moments of the Hollywood western, the deputizing of the lawman. In countless feature films and TV episodes during the heyday of the western, a judge or justice of the peace swore in a good, decent, upstanding citizen, authorizing him—always a "him"—to enforce the law, by violent means if necessary. The regularity with which such scenes took place in the westerns that proliferated on TV in the late fifties and early sixties suggests an abiding appetite on the part of the public for rituals legitimating law enforcement and law enforcers.

The acclaimed western *High Noon* (1952) did much to solidify the heroic public image of the lone lawman (Fig. 70). In an Oscar-winning performance the veteran Hollywood star Gary Cooper plays a frontier marshal who, on the day he plans to retire from office, must confront a band of outlaws whose murderous leader will be arriving on the twelve o'clock train. The gang will meet him and then exact revenge on the marshal, who sent the leader to prison. Cooper tries to enlist the aid of various townspeople, but fearing retribution, they refuse to help, unwilling to stand up for the law and order Cooper represents. They advise him to leave town before the appointed hour of noon.

Instead, the lawman literally—as well as morally—stands his ground. An extraordinary camera shot that immediately precedes the denouement encapsulates his

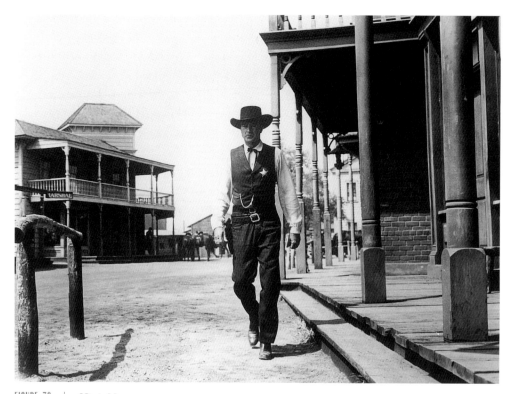

FIGURE 70 | *High Noon*, 1952

situation. From a tight close-up on Cooper's tensely lined face, the camera rapidly pulls up and away higher and higher into the air, until it gives a bird's-eye view of him standing utterly alone in the now deserted Main Street of the town he had taken an oath to protect and defend. While the camera holds that angle, the sheriff, appearing as tiny and powerless as he feels, heads slowly and miserably up the street. A few minutes later, when the gunfight has ended and he alone survives, the townspeople throng back into the street and crowd around him with cheers and congratulations. He gazes on them with contempt, plucks off his badge, and flings it to the ground.

Given the historical period in which it was made, *High Noon* is often regarded as an allegory of anti-Communist blacklisting, in which the craven townspeople represent the Hollywood establishment that was afraid or unwilling to stand up to Joe Mc-Carthy ("Frank Miller") and his thugs and quickly abandoned the few filmmakers and civil libertarians who had the gumption to resist extremism. ("Do not forsake me, oh my darlin'," crooned Tex Ritter in the wistful folk ballad that opened and closed the film.) Of course, it could just as easily have been taken as a right-wing cold war allegory condemning liberals and leftist sympathizers who were afraid to speak out against

Joe Stalin and *his* thugs and to support the efforts of courageous evil-fighters such as . . . Senator McCarthy. Either way, the film sets forth, especially in that one memorable camera shot, a powerfully sympathetic image of a middle-aged man's moral courage and willingness to accept responsibility, however lonely and dire.

This sympathetic image, in turn, surely informed the way millions of Americans, nearly a dozen years later, looked on the middle-aged man being sworn in on Air Force One. Cooper, a tall, lanky westerner who was fifty when he made the film but looked older, established a template of response for another tall, lanky westerner, the Texan Johnson, who was fifty-five when he raised his hand before Judge Hughes. The shooting in Dallas, like the shootout in the movie, had occurred shortly after twelve. Under normal circumstances, the president of the United States takes the oath of office in a ceremony that begins at twelve sharp. It was half past two when Johnson officially became the nation's chief lawman, but to anyone looking at the photo of the ceremony, the atmosphere aboard the plane (and, indeed, across the land at that hour) evokes the tense mood of *High Noon*.

AS A TERRIBLE IRONY would have it, I write these words in the immediate aftermath of the September 11, 2001, terrorist attacks on New York and Washington. Americans everywhere are still in shock, their insides knotted in disbelief, dread, and outrage. This morning's paper contains a syndicated column that begins, "In modern peacetime, only the 1963 assassination of President John F. Kennedy matches the enormity of the horror and angst produced by the attacks against the New York World Trade Center and the Pentagon." It continues: "Lee Harvey Oswald's murder of the president was a direct assault on a flesh-and-blood symbol of American power. Tuesday's assault on buildings that represent our global financial and military supremacy carried the same impact. In both cases, the country went on an emergency alert as concerns for national security and fears of a worldwide conspiracy were raised."

The columnist, Marianne Means, recalls that "a communist plot, a domestic military coup or some other unimaginable orchestrated calamity could not be ruled out in 1963, at the height of the Cold War. Johnson told me some time afterward that he had indeed originally suspected the Soviets might seek to take advantage of the American confusion to make some big military move." She describes how the new president's first task at a moment of agonizing national bewilderment and dismay was to "reassure all of us with calm leadership."

The swearing-in photograph was the very first means by which Johnson sought to offer the nation that reassurance. Along with the televised funeral proceedings that in the following days gave viewers across the globe an impressive and moving display of national strength and unity, the Stoughton photo was in itself an act of leadership.

FIGURE 71 | *High Noon*, 1952

That is, by showing Johnson's orderly assumption of the presidency—by showing leadership at its moment of inception and certification—the picture affirmed the stability and continuity of the federal government in a time of crisis.

In the photo no one is shouting, weeping, or fainting; there is no melodrama. If you didn't know who these people are and where the scene is taking place, you might think you were looking at a civil wedding ceremony, a May-December marriage conducted by a small-town justice of the peace, with the pretty young bride looking on as her groom says "I do." Oddly enough, the picture bears a resemblance to the scene at the beginning of *High Noon* where a conspicuously middle-aged Gary Cooper marries a much younger bride, played by Grace Kelly (Fig. 71). To the extent that weddings are symbolic public rituals having to do with the strengthening of community and its perpetuation across generations, the swearing-in photo is a kind of wedding picture, reassuringly invoking the vows taken every four years by the president, who swears allegiance to the Constitution. And the picture is comic rather than tragic inasmuch as comedy is the dramatic genre that says to the audience, Everything is going to work out in the end, life will go on, the sun will shine again no matter how omi-

nous the clouds, and the community will flourish. That's precisely the underlying message of the photo.

Even so, it still portrays a tense and dramatic scene, especially since anyone looking at it then or now would know the circumstances and would read emotion into the faces of the principals and onlookers. Typically, photo editors have cropped the picture when reproducing it, getting rid of the empty space above Johnson's head and thus making it seem as if the very walls press down and in on him. (I've done the same in this book.) All these figures squeezed into a tight, rounded space call to mind the early Christians gathered to worship secretly in the Roman catacombs. Or they look like civilians packed together in a concrete bunker during an enemy air raid in the war that had ended less than two decades earlier. Such images from places like London during the blitz, originally described and evoked by radio and print journalists, later in personal memoirs, films, and fiction, circulated widely in postwar culture.

Fallout shelters were an even more pertinent reference point for those looking at the photo in 1963. The strontium 90 scare of the early sixties, caused by the discovery that poisonous radioactive particles were filtering down into the atmosphere from nuclear weapons tests on the other side of the globe, and the Cuban missile crisis, which showed how close at hand Armageddon could be, led to a frenzy of bomb-shelter construction in suburban America. Those who couldn't afford to build their own underground backyard shelters or rejected the exclusionary every-family-for-itself-and-the-rest-be-damned nature of such hideouts were encouraged by civil defense films and pamphlets to wall off a section of the basement and stock it with food rations, flashlights, a battery-operated radio, and other essential provisions. The fascinating and often bizarre 1982 documentary *Atomic Café*, a compilation of period footage from science fiction and public service films of the fifties and early sixties, shows a range of customized fallout shelters, with the clips edited to elicit laughs and wonderment at the public's naïveté. In its glibness, the movie fails to convey the genuine angst of the times.

A much better way to experience the psychology of those who lived under the ever looming shadow of the bomb is to read a best-seller of the period, for example, *On the Beach*, Neville Shute's 1957 novel set in the near future. In it a small group of individuals in Australia await the inevitable arrival of a radioactive cloud unleashed by a nuclear war in the Northern Hemisphere. Even more gripping is Eugene Burdick and Harvey Wheeler's *Fail Safe*, which first appeared in print serialized in the *Saturday Evening Post* in October 1962—the month of the missile crisis.

In this story, the U.S. president confers with his Soviet counterpart over the hot line to prevent a Strategic Air Command bomber, launched in error by a computer malfunction, from reaching its target with a payload of atomic weapons. When aborting the mission proves impossible because the plane has already passed its "fail safe" callback point and the Russians are unable to strike it down from the sky, the presi-

dent, to forestall nuclear war, backs up his claim that America had not intended to bomb Moscow with an offer to destroy New York City. The movie version, in preproduction before the assassination but filmed afterward, featured Henry Fonda as a president modeled on JFK.

Because of the initial fears that Kennedy had been shot down by Soviet agents as a prelude to war, the specter of impending nuclear annihilation underlies the Stoughton photograph. Dallas police had apprehended Lee Harvey Oswald nearly an hour before the swearing in took place, but his arrest did not allay concerns that the Russians were behind the killing, especially once it became known that the suspect had sojourned in the Soviet Union and was married to a woman from Minsk. Air Force One may well have seemed to a frightened public like a movable bomb shelter that could protect the head of government from nuclear attack, at least long enough for him to organize civil defense and command retaliation.

Another movie about nuclear threat that was in the works at the time of the assassination was Stanley Kubrick's black comedy with the impish title *Dr. Strangelove, or: How I Learned to Stop Worrying and Love the Bomb*. Based most loosely on Peter George's drably serious 1958 novel *Red Alert*, Kubrick's film has basically the same plot as *Fail Safe* but spins it off in surprisingly hilarious directions. Several satirical scenes take place in a futuristic-looking command center tucked away deep beneath the Pentagon (Fig. 72). In one, the mild-mannered president, played by Peter Sellers, breaks up a fracas between two high-ranking officials by scolding, "You can't fight in here, this is the War Room." In another, the chairman of the Joint Chiefs of Staff, Buck Turgidson, played by George C. Scott, chomps enthusiastically on a wad of chewing gum while envisioning the good life of those select few, himself included, who will wait out the long nuclear winter in underground cities lavishly stocked with booze and broads.

In tone and attitude, *Strangelove* is the antithesis of Stoughton's photo. Opening only seven weeks after the assassination, it enraged many viewers (and nonviewers), who found it in bad taste. The *Washington Post* deemed it "anti-American" and the *New York Times* reviewer, calling it "beyond any question the most shattering sick joke I've ever come across," objected to its "contempt for our whole defense establishment." Those comments explain why the movie subsequently achieved cult status among a growing number of disaffected youth. To them, President Johnson's pronouncements about the escalating war in Vietnam smacked of sanctimony, and the high seriousness of the photo seemed suspect and contrived to sensibilities reeducated by the grim satire of the stand-up comics Lenny Bruce and Mort Sahl and the mordant irony of Stanley Kubrick.

In August 1964, less than ten months after taking his oath to "preserve, protect and defend" the Constitution, President Johnson used what he claimed was an unprovoked

FIGURE 72 | *Dr. Strangelove,* 1963

attack on an American destroyer in Vietnam's Gulf of Tonkin to ask Congress for per-
mission to expand U.S. involvement in the Vietnamese civil war. The resulting Tonkin
Resolution, passed unanimously in the House and with only two dissenting votes in
the Senate, authorized the president to take action in Southeast Asia as he saw fit. It
allowed him to initiate hostilities without the formal congressional declaration of war
required by the very Constitution he was sworn to preserve. Almost immediately Amer-
ican warplanes began bombarding North Vietnam.

The road from the runway of Love Field to the skies over Hanoi was paved with
many intentions. Whether they were good ones increasingly became a matter of
dispute.

DARKNESS HAD FALLEN by the time the plane carrying the two presidents, one liv-
ing, one dead, arrived at Andrews Air Force Base. Audiences nationwide looked on anx-
iously as the jet touched down, taxied, and finally came to rest. They watched as a large
catering truck with a hydraulic lift pulled up to a door near the rear of the aircraft.

While a throng of somber diplomats and government officials waited on the tar-
mac by the plane's forward door, the catering truck lifted a military unit to the door

FIGURE 73 | Andrews Air Force Base, November 22, 1963

at the rear. Their task was to remove the 400-pound solid bronze casket and the 180-pound corpse inside and place them in a waiting ambulance. Five of the Secret Service agents who had been assigned to Jack and Jackie Kennedy appeared in the doorway and brushed aside the soldiers, determined to stay by their fallen leader rather than relinquish him to strangers. They struggled with the massive coffin. Behind them stood the widow, her hand clasped by her brother-in-law, Robert Kennedy, the attorney general, her skirt and stockings still caked with presidential blood (Fig. 73).

Until this moment, the public had not glimpsed those appalling stains. Once seen, they could not be forgotten.

Down in the Basement

THE DAY I TURNED THIRTEEN, I saw a man murdered on TV. That was not extraordinary. In those days I watched what now seems an inordinate amount of television, and not a week went by when I didn't see fatal shootings. In the unequivocal moral language of my thirteen-year-old self, the men who died were always "bad guys," and their deaths usually brought me satisfaction.

I didn't know the man I saw killed that day. I lived in Ohio and he in Texas. But I did know that he was a bad guy, and therefore, even though stunned by what I witnessed, I wasn't devastated. This was vigilante justice. In the TV shows I watched and the comic books I read, vigilantes were good guys; a vigilante acting alone at the behest of conscience was to be admired. Vigilante groups, in contrast, were usually in the wrong, taking matters into their own hands and forming lynch mobs that authority figures such as *Gunsmoke*'s Marshal Dillon had to disarm, for mob rule was always bad.

One of my favorite shows, the one that appeared immediately before *Gunsmoke* every Saturday night from 1957 until the fall of 1963, was *Have Gun Will Travel*. This was a series about a gunslinger for hire (Fig. 74). Contrary to the standard iconography of western heroes, he dressed in black. Nonetheless, he was a figure of moral rectitude. He called himself Paladin, which means knight-errant. The catchy theme song, sung by Johnny Western, characterized him:

> "Have Gun Will Travel," reads the card of a man,
> A knight without armor in a savage land.

FIGURE 74 | *Have Gun Will Travel*

His fast gun for hire, he's the calling wind.
A soldier of fortune is the man called Paladin.

Four decades have passed since the Dallas striptease club owner Jack Ruby burst
out of a crowd of newsmen gathered in the basement of the Dallas city jail and pumped
a fatal bullet into Lee Harvey Oswald as the suspected assassin was being transferred
to the county jail. But still no consensus has been reached on the reason he shot Os-
wald, or Oswald the president, if indeed he did. The only consensus is that conspiracy
theories abound. In some of them, Oswald was a hired hit man, summarily liquidated
by a second hit man to keep him from talking. In other theories Oswald or Ruby or
both were acting at the behest of an extremist group on the left. Or the right. Or one
or the other of them was acting on orders from a government agency: the FBI, the
CIA, or a cabal of high-ranking military officials and arms dealers fearing that an im-
pending shift in presidential foreign policy would imperil their growing franchise in
Vietnam.

A headline written by the editors of the *Onion*, a satirical newspaper, for a book entitled *Our Dumb Century* (1999) both summed up and cleverly lampooned the delirium of possibilities the theorists had unleashed on the public: "Kennedy Slain by CIA, Mafia, Castro, LBJ, Teamsters, Freemasons." My own theory—though in this instance that's too grand a word—is that the lethal tussle in the basement of the city hall was a fight between two would-be paladins. Each of them, I suspect, regarded himself as a knight on a mission to avenge wrong and restore right. The original paladins served under Emperor Charlemagne in the ninth century; there may have been an unseen and still unknown modern Charlemagne behind Oswald, and another behind Ruby: an army general, a crime boss, a Latin American dictator, or, what seems most plausible, an inner demon. In the 1970s, when Vietnam and Watergate helped to school the American population in cynicism, it would have seemed ludicrous to propose that idealism rather than the manipulations of hidden puppeteers drove Oswald or Ruby—or Kennedy. But now, in the early 2000s, we know better. Arthur Bremer (who shot Governor Wallace), Mark David Chapman (who killed John Lennon), and John Hinckley (who wounded President Reagan) have proved that one need not belong to a conspiracy or act on orders to shoot a famous (in Ruby's case, infamous) public figure.

It wouldn't have occurred to me as a thirteen-year-old that a bad guy could act on principle, albeit a distorted one. None of my various conduits of learning—television, movies, junior high, Sunday school—allowed for moral complexity. Jean Renoir's dictum "Everyone has his reasons" carried little weight in that value system.

Oswald and Ruby were classic losers. Violent, undereducated, raised in broken homes by neurotic, paranoid, and, in Ruby's case, emotionally unstable mothers, unable to hold a steady job (Oswald) or stay out of debt (Ruby) or maintain long-term sexual relationships, and puffed up with compensatory delusions of self-importance and behind-the-scenes power, each of these men seems more his own paladin, acting for himself rather than on behalf of a Charlemagne.

THE SLIGHT YOUNG FELLOW with sandy-colored hair and a weasel face escapes into a movie theater in the middle of the day. The lights are down, the screen flickers silver. Talking heads spew dialogue. Police enter the theater. They're pursuing the fugitive and have been tipped off that he's fled here. He sees them. All exits are covered. He reaches for his gun. A shot goes off. And another. A woman cries out. Is she on-screen or in the audience? Someone's been hit. The man springs onto the stage, where he is silhouetted and dwarfed by the magnitude of the figures on the screen. "Look out!" someone shouts, "He's got a gun!" Panicked, the audience stampedes for safety. The cops fire at him and he at them. He leaps off the stage, back into the space of the audience—back, that is, into our space.

The scene I'm describing takes place in Radio City Music Hall in 1942, not in a Dallas theater in 1963. It's from Alfred Hitchcock's wartime thriller *Saboteur*, which, in a delicious little instance of life imitating art, premiered at Radio City Music Hall. The slight, sandy-haired, weasel-faced young man, who resembles the Lee Harvey Oswald of twenty-one years later, calls himself Fry. He's the villain of the piece, a member of an American pro-Nazi conspiracy group. He successfully starts a blaze in a California aircraft factory and sinks a ship in New York harbor before being cornered by the police in the movie theater. Soon after escaping, he exchanges punches with the hero atop the Statue of Liberty (no subtlety intended), loses his footing, and plummets to his death.

Oswald's place of death, the basement of the Dallas police headquarters, was more mundane than Fry's, but no less dramatic or Hitchcockian. Hitchcock often staged life-and-death struggles in crowded public locations normally considered innocent and safe: a city plaza in broad daylight, a fairgrounds at night, the Albert Hall during a concert performance, or a national park cafeteria full of tourists. On Sunday morning, November 24, 1963, the basement of police headquarters in Dallas was full of police officers, detectives, news reporters, television broadcasters, and camera crews; millions of remote onlookers, moreover, were watching from their own living rooms.

But I'm getting ahead of myself. I don't want to talk about that basement yet. I want to go back to the Dallas movie theater, or to an earlier moment, when Officer J. D. Tippit drove his patrol car alongside a pedestrian who fit the description broadcast over police radio of a slender, brown-haired, medium-height, twenty-five- to thirty-year-old Caucasian male suspect. The scene is easy to envision, because it has such a long Hollywood and television pedigree. In Chapter 1, I mentioned Anthony Mann's low-budget thriller *He Walked by Night*, with its remarkable cinematography by the Hungarian-born master of light and shadow John Alton. At the opening of the movie, a patrolman pulls alongside a young man who walks alone in the middle of the night on a residential street. The suspect picks up his pace. The officer, still in his car, orders him to stop and be identified. Nervously overreacting, the young man pulls out a concealed weapon, shoots the officer dead, and runs for cover.

Most of the rest of the movie concerns pursuit by the police of the killer, a former U.S. marine, a Dostoyevskian underground man, as I noted in Chapter 1—a bitter, secretive, self-absorbed loner scornful of the modern bureaucratic society that his adversaries, the police, embody. At the end of the movie, those adversaries corner him in a literal underworld, the drainage system beneath Los Angeles. Ferreted out of his lair by tear gas and powerful electric searchlights hooked up to portable generators, he goes down firing at the representatives of the law and order he so thoroughly despises (Fig. 75).

Oswald, himself a former marine and a bitter loner, fled the scene of Officer Tippit's murder and hurried down Jefferson Boulevard, ducking into the Texas Theater

FIGURE 75 | *He Walked by Night,* 1948

while the cashier stood out on the curb to see what had brought on the sudden clamor of police sirens. Inside, some twelve to fourteen patrons were scattered through the orchestra and balcony. The top feature of the B-movie double bill that afternoon, scheduled to follow the opener, was *Cry of Battle*. It is one of Hollywood's forgotten movies, with no status whatsoever, not even the cult status one might expect to arise from its circumstantial connection to the capture of Lee Harvey Oswald.

In the film Van Heflin plays Joe Trent, a crude and unscrupulous American seaman who finds himself stranded in the Philippine boondocks in December 1941 when war breaks out in the Pacific. At the start of the movie and several times thereafter he saves the life of a much younger man, David McVey, a wealthy, educated, and inexperienced American who is also stuck on the island but lacks Trent's survival skills. Trent, however, is no good guy. He rapes a local woman, shoots a Filipino, and tries to seduce a Filipina freedom fighter (Rita Moreno) while plotting to murder her lover, the leader of the partisan resistance (Fig. 76). Appalled by Trent's behavior, McVey finally stands up to him and kills him. In effect, Joe Trent represents America as a ruthless imperial power that rapes, plunders, and otherwise abuses a third world island people, and McVey learns "to be a man" (the movie's release title in the UK) only when he joins the resistance against that illegitimate power.

FIGURE 76 | *Cry of Battle,* 1963

Had Lee Oswald been able to stick around and see *Cry of Battle,* scheduled to begin at three o'clock, he might even have found its political views in keeping with his own, as expressed in his recent activism on behalf of Cuba, another third world island territory "liberated" from Spain by the United States during the Spanish-American War. Several months earlier, as founder, president, and sole member of the New Orleans branch of the Fair Play for Cuba Committee, he had distributed pro-Castro pamphlets in the streets and engaged in scuffles with hecklers. He had also, unsuccessfully, sought to obtain a visa allowing him to travel to Havana. Whatever his intentions and motivations—they remain a matter of controversy among Oswald-watchers—the third world was indisputably on his mind.

Earlier in 1963, in a surprisingly candid piece for the *Saturday Evening Post,* James Jones, the author of *From Here to Eternity* and *The Thin Red Line,* reported on the new wave of combat movies pouring out of Hollywood. After spending three days in the dark watching those movies (*Cry of Battle* not among them), Jones writes, "I was more depressed with the essential adolescence of America . . . than I have perhaps ever been. If our war films are any indication of our social maturity in an age when we have the capacity of destroying ourselves, there is little hope for us." According to Jones,

war films—even those purportedly for adults—were always adolescent affairs because they played on a viewer's desire to trust in a wise and good Infallible Father, who always turned out, by the end of the film, to have been acting selflessly in his men's interest and, in so doing, to have helped them along the way to their own maturity. (The Tom Hanks figure in *Saving Private Ryan*, for all his flaws and vulnerabilities, provides a recent example of the archetype.) Joe Trent, the father figure in *Cry of Battle*, turns out to be a despicable bigot, rapist, and killer whom the "son" must overthrow. Maybe its lack of an Infallible Father explains why the film never reached a broad audience. Its implied criticism of American conduct in Southeast Asia, moreover, put it at odds with prevailing views.

Someone witnessed Oswald sneaking into the Texas Theater and alerted the police, who appeared on the scene within minutes, swarming in from all directions. With the movie stopped and the house lights up, they frisked and questioned those in the audience one by one, starting from the front and working toward the rear, where their quarry, the man who had been pointed out to them by the manager, remained quietly in his seat. When they got to him, Oswald reportedly stood up and said, "It's all over." Then a fight broke out. Some believe Oswald took the first swing, others that the police instigated the violence. They outnumbered him by sixteen to one. "Don't hit me any more!" and "This is police brutality!" he shouted as he was half dragged, half carried, through the lobby to the street outside, where a crowd had gathered beneath the marquee that proclaimed in block letters: CRY OF BATTLE / VAN HEFLIN / WAR IS HELL (Fig. 77).

The third line of the marquee advertised the bottom half of the theater's B-movie double feature, ergo, the true bottom of the Hollywood barrel. *War Is Hell*, not *Cry of Battle*, awaited Oswald when he slipped down into his seat. Today, *War Is Hell* is entirely forgotten and virtually unavailable for viewing. Research indicates that it was a bargain-basement Korean War movie directed by Burt Topper, a filmmaker whose previous movies were *Hell Squad*, *Tank Commandos*, and *Diary of a High School Bride*. The villain of the piece is a cowardly sergeant who runs from a firefight in which most of his men are slaughtered and then tries to pass himself off as a hero who struggled to save his men's lives. It appears to have been another war film with an evil rather than an infallible father figure, which again may account for its virtual disappearance from the record.

The timing of events on the day of the assassination is such that Oswald most likely would have entered the theater during the movie's prologue, which is spoken by Audie Murphy. Murphy was a folk hero at the time. Having collected twenty-four combat medals, including the Congressional Medal of Honor, during the Second World War, this son of poverty-stricken Texas sharecroppers became the most decorated soldier in the history of the United States. After the war, the slim and boyish-looking Murphy went to Hollywood and parlayed his fame as a combat hero into a moderately

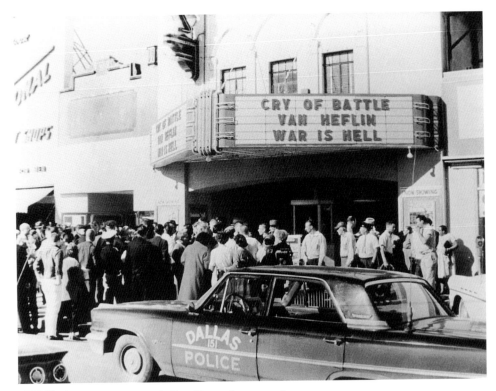

FIGURE 77 | Texas Theater, Dallas, November 22, 1963

successful career as a leading man, primarily in low-budget westerns and war stories. By 1963, however, his Hollywood career was in decline. At the end of the decade he was in bankruptcy and facing charges of attempted murder, having severely beaten a man in a barroom brawl. He died in a plane crash in 1971.

In addition to acting, Murphy wrote ballads and country-and-western songs that were recorded by the likes of Dean Martin, Eddy Arnold, and Charley Pride. Candid about his own problems with "battle fatigue" (now called post-traumatic stress disorder), which led him to prolonged periods of depression and addiction to prescribed drugs, he publicly called upon the U.S. government to study the emotional impact of war on veterans and to provide mental health care for them. In 1999 Texas Governor George W. Bush designated June 20, the actor's birthday, as Audie Murphy Day in the state of Texas.

There's no Lee Harvey Oswald Day in the Lone Star State. In many ways, Oswald was the flip side of Audie Murphy. Both were Texans from disadvantaged backgrounds, both trained as military sharpshooters, and both were beset by emotional difficulties in adulthood. One of them became a legend for killing 240 enemy soldiers, the other

FIGURE 78 | *To Hell and Back*, 1955

a disgrace for killing the president. Oswald was buried in an unmarked grave in Fort Worth. Murphy was buried in Arlington National Cemetery, where his gravesite is the second most visited. The most-visited belongs to the slain president.

Let's factor Kennedy into this equation. He would seem the antithesis of Audie Murphy, certainly in background, but also in personal style and level of achievement. Yet there are some curious overlaps, besides their burial close to each other in the national cemetery and the coincidence of their dying suddenly, unexpectedly, at the age of forty-six. Both were war heroes who capitalized on their glory to advance their careers, one as a movie star with political concerns, the other as a politician with movie star appeal. Both were subjects of Hollywood biopics made during their lifetime. In *To Hell and Back*, Murphy played himself, reenacting his battlefield exploits during the allied invasion of southern Europe (Fig. 78). Kennedy, while in the White House, approved a film script about his own wartime adventures in the Pacific and suggested

Warren Beatty for the lead. (Beatty declined. The resulting film, *PT-109*, turned out to be clumsy, dull, and a box-office dud.)

During World War II one man "starred" in the European theater of operations, the other in the Pacific theater. Then Lee Harvey Oswald came along and "starred" for a few minutes in the Texas theater. "Life imitates art far more than art imitates life," Oscar Wilde claimed in an epigram too lapidary to convey all the intricate intertwining of art and life that afternoon in the neighborhood picture show. Audie Murphy described the experience of filming his autobiography as "this strange jerking back and forth between make-believe and reality, between fighting for your life and the discovery that it's only a game and you have to do a retake because a tourist's dog ran across the field in the middle of a battle."

A "strange jerking back and forth between make-believe and reality" aptly characterizes the scene at the Texas Theater. I've already compared it to Hitchcock's self-reflexive set piece in *Saboteur*. In Ernst Lubitsch's 1942 black comedy *To Be or Not to Be*, set in Nazi-occupied Warsaw, a company of Shakespearean actors, inept in the practice of real life but adept at make-believe, dress up as Nazis to lure a real Nazi into their theater. As they pursue him through the orchestra section and onto the stage, eventually catching and killing him, the categories of "make-believe" and "reality" are deftly scrambled. The movie repeatedly draws on Shakespearean analogies between life and theater ("All the world's a stage"), taking Hamlet's statement of intent, "The play's the thing / Wherein I'll catch the conscience of the King," as a broad declaration of the power of art not only to mirror reality but to alter it. "Things are [as they are] because we see them," Oscar Wilde claimed. "And what we see, and how we see it depends on the Arts that have influenced us."

The blurring of lines between life, theater, and politics was a prominent feature of another devastating presidential assassination a century earlier. Not only did that assassination take place in a theater, but the assassin himself, John Wilkes Booth, was even an acclaimed Shakespearean actor. His father, Junius Brutus Booth, and his older brother Edwin Booth were also Shakespearean actors. President Lincoln, who loved to distract himself from his woes by attending the theater, much admired the Booths. He invited Edwin to perform *Hamlet* at the White House. And months before his death he had watched, from the very box where he was later assassinated, a performance by John Wilkes. Lincoln so enjoyed that performance that he sent a note backstage asking to meet the actor, who, as an ardent supporter of the Confederate cause, refused. One of Booth's contemporaries, Joel Chandler Harris, wrote that the tragedian "was so infected and unbalanced by his profession that the world seemed to him to be a stage on which men and women were acting, living, their parts. There was nothing real to him but that which is most unreal, the theatrical and the romantic."

Chicago's Biograph was the site of another famous movie theater arrest. On a hot summer night in 1934 the gangster John Dillinger slipped off with two female companions to the motion picture palace on Lincoln Avenue to see *Manhattan Melodrama*, a movie about a gangster played by the young film star Clark Gable, who was said to resemble Dillinger. One of Dillinger's companions, the lady in red, had tipped off the G-men beforehand, and when the picture was over and Dillinger emerged from the lobby, he walked into a trap, cut down in a flurry of bullets before he had a chance to draw his gun. So infamous but also sexually charismatic was Dillinger—he was called the Rudolph Valentino of crime—that female bystanders reportedly mobbed his dead body and dipped their handkerchiefs in his still-warm blood.

When Lee Oswald emerged from the Texas Theater, he was not shot to shreds. But a crowd gathered, and he was instantly the focus of attention. Lee Harvey Oswald went into the Texas Theater a nobody and came out a star.

INVESTIGATORS SEARCHING OSWALD'S rented room quickly turned up a pair of snapshots that have since become known as "the backyard photos." Sometime during the spring of 1963 the suspect had asked his wife, Marina, to photograph him in the garden of the apartment where they were living. Posing with a mail-order rifle in one hand and two newspapers, the Communist *Worker* and the Socialist *Militant*, in the other, he had told her where to stand and when to take the pictures (Fig. 79).

Shown the photos during police interrogation, Oswald is said to have claimed (his words have never been confirmed) that they were forgeries, his face superimposed on someone else's body. If he did indeed say that, the claim would make him the original conspiracy theorist. Others since have pointed to minute, virtually undetectable discrepancies in the shading and structure of his face in the photos as proof of an official cover-up. As with other murky facets of the Oswald affair, allegations of conspiracy that might otherwise have remained groundless were exacerbated by the dubious manner in which official investigators and the news media conveyed findings to the public.

Take, for instance, the publication of the backyard photo identified as Warren Commission Exhibit No. 133-A. It is by far the better known of the two. *Life* featured it on the cover of its February 21, 1964, special issue on Oswald. The magazine's editor later admitted to commission investigators that he had authorized minor cropping and retouching of it for pictorial reasons. The *New York Times* assistant managing editor told the commission that his paper had also retouched the photo for publication, but he claimed that doing so did not "change the facts of the photograph—that is to say, it did not alter any essential features of the photograph." He elaborated: "The only retouching that has been done is to outline Lee Harvey Oswald's head and right shoul-

FIGURE 79 | Dallas, March 31, 1963

der, to highlight the stock of the gun he is holding, to put a crease in his trousers and tone down somewhat the shadow cast by his figure." *Newsweek* revealed that it too had altered the photograph in publishing it, explaining that during retouching "the technician inadvertently brushed out the telescopic sight" of the Mannlicher-Carcano rifle that allegedly killed the president.

Of the two backyard photos, 133-A has the more striking pose and composition. Oswald, scowling, clad all in black (Marina testified that she found his choice of outfits bizarre), and packing a revolver on his hip, gunslinger style, looks like a homegrown version of Paladin. Even more, he resembles one of the most famous icons of American patriotism, the *Minute Man* statue in Concord, Massachusetts (Fig. 80). Whether or not Oswald had it in mind when he struck his pose, the photograph invoked the fa-

miliar iconography of the *Minute Man* in cold war image culture. In the imaginary world of 133-A, Oswald defines himself as a modern minute man, armed to defend liberty and resist tyranny.

Completed in 1874 and cast in bronze from a melted-down Civil War cannon, the original *Minute Man* was unveiled on the Concord Common on April 19, 1875. The date marked the hundredth anniversary of the local skirmish where, in Emerson's phrase, "the shot heard round the world" initiated the American Revolution. The sculptor Daniel Chester French chose as his subject a plowman who, like his neighbors, was prepared to leave family and fields at a minute's notice and muster with his rifle to fight the common enemy. With flashing eyes, set jaw, ready stance, and a long rifle balanced in his hand, French's idealized plowman has proved one of the enduring icons

FIGURE 81 | United States Savings Bonds advertisement, 1941

of American patriotic lore, along with Emanuel Leutze's *Washington Crossing the Delaware*, John Trumbull's *Signing of the Declaration of Independence*, and Benjamin West's *William Penn's Treaty with the Indians*.

In 1900 Concord's neighboring town Lexington erected its own patriotic statue, the *Minuteman*, by the Boston sculptor Henry Hudson Kitson. It too has achieved iconic status. Of the two, Concord's is more widely known, because it's older and by a more celebrated sculptor (who went on to create the seated *Abraham Lincoln* in the Lincoln Memorial) and because during World War II the government appropriated the image for stamps, posters, and savings bonds (Fig. 81).

When America entered the cold war, it took both minuteman icons with it. In 1959 the National Park Service created the Minute Man National Historical Park with

FIGURE 82 | Lexington, Massachusetts, April 19, 1961

French's monument as a focal point. Two years later, an exemplar of America's first intercontinental ballistic missile, known as the Minuteman, was unveiled on the Lexington village green in the shadow of Kitson's statue (Fig. 82). Accompanying the official photo was a press release whose unconscious reliance on phallic language and double entendre embodies the sexualized military discourse that Kubrick's *Dr. Strangelove* parodies with such lacerating brilliance: "Symbol of readiness: The Air Force Minuteman ICBM stands poised next to a statue of its colonial counterpart at Lexington, Mass. Minuteman, a solid-fuel, 6300-mile missile designed for instant readiness, performed with complete success on its first flight February 1, 1961, from Cape Canaveral, Fla. This symbolic photograph was taken when the Minuteman display missile was erected on the village green in Lexington, Mass."

By the end of 1962 the president, who had campaigned in 1960 on closing the so-called missile gap with the Russians, had "erected" some 5,000 operational Minuteman missiles in underground launching silos across the central and northern plains of the United States. Armed with nuclear warheads and "cocked" in readiness at potential targets in the Soviet Union, at the other end of the world, they conveyed America's eternal vigilance and hypervirility. If members of the switchblade-wielding, testosterone-soaked teenage gang the Jets in the Broadway musical *West Side Story* could boast of having "a rocket in my pocket," so all red-blooded American men throughout the country could take pride in the nation's collective rocket in its pocket, standing tall, firm, and poised for launch at a moment's notice.

LESS THAN TWO WEEKS after he posed for the photos, Oswald made a nighttime raid on the home of Major General Edwin A. Walker and attempted to assassinate him. Walker was a notorious figure at the time. One of the leaders of the extreme right-wing organization the John Birch Society, Walker had recently been relieved of his command of an infantry battalion in West Germany: he was accused of harassing his men to vote a strict anti-Communist line in the 1960 congressional elections. Marina Oswald demanded that her husband explain to her why he had tried to shoot Walker. She later wrote: "He answered that this person belonged to a Fascist organization, and that it would be better for everyone if he were dead. I answered that he did not have the right to kill a person, regardless of who he was. To this Lee answered that if Hitler had been killed early enough, people would not have suffered so much, and there would not have been a war."

The backyard photos, if authentic, testify to Oswald's view of himself as a patriot, a freedom fighter, and a paladin. Even if they are not authentic—even if they are forgeries, as conspiracy theorists have claimed—they nevertheless partake of the ideological rhetoric of noble citizen-patriot manhood that is deeply embedded in American visual imagery. Were Oswald regarded by posterity not as one of the most blameworthy figures in U.S. history but as the great hero and defender of liberty he apparently wanted to be, the backyard photos might have served to make him a poster boy for the National Rifle Association.

The origins of the National Rifle Association go back to 1871, when two veterans of the Union army, Colonel William Church and General George Wingate, were concerned that most of the men they had commanded literally didn't know how to shoot straight. To rectify the problem, Church proposed "an association . . . to promote and encourage rifle shooting on a scientific basis. The National Guard is today too slow in getting about this reform. Private enterprise must take up the matter and push it into life."

The organization was initially devoted to teaching marksmanship and popularizing target shooting as a sporting event; after World War II, it expanded its range of interests to include hunting as a sport. The NRA sought to forge close connections with law enforcement officers and agencies and established itself in Washington as a powerful special interest lobby. During the crime wave of the early 1930s, attributed to Prohibition and the Depression, a public outcry against the ready availability of automatic weapons to gangsters led to the introduction of gun control legislation in various states. The NRA found a new purpose in vigorously opposing such legislation. But only in the postwar era, with the heightened tensions of the cold war, did the NRA and affiliated groups begin to defend the unrestricted marketing of guns as a defense of American liberty.

Public outrage over the Kennedy assassination gave legislators impetus to pass a gun control bill that had been languishing in Congress since the summer of 1963, but even after it passed, the battles for and against gun control legislation raged on, with minuteman rhetoric playing an essential role. A black-bordered special editorial in the February 1964 issue of *Gun World* magazine expressed regret at the death of the president but warned its readers not to permit "the enemies of freedom, of our right 'to keep and bear arms,'" to take advantage of the national bereavement to lay siege to the Second Amendment. Senator Carl Hayden of Arizona suggested in a speech delivered in committee that even the slain president would have opposed gun control for patriotic reasons: "Have we forgotten Pearl Harbor? Have we forgotten that American chaplain who stood on a pitching destroyer's deck and shouted 'Praise the Lord and pass the ammunition,' as he braved the withering fire of the Japanese Zeros? I don't think President Kennedy would want us to forget, and start down the path that disarmed the British people, merely because one enemy bullet finally found him. What a ridiculous monument to his memory."

Lee Harvey Oswald may have been a bad guy, but by gun lobby logic, his right to keep and bear arms (and acquire them, as he did, through mail-order purchase) was inalienable. Thus the backyard photos are in essence proud patriotic documents, portraying their subject's exercise of his constitutionally assured freedom. That he did something evil with the guns afterward does not change the generic meaning of the pictures as testaments to personal initiative and private enterprise.

Oswald "quotes" the *Minute Man:* legs apart, bare-armed but bearing arms, he epitomizes rugged self-reliance, taking a stand on matters of civic importance. Both figures are linked to symbols of manual labor, the plow for the *Minute Man*, a proletarian newspaper, the *Worker*, for Oswald. The statue honored the common man of America, lowly in rank but great in spirit. In his social as well as his physical stature, Lee Harvey Oswald was a little man. But in the American dream, all little men, whether from Concord or from Dallas, have what it takes to fire a shot heard round the world.

JACK RUBY, BORN JACOB RUBENSTEIN, was another little man. Then one morning he squeezed off his own shot heard round the world.

When the Dallas police dragged Ruby from the site of the shooting and pinned him to the floor of a nearby office, a detective asked if anyone knew who he was. Ruby himself answered the question: "You all know me. I'm Jack Ruby." Packed into an elevator taking him up to the third floor, he said again, "I'm Jack Ruby. Don't you know me? Don't you know me?" Excitedly, he bragged, "I hope I killed the son of a bitch. It will save you guys a lot of trouble." He added, "I just had to show the world that a Jew has guts."

Tony Zoppi, the entertainment columnist for the *Dallas Morning News*, was acquainted with Ruby. Here is how Zoppi described him:

> He was a born loser, a real low-level loser. . . . He was a hanger-on who was very impressed by famous people, impressed by "class," and with anybody that he thought had it. He used to call me up and say, "Hey, Tony, I run a real classy joint, classy all the way, huh? Don't I have class?" But the people that knew him knew that Ruby was a zero. He used to give out passes for his club to everyone he met. He would announce: "Hi, I'm Jack Ruby," like it was supposed to mean something."

Jada Conforto, a twenty-seven-year-old stripper who worked at Ruby's Carousel Club, said of him, "He would do anything to attract attention to himself. He craved attention. He really wanted to be somebody, but didn't have it in him." According to Jada, he often remarked, "I'm a character! I'm colorful."

With its own splash of color and a brilliant lead, *Newsweek*'s report on Ruby summarized his life and actions this way: "It was as if Damon Runyon had written the last act of a tragedy by Sophocles. The most unlikely nemesis of all time was 52-year-old Jack Ruby. . . . Born to nothing in the ghetto of Chicago's West Side, [Ruby] ricocheted through a pinball destiny until he fell into place, master of the grubby revels for the bravos and backslappers of Dallas night life."

The public persona Ruby created for himself was indeed Runyonesque—no matter whether he had read a single word by the famed Broadway reporter and short story writer Damon Runyon. Runyon's panoply of small-time crooks, hoods, gamblers, and dames occupied the demimonde of nightclubs, burlesque joints, racetracks, ballparks, boxing clubs, and precinct houses that had been home to Jack Ruby all his life. Moreover, Runyon's fingerprints were all over American popular culture during Ruby's adulthood. Between 1931 and 1963 some twenty-nine Hollywood movies had been based on Runyon stories, not to mention the hit 1950s Broadway musical *Guys and Dolls*. A pub-

FIGURE 83 | Jack Ruby outside the Carousel Club, 1963

licity photo of Ruby yucking it up outside the Carousel with two of his dancers shows him in his "I'm a character! I'm colorful" mode (Fig. 83). Clad in a dark suit with a white-on-white combination shirt and tie and a felt-banded, snap-brim fedora, the strip club impresario shoves his hands into his pants pockets and rocks back from the hips. In another shot, taken in his office, he leans back with a cocky grin, his feet resting on the desk between two seated strippers.

When Earl Warren, the chief justice of the Supreme Court, came to Dallas to ask Ruby in person what had gone on that morning in the basement of city hall and why he had pulled the trigger, the club owner intimated he could not answer such questions in complete honesty, fearing for his own safety as well as that of his family. Several times during the interview he requested that he be transferred to Washington, where he could divulge information more freely. After Warren persistently refused, Ruby offered this explanation of the shooting: "I felt very emotional and very carried away for Mrs. Kennedy, that with all the strife she had gone through—I had been fol-

lowing it pretty well—that someone owed it to our beloved President that she shouldn't be expected to come back to face trial of this heinous crime."

Naturally, critics of the Warren Commission have found this explanation risible, and some consider Warren's acceptance of it evidence of a cover-up. But Norman Mailer, in the chapter of his fact-fiction novel *Oswald's Tale* entitled "The Amateur Hit Man," convincingly imagines a scenario in which alternative explanations are compatible. Mailer speculates that Mafia warlords ordered Ruby to kill Oswald and that once Ruby received word of his assignment, he had "to find impressive reasons for his intended act. He is too big a man to do such a job just because the Mob has ordered it; no, he is potentially an honorable Jewish patriot who wishes to redress a wrong in the universe." (Ruby informed the Chief Justice that when he was thrown to the ground after shooting Oswald, "I used a little expression like being of the Jewish faith, I wanted to show that we love our president, even though we are not of the same faith.")

Mailer discerns that mob criminality does not necessarily exclude maudlin sentimentality. "Ruby must have wept and/or had tears in his eyes ten to twenty times from Friday to Sunday," Mailer remarks. "But, we can remind ourselves once more, he is crying for himself. His life is slipping away from him. Nevertheless, to maintain some finer sense of himself, he is also weeping for Jack, Jackie, and the children."

Said Tony Zoppi, the columnist who knew Ruby, "He took this thing [the assassination] very personally. President Kennedy was everything Ruby wasn't and would have liked to be: polished, classy, articulate, educated, well-mannered. Ruby wasn't any of these."

OSWALD'S TRANSFER FROM THE CITY to the county jail was scheduled for 10:00 Sunday morning, but the chief of police acceded to requests by the TV networks to delay it by an hour, to 11:00 CST, so that more viewers on both sides of the country would be able to glimpse the prisoner as he was led through the basement to an armored car. The public would be awake on the West Coast by that time and, on the East Coast, home from church.

In its summation and interpretation of the events surrounding the assassination, the Warren Commission faulted the news media in general and the television networks in particular for intruding on the transfer procedure, creating such commotion that the Dallas police (in their own basement, no less) were unable to perform their job properly. As the news historian Barbie Zelizer details in her book about the media's coverage of the assassination weekend, leaders of the press agreed with that assessment. In the ongoing rivalry between older and younger news technologies, print and radio journalists resented the TV crews and equipment that clogged the space through which the prisoner was about to pass. One on-the-spot reporter described the scene:

The clutter of newsmen and their microphones in the basement corridor. The milling and talking, and then those big fat men bringing the thin pasty prisoner, and then the back of a man with a hat, and then Oswald doubled, and then pandemonium, scuffles, shouts and young Tom Truitt [Tom Pettit of NBC News] and his microphone in and out of the picture trying to find out what happened. Questions seethed through my mind: How in God's name could the police expose a President's assassin to this jumble of people at close range?

TV wasn't exclusively at fault. The press was known for mobbing its subjects long before the advent of television. A memorable news photo from 1935 shows photojournalists climbing the walls and hanging from windows outside a New Jersey courthouse to get a picture of Charles Lindbergh as he leaves during a noon recess in the trial of his son's accused kidnapper. But TV dominated the logistics of the Oswald transfer and heightened the tumult after the shooting.

Of the three national television networks, only NBC was broadcasting live. Archival footage of the broadcast shows the newsman Tom Pettit in a raincoat in the jailhouse basement. After a few moments he announces, "There is the prisoner . . . there is Lee Oswald," as the camera shows Oswald, in handcuffs, and various guards emerging from a doorway. Suddenly, a dark figure streaks into the screen. We don't see the gun, but we hear a loud boom. Oswald groans, "*Uhh*," like a bad guy taking a bullet in a bad movie, and crumples. Pettit calls into his microphone, "He's been shot! He's been shot! Lee Oswald has been shot! There's a man with a gun. It's absolute panic. Absolute panic here in the basement of Dallas police headquarters. Detectives have their guns drawn. Oswald has been shot. There's no question about it. Oswald has been shot." The TV camera wheels to a new position in an effort to see around the tangle of bodies surrounding the victim and his assailant, who has been tackled by the police, and while someone is shouting, "Back up! Back up! Get back," we see a live monitor on another television camera showing in miniature what we are seeing on ours. Tom Pettit is beside himself. "It's almost unbelievable," he says. "It's almost unbelievable."

Minutes later, during a videotape replay of the scene, he remarks, "Those of us who were literally here and watching are not sure of what we saw." His on-camera interviews underscore the accuracy of his statement: everyone Pettit manages to corral is either a police officer or a fellow journalist, and not one of them grasps any more clearly than he what has just transpired.

The technology permitting a nearly instantaneous videotape replay was so new that it had not yet been tested on network television. It was being developed as a tool for sports broadcasting. In that capacity, the instant replay first appeared two weeks later, during a telecast of the Army-Navy game in Philadelphia. After the Army quar-

terback Rollie Stichweh dashed into the end zone on a short run, his moment of glory was repeated on air. The sportscaster Lindsey Nelson cried out in excitement, "This is not live! Ladies and gentlemen, Army did not score again."

Perhaps the Saturday afternoon touchdown in Philadelphia was no less momentous than the Sunday morning shooting in Dallas. That's because it demonstrated humanity's newfound ability to control time deliberately and rationally, snagging a fleeting moment from the flux and bringing it immediately to hand to review and relive. A trained technician in a control booth could now accomplish a feat philosophers had dreamed of for centuries. In the long run the murder of the suspected presidential assassin has had less of an impact on our lives than the technology of communications unveiled that day in Philadelphia. Those instant replay capabilities led to further technologies of immediacy, as well as a changed moral and philosophical outlook, wherein we increasingly expect such innovations as fax machines, cell phones, photocopiers, e-mail, instant messenger, and so forth, to vanquish space and time.

THE *DALLAS TIMES-HERALD* assigned its young photographer Bob Jackson to record Oswald's transfer. Jackson wasn't much interested in it, though. He had been on the go almost nonstop since he had witnessed the assassination from a motorcade press vehicle forty-seven hours earlier, and he was exhausted.

He might have recognized Jack Ruby had he spotted him in the crowd, because the nightclub owner was a publicity hound who had once brought his top-billed stripper, Jada, to the *Times-Herald* photo department, where she proceeded to perform a dance with a snake. But Jackson didn't notice Ruby come down the ramp into the basement, which was filled with some forty to fifty members of the press and another seventy to seventy-five police officers. Jack Beers, the *Dallas Morning News* photographer on the beat that day, was more likely to have recognized Ruby, because he had gone on assignment to the Carousel about a year earlier to photograph the dancers. Yet even if Beers had picked Ruby out of the crowd, he wouldn't have thought it odd to see him there, because Ruby was known as a "hanger-on" who curried favor with the police. The club owner spent a lot of time at the police station, schmoozing with the officers.

Jackson secured a spot for himself against the fender of a parked police car. Beers staked out a perch atop a section of railing, where the television cameras were situated. At about 11:20 A.M., the elevator doors opened, and someone called out, "Here he comes!" A set of spotlights kicked on and the din of the crowd increased. The prisoner, dressed in a dark sweater, emerged from the elevator, accompanied by a police captain and three detectives, two of whom were attached to him by handcuffs. Cameras began whirring and clicking. Several reporters refused to heed instructions not to direct questions at Oswald, shouting them when he appeared. The archival footage shows Oswald

with what appears to be a smile or a smirk on his face. He looks as though he loved this moment in the limelight. *I'm ready for my close-up now, Mr. DeMille.*

From his perch on high, Beers followed the movement of the prisoner through the viewfinder of his camera. He sensed a sudden movement below him and to his right. A cry rose above the din. As Beers recalled years later, "A man's falsetto voice screamed, 'You son of a bitch!'" The man who screamed ran into Beers's field of vision, and the photographer, fearing his shot of the prisoner would be obstructed, hurriedly pressed the shutter release. "I had no idea the man was about to shoot Oswald," said Beers. "I was still looking into the viewfinder when the curse ended and the shot rang out, like putting a period quickly at the end of a sentence."

Beers's photo shows Oswald, his hands folded in front of him, looking straight ahead, the slight grin or smirk still on his face, while Ruby lunges forward, his right arm extended across the beltline of one of the detectives, a pistol clenched in his hand (Fig. 84). No one in the photo looks at Ruby. No one notices he's there.

The composition is brilliant, if inadvertent. Ruby's left leg trails off the bottom of the picture, like a big black comma in reverse. His right leg creates a void, a negative space, against the lighter-toned concrete floor. His fedora, probably the same one he was wearing in the publicity photo taken outside the Carousel, fills the space between the newsman in a light raincoat and the detective in a dark suit. Ruby's polished black leather shoe seems headed for a collision with Oswald's shiny black leather loafer. The pointy toe of the cowboy boot belonging to the detective in the light-colored suit completes an implicit diagonal that starts at Ruby's extended back leg. This sight line of converging shoes, together with the killer's flying arms and clenched hands, hurls the viewer into the thick of the action.

This is the "before" picture of Oswald's assassination. Bob Jackson shot the "after" (Fig. 85). To the left of Beers and below him, on ground level, Jackson too was following Oswald through his viewfinder when he saw a body moving into his line of sight. He leaned to the left to get his picture before the view was blocked. "Ruby moved three quick steps and bang," he recalls. "When he shot, I shot." The resulting photograph earned Bob Jackson—not Jack Beers, who otherwise, no doubt, would have won it—that year's Pulitzer Prize.

It may be one of the most frequently reproduced photographs of the twentieth century. Jackson shot it with a wide-angle 35-mm lens, providing an almost panoramic view of the incident, showing police Captain Will Fritz, chief of the homicide investigation, on the extreme left, and a cluster of TV and radio reporters on the right. But most newspapers severely cropped the top, bottom, and sides of the image (as this book does) to concentrate the viewer's attention on the central group of figures and thus maximize dramatic impact.

In the cropped versions, the essential elements remain the same: the welter of hats;

FIGURE 84 | Police headquarters, Dallas, November 24, 1963 (Jack Beers, photographer)

the tangle of hands; the unstudied facial expressions of shock, disbelief, horror, and dismay; and the centrality of the murder weapon, the dark, compact object around which the rest of the picture is wrapped. Detective James R. Leavelle, the man in the white Stetson and light-colored suit, recoils from the point-blank assault on the man he is guarding. Leavelle's body, seemingly joined to Oswald's from knee to hip, springs away above and below. On the other side of the victim, a short squat bulky figure, part

FIGURE 85 | Police headquarters, Dallas, November 24, 1963 (Bob Jackson, photographer)

pit bull, part Mack truck, crashes forward in visual counterpoint. In what amounts to a head-to-head confrontation between two Hollywood movie genres, crime and western, the thug in the fedora overpowers the lawman in the Stetson.

Crushed between those two archetypal figures of law and disorder, Oswald twists and moans, his eyes narrowed to slits, his mouth contorted. In the liquidity of the instant, Oswald's face amalgamates Edvard Munch's screamer and the agonized horse

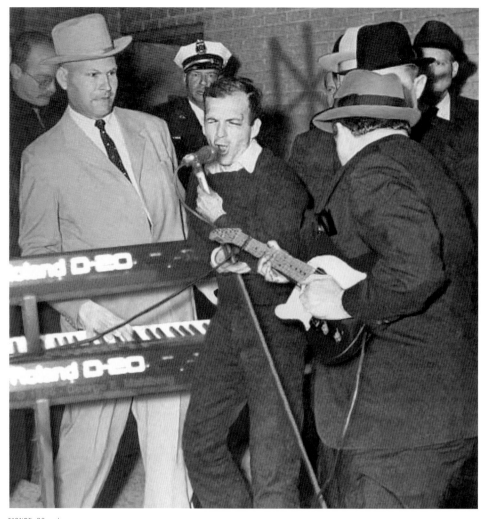

FIGURE 86 | "You ain't nothing but a hound dog!" 2000 (Bob Jackson's photo, digitally manipulated by George E. Mahlberg)

of Picasso's *Guernica*, making him yet a third modernist icon of unbearable torment. But it's possible to shift Oswald and his body language from the context of the photograph (and its relation to modern art) to the realm of rock and roll. Writhing and moaning, Oswald becomes Elvis onstage with his backup men around him. Indeed, a few years ago a digitally manipulated collage circulated on the Internet showing Oswald wailing into a microphone, Detective Leavelle pounding an electric keyboard, and Ruby hunching over an electric guitar (Fig. 86). The caption declared, "You ain't nothing but a hound dog!"

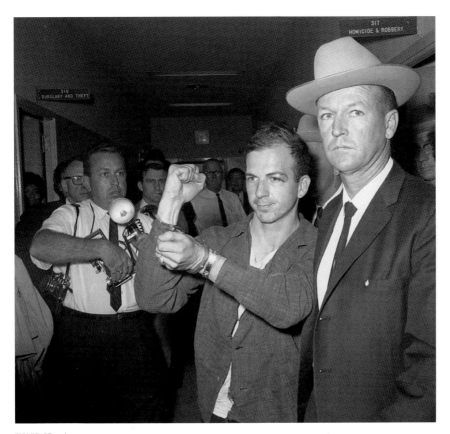

FIGURE 87 | Police headquarters, Dallas, November 23, 1963 (Bill Winfrey, photographer)

243

The parody, clever and heartless, mocks the sacred place of Jackson's photo in the historical record but also conveys the new permeability of the lines that once separated news, art, popular culture, and history from one another. Once we grasp these implicit connections between Oswald and Elvis, it's easy enough to see parallels to the 1950s movie rebels Marlon Brando and James Dean in the grimacing face of the twenty-four-year-old antisocial, anti-authoritarian nonconformist (Fig. 87).

The image of Ruby shooting Oswald resonates because it attaches and reattaches itself to so many different strands of our cultural DNA. Besides the formal similarities that link it with the various high art and popular culture artists and artifacts I have mentioned, from Picasso to Presley, it also taps into two of the most pervasive mid-twentieth-century visual discourses, tabloid photography and film noir. The pioneering figure in the first was Arthur Fellig, the crime photographer nicknamed "Weegee" (from Ouija board) because of his knack for getting to the scene of a violent crime so

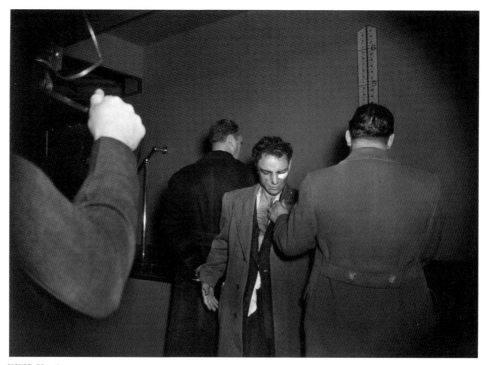

FIGURE 88 | Weegee (Arthur Fellig), *Anthony Esposito, Accused "Cop Killer,"* 1941, International Center of Photography, New York

quickly after it happened that he seemed to have been tipped off beforehand by the spirits of the dead. His book *Naked City* (1946), a selection of his flash photographs taken during the 1930s and 1940s for New York's sleaziest papers and magazines, show-cased—with an idiosyncratic blend of energy, sentimentality, and wit—a world of hoods, muggers, pimps, transvestites, drunks, derelicts, and street urchins. In one photo, for instance, two men with their backs to the camera sandwich a slight, disheveled young man whose angular cheekbones and deep-set eyes appear to have been pummeled (Fig. 88). He's being booked on suspicion of killing a policeman, and the other two men are detectives. One of them grabs his lapel; the other, to whom he's handcuffed, yanks his arm. Compositionally, the three are locked together in a sort of abstract modern dance, a pas de trois illuminated by Weegee's harsh flash.

The photography critic John Coplans writes, "All Weegee's passion was centered on getting close to his material, to snatch the explosive moment out of the air. Nothing else counted. There is a frantic edge to Weegee's imagery. He worked at point-blank range and at a desperate pitch, the better to catch people in the raw."

Bob Jackson's photo of Ruby plugging Oswald in the basement of city hall, with

its garish lighting, stark shadows, and circus atmosphere, owes much to Weegee, to be sure, but it goes one step further and out-Weegees Weegee, who never, for all his prescience, managed to arrive at the scene of a crime *before* it occurred and frame it in his viewfinder *while* it was occurring.

The basement photos of Ruby shooting Oswald also have the look of forties and fifties film noir. As I noted in Chapter 1, those films were edgy, downbeat sagas of metropolitan angst, sadistic violence, and city hall corruption. Their settings typically included back alleys, basements, police stations, and nightclubs. Their moods included jealousy, greed, lust, and paranoia. And more paranoia. Jack Ruby on a good day may have seemed like a colorful character out of Damon Runyon, but on the day Bob Jackson shot him from behind as he shot Oswald from in front, he and the setting and his act of murder were straight from film noir.

Indeed, when we view Jack Beers's photograph and then Bob Jackson's, it's like going to a film noir double feature. In the first movie, Oswald is the bad guy, the villain with a smirk (like that of Richard Widmark's sadistic punk in the 1947 film *Kiss of Death*). Despite being conspicuously smaller and slighter than the escort attached to him, Oswald exudes confidence and strides ahead of his guards, basking in the attention of the press. That movie ends abruptly, and the second one begins, when poor Oswald falls prey to a ruthless hood.

Feminist critics have noted that the world of film noir is predominantly a male universe, in which the viewer's anxiety about his personal and social status is played out symbolically in the tense calculus of masculine friendships, rivalries, and betrayals enacted on-screen. When women appear in film noir, they have only two possible roles available to them: femme fatale or domesticating (and ultimately suffocating) angel. Lurking unseen in the background of Jack Ruby's personal film noir are both types of women. Ruby claimed that if his stripper Little Lynn hadn't begged him to wire her $25 that morning from the Western Union office across the street from city hall, he wouldn't have been in the neighborhood and thus faced with the easy opportunity to kill the prisoner. And why did he want to kill the prisoner? Because of "a small comment in the newspaper that . . . Mrs. Kennedy may have to come back for the trial of Lee Harvey Oswald. That caused me to go like I did; that caused me to go like I did. I don't know, Chief Justice, but I got so carried away." Cherchez la femme. Or les femmes. They both made him do it.

In Jackson's photo, Ruby thrusts his snub-nosed revolver right into his victim's gut. He fires point-blank. That term comes from gunnery and describes firing at a target (specifically, the white—*blanc*—center of the target) so close that the projectile travels in a straight line, losing no direction or speed to gravity. Hence "point-blank" has come to mean without hesitation or quibbling; it is to be direct and blunt. Ruby was certainly direct and blunt with Oswald: "You killed my President, you rat!" As John Coplans noted above, Weegee too shot from point-blank range.

FIGURE 89 | Francisco Goya, *The Third of May, 1808,* 1814–15, Prado, Madrid

The Spanish artist Francisco Goya provides an extraordinary precedent in Western visual art for the two-dimensional depiction of point-blank violence. His startling masterpiece *The Third of May, 1808* portrays a French firing squad executing the citizens of Madrid by lamplight (Fig. 89). It is raw, blunt, and visceral in its account of an appalling episode in history that has recurred in one form or another countless times since. The executioners, like Ruby in Jackson's photo, lunge in the direction of their victims and, like him, fire at point-blank range. The lantern on the ground, like the TV klieg lights in the Dallas basement, casts a lurid glow on an array of figures, both living and dead, whose wracked bodies and tormented faces are ghoulishly, grotesquely distorted by that light. The central figure, Christlike with his outstretched arms, embodies silently screaming mankind, undone by the barbarity, the inhumanity, of kindred beings. The barren hillside behind him, like the brick wall behind Oswald, presses forward, denying any avenue of escape. Goya's painting takes place outdoors, but it too documents the murderous rage that erupts in the collective cellar of the race.

A rarely seen autopsy photograph of Oswald, laid out on the morgue gurney, his emaciated torso crudely stitched back together after its postmortem evisceration, his

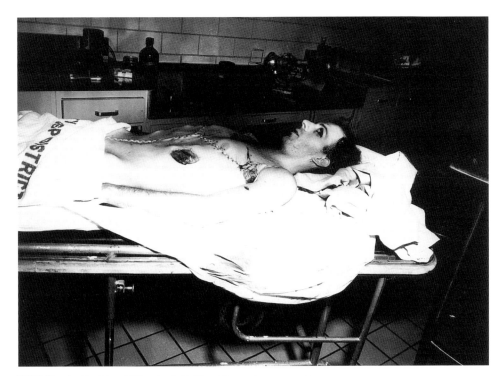

FIGURE 90 | Parkland Hospital, Dallas, November 24, 1963

side cratered by the gaping death wound, and his eye appearing to stare off blankly into the void, depicts him in a manner that invokes not only Weegee's brutalized murder victims and Goya's pathetically inglorious corpses, but also an earlier art of religious martyrdom (Fig. 90). Like a tortured Italian Renaissance saint or a flayed Flemish Christ, Oswald on the gurney bears the stigmata of suffering that have long been a hallmark of the Roman Catholic faith and the many enduring masterpieces of mortified flesh that it inspired.

RUBY FLUTTERED AROUND police headquarters on the night before he killed Oswald, trying to be helpful. He distributed sandwiches and soft drinks to overworked officers and investigators, placed phone calls for harried reporters, and liberally dispensed free-admission cards to his nightclub to anyone he thought might enjoy a relaxing break (although the club itself was temporarily closed out of respect for the deceased). Ruby seemed to enjoy showering policemen with small favors and giving gifts.

After the incident of November 24, retrospect suggested that those policemen should have heeded Virgil's famous advice to beware of strangers who come bearing

gifts. (Not that Ruby was a stranger to them, but he was decidedly strange.) The Trojan high priest Laocoön utters that advice in book 2 of Virgil's *Aeneid*. He cautions his people against accepting the gift left behind by the departing Greeks, a large, hollow wooden horse. The Trojans' suspicions should have been aroused by his warning, and they should have examined the offering before taking it inside the city walls, for as we know, the Trojan horse harbored a cache of enemy warriors, who ambushed the town from within after its citizens had gone to sleep. When Jack Ruby came down the ramp into the basement of city hall that morning, no one was alarmed, no suspicions were aroused, and no one gave warning, least of all Ruby. But he himself was a Trojan horse, an affable backslapper on the outside, a one-man raiding party on the inside.

Ruby's relationship to the Trojan myth takes on additional resonance when we consider what became of Laocoön. No sooner had he spoken his warning than the goddess Athena, who conspired with the Greeks in their plot to overthrow the Trojans, decided he must be silenced before he could say anything more. She summoned a pair of monstrous serpents from the depths of the sea, who sprang upon Laocoön and his two young sons. If we adapt Virgil's tale here, Oswald is Laocoön and Ruby the serpent sent by some unseen Athena (whether lodged in a Mafia penthouse or in his own mind) to silence him.

Bob Jackson's photo of Ruby shooting Oswald resembles the ancient multifigure Hellenistic sculpture *Laocoön and His Sons* (Fig. 91). Described by the Roman writer Pliny, who saw it in the palace of Emperor Titus, but lost after the fall of Rome, the *Laocoön* was for centuries the most fabled work of classical art. When Michelangelo heard rumors of its having been dug up during excavations of the Esquiline Hill in Rome in 1508, he is said to have thrown down his chisel and raced off on horseback to see it emerge from the ground. His subsequent art, such as his designs for the Sistine Chapel, bears the mark of the *Laocoön*, and from the Renaissance onward, its influence on Western art and visual imagery has been incalculable. Generations of artists and art students have pondered the tangled forms of the figural group and its many offshoots, in a variety of media, since its discovery. At the time he squeezed the trigger of his Nikon, Bob Jackson may not have heard of the *Laocoön* or had any recollection of ever seeing it, but as the art historian Richard Brilliant has shown, this undisputed masterpiece occupies a fundamental and unavoidable place in the modern western way of looking at the world.

The *Laocoön* portrays the Trojan high priest and his two sons as the mighty death-dealing serpents coil about them. On the father's face is an expression of agony, brought about, according to the eighteenth-century German art critic Johann Winckelmann, less by the biting pain of the blow to his side than by the recognition that he is helpless to save either himself or his sons. (The Infallible Father, as it were, comprehends

FIGURE 91 | The *Laocoön* group, 1st century A.D., Vatican Museums

that he is no longer that.) Jackson's photo, however unintentionally, creates a modern *Laocoön* group, with the principal figures entangled by hands, arms, and legs, the snub-nosed revolver taking a "bite" out of Oswald's side, and Oswald's face tormented with a sudden and awful recognition of his own mortality.

To be sure, we can never know what thought crossed Oswald's mind when the bullet perforated his flesh. The point here is not to reveal what Oswald, or Ruby, or even Bob Jackson was considering at the moment this picture was taken but rather to suggest that the enduring power of this image, its almost hypnotic pull, is in the end inseparable from its remarkable formal—and narrative—similarities to the *Laocoön* group.

LIKE THE BACKYARD PHOTOS with their resemblance to the *Minute Man*, the photo of Ruby shooting Oswald derives much of its peculiar force from the long and plentiful associations accreted to a world-famous work of visual art that precondi-

tioned our perceptions. To conclude this chapter neither with Oswald nor with Ruby, but with Oscar Wilde, let me repeat his maxim: "Things are [as they are] because we see them, and what we see, and how we see it depends on the Arts that have influenced us."

Thus *Laocoön* may stand as the emblem for this chapter and, indeed, the entire book. Its figures are inseparably entangled: the father with his sons, the sons with the man who bestowed life on them and the serpents who take it, and the serpents with the victim they were bidden to destroy. So is John Kennedy forevermore entangled, in the public memory, with Oswald, who is entangled with Ruby, who is entangled with Jacqueline, who is, of course, entangled with John in an endless loop of desires both fulfilled and otherwise.

And the entanglement extends further to the multitude of main and secondary and walk-on characters in Dallas. Emperor Charlemagne's paladins and TV's Paladin, as well as Audie Murphy, John Wilkes Booth, John Dillinger, Daniel Chester French, the founders of the NRA, Runyon, Weegee, and Goya, and all their respective products, productions, personae, and links to history are also entangled in the sudden burst of violence that flashed through the bowels of the Dallas police headquarters on the day I turned thirteen.

9

Salute

IF THE *LAOCOÖN* lurked in the basement of the Dallas police headquarters, another masterpiece of the ancient world set the tone for the funeral procession on the streets of Washington. This was the Ara Pacis Augustae, the Altar of the Augustan Peace, a marble monument commissioned by the Roman Senate in 13 B.C. to celebrate the reign of Emperor Augustus (Fig. 92).

Recovered in fragments from the rubble of history over a period of several centuries beginning in 1568, the Ara Pacis depicts a stately procession of noble Romans led by the emperor himself. A frieze along one side of the monument shows the members of the great ruler's family clustered together in a tight grouping, their faces solemn and dignified, their bodies graceful. The figures, though similar overall, are beautifully individualized by their facial expressions and hand gestures.

A lovely young mother, her head covered, occupies a central position in the composition. Two children stand before her. One of them, a little boy, tugs at the mantle of the adult in front of him. The other, older and clearly amused, seems to be telling him to behave. The mother comfortably rests one of her arms on the shoulder of this older child and extends a hand down to the shoulder of the younger one, as if she too is gently and silently signaling him to mind himself.

A similar scene was repeated on worldwide television just past noon on Monday, November 25, 1963, when the president's veiled widow and her two young children emerged from St. Matthew's Cathedral at the conclusion of the funeral mass. As they reached the bottom of the steps and waited with other members of the family for the honor guard to load the president's coffin onto the caisson that would bear it to the ceme-

251

FIGURE 92 | Imperial Procession, a portion of the frieze of the Ara Pacis Augustae, 13–9 B.C., Rome

tery, Jacqueline Kennedy stood patiently with a squirmy child at either hand (Fig. 93).

Looking back at the archival footage, we can see her adroitly balancing her new and unwanted role as the president's grieving widow with a much more practiced role as a mother of two young children. At one point, five-year-old Caroline reaches over to snatch the program of the funeral mass away from her brother, John, Jr., whose third birthday it happened to be. Discreetly, unhurriedly, not making a big deal of it, Jackie works the program out of her daughter's hand and gives it back to her son before he begins making a fuss.

The Roman peace monument, with its sublime mixture of public formality and private, familial informality, provides a striking visual template for the images recalled from the Kennedy funeral (and suggests continuities of human behavior over the intervening two thousand years). Ancient Greek and Roman analogies were certainly present in the minds of some of the key actors in these proceedings. Lady Bird Johnson, the new first lady, later recalled her ride with the Kennedy family on Sunday from the White House to the Capitol, where the closed casket lay in state:

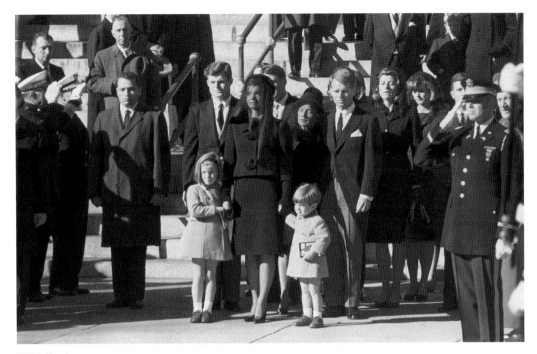

FIGURE 93 | White House, November 25, 1963

As soon as we emerged from the gates of the White House, I became aware of that
sea of faces stretching away on every side—silent, watching faces. I wanted to cry
for them and with them, but it was impossible to permit the catharsis of tears. I
don't know quite why, except that perhaps continuity of strength demands restraint.
Another reason was that the dignity of Mrs. Kennedy and the members of the fam-
ily demanded it. . . . The feeling persisted that I was moving, step by step, through
a Greek tragedy.

Months later, when Bobby Kennedy was unable to cast off his ongoing grief about
the death of his brother, Jackie gave him a book that she said had meant much to her,
The Greek Way, by Edith Hamilton. Reading it more than once, he underlined pas-
sages that spoke of the inevitability of human suffering and our inherent capacity to
endure it. He was particularly drawn to Hamilton's discussion of Aeschylus, "the first
poet to grasp the bewildering strangeness of life. . . . He knew life as only the great-
est poets can know it; he perceived the mystery of suffering. . . . He was, first and last,
the born fighter, to whom the consciousness of being matched against a great adver-
sary suffices and who can dispense with success. Life for him was an adventure, per-
ilous indeed, but men are not made for safe havens." Those are words he knew his

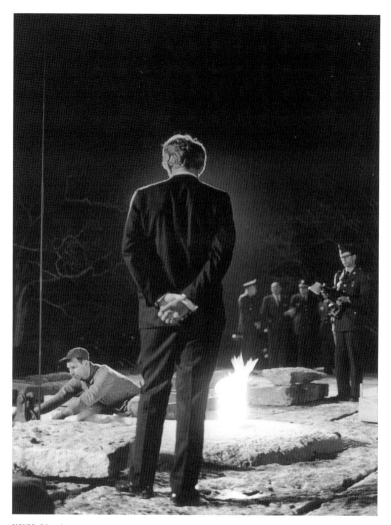

FIGURE 94 | Arlington National Cemetery, March 14, 1967

fallen brother would have admired, and Bobby made their sentiments his own. The attorney general immersed himself in the plays of Aeschylus, often carrying them with him to the Justice Department.

Hamilton, in her chapter on Thucydides, sternly criticizes Athenian imperialism: "The flame that burned so brightly in fifth-century Athens would have given more and still more light to the world if these dead had not died, and died truly in vain." That analysis prompted RFK—shown here overseeing a nighttime reinterment of his brother—to reexamine his own commitment to U.S. involvement in Vietnam and led him to his dramatic about-face in mid-decade (Fig. 94).

LIKE BOBBY KENNEDY, the ancient Roman historian Tacitus, who lived in the period of imperial decadence, longed for the vanished virtues of bygone days. He sought to revive those times in his eloquent historical treatises. In one of them he told of Agrippina, the wife of a brilliant young general named Germanicus who was assassinated while the couple resided in a foreign land. "Her misery," Tacitus relates, "was unendurable," but that did not prevent the widow from making the arduous journey back to the Italian mainland with remarkable courage and dignity: "Agrippina, with her two children, stepped off the ship, her eyes lowered, the urn of death in her hands." Though she maintained her decorum, "the cries of men and women, relatives and strangers, blended in a single groan. . . . Even people from towns far away came to meet the procession, offering sacrifices and erecting altars to the dead man's soul, and showing their grief by tears and lamentations."

The story of Agrippina, the noble widow who restrains her emotions at a time of communal grief, holds an important place in the history of American art. In London in 1768, the precocious young Quaker artist from Pennsylvania, Benjamin West, envisioned the scene described by Tacitus (Fig. 95). His *Agrippina Landing at Brundisium with the Ashes of Germanicus* is one of the foundational works of American art, as well as one of the earliest examples of neoclassicism, the new artistic style that swept European intellectual circles in the second half of the eighteenth century and in painting culminated in the works of David discussed above, *The Oath of the Horatii* and *The Death of Marat* (see Figs. 63, 52).

West contributed to the emerging style an emphasis on archaeological research and historical accuracy in the imaginative re-creation of scenes from the classical world. He based the central cortege of *Agrippina* on the procession of senators and their families from the Ara Pacis. As in that frieze, so in West's painting seventeen centuries later, two children flank their mother. West borrows from the Ara Pacis the gesture of the younger child clutching at the mantle of the man in front of him but turns it back to the mother and repeats it. Thus in West's work both children clutch at their mother's robes, and no man walks before them. The art historian Alexander Nemerov has pointed out that West's motif of an anguished parent linked by hands to her children derives from a more dramatic ancient source, the *Laocoön*, although it sifts the statue's emotionalism through the fine mesh of eighteenth-century English aristocratic reserve. The arcaded façade in the background also has a specific classical antecedent, the ruins of the Spalato palace of Emperor Diocletian, as published by West's contemporary Robert Adam in 1764.

The germinal neoclassicism of *Agrippina* goes beyond historical accuracy and sculptural style. Like Plutarch's *Parallel Lives* and Tacitus's *Annals*, West's painting offers moral instruction. It provides a "secular sermon in paint," according to the art histo-

FIGURE 95 | Benjamin West, *Agrippina Landing at Brundisium with the Ashes of Germanicus*, 1768, Yale University Art Gallery, New Haven

rian Jules Prown: "On one level the picture is a tribute to a hero who has sacrificed his life for his country—*dulce et decorum est pro patria mori*. But more importantly it dramatizes the admirable performance of Agrippina carrying her husband's ashes in a cinerary urn and followed by her grieving children. Her courage, stoicism and dignity in the face of tragic circumstances, normative behavior in classical times, is presented here to inspire emulation." Two centuries after West, amid the neoclassical architectural splendor of the American capital, the Kennedy funeral procession also embodied the classical ethos. When Professor Prown lectured on West to his Yale undergraduates a day or two after JFK's funeral, students wept when *Agrippina* appeared on the screen, so clearly did it echo the events they had all watched transpire on television (Fig. 96).

THE NEOCLASSICAL AURA of Jacqueline Kennedy was inscribed into the history of modern art by a most unlikely figure, the pop artist Andy Warhol. Starting soon after the assassination and returning to the project again and again over the next couple of years, Warhol produced the Jackie series, a large number of black-and-white or mono-

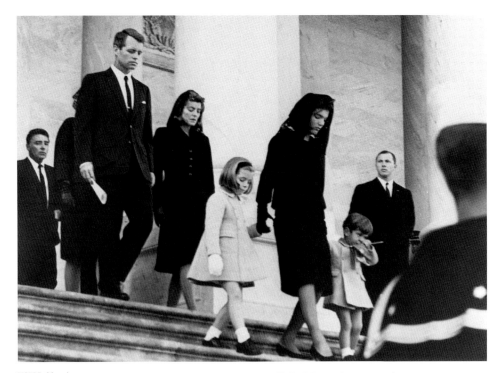

FIGURE 96 | St. Matthew's Cathedral, Washington, D.C., November 25, 1963

tone silk-screened acrylic paintings of the president's widow derived from eight different wire service photos taken during the November 22–25 weekend and cropped by the artist to headshots.

Two of these news photos, from Love Field and the motorcade, show Jackie beaming and happy, her face the essence of youthful joy. The rest depict a woman devastated but resolute as she witnessed the swearing in on Air Force One, waited beside a White House guard for her husband's casket to be carried to the Capitol, marched in the funeral procession, and stood at his grave. Warhol sometimes used one shot alone, multiplying it; at other times he mixed different shots in varying combinations and arranged them in a horizontal sequence, like a comic strip (*Jackie Triptych*), or in a grid (*Four Jackies, Sixteen Jackies, Twenty Jackies*, and so forth). *Nine Jackies* resembles a ticktacktoe board in which a diagonal line of three smiling "before" Jackies triumphs over the gloomy pairs of "after" Jackies.

During its heyday in the early sixties, pop art blatantly avoided high moral purpose (whether humanist, socialist, or avant-gardist), rejected historicism in favor of immersion in the consumer-culture present, and reveled in the bright, splashy colors and forms of comic books, movies, magazine advertising, commercial packaging, and su-

permarket display. All the same, the Jackie paintings are neoclassical in that unlike most other instances of pop art, including Warhol's, they depict a morally significant historical occasion with emotional restraint, muted tones, and architectonic control (the arrangement of the various headshots into balanced grids and schema). Moreover, insofar as the artist turned to news photographs as the basis for his depictions, he anchored his work, like any good eighteenth-century neoclassicist, in "historical" research.

Whether the various Jackie paintings tell a didactic story or merely juxtapose iconic images of a celebrity remains a matter of critical debate. Warhol's own account of his reaction to the assassination suggests that he was emotionally detached from the national trauma and did not aim to produce an edifying response to it: "When President Kennedy was shot that fall, I heard the news over the radio while I was alone painting in my studio. I don't think I missed a stroke. I wanted to know what was going on out there, but that was the extent of my reaction. . . . I'd been thrilled having Kennedy as president; he was handsome, young, smart—but it didn't bother me that much that he was dead." To this bold assertion of personal indifference about the killing he adds: "What bothered me was the way the television and radio were programming everybody to feel so sad." That statement supports the view of some critics that pop art in general, and Warhol's in particular, was concerned not with the "real" world but with the mass media's conventional and repetitive representations ("simulations") of it.

From this perspective, the Jackie series is not about Jackie Kennedy or her husband's assassination, or more enduring subjects, such as sorrow, grief, isolation, and mortality, but about the sign systems by which we communicate and in which we are enmeshed. That is, Warhol didn't paint Jackie Kennedy in mourning. He painted wire service news photos of her in mourning. In some of the works in the series, the black-and-white panels appear smudged or blurry, reminiscent of newsprint. The blocking of multiple individual panels over a larger surface area calls to mind, in various instances, a celluloid film strip or even *Life*'s layout of the Zapruder frame enlargements in grids over two-page spreads.

Some panels in the series emit a cool electric blue glow, giving them the aura of a television screen. Marshall McLuhan's *Understanding Media*, published at the time Warhol was painting these works, expounded on the inherently "cool" qualities of TV as a medium of communication. The assorted Jackie panels, stacked up in a grid of some sixteen or twenty headshots, resemble a display of TVs in an electronics store, with the sets tuned to four or five different stations, broadcasting the same celebrity, each from a different distance. Unlike cinema, the medium of television favors medium-range shots and close-ups. These best suit its purpose of eliminating extraneous visual information and concentrating the viewer's attention on either the head and shoulders or the face of the actor, newscaster, or newsmaker in question. The Jackie series supports the view that Warhol's true subject was not *history* (something that re-

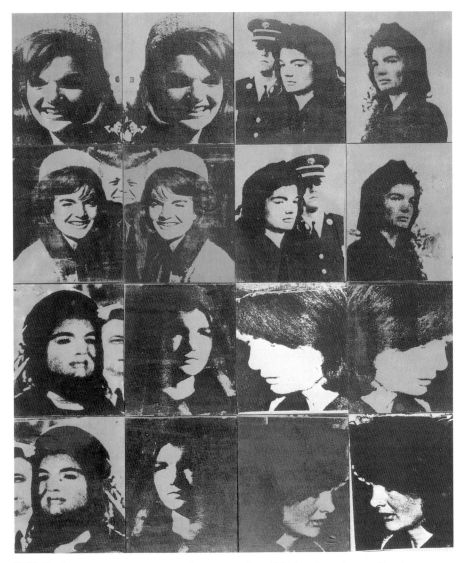

FIGURE 97 | Andy Warhol, *Jackie (The Week That Was)*, 1963, private collection

lies on the "long shot" of context) but *news* (which banishes history to "background" and concentrates on the here and now).

One of the first and most complex assemblages in the Jackie series, the only one to use all eight of the prototype news photos and possibly the only one Warhol himself arranged, is called *Jackie (The Week That Was)* (Fig. 97). The parenthetical title, which may have been added by the art dealer Leo Castelli, alludes to the trendy BBC television program, *That Was the Week That Was*, which first aired in an American version in

the fall of 1963. *TW3*, as it was called, used a faux-TV-news format to satirize the news of the week. *Jackie (The Week That Was)* is not in any discernible way satirical. Nevertheless it too constitutes a sort of news wrap-up, giving viewers the vertiginous sensation of having absorbed four days of nonstop newspaper, radio, and TV coverage and chatter with the same handful of obsessively rebroadcast images pinging off the walls of their minds.

For some viewers, however, the Jackie paintings belie Warhol's blasé response to the death of JFK and his scoffing at the collective grief "programmed" by the mass media. The poet, curator, and art critic Frank O'Hara said of one arrangement of Jackie paintings, "It's absolutely moving and beautiful. Not sarcastic, and it's not some sort of stunt. It really is a complete, compelling work when shown in the way [Warhol] wanted it to be shown." Describing the Jackie paintings as "elegiacal," David Bourdon, a onetime member of Warhol's inner circle, suggests that they attest to the artist's deep emotional investment in the Kennedy tragedy:

> By cropping in on Mrs. Kennedy's face, Warhol emphasized the heavy emotional toll upon her during those tragic closing days of November. The so-called Jackie portraits, far from displaying any indifference on Warhol's part to the assassination, clearly reveal how struck he was by her courage during the ordeal. . . . The mixed multiple portraits often make viewers feel as if they were walking along a modern-day Via Dolorosa as they relive the First Lady's agony in a new, secular version of the Stations of the Cross.

In the *Jackie Triptych* Warhol positions a three-quarter profile shot of the young widow low in the first panel, reverses and centers it in the second, and elevates it in the third, implying a gradual lifting up, an "ascension of the Virgin," that would be in keeping with his devotions as a practicing Roman Catholic (Fig. 98). This literal rising of the images in this sequence enacts the figurative change in Jackie's status in the eyes of most transfixed viewers.

To see the paintings this way, as authentic expressions of grief rather than coolly ironic glosses on the mass media and the cult of celebrity, accords with biographical evidence that Warhol, despite his hip posturing in public, was privately undone by the weekend's events. John Giorno, an intimate friend (the sleeper in Warhol's *Sleep*), rushed over to the artist's house as soon as he learned of the assassination. "We sat on the couch watching the live TV coverage from Dallas," recalls Giorno. "I started crying and Andy started crying. . . . Andy kept saying, 'I don't know what it means!'"

Warhol, whether distressed over the assassination and prompted by empathy for the widow or cerebrally detached, motivated only by his ongoing fascination with death, fame, and the consumer culture, left a series of paintings and assemblages that, in their

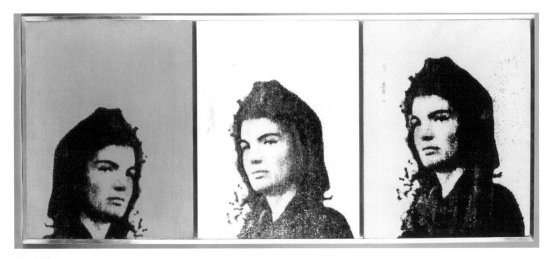

FIGURE 98 | Andy Warhol, *Jackie Triptych*, 1964, Ludwig Collection, Cologne

icy classicism, constitute the most complex and provocative American art to emerge from the shooting in Dallas. Other notable artists of Warhol's generation, among them Wallace Berman, Elaine de Kooning, Audrey Flack, Ed Paschke, and, above all, Robert Rauschenberg, used ready-made images of one or both Kennedys or Oswald or Ruby as the basis for works of modern art, but it was Warhol, in the Jackie series, who most powerfully conveyed the piercing trauma of that November weekend.

In later years Warhol became acquainted with "Jackie O," by then the chief love object and quarry of the paparazzi, and they were even spotted together at Studio 54. To those who cherished Camelot, this was a sorry case of tragedy giving way to banality. But from another point of view, Camelot itself was a banal construct, and Warhol's multiplication of the beautiful widow's grieving countenance into large decorative arrangements simply kept faith with the media cult of celebrity that her late husband had so assiduously nurtured.

THE DAY BEFORE THE FUNERAL. Leonard Bernstein led the New York Philharmonic Orchestra in a televised memorial performance for the slain president. The prominent conductor and television personality (Fig. 99) had a personal connection to the Kennedys. He had written and conducted a special fanfare for the gala in Washington the night before the president's inauguration and had been a White House guest both at state dinners and smaller informal parties.

He had even achieved a level of intimacy with the president's family. At a White House party honoring Igor Stravinsky, the conductor asked if he might watch the open-

FIGURE 99 | Leonard Bernstein on television, 1961

ing few minutes of one of his Young People's Concerts. Jackie directed him to the television in Caroline's room. He and Caroline and her nurse watched together. Bernstein held the hand of the five-year-old and assumed that she was as enthralled by his performance as he was, until she turned to him and remarked, "I have my own horse."

Jackie was the guest of honor at the televised opening of Philharmonic Hall in September 1962, during which Bernstein conducted Beethoven and Mahler. Afterward, he kissed her backstage. "Well, I never heard the end of it from the press," he recalled for an oral history deposited in the Kennedy Library. "And there was also consternation in the White House because I was so wet. I mean, that sweaty, awful conductor kissing this gorgeous creature, coast to coast on television, was just not permissible. And I'm still living it down. Horrible. But it doesn't seem to have affected our relationship."

For the memorial concert, he chose to conduct Mahler's Symphony No. 2 in C Minor (Resurrection). It would seem an odd choice, despite the symphony's affirmation that eternal life proceeds from earthly suffering and pain. In the early 1960s the work of Gustav Mahler was largely unknown to American audiences. More than anyone,

Bernstein "resurrected" the turn-of-the-century Austrian composer, whose large, baggy, often hair-raising late romantic symphonies seemed grossly out of step with both Eisenhower era blandness and Kennedy era cool. Bernstein had much in common with Mahler, a predecessor, from 1909 to 1911, as principal conductor of the New York Philharmonic (known then as the Philharmonic Society of New York). Both musicians were enormously ambitious, forever torn between conducting and composing; both were given to overpowering mood swings; and both were Jews maneuvering their way through predominantly gentile upper echelons. (Mahler actually converted to Catholicism, the Austrian state religion.)

In an influential essay on Mahler, Bernstein wrote, "The music is almost cruel in its revelations: it is like a camera that has caught Western society in the moment of its incipient decay. But to Mahler's own audience none of this was apparent: they refused (or were unable) to see themselves mirrored in these grotesque symphonies. They heard only exaggeration, extravagance, bombast, obsessive length—failing to recognize these symptoms of their own decline and fall." Only today, Bernstein claimed, were audiences beginning to grasp the relevance of Mahler's music: "The result of all this exaggeration is, of course, that neurotic intensity which for so many years was rejected as unendurable, and in which we now find ourselves mirrored."

Bernstein's recollection of his backstage faux pas with the first lady ("that sweaty, awful conductor kissing this gorgeous creature") symbolically highlights a powerful dichotomy of opposing wills to excess and control, expressiveness and restraint, that tugged at American culture at the outset of the sixties. His choice of Mahler's *Resurrection* for the memorial concert, rather than, say, Beethoven's *Eroica* or Mozart's *Requiem*, was surprising, idiosyncratic, self-serving, and absolutely appropriate. The Beethoven might better have caught the heroism of the fallen leader and the Mozart the eighteenth-century sensibility of the president's widow, but the Mahler, with its outpourings of raw feeling and its ecstatic modulations, captured the bipolar mood of the nation at large.

Later, explaining what he understood as Mahler's relevance to the 1960s and beyond, Bernstein wrote:

> It is only after fifty, sixty, seventy years of world holocausts, of the simultaneous advance of democracy with our increasing inability to stop making war . . . only after we have experienced all of this through the smoking ovens of Auschwitz, the frantically bombed jungles of Vietnam, through Hungary, Suez, the Bay of Pigs . . . the murder in Dallas, the arrogance of South Africa, the Hiss-Chambers travesty, . . . [the list continues]—only after all this can we finally listen to Mahler's music and understand that it foretold all.

If Bernstein takes considerable license in claiming that Mahler's music foretold this litany of twentieth-century traumas, nonetheless, the *Resurrection* symphony belongs to the assassination weekend as much as the Jackie series does. Its blistering passions, bitter ironies, and sudden dramatic reversals also link it to that time, even though its underlying sensibility is the opposite. Noteworthy here is Bernstein's and Mahler's shared Jewishness. True to stereotype or not, the most conspicuously emotional figures of the weekend were not the Catholic Kennedys or the Protestant Oswalds but the Jews, not only the two conductor-composers, one living, the other long dead, but also Abraham Zapruder, who wept openly when he appeared on television to talk about his fateful home movie, and Jack Ruby, whose lethal mixture of rage and sentimentality exploded in plain sight of millions.

Bernstein dedicated his newly completed Symphony No. 3, *Kaddish*, to the memory of President Kennedy, whom he lavishly admired. In Israel for the premiere of *Kaddish* a few weeks after the assassination, the composer burst into tears, grieving aloud, "Ah, what a tragic waste, what a stupid murder." *Kaddish* is Hebrew for the prayer a Jew recites at the grave of a dead parent.

MUCH OF THE COLLECTIVE GRIEF at the time focused on the loss of a parent, the symbolic father figure associated with the presidency but also the real father of a family.

Kennedy cultivated the image of himself as a caring young father, always making sure that photographers were nearby to record the seemingly offhand, unstudied moments of quiet or play that the Leader of the Free World shared with his two children (Fig. 100). However contrived such images may have been, evidence indicates that the man cared deeply about his offspring. Even as rigorous a critic of JFK's personal failings as the historian Thomas Reeves has suggested that the president's extraordinary personal restraint during the Cuban missile crisis "may well have reflected a growing sensitivity Kennedy was experiencing toward his own family. From all accounts Jack had reached out to his children and had become emotionally engaged in their lives. He enjoyed them, fretted about their well-being, and worried about their future." But unlike his wife, who sought to protect them as much as possible from public view, he saw no reason why they couldn't assist him in his ongoing efforts to charm the voters.

Photographs in the press of the young father enjoying ice cream with his kids, reading them stories, horsing around on the beach, or looking out to sea with them by his side amounted to a mirror of the times. Caroline, born in 1957, and John, Jr., born in 1960, both belonged to the baby boom, and Jack, to the World War II generation that instigated the sudden expansion of the population. Regardless of their political ori-

FIGURE 100 | Oval Office, October 10, 1963 (Cecil Stoughton, photographer)

entation, millions of American men could identify with Kennedy precisely because he, like them, was a modern father. The keystone of the 1962 comedy album *The First Family*, which sold a staggering four million copies in its affectionate send-up of daily life at 1600 Pennsylvania Avenue, was the comic impersonator Vaughn Meader's "Father," who held press conferences, greeted foreign dignitaries, and spoke with an unmistakable Back Bay patrician accent but suffered at the hands of his small children the same mundane indignities as every young dad throughout the country.

Pictures of Jack Kennedy alone with his children seem of a piece with a trend that developed in television at the end of the 1950s and grew apace in the early 1960s: shows about what today we would call single dads. *Bachelor Father*, which premiered in 1957, told of an unmarried Beverly Hills attorney whose newly orphaned teenage niece came to live with him. The western series *Bonanza*, which began its long run in 1959, revolved around a widowed ranch owner and his three grown sons. In *The Beverly Hillbillies*, 1962, widowed Uncle Jed looked after his daughter and nephew. *My Three Sons*, 1962, extracted comedy from the day-to-day tribulations of a widowed aerodynamics

FIGURE 101 | *The Andy Griffith Show*

engineer raising three growing boys with the help of a crusty old uncle. The one show that focused on a single father and a young child was the extremely popular *Andy Griffith Show*, which came on the air in 1960. Griffith played a widower, Andy Taylor, the sheriff of Mayberry, North Carolina, raising young Opie Taylor with the help of family and neighbors. Each episode of the series involved a heartwarming exchange between the mature father and his lovable scamp of a son (Fig. 101).

Even though President Kennedy in Washington and Sheriff Taylor in Mayberry inhabited separate worlds in most respects, each figured, in the collective imagination, as a wise and caring father who enjoyed an especially close and loving relationship with his offspring. That image of father-child intimacy received powerful reinforcement with Gregory Peck's 1962 Academy Award–winning performance in *To Kill a Mockingbird*. Peck played Atticus Finch, a widowed country lawyer in a bigoted southern community who teaches his twelve-year-old tomboy daughter, Scout, to understand often bitter truths about humanity. Scout may have been a girl, but she dressed and behaved like a boy, and some of the most poignant scenes of the film showed her and her father sitting together on the veranda or on her bed engaged in heartfelt conversation (Fig. 102).

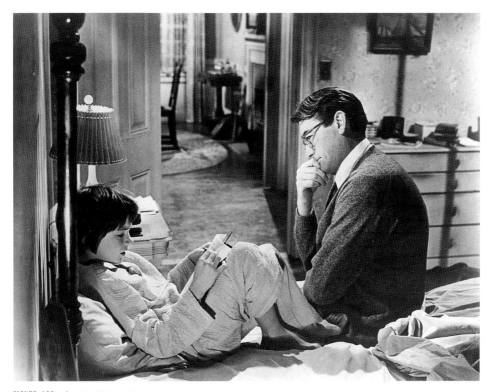

FIGURE 102 | *To Kill a Mockingbird*, 1962

The ultimate photographic record of Jack Kennedy's relationship with his little boy, whom he called John John to avoid well-worn nicknames like Johnny or Jack, appeared in a cover story for the popular biweekly magazine *Look* (Fig. 103). The issue, dated December 3, 1963, reached subscribers on Thursday, November 21, four days before John John's third birthday—and one day before the president's assassination. The feature reappeared soon after, with the same cover image but an altered layout, in *Look*'s upbeat special memorial issue, *Kennedy and His Family in Pictures*. The cover photo shows the towheaded toddler standing on a bench on which his father sits and pushing off against his dad's shoulder for support. The two of them, backlit by the morning sun, exchange a private joke. With his light hair, striped T-shirt (the official garb of the postwar American boy), suspender-straps, and impish grin, the little boy calls to mind the comic strip character Dennis the Menace. Created by the cartoonist Hank Ketcham in 1951, Dennis the Menace was not only a fixture of daily and Sunday newspaper comic strips but also the title character of a CBS television sitcom that ran from 1959 to 1963. Dennis signified "all-American boy" to readers and viewers of the time. He was a lovable mischief-maker—

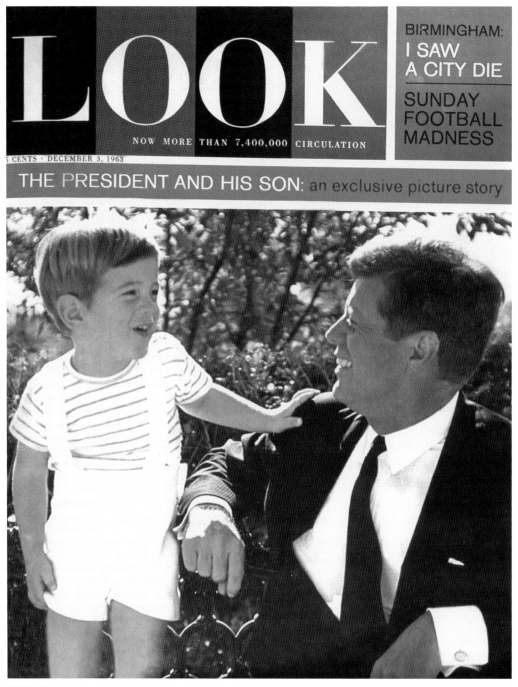

FIGURE 103 | *Look* cover, December 3, 1963 (Stanley Tretick, photographer)

clever, independent, and innately innocent—and as such seemed to personify the American spirit.

The ten-page photo spread in *Look*, titled "The President and His Son," plays up the Dennis the Menace angle without ever directly alluding to Ketcham's well-known character. Much of the text surrounding the pictures is written in John John's "voice." For instance, one shot shows the president standing in the Oval Office surrounded by no fewer than six advisors, while John John, laughing, crawls under the presidential desk. The text, straining to be clever, reads: "You can get awfully tired just waiting to see Daddy. One day, Miss Shaw [the children's nanny] said I couldn't go in because a Russian man, Mr. Gromyko [the Soviet ambassador], was there. Was that office busy! There was something bad in Berlin or someplace. So I just yelled very loud GROMYKO! GROMYKO! GROMYKO! To let everybody know I was there. That got me in trouble with Miss Shaw. . . . A boy is absolutely not allowed to yell GROMYKO! GROMKYO! to get Daddy's attention." In one picture John John scrambles onto the conference table in the Cabinet Room. In another he rocks backward in the familiar presidential rocking chair.

The *Look* spread was photographed in October, while Mrs. Kennedy, recovering from the death of her prematurely born son Patrick, was cruising off the Greek islands with her sister, Lee, on the luxurious *Christina*, the fabled yacht of the shipping tycoon Aristotle Onassis. In her absence, the president—temporarily a "single dad"—placed a call to the *Look* photographer Stanley Tretick. "Things get kind of sticky around here when Mrs. Kennedy's around," Tretick recalls the president saying. "But Mrs. Kennedy is away. So now's the time to do some of those pictures you've been asking for of John and Caroline." Tretick had five days of shooting. When he came back to the White House afterward with a set of glossy prints, the president picked one out of the group and said, "With this one, you can't lose, Stan."

In that now-famous picture, Jack attends to paperwork at his massive presidential desk in the Oval Office while his son peers out from the space below (Fig. 104). This photograph has become crucial to the iconography of JFK. Calling to mind Wordsworth's line "The child is the father to the man," it suggests that the little boy beneath the desk will grow up to be a big man like his father, while the man above the desk contains within him the playful and innocent spirit of a little boy. Intriguingly, especially with all that has been divulged about Kennedy since his death, John John's putative voice cries out enthusiastically in the caption, "Father's desk has a secret door."

Days after the original *Look* story reached newsstands and subscribers across the country, Americans wept to see the same little boy barelegged and fatherless in the cold November sun.

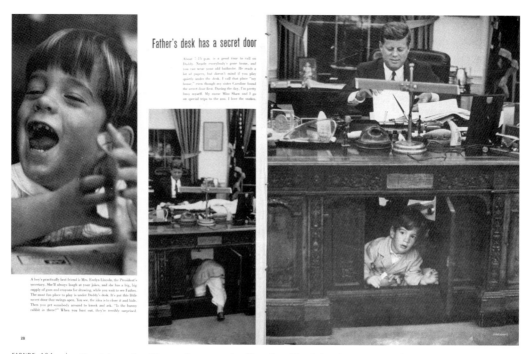

Father's desk has a secret door

About 7:15 p.m. is a good time to call on Daddy. Nearly everybody's gone home, and you can wear your old bathrobe. He reads a lot of papers, but doesn't mind if you play quietly under the desk. I call that place "my house," even though my sister Caroline found the secret door first. During the day, I'm pretty busy myself. My nurse Miss Shaw and I go on special trips to the zoo. I love the snakes.

A boy's practically best friend is Mrs. Evelyn Lincoln, the President's secretary. She'll always laugh at your jokes, and she has a big, big supply of gum and crayons for drawing, while you wait to see Father. The most fun place to play is under Daddy's desk. It's got this little secret door that swings open. You see, the idea is to close it and hide. Then you get somebody around to knock and ask, "Is the bunny rabbit in there?" When you bust out, they're terribly surprised.

FIGURE 104 | *Look* interior, December 3, 1963 (Stanley Tretick, photographer)

THE WIRE SERVICE PHOTOS of the proud and beautiful widow in black, her face obscured but not hidden by her veil, made her look to many like a figure of Greek tragedy or tragic opera. A year later, in 1964, the critically acclaimed film *Zorba the Greek*, directed by Michael Cacoyannis from the novel by Nikos Kazantzakis, featured a subplot about a beautiful young widow (Irene Papas) who perpetually dresses in black and drives the men of her Cretan village mad with desire because she remains aloof and unapproachable. When she becomes involved with a stranger from a foreign land, the jealous villagers stone her to death. No one stoned Jacqueline Kennedy when she married Aristotle Onassis in 1968, but many Americans were disappointed or angered by her abandonment of the role they continued to cherish for her as America's prettiest and most tragic widow.

In the early 1960s, before Jackie Kennedy achieved revered widowhood, few women were more universally admired as embodying the tragic spirit than the Greek diva Maria Callas (Fig. 105). In her peak years as a singer, from the late forties through the late fifties, Callas was the most sought-after soprano in the world, filling the great opera houses, where she gave astonishing performances as the tragic heroines Medea, Norma, Lady Macbeth, Lucia di Lammermoor, Violetta, Tosca, and Madame Butterfly, among many others. Leonard Bernstein, who conducted her performance at La Scala

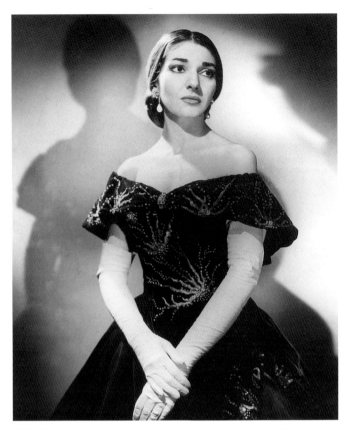

FIGURE 105 | Maria Callas at Covent Garden, 1958 (Houston
Rogers, photographer)

of Cherubini's *Medea* in 1953 (and, in so doing, was the first American ever to conduct
there), called her the world's greatest artist. Not only her remarkable vocal skills but
also her acting abilities and, above all, her electrifying stage presence made Callas a
superstar. Moreover, her tempestuous private life, not at all private, was itself like grand
opera. A fiercely competitive woman, she feuded openly with the other divas of the
time and would show up at a rival's performance, upstaging her from the audience.

Callas met Aristotle Onassis in 1957. Two years later he invited her and her hus-
band to join him on a cruise with Winston Churchill and his wife. By the end of the
voyage, the singer and her host were lovers. Their affair lasted several years, achiev-
ing international notoriety. When Onassis invited the bereaved Jacqueline Kennedy
to cruise on the *Christina*, Callas was distraught. A popular biographer, in a passage of
impressive melodrama, writes, "[Maria] knew that Jackie had been given the Ithaca
suite, the suite reserved for special guests, the suite that was Churchill's, the suite she

herself had stayed in. She knew, because she had lived it so many times, the routine on the *Christina*, the times for lunch and dinner, the ritual of cocktails on the deck at sunset; she knew the maids who would look after Jackie, the waiters who would wait on Jackie, the chef who would cook for Jackie. . . . In her private hell, Maria lived their cruise with them. It was at this time that she began to find it impossible to sleep without pills."

Callas was not the only one unhappy about Jackie's voyage on the *Christina*. The president wanted her to come home. She ignored him. The longer she stayed away, the more insistent he became, especially when photographs appeared in the press showing her on deck in her bathing attire. A Republican congressman made a speech in the House of Representatives questioning the conduct of the president's wife. Jack called the yacht and pleaded with her. When that didn't avail, he sent her a telegram, demanding that she return at once. She ignored it. That's when he invited Stanley Tretick to the White House for the photo sessions with him and the children. Thus those charming photographs of the president and John John together at play may have resulted from his desire not only to make political hay but also to settle a marital score.

Temperamentally, Jacqueline Kennedy and Maria Callas were opposites, one, as we have seen, the embodiment of cool, self-effacing, and self-restraining neoclassicism, the other the epitome of impetuous, self-aggrandizing, and, in her vexed relationship with Onassis, self-degrading romanticism. But they had more in common than the Ithaca suite on the *Christina*. In the early 1950s, each had deliberately modeled her personal appearance on that of Audrey Hepburn, although for Jackie, slender by nature, that mostly involved changing her hairstyle and wardrobe, whereas for Maria it was a matter of dropping seventy pounds. Both women gave birth to sons in 1960. Jackie did so with much fanfare as the first lady—elect. Maria did so in secret. The child, fathered by Onassis, died soon afterward, and his brief life, kept secret for decades, was discovered only recently by a biographer. Jackie's premature second son had also died shortly after birth, Onassis's ostensible reason for inviting her on the Mediterranean cruise.

In 1973 Aristotle's son Alexander perished when his private plane crashed on takeoff on his twenty-fourth birthday. Devastated, Onassis believed that Jackie, to whom he was now married, was not sufficiently grieved by the loss of her stepson, and he turned back to Maria for solace. His marriage to Jackie unraveled in all but legality, and Maria again became a fixture of his life during its two remaining years. Nearly a quarter century later, Jackie's son followed in the footsteps of his stepbrother, Alexander, and became a pilot, ultimately meeting with the same disastrous fate.

When Onassis learned of the assassination, he flew immediately to Washington to be by Jackie's side. He was with her on the night of the funeral. At coffee after din-

ner, Bobby Kennedy teased Onassis mercilessly about his extraordinary wealth. The attorney general drew up a mock legal document stipulating that the shipping magnate donate half his fortune to the poor in Latin America. Onassis signed it with a flourish. In the gaiety of the Irish wake that night behind the closed doors of the White House, the visitor from Greece amused everyone. Three thousand miles away in Paris, on the eve of her fortieth birthday, the divine Callas was not laughing.

AMUSEMENT WAS NOT HIGH on the public agenda in late November 1963. Given the enormous solemnity of the president's funeral, few observers at the time connected it in any way to one of the wittiest books published that year, Jessica Mitford's biting satire of the funeral industry, *The American Way of Death*.

Mitford, known by her admirers as "the queen of the muckrakers," was the socialist daughter of eccentric English aristocrats and had married a union lawyer in northern California. Observing through her husband's legal work the exorbitant costs paid by union workers to bury family members, she began writing the series of articles that grew into *The American Way of Death*. The exposé documented how morticians, playing on grief and guilt, induced the family of the dead person (euphemistically, "the deceased" or "the departed") to squander savings on costly floral arrangements, unnecessary embalming, elaborate coffins, theatrical memorial services, and gaudy, overpriced headstones. The book was an instant success, remaining on the *New York Times* Best Sellers list for nearly a year.

Bobby Kennedy had read the book some six months before the assassination and told the historian William Manchester that it influenced his choice of coffins while he awaited the arrival of his brother's corpse from Dallas. "He has a clear memory of talking to a girl [at Gawler's Funeral Home on Wisconsin Avenue] who told him, 'You can get one for $500, one for $1,400, or one for $2,000.' She went on about water proofing and optional equipment. Influenced by the Mitford book, he shied away from the high figure. He asked for the $1,400 coffin, and afterward he wondered whether he had been cheap."

In the end, the morticians had their way. The Kennedy family purchased the top-of-the-line coffin, which cost $2,460. "Known to the trade as a Marsellus No. 710," Manchester writes, "it was constructed of hand-rubbed, five-hundred-year-old solid African mahogany upholstered in what the manufacturer described as 'finest new pure white rayon.'" Gawler's mortuary establishment belonged to the undertaking aristocracy. It had buried President Taft and other eminences and had handled the Washington arrangements for Franklin Roosevelt's funeral. It was one of the most reputable firms in the funeral business.

But it had never provided service to blacks. William Manchester notes the irony of the attorney general, increasingly an advocate of civil rights, turning his brother over to the ministrations of a firm that in its illustrious 113-year history "had never buried a Negro."

THE NATIONAL CEMETERY was also segregated, but the president's funeral was not. Black soldiers, sailors, and marines were among those who marched in formation during the procession and were accorded the honor of serving as pallbearers. Haile Selassie, the Ethiopian emperor who was called the Lion of Judah and considered a god in the Rastafarian religion, stood beside French president Charles de Gaulle at the foot of the grave. A scattering of other black faces among the visiting dignitaries transmitted to onlookers an unmistakable message about the propriety of racial integration. All the same, whether by design or oversight, America's most prominent black advocate of civil rights, Martin Luther King, Jr., shortly to be named *Time*'s Man of the Year, had been left off the guest list for the mass.

The Reverend King both admired and envied the slain president, with whom he had much in common, not least, in the words of the civil rights historian Taylor Branch, that "between them they delivered most of the memorable American oratory of the postwar period." Three months earlier King had mesmerized a crowd of thousands who marched on Washington in support of the civil rights movement. From the steps of the Lincoln Memorial, he drew them, and millions of others worldwide, into a communal bond, envisioning a future free of racial hatred, violence, and discrimination: "I have a dream that my four little children will one day live in a nation where they will not be judged by the color of their skin but by the content of their character. On this day, I have a dream."

King's powerful rhetoric, together with his long-term efforts and those of other civil rights activists, had moved the Kennedy administration slowly from passivity or indifference toward a show of concern for racial equality in America that was immensely important at the time to the beleaguered movement. Willingly or not, Kennedy had been swept along into the social change that King advocated, and in death he gained credit for championing a cause that King and other movement leaders had forced upon him in life. By not inviting him to the late president's funeral mass, the attorney general implicitly disparaged not only King himself but also the social ideals for which he stood.

Burning at the slight, King stood in the crowd on the street as the cortege passed him by. He would have taken no comfort in the exclusion from the guest list of the nation's number one segregationist, Governor George Wallace of Alabama. King's rancor ran deep. Secret tapes of his private conversations several months after the funeral—

made by FBI agents under orders from the agency's director, J. Edgar Hoover, who believed King a Communist—reveal that the man of peace raged at the Kennedy clan and spoke of the president's widow in crudely sexual terms. In public, though, King eloquently eulogized the fallen leader, keeping his animosities well hidden.

Malcolm X, in contrast, expressed his openly. He had ridiculed the "Farce on Washington" as a Kennedy pep rally and showed no reverence for the slain president when he spoke about the assassination at a gathering of Black Muslims in Manhattan. At a question-and-answer session following his speech, the charismatic orator alluded to recent violence perpetrated against blacks (the assassination of the civil rights activist Medgar Evers; the suspected involvement of the United States in the murder of the Congolese prime minister Patrice Lumumba; and the firebombing of the church in Birmingham, Alabama, that left four little girls dead). He then called the killing of Kennedy a case of "the chickens coming home to roost." What he meant by that phrase, he later explained, was "that the hate in white men had not stopped with the killing of defenseless black people, but that hate, allowed to spread unchecked, had struck down this country's Chief of State." Most African American leaders, including the head of the Nation of Islam, Elijah Muhammad, rebuked him for his rhetoric, which seemed cavalier at best, incendiary at worst.

Much was made in the white press of the sadness of the "Negroes" at the death of the president who had championed their cause. A frequently reproduced news photograph showed two black women standing together abjectly outside Parkland Hospital in Dallas, reacting to the news that the wounds had proved fatal (Fig. 106). One wipes tears from her eyes and the other stares lost into space. This picture recalls *Life*'s April 1945 photo of a navy musician playing a hymn on his accordion at the "Little White House" in Warm Springs, Georgia, where FDR had died the previous day (Fig. 107). The musician is a black man, Chief Petty Officer Graham Jackson, and while he gazes upward, tears streak his face.

Public opinion studies in 1963, made shortly after the assassination, showed that African Americans were especially troubled by Kennedy's death. According to one national survey, over two-thirds of them, as compared with 38 percent of all respondents, agreed with the statement that they were "so confused and upset, they didn't know what to feel." More than half the blacks surveyed, compared with one-fifth of the total sample, worried about the effect of the assassination on "my own life, job and future." A study of Detroit schoolchildren indicated that 81 percent of black children, as compared with 69 percent of white, said the president's death made them feel "the loss of someone very close and dear."

In her memoir *Coming of Age in Mississippi*, the civil rights activist Anne Moody reveals how the Kennedy assassination awakened her politically. At the time she heard the news, she was working as a waitress in a segregated restaurant. "When I turned

FIGURE 106 | Parkland Hospital, Dallas, November 22, 1963

FIGURE 107 | Warm Springs, Georgia, April 13, 1945 (Ed Clark, photographer)

around and looked at all those white faces," she recalls, "I felt like racing up and down between the tables, smashing food into their faces, breaking dishes over their heads." Riding the streetcar home that evening, she writes, "I tried to look at the faces of the people. All I could see was newspapers. Every head was buried behind one. I looked especially for the faces of Negroes who had so many hopes centered on the young President. I knew they must feel as though they had lost their best friend—one who was in a position to help determine their destiny. To most Negroes, especially to me, the President had made 'Real Freedom' a hope."

STATE FUNERALS HAVE LONG BEEN USED as an occasion for rousing the sentiments of the people. The measured dirges and muffled drums, the rhythmic clip-clop of the horses, the flag-draped coffin, the solemn march of foreign dignitaries and heads of state, the grieving crowds have all been part of the spectacle of patriotic grandeur by which monarchs and national heroes have been laid to rest.

Even when the protagonist of the funeral procession has not been an officially sanctioned hero, the procession has nonetheless stirred public passions. In revolutionary Paris, Jacobin partisans bore the corpse of the assassinated Marat through the streets to rekindle the fervor of the masses, which the ongoing Reign of Terror had begun to cool. In 1824, in Regency London, the body of Lord Byron, who had died months earlier in the war for Greek independence but was denied a resting place in Westminster Abbey because of his scandalous behavior, was driven by six plumed horses through streets clogged with mourners. One hundred seventy-three years later, the corpse of another scandalous aristocrat, Diana, Princess of Wales, traced an almost identical funeral route through London, again to widespread public lamentation. Kennedy's funeral surpassed all of these in its splendor and its hold on the sentiments of the people.

The lying-in-state of Kennedy's body in the Rotunda of the Capitol was modeled on that of Lincoln in 1865. The catafalque that had borne the Great Emancipator's coffin was brought out of storage and used again. No one was allowed to miss the historical significance of this restaging, which accorded to JFK in death a Lincolnesque moral stature in relation to African American advancement that he had not attained during his lifetime. So many ordinary citizens came to pay their respects that the Rotunda was held open all night long. More than a quarter of a million mourners, eight abreast, filed past between 1:30 Sunday afternoon and 8:00 the next morning.

Although the officials in charge followed the rule book for military and state funerals to the letter, Mrs. Kennedy added a number of personal touches and orchestrated the event. When she insisted on walking behind the caisson to the funeral mass rather than ride "in a fat black Cadillac," researchers were dispatched to the Library of Congress, where they were relieved to find in the volumes of yellowed newsprint

verification that a precedent existed in the funeral processions of Presidents Washington, Lincoln, and Grant.

A more recent touch was the riderless horse carrying a pair of boots reversed in the stirrups. That funeral motif supposedly dates back to the time of Genghis Khan as a way to commemorate a leader lost in battle. It had been used for an American presidential funeral only once, eighteen years earlier, at the wartime death of Roosevelt. A gelding that ironically bore the name Black Jack—the nickname for Jackie's father—was led behind the flag-draped bier of the other Jack, her husband. As Manchester describes it, "His streaming flanks were unnatural, alarming. His steel hooves clattered in jarring tattoo, an unnerving contrast to the crack cadence in front; his eyes rolled whitely. He was nearly impossible to control." The horse brought a note of barely tamed urgency to the proceedings, but he did not upstage the first lady. The funeral, attended by delegates from eighty-two countries (including eight heads of state and ten prime ministers) and watched live by hundreds of millions of people across the globe (it was broadcast even on Soviet state television), was Jackie's show from first to last.

No actress ever trod a greater stage before a larger audience, yet for this performance she was her own wardrobe mistress, her own makeup assistant, and even the music director, asking that the plangent sounds of the Black Watch bagpipers and the poignant navy hymn "Eternal Father, Strong to Save," both favorites of her late husband, be added to the program. Her ultimate touch was the idea of the eternal flame, which she lit at his grave.

IN THE ART WORLD of the early 1960s, leaders of the avant-garde devised a type of theater-art spectacle known as Happenings (or, less frequently, as Actions, Events, or Situations). Drawing on the dada and surrealist movements of earlier generations and the influential teachings of the contemporary composer John Cage, who stressed the importance of randomness and chance in the making of art, Happenings brought groups of strangers together in haphazard combinations. As conceived by Allan Kaprow, Claes Oldenburg, Jim Dine, or the German artist Joseph Beuys, Happenings were attempts to make art out of multiple human and object actions, reactions, and interactions. They were conceptual undertakings, "happening" effervescently in the mind or the pulse of the observer, leaving behind no single artifact that could be labeled and hung on a wall or erected in a courtyard—only a vivid or fleeting set of memories.

"In principle," Kaprow explained in the *New York Times* in late 1963, "a Happening is an assemblage of events, which also includes people as part of the whole. Images in action, noise, and direct physical contact are, for me, generally more eloquent than words." A Happening was a piece of theater, he contended, but not a stage play: "Broad-

ening the definition to anything performed in a certain time and space, it may include circuses, pageantry, rituals, football games, church services, bull fights, peace marches, political rallies, TV commercials, and military war games. Happenings are theater but their place is anywhere except on stages."

Although Happenings were meant to invoke and engender spontaneity, they often began with intricate instructions or stage directions. Indeed, the first published anthology of Happening "scripts" borrowed its epigraph from act 2 of Anton Chekhov's *Cherry Orchard*—not, as might be expected, from the dialogue, but instead from a cryptic stage direction: "Suddenly there is a sound in the distance, as if from the sky— the sound of a breaking harp-string, mournfully dying away." One script by Kaprow, for *Eighteen Happenings in Six Parts* (the 1959 event that provided the new art-and-theater hybrid with its name), gave the following instructions: the participant "walks slowly along corridor (ahead of those going to Room 2), stops at entrance 5, walks slowly, in a straight line, eyes ahead, to within 3 feet of the person opposite," and so on at length. Participants knew in advance that as chance intervened, nothing would or could transpire precisely as planned. Thus even though the Happenings adhered to detailed scripts and were repeated on successive evenings, they had an aura of uniqueness about them, each one a separate event.

In December 1963, shortly after the assassination, Claes Oldenburg devised a Happening, called *Autobodys*, that took place in a rented parking lot in Los Angeles. Spectators sat inside their cars, using their headlights to illuminate the action. The "actors" were half a dozen or so automobiles that circled around the lot in a series of predetermined sequences. Passengers jumped into and out of them and laid themselves across the pavement like traffic victims. Although the artist had conceived of *Autobodys* before the assassination, its emphasis on highway death and violence became pointed, according to the art historian Barbara Rose, "when late in November President Kennedy was assassinated while riding in a motorcade, and endless images of the black cars in his funeral procession filled television screens throughout the country."

Happenings never drew large audiences, but the media attention they received, mostly mocking or patronizing them *(Those crazy artists, look what they're up to now!)*, led the avant-garde to drift away. Happenings quickly became passé, although they gave rise to a related artistic phenomenon of the 1970s, performance art, in which a single artist, relying on spontaneity, real or apparent, would appear before a small sympathetic audience in a gallery or museum exhibition space and use his or her body and/or speech to alter the observer's perceptions of and preconceptions about the world.

As unlikely as it may seem, the funeral amounted in some ways to a large-scale Happening, a piece of nonprofessional environmental theater elaborated out of what was initially an unexpected occurrence, the death of the president. (Inadvertently echo-

ing Chekhov's stage direction in *The Cherry Orchard*, a JFK advisor remarked, "The end of the service at Arlington was like the fall of a curtain, or the snapping of taut strings.") And in retrospect, the first lady appears to have been a proto–performance artist. She virtually created her performance on the spot (she put the whole thing together in less than 48 hours); she performed before a sympathetic audience that may not have been small in numbers (estimated at hundreds of millions) but was nonetheless small in Marshal McLuhan's sense of constituting a global village. Although her voice was never heard during the proceedings, she used her body—its bearing and gait and transcendent appearance through a black veil—in a manner that most assuredly altered perceptions and preconceptions around the world.

PERHAPS THE MOST ENDURING IMAGE from the funeral, if not from the entire assassination weekend, was one that Jackie played a major role in creating. It was John John's salute at the bottom of the cathedral steps (Fig. 108). He was saluting the flag-draped coffin as it was affixed to the caisson, the same caisson that had borne Lincoln and Franklin Roosevelt. He was saluting his father and, in the sense explored above, the nation's father. He was saluting the commander in chief. Film footage of the moment reveals an important detail that the still photographs do not. Immediately before John John saluted, Jackie leaned down and whispered to him, instructing him to make his move.

The December 3, 1963, issue of *Look* that was on the stands that day with its featured photo essay, "The President and His Son," shows that already back in October John John had been learning how to salute. In the *Look* photo, he mistakenly uses his left hand instead of his right, and the salute isn't crisp and smart, but the rudiments of his polished salute on the cathedral steps are clearly in the making.

A salute is a bodily gesture, a precise movement of the arm and hand meant to confer honor. It belongs to the category of what linguistic philosophers call "performative utterances." Such an utterance, for example, "I declare you husband and wife" or "I give you my word," accomplishes the act it describes. To say "I give you my word" not only tells what you are doing but actually does it; the description and the action are inseparable; the dancer cannot be distinguished from the dance, the saluter from the salute. John John's salute is a performative utterance—it says, in effect, I give you my respect, and in so doing, it does just that. It might also be regarded as a piece of performance art, though belonging more to the mother who prompted it than to the son through whom, we might say, it was performed.

John John looks so heartbreakingly vulnerable in his double-breasted coat and short pants, with his white ankle socks and his wobbly knees and his left hand at his side, fingers pointed inward, like that of his Uncle Bobby, who stands above and behind him

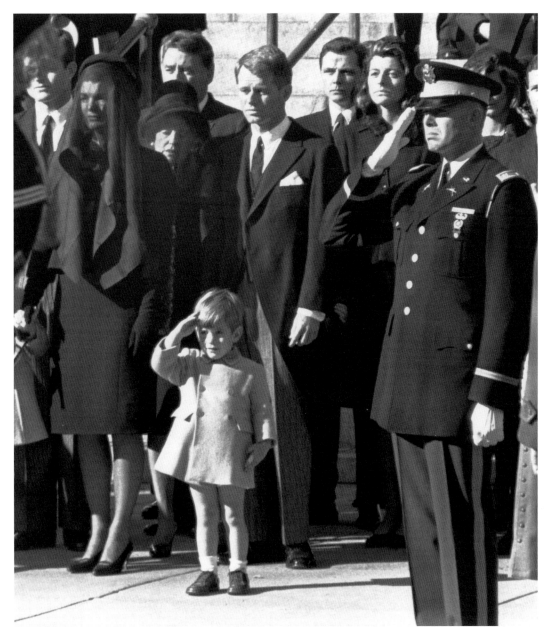

FIGURE 108 | St. Matthew's Cathedral, Washington, D.C., November 25, 1963

FIGURE 109 | Warsaw, April–May 1943

in striped trousers and morning coat. If nothing else, the picture reminds us how frag-
ile children are, how breakable. Some two and a half months earlier, back in September,
four children had died in a church bombing in Birmingham, Alabama, and that was
a tragedy, but the girls were older (one was eleven, the others fourteen), and they were
black, and they were southern, and they were not the darling little prince or princess
of the doomed Prince Charming, and, most important, no one single photograph ex-
ists to sum them up and stamp them as icons in the collective memory.

Such an image exists, however, of a young boy in the Warsaw ghetto in the spring
of 1943 (Fig. 109). The photograph first surfaced in West Germany in 1960 and quickly
attained iconic status, appearing prominently, for example, in Ingmar Bergman's 1966
masterpiece *Persona* as a sign of the depravity of the human condition. The picture
shows the child lifting both hands above his head while a German soldier points a gun
at him and a young woman, possibly his mother, turns back with alarm. Like John
John, this skinny-legged boy in short pants raises his hands, but here it is not in a per-
formative utterance of respect but in a gesture of fear and surrender.

The photograph comes from a leather-bound souvenir album that SS Major Gen-
eral Jürgen Stroop sent to Berlin to document his suppression of the armed uprising
by "Jews and bandits" that lasted nearly three weeks. During that time, according to

Stroop's report, the German forces managed to round up and kill or deport fifty-six thousand Jews. In Gothic lettering the report's title page announced triumphantly: *The Jewish Quarter of Warsaw Is No More!*

The picture of the little boy and his fellow Jews was captioned, "Pulled from the bunkers by force." Next to this photo, with its jagged asymmetries and piecemeal assemblage of upturned hands and distracted gazes, the picture of John John saluting seems coy, contrived. Although it has moved countless viewers over the past four decades, a touching reminder of childhood innocence and a symbol of American national resolve, compared with the Stroop photo—at once banal, documenting an everyday occurrence in the ghetto, and terrifying, a snapshot from hell—John John's salute comes across as a performance, and only that.

LIFE CROPPED THE PICTURE of John John saluting so as to monumentalize him at full-page size, and it used this poignant image to close the December 6, 1963, memorial edition of the magazine. On the two preceding pages *Life* ran Theodore White's "For President Kennedy: An Epilogue," which included an account of his conversation with Jackie that put the Camelot idea into circulation. White quotes the president's widow as musing:

> Once, the more I read of history the more bitter I got. For a while I thought history was something that bitter old men wrote. But then I realized history made Jack what he was. You must think of him as this little boy, sick so much of the time, reading in bed, reading history, reading the Knights of the Round Table, reading Marlborough. For Jack, history was full of heroes. And if it made him this way— if it made him see the heroes—maybe other little boys will see.

White's valedictory ends with the words, "For one brief shining moment there was Camelot," and the reader turns the page to see John John's solemn salute. Jackie's words, the mental images they invoke, and this one striking visual image orchestrate complex emotions in the reader, a sense of loss, poignancy, and inspired resolve. But that's not all. The final page of the magazine proper, the picture of John John, faces the full-page advertisement on the inside back cover, for Kentucky bourbon. At lower left an old-fashioned gent in a three-quarter-length coat tips his top hat in a gesture of courtesy or greeting. That is, he salutes.

The layout of the two pages knits them together (Fig. 110). The early-afternoon shadow cast by John John leads the eye from his leather shoes to those of the trade icon in the bourbon ad, while the copy for the ad ("What a handsome way to give pleasure!") floats unanchored on the page immediately opposite the photo of John John,

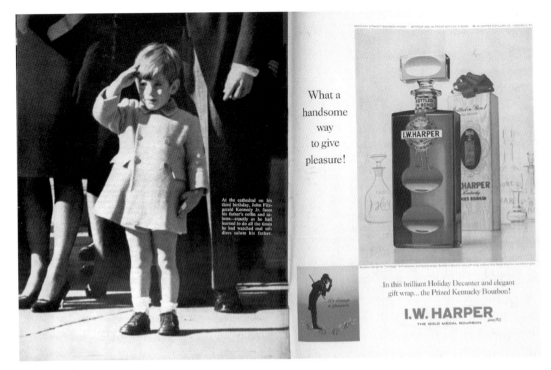

At the cathedral on his third birthday, John Fitz-gerald Kennedy Jr. faces his father's coffin and sa-lutes—exactly as he had learned to do all the times he had watched real sol-diers salute his father.

What a handsome way to give pleasure!

In this brilliant Holiday Decanter and elegant gift wrap... the Prized Kentucky Bourbon!

I.W. HARPER
THE GOLD MEDAL BOURBON *since 1872*

FIGURE 110 | *Life* interior, December 6, 1963

as if to caption both that picture and the advertisement. Little John is undeniably hand-some, and his gesture of respect to his dead father does, or at least surely did, give sen-timental pleasure to the millions upon millions of viewers who saw it.

In this juxtaposition of photo and advertisement, as in the one noted in Chapter 6 of the Dealy Plaza mourners and the "Come alive!" Pepsi ad, or the frame enlarge-ments of Jackie on the back of the Lincoln Continental followed by a Lincoln Conti-nental ad, the unintended parallel in imagery is more than merely ironic. It reminds us that images beget images, gestures, gestures, and symbols, symbols—that political, historical, and commercial mythologies reverberate off one another and draw suste-nance from the same deep wellsprings of culture. Folklorists say that the gesture we know as a salute originated during the Middle Ages when one knight would lift the vi-sor of his helmet to convey peaceful intentions to another. Thus the hand-to-the-head gesture of John John on one page and of the miniaturized trade figure on the other derives from the same Knights of the Round Table mythology that the text of White's article has just credited with inspiring young Jack Kennedy to become the modern-day embodiment of Camelot, which in turn has come to stand for liberal democratic capitalism guided by aristocratic leadership with high ideals and a common touch.

WHEN THE PRESIDENT'S WIFE and family gathered around his gravesite at Arlington, a dull roar rose in the east and fifty military jets streamed through the sky in a farewell salute. This too was an act of honor and respect, and a symbol of closure and grace. Yet perhaps, in retrospect, it didn't bode well. On the front page of the November 25, 1963, afternoon edition of the *Sacramento Bee* that a friend from California gave me are three headlines. The first and largest reads, "KENNEDY IS LAID TO REST: Joins Other Heroic Dead in Arlington." The second, smaller but in bold print, says "Oswald Is Slain in Burst of Revenge." The third and smallest headline announces, "Johnson Renews Pledge of US Viet Nam Victory." Centered amid the three narratives of heroic death, mad vengeance, and pledged military victory is a photograph of the beautiful veiled widow and her two handsome brothers-in-law, Robert and Edward, walking in measured cadence behind the caisson bearing the coffin of the dead warrior-prince.

America's Agrippina, crossing the stage of world history, models the ultimate Roman virtue, sacrifice of the self to the state. Ask not what your country can do for you. Ask what you can do for your country. Those sentiments surely would have met with the approval of Tacitus, the Roman aristocrat and senator who applied his unparalleled skills as an orator and prose stylist to a sustained criticism of imperial self-indulgence and a defense of faltering republican ideals. Agrippina in her eighteenth-century reincarnation, however, as seen in Benjamin West's neoclassical painting, served as a vehicle for state propaganda, in this case, that of Georgian England. King George III, inspired by the aristocratic sentiments of West's painting, appointed the young American Quaker history painter to the king. Neoclassicism in any of its forms seems ultimately a politically conservative force, favoring balance, restraint, the rule of tradition, and the privileging of an aristocratic elite over dynamic social change and the rise of the popular masses.

A firsthand observer of the chaos and confusion in Dealy Plaza likened the experience to witnessing an "explosion in a shingle factory." The comparison alludes to a celebrated quip that made the rounds in 1913 about Duchamp's *Nude Descending a Staircase*, a cubist painting that refracts the action into so many shards of disjointed motion that viewers found it impossible to detect either a staircase or a nude. The Kennedy assassination shattered conventional ways of seeing and understanding reality—like avant-garde art, yet, for a much larger portion of the population, with far greater force. In effect, the purpose of the funeral was to put all the shingles back in place, to restore order, or at least its semblance.

What might we conclude, then, about the great piece of theater directed, stage-managed, and performed by Jacqueline Kennedy in late November 1963? Did it liberate Americans from a national trauma by making the nation better, teaching its cit-

izens the value of inner nobility and self-sacrifice? Or did the funeral ultimately give rise to a more sustained trauma in which, in the crucible of the Vietnam War, the nation all but cracked, with loyalists to the state, inspired by patriotic idealism, in constant clash with antiwar protestors, whom they accused of rank selfishness but who themselves laid claim to a higher patriotism that cherished peaceful republicanism over war-making imperialism? To put this but another way, was the Kennedy funeral a moment of peace and healing and moral inspiration, or was it simply neoclassical theater on a giant scale, a spectacle that mesmerized the public and diverted its attention from the war on which it was already embarked? Was the funeral in essence a grand opera finale, with Jackie giving a performance that even Maria Callas couldn't rival?

John John saluted his fallen father in a gesture of loving respect. The fifty fighter jets did the same. Before long, other young sons would offer their own salutes to the nation's fathers—but their gestures would not always display respect. Later in the decade more and more of them raised a single finger instead of four.

Dulce et decorum est pro patria mori, wrote the Latin poet Horace. It is a sweet and seemly thing to die for one's country. In a very real sense, that was the underlying message of the Kennedy funeral, a message many of the nation's sons (and daughters too) came bitterly to reject, especially when they took it also to mean that it is a sweet and seemly thing to kill for one's country. In that context Mitford's phrase "the American way of death" took on an ironic new meaning, referring less to how Americans died than to how they dealt death to others, with their technologically sophisticated planes, artillery, and napalm.

The spectacle of John Kennedy's funeral, like the spectacle of his life, inspired many observers across the land to comport themselves with courage, dignity, and patriotic self-sacrifice. But in the national schism that lay ahead, what counted as courage to one American signified cowardice to another, and love of country expressed itself in radically different forms, from excessive zeal to abject shame. If the nation mourned as one during the funeral of the president, it would mourn as many in the years to come.

NIETZSCHE CLAIMED THAT MANKIND has always been tragically torn between two deep-seated human impulses, which he called the Apollonian and the Dionysian. The first of these, named for the sun god Apollo, is the craving for order, structure, and restraint. The other, named for Dionysus, the god of drunkenness and revelry, is the desire for pleasure, stimulation, and self-expression. Apollonian and Dionysian elements alike are writ large in the personalities and unfolding events that this chapter—indeed this book—has examined.

On the Apollonian side are Jackie and Bobby Kennedy with their "Camelot" poise and nobility, their well-thumbed copies of Edith Hamilton, and their enactment of dignified grief that derives, consciously or otherwise, from the eighteenth-century neo-classicism of *Agrippina* and the ancient heroine who provided its model. Similarly Apollonian are the "cool" interpretations of Warhol, who was able to transform his private tears into those wonderfully removed, distanced images of Jacqueline Kennedy. On the Dionysian side are the Happenings, with their courting of chance and unpredictability; Leonard Bernstein, the sweaty, gauchely demonstrative maestro and his searing performance of Mahler; Maria Callas, overwrought, pill-taking, and self-abasing; Aristotle Onassis, upset at Jackie when he perceived she was not sufficiently upset by the death of his son; and, most outrageous of all, the gloating of the Stroop Report over the destruction of the Warsaw Ghetto.

The tension between the two modes of experience can be summarized in John John's words, as reported in *Look:* "So I just yelled very loud GROMYKO! GROMYKO! GROMYKO! To let everybody know I was there. That got me in trouble. . . . A boy is absolutely not allowed to yell GROMYKO! GROMYKO! to get Daddy's attention." John John in his childish innocence, Oswald in his raging impotence, Ruby in his mad thirst for "class"—each, in Nietzsche's terms, was a Dionysian struggling against the Apollonian codes by which he felt himself constrained, disaffected, stifled. John John, that is, was not the only one who sought Daddy's attention.

Even Jack, it seems, wanted the attention of his own Infallible Father. When as a boy he jumped off the *Rose Elizabeth* after coming upon Joe making love to Gloria Swanson, when he went sailing with his fiancée and a *Life* photographer on Joe's boat at Joe's behest, and perhaps even when he dove into shark-infested waters, protectively ringed by coast guard vessels, to demonstrate his fearlessness, his actions shouted Gromyko! Gromyko! Gromyko!

Nude Descending a Staircase, its shingles exploding in every direction, is Dionysian. Agrippina in West's painting, with the ashes of war and death neatly contained in a sealed urn, is Apollonian. Marilyn Monroe standing astride the subway grate is both, for the statuesque blond with the white, billowing, classical garb revels in the irruption of sexualized energy from below yet also pushes her skirt back down, refusing to let it fly away. She keeps the lid on, like Agrippina with her urn and Jackie with her veil. Jack Kennedy, too, was Apollonian ("Ask not . . . ") and Dionysian (pursuing pleasure without license). His ability to serve both gods as well as he did is the reason he continues to hold such a purchase on the collective imagination. As an avatar of post-war American modernity, Kennedy in his various facets, public and private, brave and cowardly, generous and selfish, embodied both the best and the worst of democratic capitalism on its rise to global predominance. Pictures of JFK remain compelling to us today only because the story they tell is not his alone but also ours.

NOTES

These notes are keyed to the page number and opening words of the paragraph to which they pertain. Citations are not provided for well-documented biographical or historical details about the Kennedys or their period. A select bibliography follows the notes.

PREFACE AND ACKNOWLEDGMENTS

ix *John F. Kennedy's assassination:* See Bradley S. Greenberg, "Diffusion of News about the Kennedy Assassination," in *The Kennedy Assassination and the American Public: Social Communication in Crisis*, ed. Bradley S. Greenberg and Edwin B. Parker (Stanford, Calif.: Stanford University Press, 1965), 89–98, and, in the same volume, Stephan P. Spitzer and Nancy S. Spitzer, "Diffusion of News of Kennedy and Oswald Deaths," 99–111. Greenberg and Parker is also the standard source for statistical studies of emotional and psychological responses to the assassination as broken down according to race, sex, age, and political preference. On foreign reactions to the assassination, see Frank C. Costigliola, "Like Children in the Darkness: European Reactions to the Assassination of John F. Kennedy," *Journal of Popular Culture* 20, no. 3 (winter 1986): 115–24. The report from London was by Mollie Panter-Downes, "Letter from London," *New Yorker*, Dec. 7, 1963, 196–98, as quoted in Conover Hunt, *JFK for a New Generation* (Dallas: Sixth Floor Museum and Southern Methodist University Press, 1996), 19.

CHAPTER ONE: TWENTY-SIX SECONDS

2 *Still, in his straightforward account:* Ruminating on photography's relationship to time and mortality, Roland Barthes refers to cameras as "clocks for seeing" and dwells on "that rather terrible thing which is there in every photograph: the return of the dead." See *Camera Lucida: Reflections on Photography*, trans. Richard Howard (New York: Noonday Press, 1981), 15, 9. In *On Photography* (New York: Farrar, Straus and Giroux, 1977), Susan Sontag observes, "All photographs are *memento mori*. To take a photograph is to participate in another person's (or thing's) mortality, vulnerability, mutability. Precisely by slicing out this moment and freezing it, all photographs testify to time's relentless melt" (15).

2 *The eighty-four-year-old:* Georges Sadoul, "Louis Lumière: The Last Interview" (1948), in *Rediscovering French Film*, ed. Mary Lea Bandy (New York: Museum of Modern Art, 1983), 41.

3 *Abraham Zapruder died:* Conversation with Henry Zapruder, May 2, 2000. My other chief sources of information about Abraham Zapruder and his film are Art Simon, *Dangerous Knowledge: The JFK Assassination in Art and Film* (Philadelphia: Temple University Press, 1996), 35–54; and Richard B. Trask, *Pictures of the Pain: Photography and the Assassination of President Kennedy* (Danvers, Mass.: Yeoman Press, 1994), 57–153.

4 *The day the presidential visit:* William Manchester, *The Death of a President: November 20–November 25, 1963* (New York: Harper and Row, 1967), 44.

 It's worth noticing: See, for example, Syd Field, *Screenplay: The Foundations of Screenwriting* (New York: Delacorte Press, 1984).

5 *One of the biggest stars:* Gloria Swanson, *Swanson on Swanson* (New York: Random House, 1980).

6 *Kennedy believed that:* Ralph G. Martin and Ed Plaut, *Front Runner, Dark Horse* (Garden City, N.Y.: Doubleday, 1960), 461; quoted in John Hellmann, *The Kennedy Obsession: The American Myth of JFK* (New York: Columbia University Press, 1997), 92–93.

 During his sojourn: Charles ("Chuck") Spalding, quoted in Hellmann, 57.

7 *Another of Jack's friends:* Henry James, quoted in Nigel Hamilton, *JFK: Reckless Youth* (New York: Random House, 1992), 359.

9 *The catchy tune:* Music and lyrics by Jay Livingston and Ray Evans, 1956. See Susan Sackett, *Hollywood Sings! An Inside Look at Sixty Years of Academy Award-Nominated Songs* (New York: Billboard Books, 1995), 137–38.

 American popular culture: Music by James Van Heusen; lyrics by Sammy Cahn, 1959. See Sackett, 151–52.

 For the 1960 Democratic: Sackett, 152. See also Sammy Cahn, *I Should Care: The Sammy Cahn Story* (New York: Arbor House, 1974).

11 *Liz, everyone knew:* Michael Curtin, *Redeeming the Wasteland: Television Documentary and Cold War Politics* (New Brunswick, N.J.: Rutgers University Press, 1995), 239. Soon after Jackie's White House tour, Liz hosted "Elizabeth Taylor's London," a prime-time documentary that attracted a huge audience—according to Curtin, 241, it "drew close to half of all viewers watching television at the time of its broadcast." But the White House tour on the night of its original national broadcast (it was rebroadcast four nights later), captured an estimated three out of four television viewers.

12 *Whatever their differences:* See Wayne Koestenbaum, *Jackie under My Skin: Interpreting an Icon* (New York: Farrar, Straus and Giroux, 1995), 66–82, for a comparison of Jackie to Liz, as well as to Doris Day, Audrey Hepburn, and other movie stars of the time. See also Irving Shulman, *"Jackie"! The Exploitation of a First Lady* (New York: Trident Press, 1970).

18 *An eyewitness:* President's Commission on the Assassination of President John F. Kennedy, *The Warren Commission Report* (1964; reprint, New York: St. Martin's Press, 1992), 146. For another firsthand account of Oswald at the window, see Howard L. Brennan, with J. Ed-

ward Cherryholmes, *Eyewitness to History: The Kennedy Assassination As Seen by Howard Brennan* (Waco, Tex.: Texian Press, 1987), 7–9.

19 *Hitchcock, when interviewed:* François Truffaut, with the collaboration of Helen G. Scott, *Hitchcock,* rev. ed. (New York: Simon and Schuster, 1984), 216.

"Rear Window" appeared: Variants of this anecdote appear, for example, in Hellmann, 4, as well as Christopher Andersen, *Jack and Jackie: Portrait of an American Marriage* (New York: Avon Books, 1997), 149; Peter Collier and David Horowitz, *The Kennedys: An American Drama* (New York: Summit Books, 1984), 205; Ralph G. Martin, *A Hero for Our Time: The Intimate Story of the Kennedy Years* (New York: Ballantine Books, 1984), 89; and Donald Spoto, *Jacqueline Bouvier Kennedy Onassis: A Life* (New York: St. Martin's Press, 2000), 121. Sarah Bradford, *America's Queen: The Life of Jacqueline Kennedy Onassis* (New York: Viking, 2000), 99, claims Jackie would never have invited Kelly to her husband's bedside.

23 *Despite a publicity extravaganza:* Robert E. Kapsis, *Hitchcock: The Making of a Reputation* (Chicago: University of Chicago Press, 1992), 66.

The film's lack of closure: Kapsis, 78. See also Camille Paglia, *The Birds* (London: BFI Publishing, 1998).

24 *If "The Birds" attempted: Time,* Apr. 5, 1963; quoted in Kapsis, 93.

The Zapruder film, too: Andersen, 267, for the comment on Kennedy's "low-brow taste." See also Spoto, 181. On Jack's moviegoing preferences, see Paul B. Fay, Jr., *The Pleasure of His Company* (New York: Harper and Row, 1966), 173. Benjamin C. Bradlee, *Conversations with Kennedy* (New York: Norton, 1975), anecdotally recounts the president's interest in various movies of the period, including *Suddenly Last Summer* and *Private Property,* the latter a film Bradlee calls "a nasty little thing," 27; *Lonely Are the Brave* ("a brutal, sadistic little Western"), 129; *The Great Escape* ("a dreadful movie about some Englishmen in a German prison camp"), 143; the foreign-film anthology *Seven Deadly Sins,* 143; and *From Russia with Love* ("The movie was James Bond, and Kennedy seemed to enjoy the cool and the sex and the brutality"), 221 and 227, with the quoted phrase on 227. Bradlee's disdain for the movies that Kennedy enjoyed must not be left unchallenged. For example, the western *Lonely Are the Brave,* adapted by the blacklisted screenwriter Dalton Trumbo from an elegiac novel by the environmentalist Edward Abbey, offers a dark parable of nature destroyed by residential and commercial sprawl. In one scene the cowboy's silent landscape is invaded by a whining jet airplane overhead; in another the cowboy and his weary horse cross a busy highway as eighteen-wheelers fly past, horns blaring.

26 *Yet while vacationing in Ravello:* Edward Klein, *All Too Human: The Love Story of Jack and Jackie Kennedy* (New York: Pocket Books, 1997), 297–99.

29 *The director, Arthur Penn:* John G. Cawelti, ed., *Focus on "Bonnie and Clyde"* (Englewood Cliffs, N.J.: Prentice-Hall, 1973), 16.

In another interview: Cawelti, 11.

Oliver Stone's movie: See Oliver Stone and Zachary Sklar, *"JFK": The Book of the Film. The Documented Screenplay* (New York: Applause Books, 1992); also see Simon.

32 *Yet both made history:* P. Adams Sitney, *Visionary Film: The American Avant-Garde, 1943–1978,* 2d ed. (New York: Oxford University Press, 1979), 371.

32 *And both are home movies:* Jonas Mekas, "Where Are We?—the Underground," in *The New American Cinema: A Critical Anthology,* ed. Gregory Battcock (New York: Dutton, 1967), 20. The term "underground film" was introduced in 1957 by the art and film critic Manny Farber to describe low-budget Hollywood adventure or suspense movies of the thirties and forties, but by 1959 other critics were using it in reference to personal art films that rejected the domination of American cinema by the Hollywood film industry. See "Underground Films," in *Negative Space: Manny Farber on the Movies* (New York: Praeger, 1971), 12–14; and Sheldon Renan, *An Introduction to American Underground Film* (New York: Dutton, 1967), 22–23.

 In a very real sense: Stephen Koch, *Stargazer: Andy Warhol's World and His Films* (New York: Praeger, 1973), 35–36. See also Patrick S. Smith, *Andy Warhol's Art and Films* (Ann Arbor, Mich.: UMI Research Press, 1986). Wayne Koestenbaum recounts an experience different from Warhol's: "Watching dozens of hours of these early Warhol films in which little or nothing happens, I couldn't take my eyes off the screen, lest I miss something important. . . . I could barely take notes, so entirely was I hypnotized by minute gradations of light and shadow, anger and lust." Koestenbaum, *Andy Warhol* (New York: Viking, 2001), 71.

33 *Another Marcel:* David Bourdon, *Warhol* (New York: Abrams, 1989), 231. On the Duchamp revival of the early sixties, see Irving Sandler, *American Art of the 1960s* (New York: Harper and Row, 1988), 50–56. The sculptor and pioneer earthworks artist Robert Smithson recalled that the American art world of 1963 was besotted with "Duchampitis." See "Robert Smithson on Duchamp: An Interview," by Moira Roth, *Artforum* (Oct. 1973): 47.

 Duchamp spurred a reconception: Calvin Tomkins's 1962 *New Yorker* profile on Duchamp provided the general public with a lively introduction to the artist and his influence on the American avant-garde. See Tomkins, *The Bride and the Bachelors: Five Masters of the Avant-Garde* (New York: Penguin Books, 1976), 9–68.

34 *See the film:* Maurice Berger, "Andy Warhol's 'Pleasure Principle,'" in *Andy Warhol: Social Observer,* exhib. cat., curator Jonathan P. Binstock (Philadelphia: Pennsylvania Academy of the Fine Arts, 2000), 23. For a detailed account of the film and its cultural meanings, see Roy Grundmann, *Andy Warhol's "Blow Job"* (Philadelphia: Temple University Press, 2003).

36 *Don DeLillo's 1997 novel:* Don DeLillo, *Underworld* (New York: Scribner, 1997), 487–89.

CHAPTER TWO: "GENTLE BE THE BREEZE, CALM BE THE WAVES"

39 *He too leans forward:* "Senator Kennedy Goes A-Courting," *Life,* July 20, 1953, 96–99 and cover. On the role *Life* played in shaping postwar American domestic culture, see Wendy Kozol, *Life's America: Family and Nation in Postwar Photojournalism* (Philadelphia: Temple University Press, 1994).

 The photographer, Hy Peskin: "*Life* and Jackie: The Story of a Relationship," in *Remembering Jackie: A Life in Pictures,* by the editors of *Life,* with an intro. by Hugh Sidey (New York: Warner Books, 1994), n.p.

42 *"Breezing Up" shows:* Nicolai Cikovsky, Jr., and Franklin Kelly, *Winslow Homer,* exhib. cat. (Washington, D.C.: National Gallery of Art), 143.

43 *Jack's clean and innocent:* Ann Di Leonardo, Sunnyvale, Calif., letter to the editor, *Life,* Aug. 10, 1953, 11.

 Jack and Jackie were: Paul F. Healy, "The Senate's Gay Young Bachelor," *Saturday Evening Post,* June 13, 1953, 26–27, 123–29. July 1953 letter from John Kennedy quoted in Paul B. Fay, Jr., *The Pleasure of His Company* (New York: Harper and Row, 1966), 160.

 That's what this "Life" cover: Joe Kennedy, quoted in Ronald Kessler, *The Sins of the Father: Joseph P. Kennedy and the Dynasty He Founded* (New York: Warner Books, 1996), 338, from an interview with Cardinal Spellman's nephew Ned, who attended the lunch.

44 *Jack's personal aversion:* Sir Thomas Malory, *Le Morte Darthur,* ed. R. M. Lumiansky (New York: Scribner, 1982), 153.

 The term "rake" derives: Lord Chesterfield's Letters to His Son, ed. R. K. Root (London: Dent, 1959), 195 (letter dated Nov. 8, 1750), and 201 (Nov. 12, 1750).

 Jack's father bore: Christopher Andersen, *Jack and Jackie: Portrait of an American Marriage* (New York: Avon Books, 1997), 32.

45 *Jackie, too, had been:* See Edward Klein, *All Too Human: The Love Story of Jack and Jackie Kennedy* (New York: Pocket Books, 1997), 122–23.

 Called "Black Jack": Klein, 37.

46 *Perhaps we can make:* Page Smith, ed., *A Letter from My Father: The Strange, Intimate Correspondence of W. Ward Smith to His Son Page Smith* (New York: Morrow, 1996), 7; subsequent quotations from 14.

47 *Ward Smith was born:* The phrase "bitch-goddess SUCCESS" is from William James to H. G. Wells, Sept. 11, 1906, in *The Letters of William James,* 2 vols. (Boston: Atlantic Monthly Press, 1920), 2:259–60.

48 *The prologue:* David Cecil, *The Young Melbourne: And the Story of His Marriage with Caroline Lamb* (Indianapolis: Bobbs-Merrill, 1939), 2–3. Quotations in the three paragraphs that follow are from 5; 9, 11, 12; and 12–13. See John Hellmann, *The Kennedy Obsession: The American Myth of JFK* (New York: Columbia University Press, 1997), 29–32.

51 *Thus what "Playboy" sold:* On the ideology of *Playboy,* see Barbara Ehrenreich, *The Hearts of Men: American Dreams and the Flight from Commitment* (New York: Anchor Press, 1983), 42–51 and 60–62. See also Russell Miller, *Bunny: The Real Story of Playboy* (New York: Holt, 1984); the entries for *Playboy* in Richard A. Schwartz, *Cold War Culture: Media and the Arts, 1945–1990* (New York: Checkmark Books, 2000), 237–38, and *Jane and Michael Stern's Encyclopedia of Pop Culture* (New York: HarperCollins, 1992), 388–94.

 "Playboy" wasn't the only: Gay Talese, *Thy Neighbor's Wife* (New York: Doubleday, 1980), 45; the quotation in the paragraph that follows is from 127.

52 *Kinsey reported:* Statistics from Alfred Kinsey et al., *Sexual Behavior in the Human Female* (Philadelphia: Saunders, 1953), 286, 292, 417, 142, 196, and 487. Recent biographical and methodological studies that have questioned the authenticity or statistical accuracy of Kin-

sey's reports include James H. Jones, *Alfred C. Kinsey: A Public/Private Life* (New York: Norton, 1997). For a defense of Kinsey's sampling, see Jonathan Gathorne-Hardy, *Sex the Measure of All Things: A Life of Alfred Kinsey* (Bloomington: Indiana University Press, 2000).

52 *As "Life" was quick:* Ernest Havemann, "The Kinsey Report on Women," *Life*, Aug. 24, 1953, 41; quotations in the paragraph that follows are from 46; 48; and 48, 52; and Caroline Whitson, Sulphur Springs, Tex., letter to the editor, *Life*, Sept. 14, 1953, 17.

53 *By "superromantic":* Roger G. Taylor, comp. *Marilyn on Marilyn* (London: Comet Books, 1983), 34.

 During his convalescent stay: Marilyn to the troops, quoted in Richard Dyer, *Heavenly Bodies: Film Stars and Society* (New York: St. Martin's Press, 1986), 36. The poster story appears in various Kennedy biographies. J. Randy Taraborrelli recounts Jackie's suggestion in his *Jackie, Ethel, Joan: Women of Camelot* (New York: Warner Books, 2000), 92–93.

54 *Monroe's legs featured:* See George Barris, *Marilyn: Her Life in Her Own Words* (London: Headline, 1995), 111–14; and Norman Mailer, *Marilyn: A Biography* (New York: Grosset and Dunlap, 1973), 15. Marilyn's question and answer on her profile are from Taylor, comp., *Marilyn on Marilyn*, 40. Some Hollywood commentators believe Monroe's witticisms were made up for her by Roy Craft in the Twentieth Century Fox publicity department. Craft's account of the shooting of the subway grate scene on location as a Fox publicity stunt and the retaking of it on a Hollywood sound stage a few days later is in Lawrence Crown, *Marilyn at Twentieth Century Fox* (London: Comet Books, 1987), 152–56; see also 212 for Craft's disclaimer about providing the star her celebrated quips.

55 *The city-lust:* Smith, 461–62.

56 *Mailer describes:* Mailer, 124.

58 *Twice in 1953:* Taylor, 57.

 In September 1953: Andersen, 120.

 Earlier in 1953: Ian Fleming, *From Russia, with Love* (New York: Macmillan, 1957), 128–29.

60 *If sailing works as a figure:* Klein, 81.

62 *Once again the plot:* Frank Loesser, *Guys and Dolls* (New York: Frank Music Corp., 1949), 117–20. Lyrics printed by permission, Hal Leonard Music Corporation.

63 *He predicted jokingly:* John F. Kennedy, quoted in Thomas C. Reeves, *A Question of Character: A Life of John F. Kennedy* (New York: Free Press, 1991), 123. See Dalton Trumbo, *The Time of the Toad: A Study of the Inquisition in America* (New York: Harper and Row, 1972). Years later, as president, Jack enjoyed a White House screening of Trumbo's 1962 western parable *Lonely Are the Brave* (cf. note on p. 291).

64 *No, Jack Kennedy:* See Nigel Hamilton, *JFK: Reckless Youth* (New York: Random House, 1992), 306–38, on the development of *Why England Slept* from a student paper to a published book. See also Hellmann, *Kennedy Obsession*, 20–27.

 A novel published: Quotations in the paragraphs that follow are, in sequence, from Sylvia Plath, *The Bell Jar* (New York: Harper and Row, 1971), 1, 79, 92, 93–94, 111, and, on "woman-hating," 87–88.

67 *"She is Jackie Kennedy":* Quotations in this paragraph and the one that follows are from Donald Wilson, "John Kennedy's Lovely Lady," *Life,* Aug. 24, 1959, 76.

Mrs. Kennedy, "who dazzles": Wilson, 80.

69 *Eighteenth-century American:* See Margaretta M. Lovell, "Reading Eighteenth-Century American Family Portraits: Social Images and Self-Images," *Winterthur Portfolio* 22 (winter 1987): 243–64.

72 *Although little is known:* Carrie Rebora and Paul Staiti, *John Singleton Copley in America* (New York: Metropolitan Museum of Art, 1995), 318–21.

The acclaimed fashion photographer: The information on Shaw and Jacobson in the paragraphs that follow comes from Richard Reeves, intro. to Mark Shaw, *The John F. Kennedys: A Family Album,* rev. ed. (New York: Rizzoli, 2000), 12–13; and Christopher Andersen, *Jack and Jackie: Portrait of an American Marriage* (New York: Avon Books, 1997), 220–22. See also C. David Heymann, *A Woman Named Jackie: An Intimate Biography of Jacqueline Bouvier Kennedy Onassis* (New York: Lyle Stuart, 1989), 296–319.

75 *"The children appeared":* Kate Chopin, *The Awakening* (orig. pub. 1899; now available in various editions), chap. 39. The quotation in the paragraph that follows is from chap. 11, subsequent quotations from chap. 39.

79 *"My mother thinks":* Donald Spoto, *Jacqueline Bouvier Kennedy Onassis: A Life* (New York: St. Martin's Press, 2000), 138.

De Beauvoir's book: Simone de Beauvoir, *The Second Sex,* trans. H. M. Parshley (New York: Vintage Books, 1974), 802. The two quotations that follow come from 800 and 802.

In 1957, the year: Betty Friedan, *The Feminine Mystique* (New York: Norton, 1963), 18.

80 *Jackie tried to play:* The broadcasts are available for viewing at various archival institutions. I watched them at the Museum of Television and Radio in New York.

Whether the problem: Numerous Kennedy biographies mention the *Time* story, but I have not been able to track it down, not even with the assistance of the Time, Inc., archivist.

81 *Earlier in the summer:* Andersen, 170–71.

When Jack, off the Italian coast: Edward Klein, *All Too Human: The Love Story of Jack and Jackie Kennedy* (New York: Pocket Books, 1997), 203.

84 *As Edward Said has shown:* Edward Said, *Orientalism* (New York: Pantheon Books, 1978).

85 *Let's go back:* Klein, 167.

The Pre-Raphaelite photographer: Sylvia Wolf, *Julia Margaret Cameron's Women,* exhib. cat. (Chicago: Art Institute of Chicago, 1999), 66.

87 *In the worried expression:* See Therese Thau Heyman, Sandra S. Phillips, and John Szarkowski, *Dorothea Lange: American Photographs* (San Francisco: Museum of Modern Art and Chronicle Books, 1994), caption under plate 42 and headnote on p. 188. See also Vicki Goldberg, *The Power of Photography: How Photographs Changed Our Lives* (New York: Abbeville, 1991), 136–42; and Milton Meltzer, *Dorothea Lange: A Photographer's Life* (New York: Farrar, Straus and Giroux, 1978).

88 *And yet it's too simple: Life,* Dec. 29, 1959, 4, 114.

89 *Poverty was America's:* Poverty data from table 1, "Weighted Average Poverty Thresholds for Families of Specified Size, 1959 to 2000"; table 2, "Poverty Status of People by Family Relationships, Race, and Hispanic Origin, 1959 to 2000"; and table 13, "Number of Families below the Poverty Level and Poverty Rate, 1959 to 2000," from the Historical Poverty Tables provided by the U.S. Bureau of the Census, Current Population Survey (Mar. 2001), Poverty and Health Statistics Branch, Housing and Household Economics Statistics Division, as found at *http://www.census.gov/hhes/income/histinc/histpovtb.html.*

In 1957 "Fortune" listed: Ronald Kessler, *The Sins of the Father: Joseph P. Kennedy and the Dynasty He Founded* (New York: Warner Books, 1996), 342; and John H. Davis, *The Kennedys: Dynasty and Disaster, 1848–1984* (New York: McGraw-Hill, 1985), 730.

90 *Engaging Soviet Premier:* David Farber, *The Age of Great Dreams: America in the 1960s* (New York: Hill and Wang, 1994), 14–16. For a more detailed account, see Karal Ann Marling, *As Seen on TV: The Visual Culture of Everyday Life in the 1950s* (Cambridge, Mass.: Harvard University Press, 1994), 242–83.

That summer the best-known: "Donna Reed—Rightly Optimistic," *TV Guide,* Aug. 8, 1959, 8–11.

91 *Critics complained:* Christopher Paul Denis and Michael Denis, *Favorite Families of TV* (New York: Citadel Press, 1992), 77. "The Ideal Wife" was first broadcast Mar. 11, 1959.

92 *Jackie Kennedy was never:* Laura Bergquist, "A Lonely Summer for Jacqueline," in The JFK Memorial Issue, *Look,* Nov. 17, 1964, 45. The *Life* caption is from Wilson, "John Kennedy's Lovely Lady," 79.

93 *A campaign speech:* Hugh Brogan, *Kennedy* (London: Longman, 1996), 47.

94 *A week after:* Theodore H. White, "For President Kennedy: An Epilogue," *Life,* Dec. 6, 1963, 158–59. See also Theodore H. White, *In Search of History: A Personal Adventure* (New York: Harper and Row, 1978), 518–25. Edward Klein, *Just Jackie: Her Private Years* (New York: Ballantine Books, 1998), 9–19, dramatically re-creates the encounter in Hyannis Port on the basis of his conversations with White before White's death.

95 *"This much we pledge":* Garry Wills, *Lincoln at Gettysburg: The Words That Remade America* (New York: Touchstone Books, 1992), 89. Ronald H. Carpenter, a historian of American public address, provides a rhetorical analysis of JFK's inaugural speech in *Choosing Powerful Words: Eloquence That Works* (Boston: Allyn and Bacon, 1999); see 14–16 and 29–48.

The tradition of multiple: Benjamin C. Bradlee, *A Good Life: Newspapering and Other Adventures* (New York: Simon and Schuster, 1995), 216.

Now, on this celebratory: Hamish Bowles, *Jacqueline Kennedy: The White House Years. Selections from the John F. Kennedy Library and Museum,* exhib. cat. (New York: Metropolitan Museum of Art; and Boston: Bulfinch Press, 2001), 66.

97 *Jackie had encountered:* Bowles, 55.

98 *Tennyson wrote "Ulysses": The Poems of Tennyson,* ed. Christopher Ricks (London: Longman, 1969), 560.

99 *As a widow, Jackie:* "The Words JFK Loved Best," in The JFK Memorial Issue, *Look*, Nov. 17, 1964, 89.

104 *In her expanded role:* Susan J. Douglas, *Where the Girls Are: Growing Up Female with the Mass Media* (New York: Times Books, 1995), 41, 38; *London Evening Standard*, quoted in Ralph G. Martin, *A Hero for Our Time: The Intimate Story of the Kennedy Years* (New York: Ballantine Books, 1984), 331.

CHAPTER FOUR: BLUE SKY, RED ROSES

106 *One day, for example:* Oleg Cassini, *In My Own Fashion: An Autobiography* (New York: Simon and Schuster, 1987), 328.

Jack's bravado: On the PT 109 affair, see Nigel Hamilton, *JFK: Reckless Youth* (New York: Random House, 1992); and Robert J. Donovan, *PT 109: John F. Kennedy in World War II* (New York: McGraw-Hill, 1961). Robert Dallek, *An Unfinished Life: John F. Kennedy, 1917–1963* (Boston: Little, Brown, 2003), reveals new discoveries about the extent of Jack's lifelong medical conditions and physical disabilities, which he and his political handlers kept hidden from the public. In compensating for a sickly childhood by a zealous commitment to the strenuous life—if not also in using Cuba as a staging ground for his masculinity—Kennedy resembles one of his presidential predecessors, the former Rough Rider Theodore Roosevelt. See Sarah Watts, *Rough Rider in the White House: Theodore Roosevelt and the Politics of Desire* (Chicago: University of Chicago Press, 2003), chap. 2, "Inner Demons."

107 *That has the laconic:* Gore Vidal, "The Holy Family" (1967), in *United States: Essays, 1952–1992* (New York: Random House, 1992), 810.

Another of Jack's idols: See John Buchan (Lord Tweedsmuir), *Pilgrim's Way: An Essay in Recollection* (Boston: Houghton Mifflin, 1940), 60, 59, 58; and "The Words JFK Loved Best," in The JFK Memorial Issue, *Look*, Nov. 17, 1964, 89.

108 *Buchan's verbal portrait:* Buchan, 60.

"In the early deaths": John Hellmann, *The Kennedy Obsession: The American Myth of JFK* (New York: Columbia University Press, 1997), 35.

JFK's identification: Hellmann, 35.

109 *The 007 ethos:* Seymour Hersh, *The Dark Side of Camelot* (Boston: Little, Brown, 1997), 173–74. Kennedy's dinner with Fleming is detailed in John Pearson, *The Life of Ian Fleming* (New York: McGraw-Hill, 1966), 295–97. "It would have been better" is from Harold Evans, "White House Book Club," *New York Times Book Review*, Jan. 14, 2001, 31.

Take Lee Harvey Oswald: Jean Davison, *Oswald's Game* (New York: Norton, 1983), 148. Besides reading, Oswald spent much of his time watching movies in theaters and on TV. John Loken considers the possibility that three (non-Bond) feature films depicting attempted assassinations strongly influenced Oswald; see Loken, *Oswald's Trigger Films: "The Manchurian Candidate," "We Were Strangers," "Suddenly"?* (Ann Arbor, Mich.: Falcon Books, 2000). See also Don DeLillo, *Libra* (New York: Penguin Books, 1988), 369–70,

for a novelist's portrayal of Oswald watching a televised double feature of Frank Sinatra in *Suddenly* (1954) and John Garfield in *We Were Strangers* (1949) the weekend before John Kennedy came to town.

109 *A 1964 reader's guide:* O. F. Snelling, *007 James Bond: A Report* (New York: Signet Books, 1965), 35. Also on Bond, see the tribute by a novelist fan, Kingsley Amis, *The James Bond Dossier* (New York: New American Library, 1965); and the popular culture study by Tony Bennett and Janet Woollacott, *Bond and Beyond: The Political Career of a Popular Hero* (New York: Methuen, 1987). Various essays in *The Bond Affair*, ed. Oreste del Buono and Umberto Eco, trans. R. A. Downie (London: MacDonald, 1966), examine the Bond phenomenon from a mid-sixties European perspective.

111 *My point is not:* The quotation is from Martin Green, *The Adventurous Male: Chapters in the History of the White Male Mind* (University Park, Penn.: Pennsylvania State University Press, 1993), v. Kennedy's potency was a carefully cultivated illusion, his reliance on crutches, wheelchairs, painkillers, and other drugs a zealously kept secret. See Dallek, *An Unfinished Life.*

Jack's arrival at Love Field: See William Manchester, *The Death of a President: November 20–November 25, 1963* (New York: Harper and Row, 1967), 121.

113 *The public at the time:* Tennessee Williams, quoted in Gore Vidal, *Palimpsest: A Memoir* (New York: Random House, 1995), 336.

Lawrence, as his friend: Buchan, 213, 210–11.

117 *The photograph has:* My thanks to Pamela S. Johnson, a specialist in costume history and design in the School of Theatre and Dance at James Madison University, for her help in describing the photograph. Thanks, too, to Joyce Schiller, a costume historian and curator at the Delaware Art Museum, for additional insights into the Kennedys' apparel at Love Field.

The accompanying text: "The Assassination of President Kennedy," *Life*, Nov. 29, 1963, 23.

Mrs. Kennedy carries: Manchester, 111.

118 *Jackie's Chanel suit:* Lady Bird Johnson, *A White House Diary* (New York: Holt, Rinehart and Winston, 1970), 6.

119 *Born in France:* Janet Wallach, *Chanel: Her Style and Her Life* (New York: Doubleday, 1998).

Arrested as a collaborationist: Christian Dior, quoted in Nigel Cawthorne, *The New Look: The Dior Revolution* (London: Hamlyn, 1996), 162.

120 *The national origins:* Edward Klein, *All Too Human: The Love Story of Jack and Jackie Kennedy* (New York: Pocket Books, 1997), 248.

121 *Nixon did confess:* See Eric F. Goldman, *The Crucial Decade—and After: America, 1945–1960* (New York: Vintage Books, 1960), 226–29.

That is what Jack Kennedy: Hamish Bowles, *Jacqueline Kennedy: The White House Years. Selections from the John F. Kennedy Library and Museum*, exhib. cat. (New York: Metropolitan Museum of Art; and Boston: Little, Brown, Bulfinch Press, 2001), 51.

After that, Jackie: Oleg Cassini, quoted in Klein, 270. See Cassini, *In My Own Fashion,*

295–330, and idem, *A Thousand Days of Magic: Dressing Jacqueline Kennedy for the White House* (New York: Rizzoli, 1995).

122 *So when Jackie sat:* Manchester, 114, 117.

123 *Jack may have grumbled:* Manchester, 114.

 Later that morning: Manchester, 117–20.

 Jack Kennedy bought into: Ian Fleming, *The Spy Who Loved Me* (New York: Signet Books, 1962), 128–29.

124 *In Sylvia Plath's "Bell Jar":* Sylvia Plath, *The Bell Jar* (New York: Harper and Row, 1971), 119–20. Critical comment quoted in Lois Ames, "*Sylvia Plath:* A Biographical Note," as included in Plath, 294.

127 *The photo captures:* On Jack's liking for *La Dolce Vita*, see Vidal, *Palimpsest*, 366.

 As Bradlee explains: Benjamin C. Bradlee, *Conversations with Kennedy* (New York: Norton, 1975), 26–27.

 I've not been able: Sources for this paragraph include *http://www.theouterlimits.com/episodes/show_creation.html* and the Sept. 15, 1999, summary of *Private Property* on the Internet Movie Database (IMDb) by Dave Godin ("Dave G") of Sheffield, England, at *http://us.imdb.com/Details?0054209 comment*.

128 *Stevens's claim to cult status:* On the bleak tone and pessimistic social commentary of *The Outer Limits*, see Jeffrey Sconce, "The 'Outer Limits' of Oblivion," in *The Revolution Wasn't Televised: Sixties Television and Social Conflict*, ed. Lynn Spigel and Michael Curtin (New York: Routledge, 1997), 22.

 Even if no one: "Picture of the Week," *Life*, Aug. 31, 1962, 3.

129 *Jack was unhappy:* Bradlee, 151, 29; Klein, 255.

130 *"Life" describes him: Life*, Nov. 29, 1963, 23.

 The presidential historian: Theodore H. White, *In Search of History: A Personal Adventure* (New York: Harper and Row, 1978), 522.

 As I have noted: Letitia Baldrige, with menus and recipes by White House Chef René Verdon, *In the Kennedy Style: Magical Evenings in the Kennedy White House* (New York: Doubleday, 1998), 72–78.

131 *That same year:* Julia Child, with Louisette Bertholle and Simone Beck, *Mastering the Art of French Cooking*, has been published in various editions; Pierre Bourdieu, *Distinction: A Social Critique of the Judgement of Taste*, trans. Richard Nice (Cambridge, Mass.: Harvard University Press, 1984).

 At the time, America: Eric Schlosser, *Fast-Food Nation: The Dark Side of the All-American Meal* (Boston: Houghton Mifflin, 2001).

 Born in Paris: Raymond Loewy, *Industrial Design* (Woodstock, N.Y.: Overlook Press, 1979), 10. See also Paul Jodard, *Raymond Loewy* (London: HarperCollins, 1994).

132 *Given his world renown:* Loewy, 15. John H. Davis, *Jacqueline Bouvier: An Intimate Memoir* (New York: Wiley, 1996), 150–51, quotes Jackie's 1951 essay for *Vogue*'s annual Prix de Paris competition.

132 *"'Air Force One' was Kennedy's baby":* Loewy, 22.

 According to Loewy: Loewy, 25.

133 *In 1990, four years after:* Angela Schönberger, ed., *Raymond Loewy: Pioneer of American Industrial Design,* trans. Ian Robson and Eileen Martin (Munich: Prestel Verlag, 1990), 7.

 Six years after Kennedy's death: Theodore C. Sorensen, *The Kennedy Legacy* (New York: New American Library, 1970 [1969]), 121. See also Arthur M. Schlesinger, Jr., *A Thousand Days: John F. Kennedy in the White House* (Boston: Houghton Mifflin, 1965), 714–33, 739–49.

134 *Loewy claimed:* Loewy, 13–15; the quotation in the paragraph that follows is from Loewy, 19.

135 *In the early 1960s:* Marshall McLuhan, *Understanding Media: The Extensions of Man,* with a new intro. by Lewis H. Lapham (1964; reprint, Cambridge, Mass.: MIT Press, 1994). See also Paul Levinson, *Digital McLuhan: A Guide to the Information Millennium* (New York: Routledge, 1999).

 It was McLuhan: William Butler Yeats, "Among School Children" (1927), in *Selected Poems and Two Plays of William Butler Yeats,* ed. M. L. Rosenthal (New York: Collier Books, 1966), 117.

136 *Jet travel was a new:* "Jet Set," in *Jane and Michael Stern's Encyclopedia of Pop Culture* (New York: HarperCollins, 1992), 251–53.

 Even then, however: Marc Scott Zicree, *The Twilight Zone Companion* (New York: Bantam Books, 1982), 177–80, 384–87. "The Odyssey of Flight 33" appears in short story form in Rod Serling, *More Stories from "The Twilight Zone"* (New York: Bantam Books, 1961), 113–32.

137 *In 1959 the popular historian:* Martin Caidin, *Boeing 707* (New York: Ballantine Books, 1959), 194–95.

 Compare Caidin's panegyric: Daniel Boorstin, *The Image: A Guide to Pseudo-Events in America* (New York: Atheneum, 1978), 94. Subsequent quotations are from pages 57, 68, and 41–43.

140 *As a patriotic icon:* See Wanda M. Corn, *Grant Wood: The Regionalist Vision* (New Haven: Yale University Press for the Minneapolis Institute of Arts, 1983), 129–42; quotation on 134. Schlesinger, 739, writes: "The Kennedy message—self-criticism, wit, ideas, the vision of a civilized society—opened up a new era in the American political consciousness. The President stood, in John P. Roche's valuable phrase, for the politics of modernity."

CHAPTER FIVE: HIT THE ROAD, JACK

143 *Jack Kennedy loved to drive:* The friend was K. LeMoyne "Lem" Billings; quoted in Nigel Hamilton, *JFK: Reckless Youth* (New York: Random House, 1992), 173.

 Kerouac described the heroes: Jack Kerouac, *On the Road* (New York: Viking, 1957), 9; Joseph Alsop, quoted in Hamilton, 186.

145 *There's a wonderful shot:* Hamish Bowles, *Jacqueline Kennedy: The White House Years. Selections from the John F. Kennedy Library and Museum,* exhib. cat. (New York: Metropolitan Museum of Art; Boston: Bulfinch Press, 2001), 51, mentions the Givenchy coat.

147 *Jack, swiveled toward his wife:* David Sears, quoted in Robert MacNeil, *The Way We Were: 1963, The Year Kennedy Was Shot* (New York: Carroll and Graf, 1988), 129.

149 *In 1956, at the close:* Douglas T. Miller and Marion Nowak, *The Fifties: The Way We Really Were* (Garden City, N.Y.: Doubleday, 1977), 139.

The cement industry: Portland Cement Association advertisement, *Newsweek*, June 10, 1963, 77. Emphasis in original.

150 *And it was indeed:* Information in this paragraph was gleaned from personal conversations and correspondence with the architectural critic and commercial design historian Alan Hess. For details about the X-100, see Randy Mason, "The Strange Saga of the Kennedy Lincoln!" *Car Exchange* 5, no. 12 (December 1983): 42–47. For more on the social significance of changes in automobile design, see David Gartman, *Auto Opium: A Social History of American Automobile Design* (New York: Routledge, 1994); and the chapter titled "Autoeroticism: America's Love Affair with the Car in the Television Age," in Karal Ann Marling, *As Seen on TV: The Visual Culture of Everyday Life in the 1950s* (Cambridge, Mass.: Harvard University Press, 1994), 128–62.

153 *Whereas the American public:* Ad de Vries, *Dictionary of Symbols and Imagery* (Amsterdam and London: North-Holland Publishing, 1976), 142. For next paragraph, see, for example, J. C. Cooper, *An Illustrated Encyclopedia of Traditional Symbols* (London: Thames and Hudson, 1978), 391.

154 *One witness of the assassination:* Jeff Franzen, "Watching the President Die," undated transcript from BBC World Service, "My Century Archive" (http://www.bbc.co.uk/worldservice/people/features/mycentury/transcript/wk52d3.shtml).

155 *At the beginning:* Paul Henning (lyrics and music), "The Ballad of Jed Clampett." Stephen Cox, *The Beverly Hillbillies* (New York: HarperPerennial, 1993), provides a guide to the episodes of the series. On the social functions of TV comedy, see David Marc, *Comic Visions: Television Comedy and American Culture* (Boston: Unwin Hyman, 1989), and, on the *Hillbillies* in particular, idem, *Demographic Vistas: Television in American Culture* (Philadelphia: University of Pennsylvania Press, 1984), chap. 2, "The Situation Comedy of Paul Henning: Modernity and the American Folk Myth in *The Beverly Hillbillies*," 39–63.

158 *"The people" is a term:* Nunnally Johnson, screenplay for *The Grapes of Wrath*, as printed in *Twenty Best Film Plays*, ed. John Gassner and Dudley Nichols (New York: Crown, 1943), 377.

Hollywood lore has it: See Rudy Behlmer, *Behind the Scenes: The Making of . . .* (New York: Unger, 1982), 122–23. Tag Gallagher, *John Ford: The Man and His Films* (Berkeley and Los Angeles: University of California Press, 1986), 179–80, lists some of the differing accounts of the Ford film's ending. See also George Bluestone's comparison of the endings of book and movie in *Novels into Film: The Metamorphosis of Fiction into Cinema* (Berkeley and Los Angeles: University of California Press, 1968), 166–68.

159 *In that same episode:* "The Clampetts and the Dodgers," original broadcast on CBS April 10, 1963. Study reel 2839, Moving Pictures Division, Library of Congress.

But it was not a non sequitur: Newton N. Minow, *Equal Time: The Private Broadcaster and the Public Interest*, ed. Lawrence Laurent (New York: Atheneum, 1964), 52.

160 *"The Beverly Hillbillies," which premiered:* Quoted in Steven D. Stark, *Glued to the Set: The Sixty Television Shows and Events That Made Us Who We Are Today* (New York: Free Press, 1997), 107.

161 *I have already mentioned:* Michael Harrington, *The Other America: Poverty in the United States* (New York: Macmillan, 1962), 2–3.

CHAPTER SIX: KENNEDY SHOT

163 *At the very moment:* The most important source of information and ideas for this section, and for much of this chapter, is Art Simon's *Dangerous Knowledge: The JFK Assassination in Art and Film* (Philadelphia: Temple University Press, 1996). Also essential is Richard B. Trask's *Pictures of the Pain: Photography and the Assassination of President Kennedy* (Danvers, Mass.: Yeoman Press, 1994). On the rifle in question, see Henry S. Bloomgarden, *The Gun: A "Biography" of the Gun That Killed John F. Kennedy* (New York: Grossman Publishers, 1975). On Zapruder's Bell and Howell camera and the history of home movie equipment, see Douglas Collins, *The Story of Kodak* (New York: Abrams, 1990).

Immediately on learning: Richard B. Stolley, "What Happened Next . . . ," *Esquire* 80, no. 5 (Nov. 1973): 134–35.

164 *In the first issue:* My source of information for this paragraph is Trask, 95–97. See "The Assassination of President Kennedy," *Life*, Nov. 29, 1963, 24–27. And see President's Commission on the Assassination of President John F. Kennedy, *The Warren Commission Report* (1964; reprint, New York: St. Martin's Press, 1992). See also *Hearings before the President's Commission on the Assassination of President Kennedy*, 26 vols. (Washington, D.C.: Government Printing Office, 1964).

The public's first view: *Life*, Oct. 2, 1964, 40–51.

165 *The magazine asked:* *Life*, Nov. 25, 1966, 38–53.

166 *When "Life" sent:* Simon, 44.

167 *In response, Congress:* *The Final Assassinations Reports, Report of the Select Committee on Assassinations,* reprinted without the twelve accompanying volumes (New York: Bantam Books, 1979), 104.

At the climax: See Oliver Stone and Zachary Sklar, *"JFK": The Book of the Film. The Documented Screenplay* (New York: Applause Books, 1992), containing the "documented screenplay" and dozens of newspaper and magazine articles debating the movie's merits and historical accuracy. Detailed analyses of the film include Robert Burgoyne, "Modernism and the Narrative of Nation in *JFK*," in *Film Nation: Hollywood Looks at History* (Minneapolis: University of Minnesota Press, 1997), 88–103; John Orr, "Conspiracy Theory: *JFK* and the Nightmare on Elm Street Revisited," in *The Art and Politics of Film* (Edinburgh: Edinburgh University Press, 2000), 82–106; and Christopher Sharrett, "Conspiracy Theory and Political Murder in America: Oliver Stone's *JFK* and the Facts of the Matter," in *The New American Cinema*, ed. Jon Lewis (Durham, N.C.: Duke University Press, 1998), 217–47.

168 *An arbitration team:* Deb Riechmann, "Arbitrators to Decide Value of Zapruder Film," Associated Press wire service story, May 25, 1999. For a related discussion regarding the ownership of public images, see Jane M. Gaines, "Dead Ringer: Jacqueline Onassis and the Look-Alike," in Gaines, *Contested Culture: The Image, the Voice, and the Law* (Chapel Hill: University of North Carolina Press, 1991), 84–104.

In its 1964 issue: The quotations in this and the following paragraph are from *Life,* Oct. 2, 1964, 50B–51.

169 *In a neat irony:* Richard Nixon in "Ten Years Later: Where Were You?" *Esquire* 80, no. 5 (Nov. 1973): 137. See also Jules Witcover, *The Resurrection of Richard Nixon* (New York: Putnam, 1970), 60–61.

170 *The slender brunette: Life,* Oct. 2, 1964, 52–53. The legal department of the Ford Motor Company denied permission to reproduce the image.

So again we return: Warren Commission Report, 49.

When "Life" analyzed: "A Matter of Reasonable Doubt," *Life,* Nov. 25, 1966, 41.

171 *Josiah Thompson, a special:* Josiah Thompson, *Six Seconds in Dallas: A Micro-Study of the Kennedy Assassination* (New York: Bernard Geis Associates, 1967), 6. See "Jim Garrison's Closing Statement," in the "Historical Documents" section of Stone and Sklar, 548–49.

172 *Or, to the contrary:* Richard Stolley, interviewed on radio, Nov. 22, 1983, quoted in Trask, 147.

174 *When frames from the Zapruder:* A detailed examination of the Zapruder film that shows it in slow motion and with color enhancement is commercially available in VHS and DVD formats. See MPI Media Group, Orland Park, Ill., *Image of an Assassination: A New Look at the Zapruder Film* (MP 7282), color and black-and-white, approximately 45 minutes, 1998.

175 *Modernism's first theorist:* Sophie Monneret, *David and Neoclassicism,* trans. Chris Miller with Peter Snowdon (Paris: Terrail, 1999), 202–5. See also Thomas Crow, *Emulation: Making Artists for Revolutionary France* (New Haven: Yale University Press, 1995), 162–69; and William Vaughan and Helen Weston, eds., *Jacques-Louis David's "Marat"* (New York: Cambridge University Press, 2000). For details on Marat's life and cult, see Ian Germani, *Jean-Paul Marat: Hero and Anti-Hero of the French Revolution* (Lewiston, N.Y.: Edwin Mellen Press, 1992).

177 *Called "Marat/Sade": Time,* Jan. 7, 1966, 51.

178 *The play's Sade:* Peter Weiss, *The Persecution and Assassination of Jean-Paul Marat as Performed by the Inmates of the Asylum of Charenton under the Direction of the Marquis de Sade,* English version by Geoffrey Skelton, verse adaptation by Adrian Mitchell, intro. by Peter Brook (New York: Atheneum, 1965), 34. For Norman Mailer's humorous account of his misguided assumption that Jackie (with whom he corresponded) would share his fascination with de Sade, see Mailer, *The Presidential Papers* (New York: Putnam, 1963), 87–88.

179 *In the play's schematic:* See Gore Vidal, *Palimpsest: A Memoir* (New York: Random House, 1995), 19–20, and idem, "Coached by Camelot: Why Do We Still Want to Defend J.F.K.?"

New Yorker, Dec. 1, 1997, 87–88, in which Vidal quotes Seymour Hersh, who says he learned of that practice from a retired Secret Service agent, unnamed, who had worked in the Kennedy White House. Hersh, when I called him to check the story, said he had never spoken to Vidal about it.

179 *The monstrosity of:* Letter to me from Alexander Kearney, Francis Bacon Studio and Archive, Hugh Lane Gallery, Dublin, Aug. 16, 2002.

181 *David painted "The Death of Marat":* See T. J. Clark, *Farewell to an Idea: Episodes from a History of Modernism* (New Haven: Yale University Press, 1999), 40–48.

"*The colors are beautiful*": Riechmann, "Arbitrators to Decide." The estate ultimately requested $30 million, as I noted earlier.

183 *The hypermagnified:* Robert J. Groden, *The Killing of a President: The Complete Photographic Record of the JFK Assassination, the Conspiracy, and the Cover-Up* (New York: Viking Penguin, 1993), 132. See also Michael Fried, *Three American Painters: Kenneth Noland, Jules Olitski, Frank Stella* (Cambridge, Mass.: Fogg Art Museum, 1965), 33–39; and Kenworth Moffett, *Jules Olitski* (New York: Abrams, 1981).

183 *The critic Robert Goldwater:* Robert Goldwater, "Reflections on the Rothko Exhibition," *Arts* (March 1961): 44; Werner Haftmann, *Painting in the Twentieth Century*, vol. 1 (first English ed. 1961; New York: Praeger, 1965), 369, quoted in Edward Lucie-Smith, *Visual Arts in the Twentieth Century* (Upper Saddle River, N.J.: Prentice-Hall, 1996), 223.

184 *Zapruder's film, optically:* Selden Rodman, *Conversations with Artists* (New York: Capricorn Books, 1961), 93–94. See also James E. B. Breslin, *Mark Rothko: A Biography* (Chicago: University of Chicago Press, 1993); and, on people weeping before Rothko's work, James Elkins, *Pictures and Tears: A History of People Who Have Cried in Front of Paintings* (New York: Routledge, 2001).

"*Like it or not*": Frank Kappler, "Dealing With Earthly Hells," *Life*, Nov. 6, 1964, 98.

187 *Keaton's comedy:* Rudi Blesh, *Keaton* (New York: Macmillan, 1966); Anthony Cronin, *Samuel Beckett: The Last Modernist* (London: HarperCollins, 1996), 418, 448, and 530–34.

189 *Precisely such bitterness:* Quotations here and in the paragraph that follows are from Albert Goldman, *Ladies and Gentlemen—Lenny Bruce!!* (New York: Random House, 1974), 514. Caption from "The Assassination of President Kennedy," *Life*, Nov. 29, 1963, 26.

190 *Earlier I mentioned a man:* Trask, 315.

191 *Special Agent Hill told:* Warren Commission Report, 51, 49.

CHAPTER SEVEN: THE LONELIEST JOB IN THE WORLD

193 *Painted on commission:* Sophie Monneret, *David and Neoclassicism*, trans. Chris Miller with Peter Snowdon (Paris: Terrail, 1999), 69.

195 *To that end Stoughton wedged:* William Manchester, *The Death of a President: November 20–November 25, 1963* (New York: Harper and Row, 1967), 318.

196 *Lady Bird Johnson took special note:* Lady Bird Johnson, *A White House Diary* (New York: Holt, Rinehart and Winston, 1970), 6; Jim Bishop, *The Day Kennedy Was Shot* (New York: Funk and Wagnalls, 1968), 190; Geneviève Antoine Dariaux, *Elegance: A Complete Guide*

for Every Woman Who Wants to Be Well and Properly Dressed on All Occasions (New York: Doubleday, 1964), 101, 99.

196 *Lady Bird was not:* Manchester, 316.

 Jackie's gloves were thus: See Charles Spaak and Jean Renoir, screenplay for *Grand Illusion,* in *Masterworks of the French Cinema,* intro. John Weightman (New York: Harper and Row, 1974), 127–28.

 Jackie too had been raised: Manchester, 318.

197 *The scene Stoughton captured:* Manchester, 316, 321.

198 *In taking the oath:* Alexis de Toqueville, *Democracy in America,* ed. J. P. Mayer, trans. George Lawrence (Garden City, N.Y.: Anchor Books, 1969), 698–99 (pt. 4, chap. 7). See Matthew A. Pauley, *I Do Solemnly Swear: The President's Constitutional Oath: Its Meaning and Importance in the History of Oaths* (Lanham, Md.: University Press of America, 1999).

200 *By the time David painted:* Monneret, 162–63; John Canaday, *Mainstreams of Modern Art* (New York: Holt, Rinehart and Winston, 1959), 21.

201 *Before, during, and immediately:* See Richard B. Trask, *That Day in Dallas: Three Photographers Capture on Film the Day President Kennedy Died* (Danvers, Mass.: Yeoman Press, 2000), 45–51; quotation from 48.

202 *George Tames, the "Times" photographer:* "A Day with John F. Kennedy," *New York Times Magazine,* Feb. 19, 1961, 10–13.

 Years later Tames: George Tames, interviewed by Donald A. Ritchie for the Senate Oral History Program, Senate Historical Office, Jan. 13–May 16, 1988, Interview 5: The Story Behind the Photograph, available online at *www.archives.gov* under Records of Congress, Special Collections, Oral Histories. See also George Tames, *Eye on Washington: Presidents Who've Known Me* (New York: HarperCollins, 1990).

205 *Along with Garry Winogrand's:* Norman Mailer, *The Presidential Papers* (New York: Putnam, 1963), 48.

206 *Together, these various pictures:* See Joseph Leo Koerner, *Caspar David Friedrich and the Subject of Landscape* (New Haven: Yale University Press, 1990), 155–66, 179–82, and, on the *Rückenfigur* and Romantic poetry, 182–85. Thanks to Jennifer Roberts for pointing out to me the resemblance between the "turned-away" Kennedy photos and Friedrich's paintings.

 The Vathis photograph appeared: Sheryle Leekley and John Leekley, *Moments: The Pulitzer Prize Photographs* (New York: Crown, 1978), 52.

209 *This sympathetic image:* Observers at the time remarked on the similarity of the new president to the aging Gary Cooper in *High Noon;* see Manchester, 625.

 As a terrible irony would have it: Marianne Means, Hearst Newspapers, "Horror of Attack Recalls JFK's Death," *Winston-Salem Journal,* Sept. 14, 2001.

212 *In tone and attitude:* Bosley Crowther review, *New York Times,* Jan. 31, 1964, reprinted in Peter M. Nichols, ed., *The New York Times Guide to the Best One Thousand Movies Ever Made* (New York: Times Books, 1999), 231–32.

218 *Four decades have passed:* As Jean Davison notes in *Oswald's Game* (New York: Norton, 1983), "There are only two theories of history: blunder and conspiracy. Broadly speaking, these were the only theories about Dallas, as well. It was an act of random violence or a plot. Choose the first, and you run head on into the conclusion that history—life itself— is chaotic and meaningless. Choose the second, and history is a racket run by unseen, all-powerful conspirators" (16). Asked to decide between an absurdly haphazard universe and a malevolent but carefully organized one, many observers have preferred the latter.

219 *A headline written:* Scott Dikkers and Mike Loew, eds., *Our Dumb Century: The Onion Presents 100 Years of Headliners from America's Finest News Source* (New York: Three Rivers Press, 1999), 101.

220 *Oswald, himself a former marine:* Featuring Van Heflin, *Cry of Battle* (1963) has sometimes been confused with *Battle Cry* (1955), which also stars Heflin. Don DeLillo accurately describes *Cry of Battle* in *Libra* (New York: Penguin Books, 1988), 411–13, though, for dramatic purposes, he inaccurately places it, rather than the other feature on the double bill that day, on screen when Oswald enters the theater.

222 *Earlier in 1963:* James Jones, "Phony War Films," *Saturday Evening Post,* Mar. 30, 1963, 64–67; quotation from 64. Oliver Stone's *JFK* invokes the Infallible Father paradigm when the movie's Jim Garrison says in his closing statement, "We have all become Hamlets in our country—children of a slain father-leader whose killers still possess the throne." I quote from the screenplay for *JFK* as given in Oliver Stone and Zachary Sklar, *"JFK": The Book of the Film. The Documented Screenplay* (New York: Applause Books, 1992), 176.

226 *During World War II:* Audie Murphy's remark is quoted in Sol Chaneles and Albert Wolsky, *The Moviemakers* (New York: Vineyard Books, 1974), 366. For Wilde's epigram, see "The Decay of Lying" (1889), in Oscar Wilde, *The Artist as Critic: Critical Writings of Oscar Wilde,* ed. Richard Ellmann (New York: Random House, 1969), 307, 311, and 320; the Wilde quotation in the paragraph that follows is from 312.

The blurring of lines: See Albert Furtwangler, *Assassin on Stage: Brutus, Hamlet, and the Death of Lincoln* (Urbana: University of Illinois Press, 1991). The Harris quotation is from M. Christopher New, "The Search for the Real John Wilkes Booth," *America's Civil War* (Mar. 1993): 36.

227 *Take, for instance, the publication:* Art Simon, *Dangerous Knowledge: The JFK Assassination in Art and Film* (Philadelphia: Temple University Press, 1996), 71–74. See also Gerald Posner, *Case Closed: Lee Harvey Oswald and the Assassination of JFK* (New York: Random House, 1993), 106–9.

229 *Completed in 1874:* Michael Richman, *Daniel Chester French: An American Sculptor* (1976; reprint, Washington, D.C.: National Trust for Historic Preservation, 1983).

230 *When America entered:* Public Relations Department of Avco Research and Advanced Development Division; caption from the reverse of photograph 7B-22390, in Herbert Stephen Desind Collection (1997-0014), Smithsonian National Air and Space Museum, Washington, D.C.

232 *Less than two weeks:* Marina Oswald's biographical testimony is in *Hearings before the President's Commission on the Assassination of President John F. Kennedy*, 26 vols. (Washington, D.C.: Government Printing Office, 1964), 18:628–29. Exhibit 933, her handwritten testimony in Cyrillic, is reproduced on pp. 548–95; Exhibit 934, the typewritten translation, is on pp. 596–642. The original documents can be viewed at the National Archives and Record Administration in the Marina Oswald biography file, RG 272, Entry 9, Box 46.

The origins of: See "A Brief History of the NRA" for the quotation from the organization's co-founder, William Church, online at *www.nrahq.org/history.asp.*

233 *Public outrage over:* Sen. Carl Hayden, quoted in Robert Sherrill, *The Saturday Night Special* (New York: Charterhouse, 1973), 173, 181.

234 *When the Dallas police:* Norman Mailer, *Oswald's Tale: An American Mystery* (New York: Random House, 1995), 757; Posner, 398.

Tony Zoppi: Tony Zoppi, quoted in Posner, 355–56.

Jada Conforto: Jada Conforto, quoted in Posner, 356. Diana Hunter and Alice Anderson, two of Ruby's "girls," published an affectionate tribute to him in *Jack Ruby's Girls* (Atlanta: Hallux, 1970), dedicated to "Jack Ruby, Our Raging Boss, Our Faithful Friend, the Kindest-Hearted Sonuvabitch We Ever Knew."

With its own splash: [Jack Kroll], "I Got Principles," *Newsweek*, Dec. 9, 1963, 44.

235 *When Earl Warren: The Witnesses: Selected and Edited from the Warren Commission's Hearings by the "New York Times,"* intro. by Anthony Lewis (New York: McGraw-Hill, 1964), 407.

236 *Naturally, critics:* Quotations here and in the paragraph that follows are from Mailer, *Oswald's Tale*, 750–51; Ruby testimony, *Witnesses*, 410.

Said Tony Zoppi: Newsweek, Dec. 9, 1963, 44.

In its summation: Warren Commission Report, 240–42; Barbie Zelizer, *Covering the Body: The Kennedy Assassination, the Media, and the Shaping of Collective Memory* (Chicago: University of Chicago Press, 1992); Marya Means, "The Long Vigil," *Reporter*, Dec. 19, 1963, 15–17, quoted in Zelizer, 72.

237 *Of the three national:* I quote from my own transcription of the NBC News broadcast, Nov. 24, 1963, reel 66 in Moving Pictures Division collection, Library of Congress, Washington, D.C.

The technology permitting: Paul Dickson, *From Elvis to E-Mail* (Springfield, Mass.: Federal Street Press, 1999), 136.

239 *From his perch on high:* Jack Beers, quoted in Richard B. Trask, *Pictures of the Pain: Photography and the Assassination of President Kennedy* (Danvers, Mass.: Yeoman Press, 1994), 463–64.

This is the "before" picture: Bob Jackson, quoted in Sheryle Leekley and John Leekley, *Moments: The Pulitzer Prize Photographs* (New York: Crown, 1978), 56.

244 *The photography critic:* John Coplans, intro. to *Weegee's New York: Photographs, 1935–1960* (New York: te Neues, 1996), 7.

245 *Feminist critics have noted: Witnesses,* 408.

248 *Bob Jackson's photo:* Richard Brilliant, *My Laocoön: Alternative Claims in the Interpretation of Artworks* (Berkeley and Los Angeles: University of California Press, 2000).

CHAPTER NINE: SALUTE

252 *The Roman peace monument:* Lady Bird Johnson, *A White House Diary* (New York: Holt, Rinehart and Winston, 1970), 8–9.

253 *Months later, when:* Edith Hamilton, *The Greek Way,* (New York: Norton, 1942), 243, 203.

255 *Like Bobby Kennedy:* Tacitus, *The Annals of Imperial Rome,* trans. and intro. by Michael Grant, rev. ed. (Baltimore: Penguin Books, 1959), 117–18.

 West contributed: Alexander Nemerov, "The Ashes of Germanicus and the Skin of Painting: Sublimation and Money in Benjamin West's *Agrippina,*" *Yale Journal of Criticism* 11 (spring 1998): 11–27.

 The germinal neoclassicism: Jules David Prown, *American Painting: From Its Beginnings to the Armory Show* (New York: Rizzoli, 1980), 39; Prown told me the *Agrippina* anecdote March 4, 2001.

258 *Whether the various:* Andy Warhol and Pat Hackett, *POPism: The Warhol Sixties* (New York: Harcourt Brace Jovanovich, 1980), 60.

 Some panels: Keith Tester, *Media, Culture, and Morality* (London: Routledge, 1994), 109–16, argues that the Jackie paintings transform moments of genuine personal and public grief into repetitive pop art collages and, in so doing, resemble television and other entertainment media in numbing the emotions and dulling the moral sensibilities of the viewer.

259 *One of the first:* Sidra Stich, *Made in U.S.A.: An Americanization in Modern Art, the Fifties and Sixties,* exhib. cat. (Berkeley and Los Angeles: University of California Press, 1987), 206 n. 23.

260 *For some viewers:* Frank O'Hara, quoted in Victor Bockris, *Warhol* (New York: Da Capo, 1977), 187; David Bourdon, *Warhol* (New York: Abrams, 1989), 181.

 In the "Jackie Triptych": Klaus Honnef, *Warhol, 1928–1987: Commerce into Art,* trans. Carole Fahy and I. Burns (Cologne: Taschen, 1990), 66.

 To see the paintings: John Giorno, quoted in Bockris, 186.

 Warhol, whether: Art Simon, in *Dangerous Knowledge: The JFK Assassination in Art and Film* (Philadelphia: Temple University Press, 1996), examines some of the art of the sixties and seventies that was produced in response to the Kennedy assassination. On the social and psychological implications of Warhol's forms, see Thomas Crow, "Saturday Disasters: Trace and Reference in Early Warhol," in *Modern Art in the Common Culture* (New Haven: Yale University Press, 1996), 49–65; and Hal Foster, "Death in America," in *Who Is Andy Warhol?,* ed. Colin MacCabe with Mark Francis and Peter Wollen (London and Pittsburgh: British Film Institute and Andy Warhol Museum, 1997), 117–30. In 1968, before a near-fatal attempt on his own life by a would-be assassin, Warhol returned to the subject of JFK's killing with a folio of prints entitled *Flash—November 22, 1963.*

See Joseph W. Brandon, "You Are There: Andy Warhol's *Flash—November 22, 1963*," in *Dear Print Fan: A Festschrift for Marjorie B. Cohn*, ed. Craigen Bowen, Susan Dackerman, and Elizabeth Mansfield (Cambridge, Mass.: Harvard University Art Museums, 2001), 175–80.

261 *He had even achieved:* Christopher Andersen, *Jack and Jackie: Portrait of an American Marriage* (New York: Avon Books, 1997), 322.

262 *Jackie was the guest:* Andersen, 341. See also Humphrey Burton, *Leonard Bernstein* (New York: Doubleday, 1994), 330–31. On Jackie's lingering distaste for the kissing episode, see Ralph G. Martin, *A Hero for Our Time: An Intimate Story of the Kennedy Years* (New York: Ballantine Books, 1984), 358–59.

 In an influential essay: Leonard Bernstein, "Mahler: His Time Has Come" (1967), in Bernstein, *Findings* (New York: Simon and Schuster, 1982), 256 and 261.

 Later, explaining: Bernstein, 257.

264 *Bernstein dedicated:* Burton, 336–38; Meryle Secrest, *Leonard Bernstein: A Life* (New York: Knopf, 1994), 288–89. In remarks delivered at a United Jewish Appeal benefit event on the night of the president's funeral, Bernstein explained why he had chosen to perform the *Resurrection* symphony on nationwide TV the previous evening. See Bernstein, "Tribute to John F. Kennedy," in Bernstein, *Findings*, 216–18.

 Kennedy cultivated: Thomas C. Reeves, *A Question of Character: A Life of John F. Kennedy* (New York: Free Press, 1991), 394.

 Photographs in the press: Bob Booker and Earl Doud, producers, *The First Family*, featuring Vaughn Meader (New York: Cadence Records, 1962). On fatherhood in the fifties and sixties, see Robert L. Griswold, *Fatherhood in America: A History* (New York: Basic Books, 1993), 185–218; and Arlene Skolnick, *Embattled Paradise: The American Family in an Age of Uncertainty* (New York: Basic Books, 1991).

267 *The ultimate photographic record:* Henry Jenkins, "Dennis the Menace, 'The All-American Handful,'" in *The Revolution Wasn't Televised: Sixties Television and Social Conflict*, ed. Lynn Spigel and Michael Curtin (New York: Routledge, 1997), 118–35. On TV and domestic change in the postwar era, see Lynn Spigel, *Make Room for TV: Television and the Family Ideal in Postwar America* (Chicago: University of Chicago Press, 1992); and Cecelia Tichi, *Electronic Hearth: Creating an American Television Culture* (New York: Oxford University Press, 1991). James B. Hill, the audiovisual archivist at the John Fitzgerald Kennedy Library, informed me on August 21, 2002, that no clear record exists to confirm whether the president actually did call his son John John (or, in the alternate spelling, John-John).

269 *The ten-page photo spread:* "The President and His Son," *Look*, Dec. 3, 1963, 26–34, 36.

 The "Look" spread: Stanley Tretick, quoted in Edward Klein, *All Too Human: The Love Story of Jack and Jackie Kennedy* (New York: Pocket Books, 1997), 317.

270 *The wire service photos:* Irving Shulman, *"Jackie"! The Exploitation of a First Lady* (New York: Trident Press, 1970).

271 *Callas met Aristotle Onassis:* Arianna Stassinopoulos, *Maria Callas: The Woman behind the Legend* (New York: Simon and Schuster, 1981), 287.

272 *Callas was not the only one:* Stassinopoulos, 252–53; Klein, 316–18.

Temperamentally, Jacqueline: See Nicholas Gage, *Greek Fire: The Story of Maria Callas and Aristotle Onassis* (New York: Knopf, 2000), 197–214.

When Onassis learned: Stassinopoulos, 254–55.

273 *Bobby Kennedy had read:* William Manchester, *The Death of a President: November 20–November 25, 1963* (New York: Harper and Row, 1967), 432, 382 (my interpolation). The quotations in the paragraphs that follow are from 432 and 383.

274 *The Reverend King:* Taylor Branch, *Parting the Waters: America in the King Years, 1954–1963* (New York: Simon and Schuster, 1988), 918.

Burning at the slight: Taylor Branch, *Pillar of Fire: America in the King Years, 1963–1965* (New York: Simon and Schuster, 1998), 250. On the FBI's taping of King, see David J. Garrow, *The FBI and Martin Luther King, Jr.: From "Solo" to Memphis* (New York: Norton, 1981), 109–10.

275 *Malcolm X:* Branch, *Parting the Waters*, 874. See *The Autobiography of Malcolm X*, with the assistance of Alex Haley, intro. by M. S. Handler, epilogue by Alex Haley (New York: Grove Press, 1966), 300–301. The speech that preceded the "chickens coming home to roost" remark is "God's Judgment of White America," in *The End of White World Supremacy: Four Speeches by Malcolm X*, ed. with an intro. by Imam Benjamin Karim (New York: Arcade, 1989); see 136–46 on JFK's complicity with "Uncle Tom" black leaders in co-opting the March on Washington.

Public opinion studies: Carl M. Brauer, *John F. Kennedy and the Second Reconstruction* (New York: Columbia University Press, 1977), 312–13. See also Bradley S. Greenberg and Edwin B. Parker, eds., *The Kennedy Assassination and the American Public: Social Communication in Crisis* (Stanford, Calif.: Stanford University Press, 1965).

In her memoir: Anne Moody, *Coming of Age in Mississippi* (New York: Dell, 1968), 353–54.

277 *Although the officials:* Manchester, 485.

278 *A more recent touch:* Kevin G. Barnhurst and John C. Nerone, "The President Is Dead: American News Photography and the New Long Journalism," in *Picturing the Past: Media, History, and Photography*, ed. Bonnie Brennen and Hanno Hardt (Urbana: University of Illinois Press, 1999), 83; Manchester, 578.

"In principle," Kaprow: Allan Kaprow, "An Artist's Story of a Happening," *New York Times*, Oct. 6, 1963. For another firsthand look at the Happenings by a member of the Fluxus group who made his name pushing pianos off the roofs of buildings, see Al Hansen, *A Primer of Happenings and Time Space Art* (New York: Something Else Press, 1965).

279 *Although Happenings were meant:* See Allan Kaprow, "A Statement" and "Eighteen Happenings in Six Parts," in Michael Kirby, ed., *Happenings: An Illustrated Anthology* (New York: Dutton, 1965), 44–83, where the epigraph from Chekhov can also be found.

In December 1963: Barbara Rose, *Claes Oldenburg* (New York: Museum of Modern Art, 1970), 185. For the script of *Autobodys*, see Kirby, ed., 262–71, and for notes on the production, 272–88.

279 *As unlikely as it may:* McGeorge Bundy, quoted in Manchester, 603. Had Jackie's voice been heard during the funeral proceedings, her moral splendor might have been diminished. Instead, she remained augustly silent, her evocative televisual presence imbued with a haunting vocal absence. See Norman Mailer, *The Presidential Papers* (New York: Putnam, 1963), 93–98, for a wickedly funny critique of the first lady's vocal mannerisms on the occasion of her nationally broadcast tour of the White House. On the cold, astringent purity of silence in high modernist art and poetry, see the essay entitled "The Aesthetics of Silence" (1967), in Susan Sontag, *Styles of Radical Will* (New York: Farrar, Straus and Giroux, 1969), 3–34.

282 *The photograph comes from:* The Stroop Report, intro. to facsimile ed. by Andrzej Wirth (New York: Pantheon Books, 1979), and information provided in worksheet no. 26543 from the Photo Archives of the United States Holocaust Memorial Museum in Washington, D.C.

283 *"Life" cropped the picture: Life,* Dec. 6, 1963, 159.

285 *When the president's wife: Sacramento Bee,* Nov. 25, 1963.

 A firsthand observer: Charles Roberts, *The Truth about the Assassination* (New York: Grosset and Dunlap, 1967), 15.

286 *Nietzsche claimed:* Friedrich Nietzsche, *The Birth of Tragedy* (1872).

SELECT BIBLIOGRAPHY

JFK BIOGRAPHIES, BIBLIOGRAPHIES, AND STUDIES

Blair, Joan, and Clay Blair, Jr. *The Search for JFK*. New York: Berkeley Publishing; distributed by Putnam, 1976.

Bradlee, Benjamin C. *Conversations with Kennedy*. New York: Norton, 1975.

Brogan, Hugh. *Kennedy*. New York: Longman, 1996.

Brown, Thomas. *JFK: History of an Image*. Bloomington: Indiana University Press, 1988.

Crown, James Tracy. *The Kennedy Literature: A Bibliographical Essay on John F. Kennedy*. New York: New York University Press, 1968.

Dallek, Robert. *An Unfinished Life: John F. Kennedy, 1917–1963*. Boston: Little, Brown, 2003.

Giglio, James N. *John F. Kennedy: A Bibliography*. Westport, Conn.: Greenwood Press, 1995.

Hamilton, Nigel. *JFK: Reckless Youth*. New York: Random House, 1992.

Hellmann, John. *The Kennedy Obsession: The American Myth of JFK*. New York: Columbia University Press, 1997.

Hersh, Seymour. *The Dark Side of Camelot*. Boston: Little, Brown, 1997.

Hunt, Conover. *JFK for a New Generation*. Dallas: The Sixth Floor Museum and Southern Methodist University Press, 1996.

Mailer, Norman. *The Presidential Papers*. New York: Putnam, 1963.

Martin, Ralph G. *A Hero for Our Time: An Intimate Story of the Kennedy Years*. New York: Macmillan, 1984.

Parmet, Herbert S. *Jack: The Struggles of John F. Kennedy*. New York: Dial Press, 1980.

Reeves, Richard. *President Kennedy: Profile of Power*. New York: Simon and Schuster, 1993.

Reeves, Thomas C. *A Question of Character: A Life of John F. Kennedy*. New York: Free Press, 1991.

Schlesinger, Arthur M., Jr. *A Thousand Days: John F. Kennedy in the White House*. Boston: Houghton Mifflin, 1965.

ON JACQUELINE BOUVIER KENNEDY ONASSIS

Abbott, James A., and Elaine M. Rice. *Designing Camelot: The Kennedy White House Restoration*. New York: Van Nostrand Reinhold, 1998.

Baldrige, Letitia, with menus and recipes by White House Chef René Verdon. *In The Kennedy Style: Magical Evenings in the Kennedy White House*. New York: Doubleday, 1998.

Birmingham, Stephen. *Jacqueline Kennedy Bouvier Onassis*. New York: Grosset and Dunlap, 1978.

Bowles, Hamish. *Jacqueline Kennedy: The White House Years. Selections from the John F. Kennedy Library and Museum*. Exhib. cat. New York: Metropolitan Museum; Boston: Bulfinch Press, 2001.

Bradford, Sarah. *America's Queen: The Life of Jacqueline Kennedy Onassis*. New York: Viking, 2000.

Cassini, Oleg. *A Thousand Days of Magic: Dressing Jacqueline Kennedy for the White House*. New York: Rizzoli, 1995.

Davis, John H. *Jacqueline Bouvier: An Intimate Memoir*. New York: Wiley, 1996.

Editors of *Life*. *Remembering Jackie: A Life in Pictures*. New York: Warner Books, 1994.

Gaines, Jane M. "Dead Ringer: Jacqueline Onassis and the Look-Alike." In Jane M. Gaines, *Contested Culture: The Image, the Voice, and the Law*, 84–104. Chapel Hill: University of North Carolina Press, 1991.

Heymann, C. David. *A Woman Named Jackie: An Intimate Biography of Jacqueline Bouvier Kennedy Onassis*. New York: Lyle Stuart, 1978.

Kelleher, K. L. *Jackie: Beyond the Myth of Camelot*. New York: Xlibris, 2001.

Kelley, Kitty. *Jackie Oh*. New York: Ballantine Books, 1979.

Klein, Edward. *Just Jackie: Her Private Years*. New York: Ballantine Books, 1998.

Koestenbaum, Wayne. *Jackie under My Skin: Interpreting an Icon*. New York: Farrar, Straus and Giroux, 1995.

Learning, Barbara. *Mrs. Kennedy: The Missing History of the Kennedy Years*. New York: Free Press, 2001.

Mulvaney, Jay. *Jackie: The Clothes of Camelot*. New York: St. Martin's Press, 2001.

Pottker, Jan. *Janet and Jackie*. New York: St. Martin's Press, 2001.

Shulman, Irving. *"Jackie"! The Exploitation of a First Lady*. New York: Trident Press, 1970.

Spoto, Donald. *Jacqueline Bouvier Kennedy Onassis: A Life*. New York: St. Martin's Press, 2000.

ON JACK AND JACKIE'S MARRIAGE AND THE EXTENDED KENNEDY FAMILY

Andersen, Christopher. *Jack and Jackie: Portrait of an American Marriage*. New York: Morrow, 1996; Avon Books, 1997.

Collier, Peter, and David Horowitz. *The Kennedys: An American Drama*. New York: Summit Books, 1984.

Davis, John H. *The Kennedys: Dynasty and Disaster, 1848–1984*. New York: McGraw-Hill, 1984.

Kessler, Ronald. *The Sins of the Father: Joseph P. Kennedy and the Dynasty He Founded*. New York: Warner Books, 1996.

Klein, Edward. *All Too Human: The Love Story of Jack and Jackie Kennedy*. New York: Pocket Books, 1997.

Mahoney, Richard D. *Sons and Brothers: The Days of Jack and Bobby Kennedy*. New York: Arcade, 1999.

Rachlin, Harvey. *The Kennedys: A Chronological History, 1823–Present*. New York: World Almanac, 1986.

Smith, Amanda, ed. *Hostage to Fortune: The Letters of Joseph P. Kennedy*. New York: Viking Press, 2001.

Steel, Ronald. *In Love with Night: The American Romance with Robert Kennedy*. New York: Simon and Schuster, 2000.

Taraborrelli, J. Randy. *Jackie, Ethel, Joan: Women of Camelot*. New York: Warner Books, 2000.

Thomas, Evan. *Robert Kennedy: His Life*. New York: Simon and Schuster, 2000.

Whalen, Richard J. *The Founding Father: The Story of Joseph P. Kennedy*. New York: New American Library, 1964.

Wills, Garry. *The Kennedy Imprisonment: A Meditation on Power*. Boston: Little, Brown, 1982.

ON OSWALD

Davison, Jean. *Oswald's Game*. New York: Norton, 1983.

DeLillo, Don. *Libra*. New York: Viking Press, 1988.

Loken, John. *Oswald's Trigger Films: "The Manchurian Candidate," "We Were Strangers," "Suddenly"?* Ann Arbor, Mich.: Falcon Books, 2000.

McMillan, Priscilla Johnson. *Marina and Lee*. New York: Harper and Row, 1977.

Mailer, Norman. *Oswald's Tale: An American Mystery*. New York: Random House, 1995.

Sites, Paul. *Lee Harvey Oswald and the American Dream*. New York: Pageant Press, 1967.

Stafford, Jean. *A Mother in History*. New York: Farrar, Straus and Giroux, 1966.

ON RUBY

Belli, Melvin M., with Maurice C. Carroll. *Dallas Justice: The Real Story of Jack Ruby and His Trial*. New York: David McKay, 1964.

Hunter, Diana, and Alice Anderson. *Jack Ruby's Girls*. Atlanta: Hallux, 1970.

Kantor, Seth. *Who Was Jack Ruby?* New York: Everest House, 1978.

Wills, Garry, and Ovid Demaris. *Jack Ruby*. New York: Da Capo, 1994.

Bishop, Jim. *The Day Kennedy Was Shot*. New York: Funk and Wagnalls, 1968.

Manchester, William. *The Death of a President: November 20–November 25, 1963*. New York: Harper and Row, 1967.

President's Commission on the Assassination of President John F. Kennedy. *The Warren Commission Report*. 1964. Reprint. New York: St. Martin's Press, 1992.

Report of the Select Committee on Assassinations. Washington, D.C.: Government Printing Office, 1979. Issued simultaneously as *The Final Assassinations Report* (New York: Bantam Books).

The Witnesses: Selected and Edited from the Warren Commission's Hearings by the New York Times, with an Introduction by Anthony Lewis. New York: McGraw-Hill, 1965.

CHRONOLOGIES OF EVENTS, NOVEMBER 22–25, 1963

Associated Press. *The Torch Is Passed*. New York: Associated Press, 1963.

Dallas Morning News. *November 22: The Day Remembered*. Dallas: Taylor Publishing, 1990.

United Press International and American Heritage Magazine. *Four Days: The Historical Record of the Death of President Kennedy*. New York: American Heritage Publishing, 1964.

ON CONSPIRACIES, CONSPIRACY THEORIES, AND THE CULTURE OF CONSPIRACY

Fenster, Mark. *Conspiracy Theories: Secrecy and Power in American Culture*. Minneapolis: University of Minnesota Press, 1999.

Frewin, Anthony (compiler). *The Assassination of John F. Kennedy: An Annotated Film, TV, and Videography, 1963–1992*. Westport, Conn.: Greenwood Press, 1993.

Groden, Robert J. *The Killing of a President: The Complete Photographic Record of the JFK Assassination, the Conspiracy, and the Cover-Up*. New York: Viking Penguin, 1993.

Hofstadter, Richard. *The Paranoid Style in American Politics, and Other Essays*. New York: Knopf, 1965.

Knight, Peter. *Conspiracy Culture: From Kennedy to "The X-Files."* New York: Routledge, 2001.

Knight, Peter, ed. *Conspiracy Nation: The Politics of Paranoia in Postwar America*. New York: New York University Press, 2002.

Lasch, Christopher. "The Life of Kennedy's Death." *Harper's* (October 1983): 32–40.

Meagher, Sylvia. *Accessories after the Fact: The Warren Commission, the Authorities, and the Report*. 1967. Reprint, New York: Vintage Books, 1992.

Melley, Timothy. *Empire of Conspiracy: The Culture of Paranoia in Postwar America*. Ithaca, N.Y.: Cornell University Press, 1999.

Oglesby, Carl. *The Yankee and Cowboy War: Conspiracies from Dallas to Watergate*. Kansas City: Sheed Andrews and McMeel, 1976.

Orr, John. "Conspiracy Theory: *JFK* and the Nightmare on Elm Street Revisited," in *The Art and Politics of Film*, 82–106. Edinburgh: Edinburgh University Press, 2000.

Pipes, Daniel. *Conspiracy: How the Paranoid Style Flourishes and Where It Comes From*. New York: Free Press, 1997.

Posner, Gerald. *Case Closed: Lee Harvey Oswald and the Assassination of JFK*. New York: Random House, 1993.

Rosenbaum, Ron. "Oswald's Ghost," in *Travels with Dr. Death and Other Unusual Investigations*, 55–91. New York: Penguin, 1991.

Scott, William E. *November 22, 1963: A Reference Guide to the JFK Assassination*. Lanham, Md.: University Press of America, 1999.

Simon, Art. *Dangerous Knowledge: The JFK Assassination in Art and Film*. Philadelphia: Temple University Press, 1996.

Sondheim, Stephen, with John Weidham. *Assassins*. New York: Theatre Communications Group, 1991.

Stone, Oliver, and Zachary Sklar. *"JFK": The Book of the Film. The Documented Screenplay*. New York: Applause Books, 1992.

Thompson, Josiah. *Six Seconds in Dallas: A Micro-Study of the Kennedy Assassination*. New York: Bernard Geis Associates, 1967.

ON PHOTOGRAPHY, PHOTOJOURNALISM, AND NEWS REPORTING

Appel, Alfred, Jr. *Signs of Life*. New York: Knopf, 1983.

Fulton, Marianne. *Eyes of Time: Photojournalism in America*. Boston: A New York Graphic Society Book published by Little, Brown in Association with the International Museum of Photography at George Eastman House, 1988.

Goldberg, Vicki. *The Power of Photographs: How Photographs Changed Our Lives*. New York: Abbeville, 1991.

Kozol, Wendy. *Life's America: Family and Nation in Postwar Photojournalism*. Philadelphia: Temple University Press, 1994.

Loengard, John. *What They Saw: Life Photographers*. Boston: Little, Brown, 1998.

Policoff, Jerry. "The Media and the Murder of John F. Kennedy." *New York Times*, Aug. 8, 1975, 28–37. Revised and expanded with Robert Hennelly as "JFK: How the Media Assassinated the Real Story." *Village Voice*, Mar. 31, 1992; reprinted in Oliver Stone and Zachary Sklar. *"JFK": The Book of the Film. The Documented Screenplay*. New York: Applause Books, 1992.

Trask, Richard B. *Pictures of the Pain: Photography and the Assassination of President Kennedy*. Danvers, Mass.: Yeoman Press, 1994.

———. *Photographic Memory: The Kennedy Assassination, November 22, 1963*. Dallas: The Sixth Floor Museum, 1996.

———. *That Day in Dallas: Three Photographers Capture on Film the Day President Kennedy Died*. Danvers, Mass.: Yeoman Press, 2000.

Zelizer, Barbie. *Covering the Body: The Kennedy Assassination, the Media, and the Shaping of Collective Memory* (Chicago: University of Chicago Press, 1992).

PICTORIAL RECORDS OF THE KENNEDYS AND THEIR ERA

Anthony, Carl Sferrazza. *The Kennedy White House: Family Life and Pictures, 1961–1963.* New York: Touchstone, 2001.

Kenney, Charles. *John F. Kennedy: The Presidential Portfolio, History as Told through the John F. Kennedy Library and Museum.* New York: PublicAffairs, 2000.

Lowe, Jacques. *JFK Remembered.* New York: Gramercy Books, 1993.

MacNeil, Robert, ed. *The Way We Were: 1963, the Year Kennedy Was Shot.* New York: Carroll and Graf, 1988.

Shaw, Mark. *The John F. Kennedys: A Family Album.* Revised and expanded version of 1964 edition. New York: Rizzoli, 2000.

Stoughton, Cecil. *The Memories: JFK, 1961–1963.* New York: Norton, 1973.

VIDEO/DVD DOCUMENTARIES CONTAINING RELEVANT FILM AND TELEVISION FOOTAGE FROM BEFORE AND AFTER THE ASSASSINATION

Four Days in November (Los Angeles: MGM/UA Studios, 1964; released on video in 2000).

Images of an Assassination: A New Look at the Zapruder Film (Orland Park, Ill.: MPI Home Video, 1998).

JFK: The Day the Nation Cried (New York: V.I.E.W. Video, 1989).

The Men Who Killed Kennedy (New York: A&E Entertainment, 1988; released on video in 1996).

The Speeches of John Kennedy (Orland Park, Ill.: MPI Home Video, 1990).

PICTURE CREDITS

Artists Rights Society: FIG. 55 (Francis Bacon, *Three Studies of the Human Head*, 1953, oil on canvas, triptych. Private collection—courtesy Massimo Martino S.A., Mendrisio, Switzerland. © 2003 The Estate of Francis Bacon/ARS, New York/DACS, London); FIG. 97 (Andy Warhol, *Jackie [The Week That Was]*, 1963, acrylic and silkscreen ink on canvas, sixteen panels. Private collection. © 2003 Andy Warhol Foundation for the Visual Arts/ARS, New York); FIG. 98 (Andy Warhol, *Jackie Triptych*, 1964, acrylic and silkscreen ink on canvas. Ludwig Collection, Cologne [Photo: Rheinisches Bildarchiv Köln]. © 2003 Andy Warhol Foundation for the Visual Arts/ARS, New York)

Boeing Historical Archive: FIG. 81 (*Boeing News*, July 1941)

Corbis: FIG. 45 (© Bettmann/CORBIS); FIG. 46 (© Bettmann/CORBIS); FIG. 47 (© Bettmann/CORBIS, photo by Walt Cisco); FIG. 54 (© Bettmann/CORBIS); FIG. 61 (© Bettmann/CORBIS, photo by Stanley Tretick); FIG. 96 (© CORBIS); FIG. 106 (© Bettmann/CORBIS); FIGS. 108, 110 (© Bettmann/CORBIS)

Fraenkel Gallery: FIG. 33 (Garry Winogrand, *Democratic National Convention, 1960*, gelatin silver print. Courtesy Fraenkel Gallery, San Francisco. © Estate of Garry Winogrand)

Galella, Ron: FIG. 43 (October 7, 1971, Jackie walking on Madison Avenue while Ron Galella took several photographs of her. Photo by Joy Smith. © 1974 Ron Galella, all rights reserved)

International Center of Photography: FIG. 88 (Weegee [Arthur Fellig], *Anthony Esposito, Accused "Cop Killer,"* 1941, gelatin silver print. © Weegee/International Center of Photography/Getty Images)

Jackson, Bob: FIG. 85 (Jack Ruby shooting Lee Harvey Oswald, Photo © Bob Jackson); FIG. 86 (The same photo, digitally manipulated by George E. Mahlberg, photo © Bob Jackson)

Jerry Ohlinger's Movie Material Store: FIG. 8 (*North by Northwest*, 1959, MGM); FIG. 9 (*The Birds*, 1963, Universal Pictures [now MCA/Universal Pictures]); FIG. 28 (*The Donna Reed Show*, produced by Screen Gems Television, broadcast on ABC, now distributed by Columbia TriStar Television); FIG. 35 (*Tom Jones* advertisement, 1963, United Artists); FIG. 36 (*Lawrence of Arabia*, 1962, Columbia Pictures); FIG. 40 (*Sunset Boulevard*, 1950, Paramount Pictures); FIG. 49 (*The Grapes of Wrath*, 1940, 20th Century Fox Film Corporation); FIG. 71 (*High Noon*, 1952, United Artists); FIG. 102 (*To Kill a Mockingbird*, 1962, Universal International Pictures)

John Fitzgerald Kennedy Library: FIG. 100 (Photo by Cecil Stoughton)

Library of Congress, Prints and Photographs Division: FIG. 27 (Dorothea Lange, *Migrant Mother*, 1936); FIGS. 103, 104 (*Look* Magazine Collection, photos by Stanley Tretick)

Los Angeles Times: FIG. 39 (Photo by Bill Beebe)

Lowe, Jacques: FIGS. 21, 44 (© Jacques Lowe/Jacques Lowe Visual Arts Project, Inc.)

Lyndon Baines Johnson Library: FIGS. 62, 66 (Photos by Cecil Stoughton)

Metropolitan Museum of Art, New York: FIG. 6 (Edward Hopper, *Office in a Small City*, 1953, oil on canvas, 28 × 40 in. © The Metropolitan Museum of Art, George A. Hearn Fund, 1953 [53.183], all rights reserved); FIG. 64 (Jacques-Louis David, *The Death of Socrates*, 1787, oil on canvas, 51 × 77 1/4 in. © The Metropolitan Museum of Art, Catharine Lorillard Wolfe Collection, Wolfe Fund, 1931 [31.45])

National Air and Space Museum, Smithsonian Institution: FIG. 82 (Courtesy of Lycoming Engines via National Air and Space Museum, NASM Videodisc No. 7B-22390)

National Archives and Records Administration: FIGS. 77, 79, 83, 90, 94 (Courtesy of JFK Assassination Records Collection)

National Gallery of Art: FIG. 13 (Winslow Homer, *Breezing Up [A Fair Wind]*, 1876, oil on canvas, 24 3/16 × 38 3/16 in. National Gallery of Art, Washington, Gift of the W. L. and May T. Mellon Foundation. Photo © 2003 Board of Trustees, National Gallery of Art, Washington)

New York Public Library: FIG. 3 (*Photoplay*, November 1963. Cover. Billy Rose Theatre Collection, The New York Public Library for the Performing Arts, Astor, Lenox and Tilden Foundations)

New York Times: FIG. 67 (Photo by George Tames/The New York Times)

Pepsi-Cola Company: FIG. 51

Philadelphia Museum of Art: FIG. 18 (John Singleton Copley, *Portrait of Mr. and Mrs. Thomas Mifflin [Sarah Morris]*, 1773, oil on ticking, 61 5/8 × 48 in. Philadelphia Museum of Art: Bequest of Mrs. Esther B. Wistar to the Historical Society of Pennsylvania in 1900 and acquired by the Philadelphia Museum of Art by mutual agreement with the Society through the generosity of Mr. and Mrs. Fitz Eugene Dixon, Jr., and significant contributions from Mrs. Myer Eglin, and other donors, as well as the George W. Elkins Fund and the W. P. Wilstach Fund. Photo by Graydon Wood, 1999)

Photo Researchers: FIGS. 17, 19, 23, 69 (© Mark Shaw/Photo Researchers)

Photofest: FIG. 1 (*Pillow Talk*, 1959, Universal International Pictures); FIG. 2 (*Cleopatra*, 1963, 20th Century Fox Film Corporation); FIG. 4; FIG. 5 (*National Velvet*, 1944, MGM); FIG. 7 (*Rear Window*, 1954, Paramount Pictures; re-released by MCA Universal Pictures); FIG. 10 (*Blow-Up*, 1966, MGM); FIG. 11 (*Bonnie and Clyde*, 1967, Warner Brothers/Seven Arts); FIG. 14 (*The Seven Year Itch*, 1955, 20th Century Fox Film Corporation); FIG. 15 (*Roman Holiday*, 1953, Paramount Pictures Corporation); FIG. 16 (*Niagara* advertisement, 1953, 20th Century Fox Film Corporation); FIG. 32 (*Citizen Kane*, 1941, RKO); FIG. 34 (*Dr. No*, 1962, Danjaq Productions; distributed by United Artists); FIG. 38 (Photofest/Icon Archives); FIG. 41 (*Private Property*, 1960, Citation Films, Inc.); FIG. 46; FIG. 48 (*The Beverly Hillbillies*, CBS Television); FIG. 53 (New York production of *Marat/Sade*, 1965, photo by Morris Newcombe); FIG. 57 (*Last Year at Marienbad*, 1961; distributed in the United States by Astor Picture Corporation); FIG. 58 (*The General*, 1927, United Artists); FIG. 70 (*High Noon*, 1952, United Artists); FIG. 72 (*Dr. Strangelove*, 1963, Columbia Pictures); FIG. 74 (*Have Gun Will Travel*, CBS Television); FIG. 75 (*He Walked by Night*, 1949, Eagle-Lion Films, Inc.); FIG. 76 (*Cry of Battle*, 1963, Allied Artists Pictures Corporation); FIG. 78 (*To Hell and Back*, 1955, Universal Pictures Company, Inc.); FIG. 99 (CBS Television); FIG. 101 (*The Andy Griffith Show*, CBS Television); FIG. 105 (Photo by Houston Rogers)

Sixth Floor Museum at Dealey Plaza: FIGS. 50, 56, 59 (Zapruder Film © 1967 [Renewed 1995], The Sixth Floor Museum at Dealey Plaza, Dallas, all rights reserved); FIG. 87 (Photo by Bill Winfrey, Tom Dillard Collection)

Time: FIG. 12 (© 1953 TIME, Inc., reprinted by permission; photo by Hy Peskin/TimePix); FIG. 51 (© 1964 TIME, Inc., reprinted by permission); FIGS. 59, 110 (© 1963 TIME, Inc., reprinted by permission)

TimePix: FRONT, p. viii (Photo by Carl Mydans); FIG. 12 (Photo by Hy Peskin); FIG. 29 (Photo by Paul Schutzer); FIG. 37 (Photo by Art Rickerby); FIG. 107 (Photo by Ed Clark)

University of Michigan Museum of Art: FIG. 26 (Julia Margaret Cameron, *The Kiss of Peace*, ca. 1865, albumen print, 9 1/8 × 7 1/8 in. University of Michigan Museum of Art, Museum Purchase, 1975/1.63)

United States Holocaust Memorial Museum: FIG. 109 (Main Commission for the Prosecution of the Crimes against the Polish Nation, courtesy of United States Holocaust Memorial Museum Photo Archives)

Yale University Art Gallery: FIG. 95 (Benjamin West, *Agrippina Landing at Brundisium with the Ashes of Germanicus*, 1768, oil on canvas, 5 ft. 4 1/2 in. × 7 ft. 10 1/2 in. Yale University Art Gallery, Gift of Louis M. Rabinowitz)

INDEX

INDEX

Kennedy, John F. (JFK) *(continued)*
finger-pointing gesture of, *96, 146, 147, 148;* funeral coffin of, 213, 215, 273; gravesite of, 108, 225, 278; hair of, 85; health problems of, 106, 113, 129, 202, 297n; in Hyannis Port garden photo, *68,* 69–70; image making of, xi–xii, 6–7, 43–44, 106–7, 269; inaugural address of, 94–95, 97, 99–100; inaugural ball photo of, 95, *96,* 97–98; and Jackie-Agnelli liaison, 26; Jackie's comments on, 92, 94, 108, 130, 283; literary tastes of, 44, 47–48, 98–100, 107–8; Loneliest Job photo of, 202–4, *203;* Marat-Sade duality of, 179, *180,* 303n; on marrying a virgin, 60; Monroe movie poster of, 53, 294n; *On the Road* analogy to, 143–45; in Oregon diner photo, 77, *78;* poverty concerns of, 89–90, 160–61; presidential limo of, 150–51, *152; Rear Window* analogy to, 20, 291n; risky activities of, 106–7, 108, 297n; *Rückenfigur* (figure seen from behind) motif of, 202, *203,* 203–7, *204, 205;* sailing photo of, 39, 41–42, *42;* sexual attractiveness of, 43, 124–26, *125;* sexual exploits of, 26, 44, 62, 81, 179, 303n; Sinatra's campaign anthem for, 9; style/substance notions of, 133–34, 135–36, 139; weight concerns of, 129–30; Zapruder's feelings for, 3, 4, 264. *See also* assassination of JFK; funeral of JFK

Kennedy, John F., Jr. (JFK, Jr.), xi; birth of, 95, 264; death of, 272; with JFK, on *Look* cover, 267, *268;* at JFK's funeral, 252, *253, 257;* nickname for, 267, 309n; in Oval Office, *265, 268,* 269, *270;* salute of, 280, *281,* 283–84, *284*

Kennedy, Joseph (JFK's father): Catholicism concerns of, 93; extramarital exploits of, 5, 44–45, 47; film business of, 5–6; image-making role of, 6, 20, 43–44, 72; and Jackie's wardrobe, 120; and JFK divorce rumors, 80–81; net worth of, 89

Kennedy, Patrick (JFK's son), 14, 151, 269

Kennedy, Robert F. (RFK, JFK's brother), 4, 89, 167; anti-Communism stance of, 63–64; as Apollonian, 287; classicism's influence on, 253–54; with Jackie, after JFK's assassination, *214;* and JFK's funeral, *253, 257,* 273–74; at JFK's reinterment, *254*

Kennedy, Teddy (JFK's brother), 81, *253*

The Kennedy Obsession (Hellmann), 6

Kerouac, Jack, *On the Road,* 143–46

Kerr, Deborah, 43

Ketcham, Hank, 267, 269

Khrushchev, Nikita, 90, 121, 132

killers. *See* villains

The Killers (film), 77

The Killing of a President (Groden), 183

King, Martin Luther, Jr., 93, 134, 167, 274–75

King Kong (film), 6

Kinsey Report, 52–53, 60, 293–94n

Kiss of Death (film), 245

The Kiss of Peace (Cameron), 86

Kitchen Debate (Nixon and Khrushchev), 90, 132

Kitson, Henry Hudson, 230

Klein, Edward, 45, 296n

Koestenbaum, Wayne, 292n

Kraft Theater (TV series), 128

Krock, Arthur, 202

Kubrick, Stanley, 9–10, 212, 231

laissez-faire economics, 49

Lamb, Lady Caroline, 48

Lancaster, Burt, 43

Lange, Dorothea, 87–88

Lansbury, Angela, 17

Laocoön and His Sons (Hellenistic sculpture), 248–49, *249,* 255

Last Year at Marienbad (film), 25, 185

Lawford, Pat (JFK's sister), 124

Lawrence, T. E., 113–15

Lawrence of Arabia (film), 113–15, *114*

Lean, David, 113

Leave It to Beaver (TV series), 157

Leavelle, James R., 240, *241, 242*

Taylor, Elizabeth, 7, 73; in *Cleopatra*, 2, *11*; as host of TV documentary, 290n; Jackie compared to, 10–14, *12, 13*; in *Suddenly Last Summer*, 127

Teague, Walter, 132

television: as communication medium, 258–59, 308n; consumerism message on, 158–59; fatherhood images on, 265–66, *266*; hillbilly stereotypes of, 161; husband images on, 123; "idiotcom" populism of, 157; instant replay technology of, 237–38; JFK's funeral on, 278; motherhood images on, 90–92, *91*; poverty's treatment on, 89, 158; shooting of Oswald on, 236–37, 238–39; Warhol's criticism of, 258; wartime coverage on, 30–31; Zapruder film on, 28, 31

Tennyson, Alfred, Lord, "Ulysses," 98–100

Tester, Keith, 308n

Texas School Book Depository (Dallas), 18, 164

Texas Theater (Dallas): and Biograph theater, parallel with, 227; films featured in, 221–22, *222, 223*; and Hitchcock's *Saboteur*, parallel with, 219–20; make-believe/reality in, 226; Oswald's arrest in, 223

That Touch of Mink (film), 8

That Was the Week That Was (TV series), 259–60

The Thin Red Line (Jones), 222

The Third of May, 1808 (Goya), 246

Thirty-nine Steps (Buchan), 107

Thomas, Albert, 201

Thompson, Florence, 88

Thompson, Josiah, 171

Three Studies of the Human Head (Bacon), 179, *181*

The Thrill of It All (film), 8

Thucydides, 254

Thy Neighbor's Wife (Talese), 51

Till, Emmett, 56

Time (magazine), 13, 132, 274; on *The Birds*, 24, 25; on Kennedy divorce rumors, 80–81, 295n; on *Marat/Sade*, 177, 178

Tippit, J. D., 164, 220

Tobacco Road (Caldwell), 161

Tobacco Road (film), 161

To Be or Not to Be (film), 226

Tocqueville, Alexis de, 198

Todd, Michael, 14

To Hell and Back (film), 225

To Kill a Mockingbird (film), 266, *267*

Tolstoy, *Anna Karenina*, 76–77

Tom Jones (Fielding), 111

Tom Jones (film), 111–13, *112*, 123, 141–42

Tonkin Resolution (1964), 213

Topper, Burt, 223

Tournament of Roses (Pasadena, California), 153

Tracy, Spencer, 6

The Train Enters the Station (film), 2

Trask, Richard, 201

Tretick, Stanley, 269, 272

Truffaut, François, 25

Truman, Harry, 137

Trumbo, Dalton, 64, 291n

Trumbull, John, 72

Tucker, Richard, 60

TV Guide (magazine), 24, 90

TW3 (TV series), 259–60

Twenty Jackies (Warhol), 257

The Twilight Zone (TV series), 128, 136–37

Two Men Contemplating the Moon (Friedrich), 206

"Ulysses" (Tennyson), 98–100

uncertainty principle, 172

underground films. *See* film noir

Understanding Media (McLuhan), 135, 258

Underworld (DeLillo), 36

Valley Hunt Club (Pasadena, California), 153

Van Dyke, Dick, 185

Vathis, Paul, Camp David photo by, *204*, 204–5, 206–7

Vedon, René, 130

Z (film), 30

Zanuck, Darryl, 158

Zapruder, Abraham, 1; background of, 3–4; death of, 166; grief of, 264; sale of film by, 163–64; Warhol's ties to, 36

Zapruder film: bootlegged viewings of, 36–37, 166; camera used for, 163, 173; cinematic power of, 14–15, 37; commodity status of, 163–64, 167–68; Connally's examination of, 165–66; dadaism of, 34; existentialism of, 185; freeze-framing of, 173; House Committee's review of, 167; *Life*'s enlarged frames of, 28, 164–65, *165, 186, 189*; loner villain of, 15, 17; narrative structure of, 4–5; nouvelle vague traits of, 24, 25, 28, 29; as political thriller, 30; reaction time component of, 32–33; roses' color in, 117; sadness of, 1–2, 3; as scientific evidence, 170–71; star power of, 5, 7; televised broadcast of, 28, 31. *See also* Zapruder film analogues

Zapruder film analogues: *L'Avventura* as, 25, 34–35; *Blow-Job* as, 34–35; *Blow-Up* as, 28; *Bonnie and Clyde* as, 29–30; in color-field painting, 182–84; *Death of Marat* as, *175*, 176, 177, 181; *The General* as, 187–88; *Marat/Sade* as, 180–81; *North by Northwest* as, 21; in pop art, 182; in popular culture, 9–10; *Rear Window* as, 19–21; Rothko paintings as, 183–84; *Sleep* as, 31–32, 34; *Three Studies of the Human Head* as, 179, *181. See also* Zapruder film

Zelizer, Barbie, 236

Zola, Émile, 33

Zoppi, Tony, 234, 236

Zorba the Greek (film), 270

Zorba the Greek (Kazantzakis), 270

DESIGNER	Victoria Kuskowski
INDEXER	Patricia Deminna
TEXT	11/14.25 Walbaum
DISPLAY	Radiant and Didot Display
COMPOSITOR	Integrated Composition Systems
PRINTER AND BINDER	Friesens Corporation